6⁰⁰

TREASURES

OF

THE JEWISH MUSEUM

This catalogue is dedicated to the Centennial of The Jewish
Theological Seminary of America which established
The Jewish Museum in 1904.

The Jewish Museum
is under the auspices of
The Jewish Theological Seminary of America

TREASURES
OF
THE JEWISH MUSEUM

NORMAN L. KLEEBLATT VIVIAN B. MANN

WITH AN ESSAY BY COLIN EISLER

THE JEWISH MUSEUM, NEW YORK

UNIVERSE BOOKS
New York

The exhibition, Treasures of the Jewish Museum, and the accompanying catalogue, were funded by grants from the National Endowment for the Arts, a Federal agency, the S. H. and Helen R. Scheuer Family Foundation, the Joe and Emily Lowe Foundation, Inc., and the Morris S. and Florence H. Bender Foundation, Inc., as well as an anonymous donor.

Additional funding for the catalogue was provided by The Lucius N. Littauer Foundation.

Published in the United States of America in 1986 by Universe Books 381 Park Avenue South, New York, N.Y. 10016

86 87 88 89 90 / 10 9 8 7 6 5 4 3 2 1

Printed in Japan

Library of Congress Cataloguing in Publication Data

Jewish Museum (New York, N.Y.)

Treasures of the Jewish Museum.
"The Jewish Museum, New York."
Bibliography: pp. 207
1. Jewish Museum (New York, N.Y.) — Catalogs.
2. Jewish art and symbolism — Catalogs. 3. Judaism —
Liturgical objects — Catalogs. 4. Art, Jewish — Catalogs.
5. Art — New York (N.Y.) — Catalogs. I. Kleeblatt,
Norman L. II. Mann, Vivian B. III. Title.
N620. J48A67 1986 704'.03924'07401471 85-28913
ISBN 0-87663-493-5
ISBN 0-87663-890-6 (pbk.)

Editor: Sheila Schwartz

Catalogue and Exhibition Graphics Design: George Sadek and Mindy Lang

Installation Design: Stuart Silver

Cover Illustration:

front:
Torah Shield
Augsburg, ca. 1715
Zacharias Wagner (ca. 1680-1733)
Silver: repoussé, cast, engraved and gilt
16 5/8 x 11 15/16 in. (42.2 x 30.3 cm)
Gift of Dr. Harry G. Friedman, F70c

back:
El Lissitzky (Russian 1890-1940)
Illustration for *An Only Kid (Ḥad Gadya)*
Kiev, 1919
Colored lithograph on paper
Promised gift of Leonard and Phyllis Greenberg

TABLE OF CONTENTS

The history of Jewish art has largely been written from the vantage points of religious practice and social history. Little acknowledgment has been given either to the stylistic milieu in which the works were created or to their artistic and iconographic sources outside the realm of Jewish life. *Treasures of The Jewish Museum* provides a long overdue opportunity to place some of The Jewish Museum's finest works in their artistic context.

In effect, our approach is "revisionist." This adjective has frequently been applied to art historical literature of the last two decades, which has broadened the study of art beyond formalistic concerns to include social, religious, political, and economic issues. The revisionist approach has resulted in the expansion of the corpus available for study because of the broadened and more intricate context in which art is viewed. Ironically, the traditional historical view of Jewish art has generally taken the new "revisionist" approach, but in a narrow sense; it has focused on Jewish history and social values and ignored the influence of contemporaneous dominant cultures. Jewish art history was largely oblivious to the formal stylistic, iconographic, and ideological analysis that dominated art history for most of the twentieth century. The lack of rigorous scholarship and the narrow approach of that which was published led to the neglect of Jewish art within general art history. Just as the study of Jewish art ignored general art historical concerns, so the world of art history ignored Jewish art.

The aim of this exhibiton is to create an integrated view of treasures from The Jewish Museum's collection with the goal of making each work accessible on several levels. The works were chosen first for their intrinsic aesthetic value, with an eye toward their stylistic relationship to the art of their time. In many cases, these treasures also reflect the iconographic concerns of non-Jewish parallels in addition to specifically Jewish symbolism and function. Other works have become treasures because of their rarity or unusual character.

We feel privileged to have been able to choose from one of the world's great collections of Jewish art. The Jewish Museum is the custodian of antiquities, numismatics, ceremonial art of all media, paintings, graphics, sculpture, and photography that draw upon Jewish culture of the last three millenia. The result was often a plenitude of great works in some areas and a paucity in others. Because of the patterns of Jewish immigration to the United States, European art is well represented, whereas works of Jewish art from the Near East are less numerous. At the same time, we recognize that The Jewish Museum's collection, as that of any such assemblage, is the remnant of the riches that once existed and were destroyed with the communities that treasured them. In effect, the corpus of Jewish art today, though largely the product of the last five centuries, is more akin in character to the fragmentary corpus of an ancient art than to its contemporaneous creations. Each work in this exhibition is the rare survivor of a once larger group. At the same time, the art is, for most periods, that of an extremely small cultural minority without the resources and freedom of a majority.

We recognize that this catalogue is only the beginning of an integrated view of these works, limited by the amount of space allotted for discussion, and affected by our own tastes and those of our time. At the same time, it has been exciting to use this opportunity to bring to public attention many previously unknown works. In our need to cover the many periods and styles of Jewish art we have been helped by discussion with numerous colleagues: Charles Avery, Christie's London; Caroline Keane, Jean Malley, and Marica Vilcek of the Metropolitan Museum of Art, New York; Catherine Lippert of the Nelson-Atkins Gallery, Kansas City; Grace Grossman and Shalom Sabar of the Jack Skirball Museum, Los Angeles; Edward van Voolen of the Jewish Museum, Amsterdam; Evelyn Cohen, Menahem Schmelzer, and Ismar Schorsch of The Jewish Theological Seminary of America, New York; David McFadden of the Cooper-Hewitt Museum, New York; Jay Weinstein of Sotheby Parke Bernet, New York; also Dennis Corrington, Peter J. Prescott, and J. E. Sillevis. We also benefited from discussing individual works with the conservators who restored them: Konstanze Bachman, Judith Eisenberg, Hermes Knauer, Charles von Nostitz, Patsy Orlofsky, and Victor von Reventlow.

No exhibition at The Jewish Museum is mounted without a concerted effort by its staff. Joan Rosenbaum, Rosemarie Garipoli, and Board Vice-Chairman Stuart Silver contributed toward the conceptualization of *Treasures of The Jewish*

Museum. We also profited from discussions on individual works with Emily D. Bilski, Susan Braunstein, Irene Z. Schenck, Sharon J. Makover, Nancy Satuloff, and Karen Wilson. Anita Friedman and Irene Schenck also did extensive research on many of the paintings, graphics, and sculpture. Diane Lerner, Tamar Finkelstein, Barbara Treitel, and intern Mitchell Stein gave indispensible technical assistance. We also wish to thank all members of the administrative and operations staff without whom the exhibition could never have been realized.

The efforts of Adele Ursone, Eileen Schlesinger, and the staff at Universe Books afforded us the possibility of a richer publication than would otherwise have been possible. We are especially grateful to George Sadek and Mindy Lang whose enthusiasm and refined taste are reflected in the beautiful appearance of the book. Sheila Schwartz helped us to create the format of the book and guided us in our writing.

As always in a scholarly endeavor, the research of our predecessors at The Jewish Museum is both a stimulus and a challenge. We are grateful to them for having acquired many of the treasures from which we were able to choose. We also thank all the patrons who saw The Jewish Museum as the appropriate home for many important works of art related to Jewish life.

NLK VBM

The moment just past
is extinguished forever
save for the things made by it.
George Kubler,
The Shape of Time

Jewish culture and all the material forms that relate to it determine the collecting process in a Jewish museum. Consequently, art and artifacts gathered for exhibition and study cross many boundaries, and include works of historic, artistic, and religious significance. Ethnographic material, folk art, archaeological artifacts, and documentary photography are collected along with ceremonial metalwork, textiles, numismatics, painting, and sculpture. Objects produced over a period of four thousand years and originating from all over the world attest to the antiquity and geographic dispersion of the Jewish people. Seen in the context of a museum, these works embody a complex set of meanings.

The majority of works in The Jewish Museum collection were made for the rituals and ceremonies of Jewish religious life. Their content and purpose is rooted in the continuity of Jewish values and traditions, while their aesthetic variety documents the broad historic and geographic range of the Jewish visual arts. Moreover, the beauty of these ceremonial objects attests not only to the reverence of the users, but to the artists' adaptation of prevalent artistic styles.

Painting and sculpture represent a smaller part of The Jewish Museum's collection but these works complement and enhance the ceremonial objects. Depicting Jewish personalities, customs, and environments, they comment on the meaning of Jewish life and history, and explore the issues of Jewish identity from the perspectives of both Jewish and non-Jewish artists. The acquisition of fine arts involves knotty questions of appropriateness, and in this regard the museum has taken a broad view, collecting material that is both specifically and implicitly related to Jewish culture: by virtue of the subject depicted; because of the implicit intent of the artist; or because a work by a Jewish artist represents a significant contribution to the history of art.

Because of the catastrophic history of the Jewish people, there are relatively few art works and artifacts available. The collection of The Jewish Museum thus provides precious evidence of an ancient but dispersed culture and its historical relationship with other societies. In this sense, the whole collection is a treasure through which one can discover an artistic patrimony, a past history, and a self-identity within the process of continuity and change.

In the development of The Jewish Museum, there are three particularly outstanding aspects. The first is the nature of the values and ideals of those German Jews who, at the end of the 19th century, founded The Jewish Theological Seminary of America and, eighteen years later, created The Jewish Museum. The second is the destruction of European Jewry during the Holocaust, and the resulting dispersion of the material culture that remained. The third is the Jewish identity and connoisseurship of collectors involved in donating large bodies of material as well as individual works, from the founding of the museum to the present.

The Jewish Museum came into existence at the same time as a number of Jewish museums in European cities. Their establishment reflected the concerns of post-emancipation assimilated Jews whose cultural self-consciousness generated the possibility of moving a ritual object from its religious context in the synagogue to a museum setting in which the work could promote the scholarly study of Jewish culture. This approach to Jewish life was of interest to American Jews as well. The Jewish Theological Seminary of America, founded in 1866, was established as an educational institution that addressed the scientific study of Judaism while helping Jews nurture an identity that allowed them to remain Jewish yet live a full life in another culture. In 1904, Judge Mayer Sulzberger donated twenty-six objects to the library of the Seminary, thereby establishing The Jewish Museum. In addition to Sulzberger, others with a dedicated, long-range vision—Jacob Schiff, Solomon Schechter, and Cyrus Adler—provided objects that fostered the intellectual environment in which The Jewish Museum took root and flourished. It is therefore particularly fitting that the museum should present this exhibition and catalogue of our greatest treasures during the year in which the Seminary is celebrating its one-hundredth anniversary. We are proud to dedicate *Treasures of The Jewish Museum* in honor of the Centennial of our parent institution.

Cyrus Adler, who became chancellor of the Seminary in the 1920s, epitomized the intellectual idealism of a group of German Jews at the beginning of the new century. Formerly

curator of the Smithsonian Institution, Adler had a vision of a Jewish renaissance in the English-speaking world.[1] A founder of the Jewish Publication Society in 1888, the American Jewish Historical Society in 1892, and the Harvard Semitic Museum (with Jacob Schiff) in 1903, Adler believed that "Judaism, Americanized according to the canons of modern scholarship, could raise the level of knowledge and respect on the part of both Jews and non-Jews for the ancient but still vibrant culture."[2] Information provided by books and art would not only inspire and educate, it would combat anti-Semitism and create a new world of tolerance and understanding.

The founders of The Jewish Museum were also well versed in the origins and uses of Jewish objects, an expertise that significantly influenced the way in which the collection grew. In 1902, for example, Cyrus Adler had persuaded the collector Hadji Ephraim Benguiat to lend his extraordinary collection of Jewish ceremonial art to the United States National Museum (now the Smithsonian Institution), where it remained for twenty-two years. In 1924, when Adler was chancellor of the Seminary, he arranged, with the help of Felix Warburg, the purchase of the collection, making it the first major acquisition for The Jewish Museum since its founding.

Benguiat, born in Izmir, the son and grandson of dealers in antiquities, amassed a broad and distinguished collection from all cultures, including four hundred works that are now part of the collection of The Jewish Museum. The Benguiat collection is important not only because of the large number of Sephardic works, including many fine examples of Ottoman Judaica, but also for its exceptional quality. Passionate and visionary about his collecting, Benguiat was also devoted to the idea of a Jewish museum in America. In a 1931 document in The Jewish Museum Archives, Benguiat states:

> The Jew could not preserve his treasures because he has always been longing to have a country. He has been practically always with a traveling bag on his shoulders and without knowing where he would have to go the very next day. Therefore any antiquities saved from the repeated catastrophes and diaspora are of the greatest value, although they may not all possess the same merit or value as the antiquities of other nations.[3]

The period encompassing World War II and the Holocaust account for approximately 7,500 works, virtually half of The Jewish Museum's collection. This group — primarily ceremonial objects, but also 19th- and 20th-century fine arts — originated from public and private collections created before the war and sent to America for safekeeping as well as from works gathered by individuals and organizations as a means of rescuing the remaining culture from destroyed communities.

Benjamin Mintz and his wife brought their collection of four hundred Polish Jewish objects with them to New York for exhibition at the 1939 World's Fair. The Nazis overran Poland shortly after the Mintzes arrived in America, and the couple and their collection were spared. They remained in New York and, after Benjamin Mintz died in 1957, Rose Mintz made

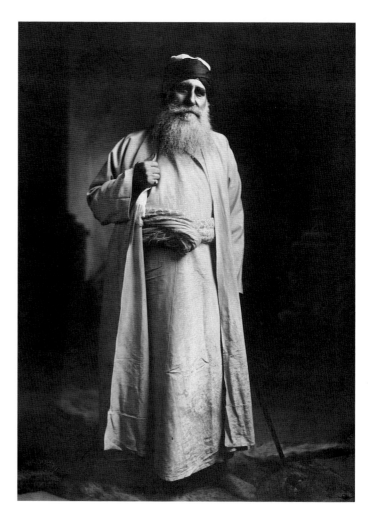

Hadji Ephraim Benguiat originally of Smyrna (Izmir), Turkey.

the collection available to the Seminary, where it became a major resource for The Jewish Museum. Mintz had been a dealer in antiquities. The combination of his knowledge about art, his ardent Zionism, and his devoutness as a Jew contributed to the creation of a collection that reflects a love for all things related to Jewish culture, from paper Simḥat Torah flags to exquisitely embroidered Torah curtains — all chosen with an eye for the original and the authentic.

In 1904, the same year as the founding of The Jewish Museum, Lesser Gieldzinski, art collector, connoisseur, and art adviser to Kaiser Wilhelm II, donated his Judaica collection to the Jewish community of Danzig, where it was housed in a special room in the Great Synagogue, thus establishing one of the early Jewish museums in Europe. In 1939, the American Jewish Joint Distribution Committee, in cooperation with leaders from the Danzig Jewish community, negotiated the shipment of the Gieldzinski collection along with ceremonial objects belonging to the Danzig synagogues and individual Jews to the Jewish Theological Seminary for safekeeping. The stipulation was that these three hundred objects were to be housed in the Seminary. If, after fifteen years, there was still a Jewish community in Danzig, these objects were to be returned. If not, they were to remain in New York "for

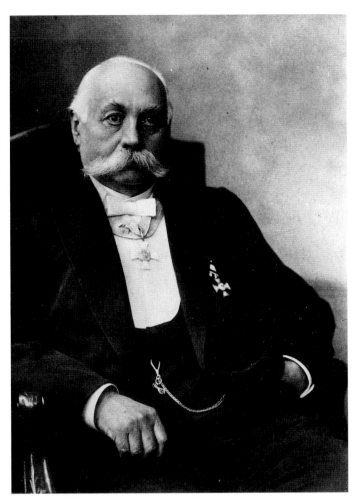

Lesser Gieldzinski of Danzig (1830–1910), ca. 1904.

the education and inspiration of the rest of the world." The works arrived in New York one month before the German army occupied Danzig. The Danzig material, which since 1980 has traveled in an exhibition to cities throughout the United States, Germany, and Israel, is the only collection of Jewish ceremonial art that completely documents the life of a community, and where the provenance of virtually all of the works is known.

Six thousand objects in the collection of The Jewish Museum were gathered and donated by the extraordinary businessman and philanthropist Harry G. Friedman. At the time of the Holocaust, when great collections in Europe were being dispersed, Friedman collected enormous numbers of objects. He did this not only to rescue the works, but also because he believed that, as a matter of history, the works belonged to the public domain and, therefore, that their existence would be perpetuated in The Jewish Museum. Between 1941 and 1965, Friedman donated ceremonial art, fine arts, and archaeological material. Although these works were not documented as well as the Mintz and Danzig collections, Friedman's rabbinical training made him knowledgeable about inscriptions and symbols, and he contributed much valuable information to the museum's records.

A major postwar effort for the rescue of material confiscated from Jewish owners was the Jewish Cultural Reconstruction (JCR), managed by a distinguished committee, including Dr. Guido Schoenberger, who had worked for the Frankfurt Jewish Museum and continued his research at The Jewish Museum in New York. One hundred and twenty objects entered the museum's collection through the effort of the JCR.

Important acquisitons continued to be made in the postwar years, both through the knowledge and generosity of individual collectors and through the vision and expertise of directors and curators. The museum's collection of three thousand coins and medals, for example, is the most distinguished of its kind. Assembled and donated between 1935 and 1948 by the late Samuel Friedenberg and his son Daniel, the collection continues to grow. Today it contains over 80% of all known coins and medals illustrating Jewish history and culture. Individual gifts from numismatics collectors are continually added to the collection, perpetuating a documentation of current Jewish history.

Three hundred ancient coins from the Friedenberg collection augment the museum's biblical archaeological holdings, which are used in exhibitions to document and evoke the ancient history of the Jewish people. Archaeological material was acquired with the Benguiat and Friedman gifts as well as with other smaller and individual donations. In 1973, Joy Ungerleider-Mayerson, then director of the museum, negotiated the acquisition of a group of nearly six hundred excavated pieces found in ancient Israel from the New York University Classics Department. Since then, generous gifts, including the collection of Betty and Max Ratner, acquired in 1981, have added immeasurably to the diversity of the collection.

It has already been noted that the people who were involved with the founding and early development of The Jewish Museum were also involved with its collections. This tendency continued in the postwar period, when both the Judaica and fine arts collections were enhanced by gifts of one or more objects or acquisitions funds. In 1952, the heirs of Jacob Schiff donated over three hundred turn-of-the-century paintings illustrating the Hebrew Bible by James Jacques Tissot. In 1947, Mrs. Felix Warburg (Jacob Schiff's daughter Frieda) presented her former home to the Seminary for use as a museum. She also donated the beautiful 18th-century Frankfurt menorah illustrated on page 83 and the 18th-century English Staffordshire coffee service illustrated on page 105. Mr. and Mrs. Albert List sponsored the building of an addition to The Jewish Museum in 1963, and Mrs. List's interest in the museum's collection of contemporary art continued throughout the years of her involvement. The sculpture by Alan Kirili, Lipchitz's *The Sacrifice,* and Ben Shahn's *ketubbah* are part of her extensive donation (see pp. 204–5 and 188–91).

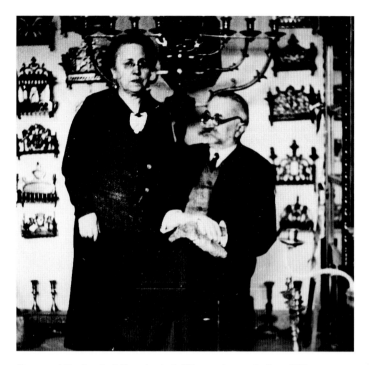

Rose and Benjamin Mintz in their Warsaw home, before 1939.

Just as the ideals, tastes, and ambitions of The Jewish Museum's founders, collectors, and donors shaped the direction of the museum over the years, so did the varying vision of its directors and curators. The museum's move from the Seminary library to the Warburg mansion and, subsequently, its addition of a modern wing has allowed for the installation of a great number of exhibitions that have appealed to a variety of audiences and influenced the museum's collection policy. The museum's interest in avant-garde art during the 1960s, for example, reflects our ongoing willingness and eagerness to collect contemporary art as it relates to the Jewish experience.

It is impossible to mention each person who has contributed to The Jewish Museum collection. We hope, however, that this exhibition and catalogue will serve as a tribute to those who have recognized the importance of collecting art and artifacts for a Jewish museum. The museum setting provides a context in which each object takes on new significance. A pair of Torah finials from 18th-century Frankfurt (p. 85) has a great deal to tell us about Jewish life and patronage in that city. When viewed alongside finials for Torah cases from 19th-century India (p. 49), we learn even more about transformation in Jewish art and culture and the myriad possibilities for adaptation and creativity. Thus the whole of the collection is truly greater than the sum of its individual parts. This totality provides a unique opportunity for presenting interpretive exhibitions, publications, and programs which continue to explore the many aspects of the Jewish experience. It is a challenge we at the museum — staff, trustees, donors, and public — look forward to meeting with energy and passion in the years to come.

Notes

[1]Cohen, Naomi. *Encounter with Emancipation, The German Jews in the United States 1830-1914.* Jewish Publication Society of America, 1984. p. 203.

[2]Ibid, p. 204.

[3]Jewish Museum Archives, document written by Hadji Ephraim Benguiat, 1931.

Sources

1. Jewish Museum files. Information on the collection written by former Assistant Curator Cissy Grossman.

2. Introductions from the following Jewish Museum catalogues: *Danzig 1939: Treasures of a Destroyed Community,* 1980; *Israel in Antiquity,* 1982; *A Tale of Two Cities: Jewish Life in Frankfurt and Istanbul 1750–1870,* 1982; *Coins Reveal,* 1983.

3. Suggestions from Associate Curator, Emily Bilski.

For Rachel Wischnitzer,
still learning and writing
of art's history in our service,
in this, her 101st year.

God is the supreme artist. All creation is his handiwork, with mankind his masterpiece, made from clay shaped in his image, brought to life by his breath.[1] Job, the faithful, suffering servant, pleads his case before God by reminding him: "Your hands shaped and fashioned me, then destroyed every part of me. Consider that You fashioned me like clay; will You then turn me back into dust?" (Job 10:8-9). He appeals to the First Sculptor's pride in his handiwork for his own preservation. God is also seen as a stonecutter, chiseling, cutting, and incising the hardest surfaces, and as a potter.[2] Self-described world architect and builder, the Lord asks Job, "Where were you when I laid the earth's foundations? Speak if you have understanding. Do you know who fixed its dimensions or who measured it with a line? Onto what were its bases sunk? Who set its cornerstones?" (Job 38: 4-6).

God's jealous monopoly of the image, to be codified in the Second Commandment, safeguards the uniqueness, priority, and originality of his initial achievement, the first copyright. Any attempt to duplicate his feat is seen for what it might have been, the making of rival idols. "He sealeth up the hand of every man, that all men may know his work." (Job 37:7). Delivery of the Decalogue is preceded and followed upon by definitive instruction from heavenly to earthly creator, from God to Bezalel, the artisan entrusted with the fabrication of the tabernacle and all its sacred furnishings, the instruments of sacrifice and liturgy.

Like Adam, Bezalel is divinely inspired. The artisan, the personification of earthbound craftsmanship, is "endowed . . . with a divine spirit of skill, ability, and knowledge in every kind of craft" (Ex. 31:3). Those beautiful words are the biblical definition of the highest art, seen as a trinity of special intelligence. "Skill" signifies a special expertise; "ability" pertains to critical, definitive insight; "knowledge" to the mastery of technique.[3] This emphasis upon intelligence, a special holy wisdom, is repeated over and over again in the fashioning of the tabernacle and all its furnishings. God spells these out in extraordinary detail, the dimensions and components entirely of his own devising, as close a reflection of his creative skills as anything in the universe. "Let, then, Bezalel and Oholiab and all the skilled persons whom the Lord has endowed with skill and ability to perform expertly all the tasks connected with the service of the sanctuary, carry out all that the Lord had commanded" (Ex. 36:11).

Few if any other early cultures accord the artist such significance as Bezalel, working as a conscious agent of divine design. Idolatry required the gods to inspire the completed works of art, not their makers. The spirits of the deities first entered their images upon the sculptors' completion of their statues. Even when the importance of the image makers' role was acknowledged, it was also an embarrassment, in potential conflict with the enlivening presence and process of divine action.

Study of the significance of Bezalel's name and those of his forebears and collaborators illuminates biblical concepts of the artist's role in the service of faith. His grandfather (probably also a metal worker) was called Uri, meaning "my light," a critical aspect of all creativity, which, by reflecting upon its source, leads to heightened understanding. Early biblical commentaries relate that Uri was one of those who worshipped the Golden Calf. His grandson's selection for the crafting of the Tabernacle has been understood as an act of contrition and compensation, atoning for Uri's idolatry, and, perhaps, for his possible role in casting the Calf. The artist's father's name is Chur, or "Revelation," a word also associated with freedom or liberation which is central to the artist's vision.[4]

Bezalel's name has been interpreted as signifying "That he made a place of light for God" or "That he made a shelter for God," but a Midrashic legend, a gloss upon the meaning of the artisan's name and role, comes right to the heart of the matter.[5] This account answers the question of why was it not Moses, the leader, lawgiver, and liberator, who was given the honor of conveying the *menorah*'s design. Moses was indeed the first to receive God's directions for its fashioning, not only once but twice, climbing Mount Sinai to obtain such guidance, but forgetting the design upon each descent. The third

*Note: As elsewhere in the catalogue, the new translations of the Hebrew Bible published by the Jewish Publication Society have been used (see p. 25), except when the older, King James Version, is more appropriate.

time God provided him with a *menorah* of fire, yet not even that flamboyant image remained in Moses' mind. God then said to Moses, "Go to Bezalel and he will make it."

When Moses saw the artisan's easy completion of his task, he exclaimed, "To me it was shown many times by the Holy One, blessed be He, yet I found it hard to grasp, but you, without seeing it, could fashion it with your intelligence. Surely you must have been standing in the shadow of God (*bezel-el*) while the Holy One was showing me its construction."

The meaning of his name makes the artist's work the perpetuation of divine outlines, a craft of celestial photography, filling in the contours of a sacred silhouette. The inspired artist enjoys a special proximity to the first creator. The name of Bezalel's fellow worker on the tabernacle, Oholiab, combines the words for "tent" and "father." So, while Oholiab literally "is what he does," Bezalel works where he is, in God's shadow.

Shadow and reflection are also seen at the center of creativity in Greek legends of the origin of art. The maid of Corinth was credited with the discovery of portraiture when, wishing to record the features of her lover who was leaving her, she traced his shadowed profile, cast against the wall by candlelight.[6] Art and love were also united in Ovid's *Metamorphoses,* which tells the story of Narcissus, a fair youth, who was changed into the white flower after his death. During the Renaissance it was believed that Narcissus was the inventor of painting because he accepted illusion as reality.[7] Martyred by the power of reflection, he fell fatally in love with his own image and drowned in the mirrored waters. His love of art as strong as his *Art of Love,* Ovid wrote, "There is a god within us. It is when he stirs that our bosom warms; it is his impulse that sows the seeds of inspiration."

The Midrashic legend of the shadow is close to Neoplatonic concepts of *Idea* and of *disegno interno,* of the drawing within the artist's mind, divine in origin and outline, first a form of inner revelation, then externalized by the artist's illusionistic powers. But Bezalel's art is toward the function, not the image or illusion, of furnishings in the Lord's service, these objects never more or less than themselves.

The artisan's labors, unlike those of legendary creators in other cultures, do not involve an ecstatic loss of consciousness in the mystical transfer of idea from God to man. Adam goes into a deep sleep as his rib is removed for God's creation of Eve but Bezalel enters a state of heightened consciousness for the fullest operation of his creative gifts, the terrestrial parallel to God's powers.[8]

Art in most tongues means no more than work or craft; craft just another form of power or skill. But in the Hebrew perception, art, seen as the very wisest of work, tends to be separated more and more from labor, so, by the time of the Talmud, the two concepts find themselves far apart, "art" at one end of the spectrum and "work" at the other. This view resembles that of Renaissance artists. Reluctant to be seen as lowly artisans, they wanted their skills freed to join the Liberal Arts, in touch with celestial harmony, far from manual labor.[9]

Under Moses, migrant life was freed as much from the shackles of Egyptian material culture as from those of slavery, and art was viewed as dangerous, idolatrous, immoral. A return to the wilderness from the fixed, predictable, agricultural wealth of Egypt was also a return to the ethos of the founding father, to a new fundamentalism, and "back-to-basics," to salvation by God's first creation, nature. These rugged early values are so well sensed by Grace Paley in her essay on "Faith in a Tree":

If it's truth and honor you want to refine, I think the Jews have some insight. Make no images, imitate no God. After all, in His field, the graphic arts, He is pre-eminent. Then let that One who made the tan deserts and the blue Van Allen belt and the green mountains of New England be in charge of Beauty, which He obviously understands, and let man, who was full of forgiveness at Jerusalem, and full of survival at Troy, let man be in charge of Good.[10]

The original Tabernacle with all its contents was designed by God for life and faith on the go—to be kept in a tent. In eight long chapters (Ex. 25-31, 35), he provided the dimensions, stipulated every detail of proportion and shape, acting as architect, planner, designer, and coordinator of his portable sanctuary. Though its two-winged cherubim may have had animal or human heads,[11] and pomegranate motifs were on the priests' robes (Ex. 25:18–20), no other elements conflicted with his Second Commandment—"not to act wickedly and make for yourselves a sculptured image in any likeness whatever: the form of a man or a woman, the form of any beast on earth, the form of any winged bird that flies in the sky, the form of anything that creeps on the ground, the form of any fish that is in the waters below the earth" (Deut. 4:16–18)

The first Tablets of the Law are themselves described as the work of God, and the writing his, engraved by him upon the stone (Ex. 32:15–16). Broken by Moses, their making the second time around was collaborative, with Moses as mason, cutting the two stones and bringing them up Mount Sinai for divine inscription (Ex. 34:1–4).

Fear of art's capacity for abuse is so strong that when God asks for an earthen altar for sacrifices, he adds that should this have to be of stone instead, then the maker should be sure to use the living or uncut rock rather than "hewn stones; for by wielding your tool upon them you have profaned them" (Ex. 20:24–25). These passages come just after the explicit commands "not [to] make any gods of silver, nor shall you make for yourselves any gods of gold" (Ex. 20:23). Close to magic, art must be restrained, inhibited, lest its own great creative powers rival the Lord's. As Isaiah said, "They bow down to the work of their hands" (Isa. 2:8).

Long before, with saving by the Ark and the sacrifice of a ram instead of a son, covenants were sealed between Noah and God, and then Abraham and God, marked by signs on heaven and on earth. For the first, that ultimate "natural ar-

tifice"—the curved and multicolored rainbow—appeared above; with Abraham a visual sign—circumcision—was instituted. Renewed emphasis upon such circular cutting came with the Mosaic return to the wilderness, in all its primal, patriarchal associations. Whether arched in the sky or cut around the flesh, art was to work as an act of witness, a pledge of fidelity. Only the return to that direct communion between God and man allowed by the nomadic life in the landscape of Abraham led to the dispensation of the Decalogue, to those Ten Commandments which codified a reaffirmation of faith.

But after wandering in the wilderness, affluence and a victorious army ended with a new kingdom. A fresh sense of establishment led to a radically different cultural climate, to a new awareness of the need and force of beauty, an awareness embodied in the name of David. A deliberate, unabashed response to the aesthetic is found in the Psalms ascribed to his authorship, with their musicality, poetry, and passionate, compelling quality of autobiography. "O worship the Lord in beauty of holiness" (Ps. 96:9), sang David, where "strength and splendor are in His Temple" (Ps. 96:6). These views are an essential prelude to the lavish ornament, virtuoso craftsmanship, and identification with fabulous wealth which would be part and parcel of his son's patronage of the great new Temple of Jerusalem.

David's unification of the kingdoms of Israel and Judah brought about new wealth and national identity, making the Temple possible. Forbidden by God to build it, because he was a man of war, that honor fell to David's son, a man of judgment (1 Chron. 28:3). But it was to David, by divine inspiration, that the design of the Temple was transmitted; the father then transferring "the plan" for the entire design to his son (1 Chron. 28:11–12). Part of a new, visually sophisticated world, Solomon could write: "A word fitly spoken is like apples of gold in pictures of silver" (Prov. 24:11).

With the construction of his Temple came the enduring paradox of all monumental Jewish art. To honor God in a manner consonant with the apparatus and grandeur of a sovereign state, one far in spirit from the patriarchs' wandering life, Solomon turned to the art and artists of polytheism, to neighboring Phoenicia (present-day Syria), calling upon its king and architect Hiram of Tyre to help build his Temple with gifts of cedars of Lebanon. Now all the proscriptions of the Decalogue, its constant invocations against images, were reinterpreted. Solomon's Temple was an extravaganza of pagan art and ornament. Hundreds of decorative motifs and images were taken from nearby cultures along with their artisans.

New national authority allowed for a lavish theater of piety in the great Temple, with its performance of sacrifice and priestly observances. Not only the look of polytheism, but also its practice was taken over. Solomon, a firm believer in intermarriage, worshipped idols, probably those brought by his pagan brides as part of their dowries (1 Kings 11:4).

So, starting with the wise king's patronage, and down

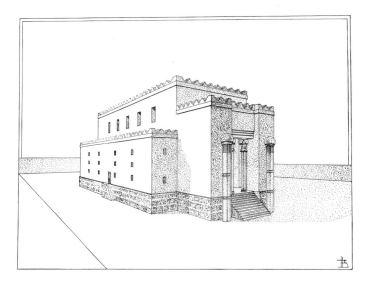

Thomas A. Busink, *The Temple of Solomon,* Reconstruction.

through the ages, there is almost always a factor of irony or tragedy, pathos or even comedy arising from the intrinsic or overt conflict that must exist between the commitment to the absolute of spiritual freedom in the dictates of a migratory, tribal culture, as codified by the Decalogue, and the contrasting, opposing urge to express a sense of security in success, by established achievement. This need necessarily depends upon an adaptation of styles used by affluent neighbors or host societies, be they Phoenician or Greek, Roman or Islamic, Romanesque or Gothic, all worlds of appearance often linked with idolatry or oppression. Thus an "Art Deco" Tel Aviv, a Romanesque Temple Emanuel, a "Miami-Modern" Knesset, or the many Gothic, Islamic, and even Egyptian Revival temples in Europe and America.

Authored in the name of Solomon, the Jewish text with the keenest awareness of the dangers and virtues of art was prepared in Greek by a resident of Alexandria, to warn his Hellenistic co-religionists against the evils of idolatry. Written about the year 50 B.C.E., Solomon's book, entitled *Wisdom,* reminds his readers ". . . both we and our words are in His [God's] hands, as are all understanding and skill in crafts" (7:16). Wisdom, which he equates with all the arts, "is a breath of the power of God. . . . a reflection of eternal light, a spotless mirror of the working of God, and an image of his goodness" (15:26). Torah or wisdom is described in terms of loveliness "more beautiful than the sun, than every constellation, brighter than the light" (7:30).

Solomon of Alexandria speaks of having "loved her [wisdom] and sought her from my youth and I desired her for my bride and I became enamoured of her beauty" (8:2). He contrasts the wise design of the ark's salvation with the folly of crafting pagan idols; divine virtues are compared with the evil intent of artistic illusion, to that "fruitless toil of painters." Though condemning the arts of imitation, Solomon testifies to the enormous Jewish interest in the moral and aesthetic

questions surrounding the power of creativity in classical antiquity.

Lavish synagogues, teeming with the imagery of Greek and Roman mythology, have been brought to light by archaeology in Israel, North Africa, and the Near East. figurative frescoes abound at Dura-Europos, an ancient synagogue in Syria; they take over almost the whole visual repertoire of Greco-Roman faith, adapting its symbolism toward Jewish ends. The same is true for the Jewish catacombs of ancient Rome, which appropriate classical mythology, and also come close to contemporary Christian images as the funerary practices of both religions were much the same. Recent scholarship also points to the derivation of most early Christian biblical imagery from Jewish precedents, taken from Hebrew manuscripts that were often richly illustrated.

After the destruction of Solomon's Temple, no other was allowed to take on its sacrificial role, one that was only to be revived with the Messiah's return to Jerusalem and the Temple's rebuilding. So, following the fall of the Holy City, a most vital aspect of worship, the slaughter of animals and the offering of flesh and oil, left the Jewish service, to be recalled by prayer and symbols. This recreation by art of the instruments of sacrifice, the great oil-burning *menorah* and the altars, underlined the new commemorative role of the synagogue as a center of recollection, of recitation of past glories and of prayer for their return. Solomon's Temple is also central to the dedication and function of every church, each viewed as its spiritual and functional rebuilding. Those four great twisted columns sheltering Saint Peter's most sacred site are called Solomon's, symbolic souvenirs of monotheism's definitive structure. While any three-dimensional reconstructions of the Temple's furnishings were discouraged among Jews, mammoth bronze *menorot* were cast for the altars of many medieval churches, some still so situated, as in Braunschweig (see p. 76).

Throughout the Middle Ages and Renaissance, the finest Christian as well as Jewish artists saw themselves in the role of God's artisan, the name of Bezalel being given to them in praise.[12] It was also applied to Paulinus, the early 4th-century bishop of Tyre, for his building and restoration of churches. Lauding him, Eusebius asked "Whether one should call thee a Bezalel, the architect of a divine tabernacle, or Solomon, the king of a new and far godlier Jeusalem, or even a new Zarubabel, who bestowed upon the temple of God that glory which greatly exceeded the former?"[13]

Without a separate, awesome priestly class, synagogues furthered the communal experience of learning, celebration, and penitence. Writing of these meeting places in the 14th century, a Spanish grammarian, Profiat Duran, observed: "The House of Learning should be beautiful and pleasing in structure. This increases the desire for learning, and strengthens the memory because the viewing of pleasing forms and beautiful reliefs and drawings rejoices the heart and strengthens the mind."[14] All the instruments of the Tem-

Hamman Lif, Tunisia, *Synagogue. Detail of Mosaic Pavement,* second half of the 5th century C.E. New York, The Brooklyn Museum, Museum Collection Fund.

ple are now treated in referential, symbolic, usually two-dimensional form; the Temple became a Messianic hope, a fact of past and future.

Many of art's strengths are, and always were, at our service, in our liturgy and home, wrought for the special observance of holy days, for the design of the synagogue and all its contents, and employed for portraiture, funerary commemoration, and many other uses. Art and literature can perpetuate our memories and feelings, speaking for us when we are gone. Such survival is art's greatest power. A stonecutter's skills can carve sentiments in marble so that the mute stones speak over the centuries. A slab taken from a Jewish graveyard of Roman times still declaims a daughter's love and gratitude. Funerary arts have always been among the strongest throughout our history, sometimes the handiwork of artisans from the host society.

Art's immediacy is so intense that looking at its random remains from thousands of years of Jewish history leads to sadness as well as pleasure. Both are sensed in those domestic works that bear witness to faith and pride in daily life, and to the happy predictability and function of the home. Such decorative objects are signs of hope, even of complacency. But their sense of "belonging" was often doomed to betrayal, by both neighbor and history. These conflicting messages are carried by implication, preserved in ceramic and silver, textile and glass. Just as their making was made possible by belief in heritage, in happy continuity and grace, so does their arbitrary preservation convey unwitting testimony to the terrible consequences of misplaced trust, to the fickle injustice of survival.

Hebrew culture had an unusually productive time when living within the third and final major monotheistic faith, Islam, which believed Abraham to be the first Moslem. Firmest of adherents to the Second Commandment, Mohammed's followers' exquisitely evolved sense of ornament was sympathetic to the many Jewish communities in Islam, who cultivated their hosts' craft skills in weaving, metalwork, leather, and architecture. A Jewish builder is even credited with designing the 11th-century palace of the Alhambra at

Granada.[15] Arabic script, whose beauty nears that of Hebrew, was used by Maimonides in the writing of his *Guide for the Perplexed*. Tribute to this cooperation between two cultures is found in the handsome ceramic synagogue wall with recesses for three Torahs (pp. 38–39). It was probably fired in the mid-16th century in Isfahan, where the lively interlaces of Islam work so well with the dynamic profile of the Hebrew alphabet.

Woven prayer rugs (pp. 44–45), inlaid or embossed ritual vessels (pp. 50–51), hanging lamps, and leather work, all evidence the many ways in which Jewish artisans and Islamic colleagues adapted the decorative vocabulary of a vast empire reaching from the Near East over North Africa to the Iberian peninsula. Theirs was a visual language of remarkable vitality and beauty, where line and letter and color were interwoven in a brilliant mosaic of ornament and meaning soon to be followed in Northern Europe in the medieval manner of so-called Romanesque art. That decorative style, shaped in part by the abstract animal motifs of the Migration, was close to the glories of Islam, so much admired by crusaders and empire builders in the Near East and Sicily.

Kabbalistic and biblical concepts of creativity meant much to one of the greatest of all painters, Jan van Eyck, who studied alchemy as part of his technical education as an artist. Working in the early 15th century, he had some knowledge of Hebrew and Greek as well as Latin. Jan included his monogram in Hebrew letters (*yod, feh, aleph*), which he painted on the hat of a bearded, Semitic figure standing among the Prophets and Virgil on the lower central panel of the Ghent Altarpiece.[16] He may have meant this man to personify Bezalel, the archetypal artist of God. As the painter was probably first trained as a goldsmith, that would make Jan's identification with the divinely inspired artisan of the tabernacle all the more compelling. The Flemish master enframed most of his paintings with a quotation from the *Wisdom of Solomon* which, since early Christian times, had been interpreted as praising the Virgin rather than the Torah. But Jan may also have chosen the passage for that text's (and the Jewish tradition's) equation of art with the highest wisdom, an exaltation of his painting in divine service, placed like Bezalel's art above the altar.

The first Renaissance text on painting compares art to God's work, "which calls for imagination and skill of hand, in order to discover things not seen, hiding themselves under the shadow of natural objects, and to fix them with the hand, presenting to plain sight what does not actually exist."[17] With the Renaissance revival of classical concepts of genius and the new association of the arts of painting and sculpture with the liberal arts, the *Deus artifex* concept reached new popularity. Vasari, the painter, architect, and historian of art, wrote in the mid-16th century that our genesis from the dust of the earth demonstrated how the "Divine Architect of time and nature, being wholly perfect, wanted to show how to create by a process of removing and adding material that was im-

perfect in the same way that good sculptors and painters do when, by adding and taking away, they bring their rough models and sketches to the final perfection for which they are striving."[18]

Christian philosophers' studies of the Talmud and Kabbalah led to a renewed fascination with biblical and later Jewish ideas of divine creativity, and of the artist's parallels to God's handiwork. Movable Hebrew type made such mystical literature widely accessible by the High Renaissance. Much of Michelangelo's frescoed imagery for the Sistine Chapel, meant as a reconstruction of Solomon's temple, drew upon such scholarship.

Writing of the marble *Moses* as "unequalled by any modern or ancient work," Michelangelo's biographer Vasari noted how, about forty years after the statue's Roman installation, "the Jews still go every Saturday in droves to visit and adore it as a divine, not a human thing."[19] Such pilgrimages, if they took place, were more likely made because the statue was part of the tomb of Julius II, who reduced the virulence of the Inquisition against the Jews of Rome, founded by the pope's Borgia predecessor, Alexander VI.

Two of the leading Renaissance masters were named after archangels. "Angel" in Hebrew means messenger, and Michelangelo's name, in terms of his art, is especially significant: "The messenger who is like God." Almost worshiped in his own lifetime, the sculptor-painter-architect was known as "The Divine." By giving his son the name Raphael, the painter Giovanni Santi created a composite name meaning "Holy God heals." In the Book of Tobit the archangel Raphael is entrusted with guarding the spirit of humanity (Tob. 20:31), and is also responsible for restoring the gift of sight. Both Michelangelo and Raphael, along with Leonardo, were keenly aware of their God-like vocation. Vehicles of divinity, they saw themselves as privileged messengers of the Lord's history and eternity.[20]

That Raphael proclaimed himself as heir to Solomon's wisdom and to the Temple's art can be seen by his signature, placed above that building's entrance in his *Marriage of the Virgin* (Milan, Brera). Both he and Michelangelo, in their unusually extensive fresco cycles for the Vatican, the first in the Loggie and the second in the Sistine Chapel, recreated the bible in art. The Loggie's many scenes came to be known as "Raphael's Bible." So these masters, like many artists of lesser stature, saw themselves as prophetic, visionary, and evangelical, recreating God's word by working in his shadow. Such a self-image must have been especially strong for Bernini, Rubens, and Delacroix, all unusually pious Catholic artists. Protestantism, with its waves of iconoclasm and puritanism, often inhibited quite such an overtly personal and immediate identification of mortal with immortal.

God's crafting of those triumphs of mechanical engineering, the monsters Leviathan and Behemoth, anticipates the skills of Rabbi Elijah of Chelm, who devised a Frankenstein-like golem with divine aid, inscribing the lord's name — the

shem — on a tablet as part of the creature's manufacture. Later in the 16th century, the best-known golem — an automaton made to solve the servant problem — was engineered by the chief rabbi of Prague, Judah Löw, known, unsurprisingly, as Bezalel.[21]

"This is for a celebration," the words inscribed above the 145th Psalm on a Dead Sea Scroll, represent the essence of Jewish ceremonial art. Celebration, that dynamic combination of gathering for remembrance, ritual observance, and praise, calls upon many visual and aural resources to increase its vitality and effect. Unlike good children, God is heard but not seen. Voice and word, not sight, communicate his presence and will. But when he "would speak to Moses face to face, as one man speaks to another. . ." (Ex. 33:11), such confrontation led to massive, blinding illumination. Light, streaming from Moses' features, required their veiling (Ex. 34:30–35).

Illumination is always a sign of divine presence, light and truth, *urim* and *tumin.* The effect of light, caused by truth, is revealed by all the liturgical arts. This is made manifest by adding gold and silver to the words, gilding of pages, couching of gold and silver threads on tabernacle curtains, crowning the Torah with glittering gilded coronets and shimmering silver ornament, the use of gleaming ritual goblets and sabbath candlesticks and polished brass or precious *menorot* — all these lighted surfaces reflect the sanctity of their function. fire and rainbows, sun, moon, and stars, crystalline water springing from the rock, the glistening brazen serpent, all are signs of salvation and covenant, truth in light.

More often than not, despite the old saying, "less is more," less is less. Functionalism's credo, that all that is needed for good design is to call attention to the objects' use in the most stripped-down, deliberate fashion, leads to a certain sameness, with wine glass and bathroom tumbler looking just alike. Such monotony fails to convey the important message only ornament can provide — that the object cares. Decoration is that extra gift of time and labor that lends value and interest, it provides signs of love and respect. Embroideries, carvings, hangings, ceremonial embellishments of all sorts proclaim a sense of celebration, a sense of community and communion of ritual power.

Appeals of contrasted visual arrest and movement, opening and closing, of sound and silence, of the Torah dressed in bridal splendor, then stripped to the authority of calligraphy, all these stress significant changes in the order of ritual. They stimulate the mind and the heart, heightening the meaning of the moment. The shape and time of the service are intensified by the artisans' skills. Using light and space, brass and silver, velvet and linen, inlaid woods and glass, all these provide stimuli which, at their best, move one toward greater meaning and being, enlarging the gesture, enhancing sound and sentiment, increasing wisdom, understanding and knowledge "by all manner of workmanship."

Heraldry is the art of power; its symbols and fixed formulae often use animals to betoken vigilance and strength, royalty and leadership. The lion, emblematic of the kings of Judah, is one of heraldry's oldest beasts, found on a seal ring of Shema, steward of Jeroboam, King of Israel, dating from between 922 and 901 B.C.E. The lion's fierce presence stalks through centuries of Jewish ritual art. Referred to in the plural as "a pride," that fine phrase returns to the poetic biblical name for lions as "sons of pride" (Job 28:8). Solomon's great stepped throne had six lions on either side, stressing the noble animals' links to the seat of wisdom. Three pairs of lions fortify a triple-tiered Polish *Seder* set from late-18th-century Danzig (pp. 122-23), giving it ceremonial splendor. Looking like a great bridal or Byzantine crown, the glittering brass circle has a vital heraldic force, enhanced by the animals' powerful presence. Celebrating survival and divine providence, this *pièce de resistance* of the Passover service is itself a trophy, a sign of triumph, the *matzah* within commemorative, edible relics of God's catering. In the 20th century the same ritual object will take on all the architectural rigor and austerity of the Bauhaus, a reflection of the newly stripped-down, functional look that bespoke the True, the Good, and the Beautiful in 1930 (pp. 178-79).

Extraordinarily fine illuminated manuscripts survive from the Jewish communities of medieval Germany along with incised Hebrew tombstones. Post-antique synagogue architecture goes back as far as the year 1000 C.E. with the building at Worms.

In Renaissance Italy, in those areas where their activities were not confined to moneylending, especially the regions around Ferrara, Jews entered the arts and crafts, teaching singing and dancing, and other social skills along with the traditional practice of medicine. Close interest in contemporary Jewish life is reflected in Christian Renaissance painting, which followed the ceremonies of the synagogue in order to create the most authentic renderings of biblical times.

The beautiful tabernacle from Urbino (pp. 52–53), a major North Italian center for the growth of architecture and painting, shows how synagogues shared in the finely devised art of the Renaissance, taking over the harmonious, balanced use of classical elements so important to the painting of Raphael and Bramante, both native to that small town. Purely secular bronze medals, such as that of a rich young woman (pp. 54–55), struck at the time of her marriage, follow an art form first popular in classical antiquity.

Jewish life in 17th-century Holland continued the splendors realized by those of Venice; her most famous souvenirs of our presence other than the great synagogue, are Rembrandt's etchings (pp. 68–69). The Dutch, like the citizens of Venice, identified themselves unusually closely with the children of Israel, their art abounding with biblical subject matter.

Eighteenth-century England, where such artists as Zoffany could establish themselves, was far from typical of that "enlightened" century. Silverwares offered by the Jewish com-

munities to London's Lord Mayors testify to the gratitude and acceptance felt by their donors (pp. 78–79). Elsewhere Jews often had to change their faith to obtain important patronage — a situation true in Vienna until the first World War. Anton Raphael Mengs was baptized at birth in 1728, as were both of his sisters. Their father, a Danish painterly equivalent to Papa Mozart, pushed all three children into the arts; his son became as great a success as Wolfgang Amadeus, known as "the German Raphael."

Unlike most of western continental Europe, where the only acceptable Jewish occupation was usury, Eastern Europe allowed many Jewish craft guilds, so that embroiderers, weavers, and all sorts of metal workers flourished, making fine goods, as had their forefathers in Islamic times and territories.[22] How much of this production was restricted to communal consumption and how much was allowed for sale outside, in competition with Christian guilds, is hard to know. Some of these guilds, such as the weavers, had their own synagogues and burial societies. Abundant folk arts, unusually beautiful *menorot*, and the most original synagogue architecture of wood, are all characteristic of Eastern Europe.

With the legal support of the Napoleonic Code and the moral support of the romantic movement, Jews rapidly entered the mainstream of French and German cultural life. From Walter Scott's Rebecca in *Ivanhoe* (1819) to George Eliot's *Daniel Deronda* (1876), Jews became heroic figures in major novels — *Daniel Deronda* is almost a vision of Zionism. Delacroix's paintings of Tangiers' Jews in 1832 were stirring reminders of the picturesque survival of biblical ways in far-away North Africa.

A marriage seat of 1838 (pp. 146–47) in the elegant Biedermeier manner, was probably used for the veiling of the Jewish bride by her groom. This bourgeois German adaptation of Napoleonic camp classicism manifests the liberation of the Jews of the Hanseatic harbor city of Danzig, who were freed to take on contemporary fashions and life styles. Scenes of Jewish community and piety by Moritz Oppenheim (pp. 148–49), seen through the calm conventions of Ingres, convey the same sense of order and classical security found in Danzig synagogue furniture. A Hanukkah lamp (pp. 142–43) is also in the solidly imperial style taken on by prosperous families in the early 19th century.

The legend of the Wandering Jew put us on the map of western "contemporary" art from the 12th century onward, if only as a symbol of disbelief.[23] Another genre, that of the poor and, by implication, good Jew was first popular in 17th-century Holland. This theme became most widespread in the late 19th century, among such artists as Josef Israëls, Max Liebermann, Lesser Ury, and Sir William Rothenstein. Scenes of humble life and reverence acted as surrogates for these values and virtues among art collectors, working as prayers by pictorial proxy. Such themes always sold well; turning the act of acquisition into one of piety, they realized a new twist on the traditional *imago pietatis*. Reminiscent of the

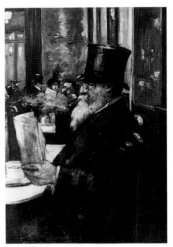

Lessery Ury, *Man Reading Newspaper in Café,* 1910, oil on canvas.

Max Liebermann, *In the Backyard,* 1910, oil on canvas.

Dutch masters, the lovely light of Kaufmann's unfinished *Friday Evening* (pp. 168–69), has a rare sense of serenity. For once, a woman's work allows her the illusion of completion and the pleasure of repose as she lets herself enjoy Sabbath candles she has just blessed, their light doubled by a reflecting mirror.

In the 19th century, though viewed as the century of science, religion was a burning issue. Synagogue and church building boomed beyond all precedent. Their drive to "Dig We Must" led Victorian amateur archaeologists to the rediscovery of biblical cities, to a recovery of historical Hebrew life, paralleling Renan's pursuit of the historical Jesus. This was a period of documentary obsession, beginning with the Pre-Raphaelites's realistic painting that aspired toward sacred truth. Tissot's reconstructions of biblical times typify such infatuation with the "facts" of ancient Hebraic life (see pp. 164–65).

Photography played a major role in innumerable conquests by camera, graphic crusades to the Holy Land, achieved by the fine photographs of Salzmann and Bonfils (pp. 158–59). Daguerre's discovery has been used with distinction by innumerable Jewish photographers, such as Paul Strand, and especially in photo-journalism as practiced by Salomon, the Capas, Penns, and Blumenfeld. (Emmanuel "God is with us" Radenski converted his name into one that is emblematic of his role as photographer and inspired artist — Man Ray.) Just before the Second World War, using a hidden camera, Roman Vishniac photographed the ardent piety and material poverty of Poland's village Jews. Though they feared it as the evil eye, the unseen lens has saved their lives on paper, if not, alas, in fact.

Germany, the *Vaterland* of both art history and so much Jewish art, has with its own inimitable thoroughness done the most, in the very best and the very worst ways, to accentuate our visual heritage. Commissioned in 1895 to design a dec-

orative wrought iron grill with Jewish symbols for a funerary monument, a German architect consulted Heinrich Frauberger, director of Düsseldorf's Industrial Arts and Crafts Museum, whose massive archive contained religious imagery of many faiths. Finding nothing whatever among his 30,000 prints, Frauberger resolved to establish the first society devoted to the collection and study of Jewish ceremonial art, situated in Frankfurt. Vienna founded a similar organization shortly thereafter. Forty years later, Adolph Eichmann zealously collected art from the 153 Bohemian and Moravian Jewish communities that he had decimated, to be housed in a Prague museum erected as an enduring tribute to his remarkable powers of extinction.[24]

From the time of the first World War, if not well before, so many Jews entered the arts that, happily, it is almost impossible or pointless to attempt to list or single them out. Perhaps two painters of unusual talent might be mentioned because their dramatic lives and still mostly unknown works may reveal some of the conflicts of the creative role. Handsome Mark Gertler, who left London's poor East End to ascend the rarified intellectual heights of Bloomsbury, killed himself. A similar fate befell an equally outstanding young Austrian painter, Richard Gerstl. Predominantly a portraitist and from a rich family, he was dead at twenty-five. A remarkable Alsatian entrepreneur of that period, Siegfried (for Solomon?) Bing, by establishing a Parisian art gallery devoted to Art Nouveau, helped put that insinuating style on the map.

Though the creative arts are the subject at hand, their collecting, sale, study, and curatorship cannot be forgotten. Everard Jabach, in the 17th century, may be the first major Jewish collector of painting. Julius Angerstein's thirty-eight paintings provided the cornerstone of London's National Gallery, founded in 1824. With the fervor of the *fin de siècle,* "art for art's sake" was a battle cry joined by many Jews. They too worshiped beauty and the cult of art; now the gallery, studio, and museum became the center of their faith.

Alfred Stieglitz personifies this flight into aestheticism, using his fine photography and the art of the avant-garde to escape a heritage that only embarrassed him. Long a passionate advocate of all things German, Stieglitz was so close to the modern movement in Germany and in Vienna, known as the *Sezession,* that he insisted on naming his own photography group the Photo-Secession even though that was a word with tragic associations for many of its American members. Later, Stieglitz's "291" was the American center for Dada whose Parisian review was directed by Tristan Tzara, born Saemi ("his name is God") Rosenstock. Peggy Guggenheim, another collector-patron-dealer, was a far happier example of a similar trend. Her *Art of This Century* and Stieglitz's *An American Place* were showcases for fresh talent. Her uncle Solomon's Museum of Non-Objective Art is an enduring, if regrettably renamed, monument to the passionate commitment to visual expression so characteristic of, but scarcely limited to, Jewish wealth.

Georg Levin, a composer and writer, was at the center of German Expressionism. His periodical *Der Sturm* (The Storm) was named after the 18th-century movement wishing to replace nationalism by sentiment. *Der blaue Reiter* (The Blue Rider) was a pioneering exhibition which he organized in 1912, its title encapsulating Kandinsky's chivalric, medieval concept of the new school. Levin's first wife Elsa Lasker-Schuler, very close to Jewish mystical currents in her poetry and painting, invented the Teutonic *Deckname* (covername) of Herwarth Walden as suitable to her husband's new role. Herwarth, entirely her creation, may come from an adverb signifying "on the way," while Walden (the woods) alludes to the forest primeval, sacred to German mythology. He went from Expressionism to Communism in 1930 and soon vanished in one of Stalin's camps. She fled to Israel, where, miserable for lack of recognition, Lasker-Schuler longed for the *Kultur* of happier German days.

Shortly after Buber despaired of defining a national Jewish style, despite his own art historical studies and his arranging of an art exhibition for the Zionist Congress of 1901, the Arts and Crafts movement came to the rescue with the establishment of the Bezalel School in Jerusalem. Its founder, Boris Schatz, is shown in a self-portrait (pp. 170–71) surrounded by the products of his school. A medallion of Bezalel in the frame above cements the painter's identification with the biblical artisan.

Folk art, shared by the then largest Jewish population in the world, the five million living in Russia and Poland before the first World War, provided a rallying point for young artists on the threshold between provincial isolation and urban sophistication, such as El Lissitzky. Delighting in patterns from the past, hand-me-downs of previous fashions, folk art is defined by use and disuse, a reservoir of memory, of past moods and decorative devices, as recreated by loving hands in rustic homes. Although called naive, such creativity is also courageous, a brave whistling in the dark of brutal farm life. Folk art is often owned by its maker, and there is a happy sense of self-satisfaction, of joy in work, and devotion to the pleasure of creation that give folk art its special appeal.

Leading master of this style was an itinerant synagogue decorator of the 18th century, his masterpiece the wall painting of the wooden synagogue of Mohilev. He signed this work, "By the artisan who is engaged in sacred craft, Hayyim (Life), the son of Isaac Segal of Sluzk." Legend has it that when he had completed the decoration of three synagogues in three separate towns, he fell from a ladder and died, with all three synagogues vying for the honor of being the cause of his downfall. Chagall, apprenticed to Bakst (Andrei Iakovlevich Levinson), the designer for ballet and theater, claimed Hayyim as his spiritual ancestor, his grandfather in art (pp. 174–75).[25] Just as the revival of Jewish folk art was of extremely short duration, so was that of the happy renaissance of the Yiddish language and literature, soon found embarrassing by Zionism, which preferred Hebrew over Middle High German.

The sudden shift from Poland and Russia to Paris was made tolerable by a sense of community that various groups of Jewish artists preserved in Montparnasse. Pascin, Soutine, and Modigliani (pp. 180–81) were one such Bohemian band, but more remarkable were the *Machmadim*—"the precious ones"—to which the gifted Tchaikov, a graphic artist and printmaker, belonged.[27] Theirs was a Jewish art journal that only showed and never told—textless. Like Lissitzky, Tchaikov soon embraced totally abstract art.[26] Only Chagall, ever the opportunist and ironist, managed to go on juggling the peasant, the Parisian, and the pious in his profitable art that in its first years was compelling and convincing. Among the best of Chagall's early works are prints devoted to a death in the family (pp. 174–75), etched by the acid of parental loss.

Much more recent art of Jewish themes is still indebted to the mystical spirit of Eastern European village life and its folk art. The carvings of Leonard Baskin and Ben Shahn's prints and calligraphy share a complex primitivism, at a far remove from the classical and the academic. They seek a more personal authenticity, a visual equivalent to the roots of faith as rediscovered in rustic community (see pp. 192–93 and 196–97). Art of primitive cultures, distilled by the School of Paris, has found its way into these masters' work, as is true for that of Jacques Lipchitz (see pp. 188–89).

The abstract has had incalculable consequences for painters and sculptors of Jewish birth. El Lissitzky made a protean leap from folk art to modernism just after the first World War, following the new absolutes of Malevitch's homage to the square, opposing "art," reducing painting to zero and beginning all over again.[27] Contemporary Jewish masters like Gabo and Pevsner created similar abstract movements—theirs was Constructivism—each has its own commandments. Surrealism's revealed Freudian and other wisdoms, occult dimensions and hermetic references, often went back to the mystical genesis of Kabbalism.

In the New York School of the 1950s a sense of primal vision remarkably close to the immaterial, absolute issues of Genesis came to light. This return to the primeval splendors of creation, beyond carnality or possession, is found in the work of many Jewish painters, as seen in the canvases of Rothko, Newman, Helen Frankenthaler, or Lee Krasner.[28] Sculpture by Eva Hesse, Louise Kaish, George Segal, and di Suvero took on deliberate moral challenges, concerned with the anonymity of suffering and sacrifice, with the distance of justice, while Nevelson and Louis Kahn (his name that of the hereditary priests, *kohanim*, descendants of Aaron, with exclusive rights to that sacred role) offered a reliquary-like enclosure, the sanctuary of the Tabernacle. All these men and women share a concern with truth beyond illusion. Theirs are values that may be associated with the rock-ribbed dictates of the oldest religion. They return to the sacred basics of divine design, to the artist who worked "In the beginning."

Survival, as exemplified by the genius of escape artist Harry Houdini (Erich Weiss), is our greatest gift, the ultimate

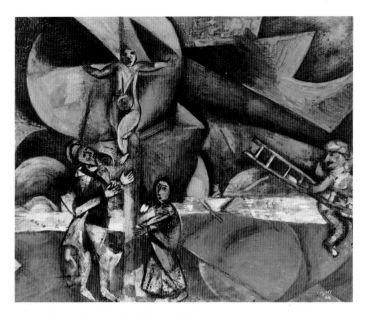

Marc Chagall, *Study for Calvary*, 1911, gouache, watercolor, and pencil. New York, The Museum of Modern Art, The Joan and Lester Avnet Collection.

Jewish craft and skill. His magic is just another word for wisdom, the key to creativity. Martyrdom means witness, to be shared by art and life, a sign of survival and grace. Our arts bear witness to the will to get up and go, to begin again in the Lord's service and shadow, *Bezalel*.

Notes:

[1] W. Cahn, *Masterpieces: Chapters of the History of an Idea,* Princeton: 1979, pp. 23–42.

[2] T. H. Gaster, *Thespis,* New York, 1950, x, for a discussion of these craft terms. For God the potter, see Jeremiah 17:18 and Isaiah 64:8.

[3] I am grateful to Dr. T. H. Gaster for elucidating these words with his own habitual wisdom and erudition.

[4] Irving Ruderman has most kindly translated the commentaries upon Exodus 31:2, as taken by him from *Daat zikanim mi Baalee.*

[5] Midrash Numbers Rabbah 15:10, cited by J. Gutmann, "The Precious Legacy," *Rotunda,* Royal Ontario Museum, 18, no.2 (1985), pp. 17–23, see p. 17.

[6] See R. Rosenblum, "The Origin of Painting: a Problem in the Iconography of Romantic Classicism," *The Art Bulletin,* 39 (1957), pp. 279–90, see p. 281.

[7] L. B. Alberti, *On Painting,* trans. and ed. J. R. Spencer, New Haven, 1956, p.64.

[8] Exodus 31:6, 35:10; 1 Kings 7:14; 2 Chronicles 22:15; 2 Chronicles 2:6. Though the earlier Bible claims no use for images, pillars and piles of stones were assembled as symbols of witness (Gen. 31:44–54) to the covenant between Jacob and Laban.

[9] P. O. Kristeller, "The modern system of the arts," in *Renaissance Thought II: Papers on Humanism and the Arts,* New York, 1965, pp. 163–227.

[10] Grace Paley, "Faith in a Tree," *Enormous Changes at the Last Minute,* New York, 1974, p. 89.

[11] For the cherubim see F. Landsberger, *A History of Jewish Art,* Cincinnati, 1946, pp. 92–93; W. F. Albright, "What were the Cherubim?," *The Biblical Archaeologist,* I (1938), p. 1 ff.

[12] M. M. Gauthier, "L' or et l'église au moyen age," *Revue de l'art,* no.26 (1974), pp. 64–77, see p. 72.

[13] Eusebius, *Ecclesiastical History,* vol X, iv, 3–4, Loeb ed. London, 1953, trans. and ed. J. E. L. Oulton, p. 399.

[14] F. Landsberger, *op. cit.,* p. 195.

[15] F. P. Bargebuhr, "The Alhambra Palace of the Eleventh Century," *Journal of the Warburg and Courtauld Institutes,* 19 (1956), pp. 192–258.

[16] R. Homa, "Jan van Eyck and the Ghent Altarpiece," *The Burlington Magazine,* 116 (1974), pp. 326–27 has studied the inscription and read it as a monogram. For Jan van Eyck and Hebrew see also L. B. Philip, *The Ghent Altar and the Art of Jan van Eyck,* Princeton, 1971, pp. 148–49, 161.

[17] Cennino d'Andrea Cennini, *The Craftsman's Handbook,* trans, D. V. Thompson, Jr., New York, 1933, p. 1.

[18] G. Vasari, *Le vite de' più eccellenti pittori, scultori e architettori . . .* vol I, ed. G. Milanesi, Florence, 1878, p. 216.

[19] G. Vasari, *Lives of the Painters, Sculptors and Architects,* Everyman edition, vol. 4, trans, A. B. Heinds, London, 1927, pp. 120–21.

[20] Leonardo's *Notebooks* are filled with analogies between the divine creativity of God and that of the artist.

[21] See "Golem," *The Jewish Encyclopaedia,* New York and London, 1901–1906. While Löw's golem had the *shem* removed on the Sabbath, so his automatic servant could rest on the seventh day, another, late golem was made as a *shabbes goy,* designed for labor on that day alone.

[22] For the crafts in Eastern Europe see M. Wischnitzer, *A History of Jewish Crafts and Guilds,* New York, 1965.

[23] G. K. Anderson, *The Legend of the Wandering Jew,* Providence, 1965; D. Wolfthal, "The Wandering Jew: Some Medieval and Renaissance Depictions," pp. 217–27 in *Tribute to Lotte Brand Philip,* New York, 1985.

[24] J. Gutmann, *op. cit.,* p. 17.

[25] A. Kampf, "In search of the Jewish style in the era of the Russian Revolution," *Journal of Jewish Art,* 5 (1978), pp. 48–75, see p. 58.

[26] *Ibid.,* pp. 65–66.

[27] S. Lissitzky-Küppers, *El Lissitzky: Life, Letters, Text,* London, 1980, p. 337.

[28] For a view of abstract art as Jewish see R. Pincus-Witten, "Six propositions on Jewish Art," *Arts Magazine* (December 1975), pp. 66–70.

TREASURES
OF
THE JEWISH MUSEUM

In general, two formats were followed for the entries. The first, for the decorative arts, emphasizes the place and date of fabrication. The second, for fine arts, places the work within the oeuvre of an individual artist whose nationality often changed over time. In general, the assigned nationality follows conventional usage.

Maximum dimensions are given, in the following order: height or length, width, then depth. For circular objects, height is followed by diameter, designated diam. A glossary of terms used in the entries begins on p. 208.

For the sake of brevity, the transcriptions of Hebrew inscriptions are selective. Standard biblical and liturgical passages are given only in translation. Omissions within transcribed passages, such as standard honorifics, are indicated by ellipses. An interesting feature of Hebrew inscriptions is the use of chronograms, based on the numerical value traditionally assigned to each letter. The chronograms that appear on objects included in this exhibition generally omit the first digit of the Hebrew year. The remaining numbers are sometimes incorporated into quotations from Scriptures or the liturgy, with relevant letters marked by accents. Because of printing limitations, the range of diacritical marks used in the inscriptions could not be reproduced exactly, but an attempt has been made to suggest their variety. Since the Jewish lunar year does not exactly correspond to the Gregorian year, if the month of the Hebrew date is not specified both possible Gregorian equivalents are given.

Translations of biblical verses are mostly from the latest Jewish Publication Society of America editions (1974, 1978, and 1982) except in cases where the new translations do not express the intent of the inscription. The transliteration of Hebrew terms is in accordance with the system set forth in the *Encyclopaedia Judaica.* However, names and terms that have entered English usage have been given their most common spellings.

Three Burial Plaques
Left: Venosa (?), 4th–5th century
Marble: incised
9½ x 11 x 1 in. (24.1 x 28.2 x 2.9 cm)
Gift of Mr. Samuel Friedenberg, JM 3-50
Inscription: *Here lies Flaes the Jew.*

Center: Rome, 1st–3d century
Marble: carved and painted
11½ x 10⅜ x 1⅛ in. (29.5 x 26.5 x 3.0 cm)
Gift of Henry L. Moses in memory of
Mr. and Mrs. Henry P. Goldschmidt, JM 5-50

Right: Rome, 1st–3d century
Marble: incised
9½ x 9 15/16 x ⅞ in. (24.2 x 25.3 x 2.2 cm)
Gift of Dr. Harry G. Friedman, F4714
Inscription: *Ael[ia] Alexandria set up [this stone]
to Ael[ia] Septima, her dearest mother,
in grateful memory.*

Fig. 1. Rome, *Tombstone from the St. Callixtus Catacomb,* 3rd century C.E., marble. Rome, Museo Nazionale delle Terme.

Jews settled in Rome in the 2d or 1st century B.C.E. Their ranks swelled with the coming of diplomats, merchants, and captives taken after the Roman invasion of Judea in 63 B.C.E. Some Latin authors who mention the Jews living in their midst confused them with early Christians, since both groups shared common practices. One of these practices was burial of the dead, a sharp contrast to the usual pagan custom of cremation. Both Jews and Christians owned cemeteries outside Rome, which were extended as a series of subterranean chambers. Though Christian examples of these burial grounds, called catacombs, are widely known, there are also six Jewish sites in Rome and another in Venosa, near Naples.

In Jewish catacombs, as in Christian, the dead were buried in niches dug into the walls of underground chambers that were sealed with plaster. A tombstone, inserted in the plaster, identified the deceased. They were generally written in Greek or Latin, with, occasionally, an added Hebrew word, sometimes misspelled as in the example at left. Like most of the Christian tombstones of the same period (fig. 1), ancient Jewish grave markers from Italy were decorated only with rudely executed symbols. However, while the Christian symbols represent faith in personal salvation, the symbols used on Jewish tombstones express belief in national redemption. Implements of the destroyed Temple — the *menorah* (left and center), the *shofar,* incense shovel, and amphora (center) — signify the hope that the Temple will be rebuilt. So do the palm frond and citron (*lulav* and *etrog*), which are used on Tabernacles, once a major Temple festival. The tombstone at right features symbols that probably represent offerings brought to the Temple: the pomegranate for first fruits, and the ram for an animal sacrifice. The same symbols appear on other works made for Jews during the Roman period: gold glasses, stone reliefs, mosaics and the frescoes that decorated the catacomb walls.
VBM

Reference:
The Jewish Museum, New York, *Israel in Antiquity,* exh. cat. by A. Ackerman and S. Braunstein, 1982, nos. 127, 128, and 130.

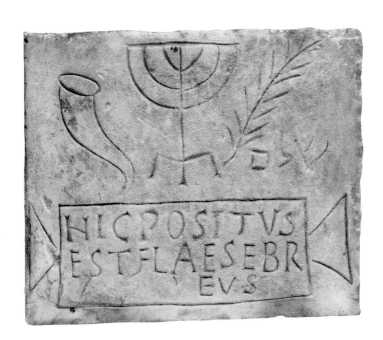

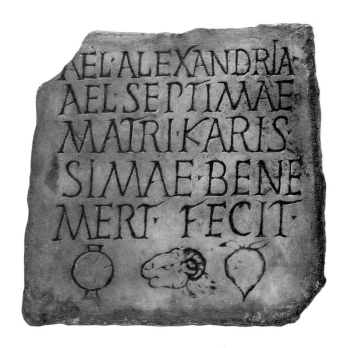

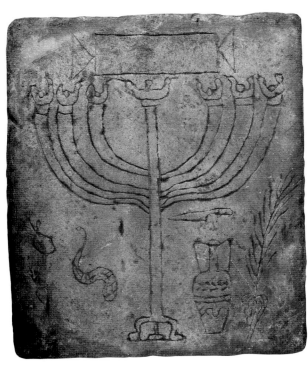

Oil Lamp
Southern Israel, 4th–5th century
Clay: mold-formed, rolled handle, fired
4 13/16 x 3 7/16 in. (12.2 x 8.8 cm)
Gift of Dr. Harry G. Friedman, S946

Fig. 2. Rome, *Oil Lamp*, 4th century C.E., clay. New York, The Jewish Museum, Gift of the Betty and Max Ratner Collection, 1981–91.

The inhabitants of ancient Palestine used clay lamps fueled with olive oil to illuminate their homes, sanctuaries, and tombs; such lamps were still employed in parts of Palestine until recently. Over the millennia, the form of the oil lamp underwent one basic change, from a simple open bowl with one or more pinched spouts for the wicks, to a closed, globular form with a conical spout that was introduced during the Hellenistic Period (4th–1st century B.C.E.). In the Middle Roman Period (late 1st century C.E.), Palestinian potters began using a technique, developed by the Romans, of producing the lamps in molds, thus enabling them for the first time to depict a variety of raised designs on the upper surface of the lamp.

The form and decoration of this Byzantine mold-made lamp mark it as one of the most elaborate types produced in Palestine. While the majority of East Mediterranean lamps in the Hellenistic, Roman, and Byzantine Periods (4th century B.C.E. — 7th century C.E.), are small and have only one spout for the wick (fig. 2), this larger lamp has a wide, square end that can accommodate six wicks. The lamp is decorated with a structure consisting of two inner columns that support an arch and frame an amphora, and two outer columns that support a triangular pediment. This structure, Greco-Roman in style as were many monumental buildings in Palestine during this period, represents a Torah shrine that stood in the synagogue and housed the Scroll of the Law. The appearance of these shrines is known from existing shrines, fragments found in secondary use, and depictions on the mosaic floors and stone lintels of synagogues, as well as in decorated gold glass, dating to the 3rd–6th centuries C.E. The amphora represented within the arch probably symbolizes the wine that is so important in Jewish ritual.

The significance of multiple wick lamps, particularly those ornamented with religious objects, is not known. The fact that the kindling of light plays an important role in Judaism for the sanctification of Sabbath and festivals suggests that these specially formed and decorated lamps were perhaps used on ceremonial occasions.
SLB

Reference:
The Jewish Museum, New York, *Israel in Antiquity*, exh. cat. by A. Ackerman and S. Braunstein, 1982, no. 117.

Star-shaped Hanging Lamp
Germany, 14th century
Bronze: cast and engraved
6⅝ x 7 in. diam. (16.8 x 17.8 cm diam.)
Gift of Mr. and Mrs. Albert A. List, JM 200-67

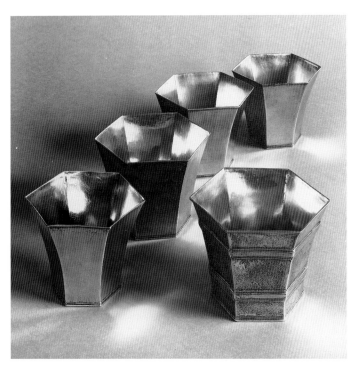

Fig. 3. Bohemia, *Nested Beakers,* before 1330–35, silver. Nuremberg, Germanisches Nationalmuseum.

During the Middle Ages, star-shaped hanging lamps illuminated rooms in houses and castles throughout Europe. Each lamp consisted of a shaft from which was suspended a star-shaped container for oil and wicks, and a catch basin for overflow fuel (missing on this example). In Jewish communities, such lamps were also used for rituals — the kindling of lights in the home to inaugurate Sabbaths and festivals, and for *havdalah. Havdalah* — literally, "separation"— is the ceremony that marks the conclusion of holy days, that is, their separation from the workday week (see p. 34). By the 16th century, the star-shaped lamp had fallen into disuse among Gentiles, but it retained both its form and function in Jewish homes. In fact, the type had become so closely associated with Jewish ritual that it was known as a *Judenstern,* or Jewish star.

The faceted form of this lamp is characteristic of 14th-century Gothic metalwork, as in a set of five nested beakers, dated before 1330–35 (fig. 3). Like the lamp, the beakers are decorated with ridged moldings that run horizontally. On the lamp, however, the moldings are interpreted as architecture — they become part of the cupola that serves as the lamp shaft. In this sense, the Jewish Museum's lamp follows an established practice of the time, for miniature architectural forms were incorporated into a wide variety of medieval metalwork, including reliquaries, monstrances, and censers, as well as lamps.

According to the records of the first known owner of the Jewish Museum lamp, Siegfried Strauss, it was excavated in the Jewish quarter of Deutz, a city across the Rhine from Cologne. There is a Star of David incised on the underside of the star-shaped section, but its use in the 14th century does not necessarily indicate Jewish ownership.
VBM

References:
G. Schoenberger, "A Silver Sabbath Lamp from Frankfurt-on-the-Main," *Essays in Honor of Georg Swarzenski,* Chicago, 1951, p. 196, n. 23; Oklahoma Museum of Art, Oklahoma City, *Songs of Glory: Medieval Art from 900–1500,* exh. cat., 1985, no. 54.

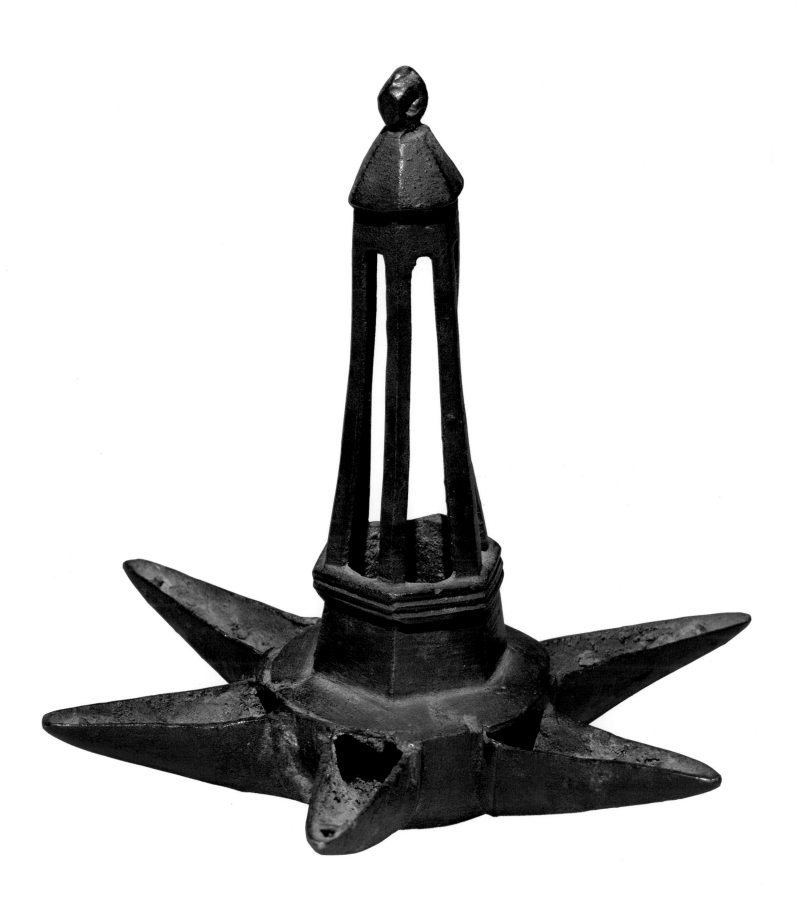

Casket with Zodiac Signs and Other Motifs
Germany, 15th–16th century, later additions
Fruitwood: carved and painted
9½ x 2 1/16 x 1 9/16 in. (24 x 5.5 x 4.5 cm)
Gift of Mr. and Mrs. Norman Zeiler in memory of Mrs. Nan Zeiler,
JM 35-66

The entire surface of this small casket is covered with carved decoration. Zodiac signs in roundels surrounded by decorative motifs range along the front and back. There are single birds carved on the end panels, and four of the five cover panels are filled with vine scrolls inhabited by human and animal figures. The fifth panel bears a mnemonic Hebrew inscription that signifies the blessing over circumcision, and the date, [5]498 (=1737/8). This inscription and the present contents of the box show that the casket had been transformed into a container for circumcision implements during the 18th century. The remaining reliefs, as well as evidence of structural alteration, indicate that the box had another, prior use.

In shape and decoration, this work belongs to a group of late medieval caskets called *Minnekästchen* or *Briefladen,* which were given as love gifts, wedding presents, or New Year's gifts. Guilds and fraternal societies used similar boxes to hold important documents. The size, form, and decoration of the Jewish Museum box are closest to a painted *Minnekästchen* which is dated circa 1300 (fig. 4). However, the style of the carving of the Jewish Museum casket suggests a later date, circa 1550.

The zodiac signs are the key to understanding the original purpose of the casket. When viewed from the front, the sequence starts with Libra, the sign for Tishri, the first month of the Jewish year. Further, the cycle reads from right to left, the way Hebrew is read, rather than from left to right, and nearly all the signs shown in profile are oriented from right to left. This consistency of orientation suggests that the zodiac reliefs were based on the illuminations of a Hebrew manuscript.

Zodiac cycles appear in two types of medieval Hebrew manuscripts: *mahzorim* (festival prayer books) and *haggadot* (service books for Passover). In the *mahzorim* the cycle is illustrated alongside prayers for dew, and has the meaning of an orderly passage of time through the year during which God ensures the fertility of the soil. Several later printed books with zodiac cycles contain commentaries to the illustrations indicating that the cycle expresses the wish for a good year. By beginning his zodiac series with the sign for the first month of the Jewish year, the carver of this casket created a pictorial equivalent to the messages on other *Minnekästchen* wishing the owner a happy new year.

VBM

Fig. 4. Germany, Upper Rhine region, *Casket,* late 13th century, lindenwood, tempera on gesso and iron. New York, The Metropolitan Museum of Art, Gift of J. Pierpont Morgan by exchange, 1976 (1976.327).

References:
V. B. Mann, "A Carved Mohel's Box of the Eighteenth Century and its Antecedents," *Proceedings of the Eighth World Congress of Jewish Studies,* Jerusalem, 1982, 45-49; The Jewish Museum, *A Tale of Two Cities,* 1982, no. 36; V. B. Mann, "A Sixteenth Century Box in the New York Jewish Museum and its Transformation," *Journal of Jewish Art,* IX (1983), 54-60; Oklahoma Museum of Art, Oklahoma City, *Songs of Glory: Medieval Art from 900-1500,* exh. cat., 1985, no. 171.

Spice Container
Frankfurt (?), ca. 1550; repairs and additions, 1651
Silver: cast, engraved, and gilt
9 5/16 x 2 15/16 x 2 7/8 in. (23.6 x 7.5 x 7.3 cm)
Jewish Cultural Reconstruction; JM 23-52

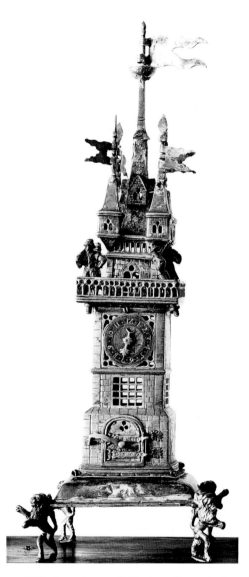

Since antiquity, the ceremony known as *havdalah* has marked the conclusion of Jewish Sabbaths and holy days. As early as the first centuries of this era, the smelling of aromatic spices was part of this ritual. Nevertheless, the first literary mention of a container for *havdalah* spices only appears in a 12th-century source, and the earliest known example of tower form dates from the 13th century.

This 16th-century work is one of the oldest known spice containers used for *havdalah*. It is shaped like a four-story Gothic tower whose masonry is pierced by various openings: two rose windows, pairs of lancets with an oculus above, surrounded by an ogival arch, and rectangular fenestrations. A pinnacle with four surrounding turrets caps the tower. The silversmith created an appealing balance between the lightness provided by the openings and the heaviness of the articulated masonry, between the verticality of the tower form and the horizontality of the moldings and the balustrade separating the stories.

Comparison with a similar German table decoration suggests that The Jewish Museum's example dates from about 1550 (fig. 5). Many areas, including the balustrade, were repaired later. A second flat base was riveted to the original and there are silver patches on the turrets. A Hebrew inscription on the back apparently dates these changes:

רעכלה בת / אליעזר / דין תי"א לפק

"Rekhlah daughter of Eliezer Dayan [5]411 (=1650/1).

That the earliest spice containers are shaped like towers is not surprising given the widespread use of architectural forms in medieval metalwork (see p. 31), including censers for church ceremonies. It is very likely that the similarity in function between censers and spice containers (to give off aromatic odors) led to the adoption of the tower shape for *havdalah* containers. Among the objects made for Jews that are recorded in the 16th-century register of the Frankfurt Goldsmiths Guild is a *Hedes oder Rauchfass*. *Hedes* is Hebrew for myrtle and was the term used for a spice container in the Middle Ages; the Frankfurt records equate it with the German word for a censer. VBM

Fig. 5. Hesse, *Table Decoration*, ca. 1543, silver. Formerly Kassel, Hessisches Landesmuseum.

References:
The Jewish Museum, *A Tale of Two Cities*, 1982, no. 74; The Israel Museum, Jerusalem, *Towers of Spice: The Tower Shape Tradition in Havdalah Spice Boxes*, Jerusalem, 1982, no. vi; Oklahoma Museum of Art, Oklahoma City, *Songs of Glory: Medieval Art from 900-1500*, exh. cat., 1985, no. 72; V.B. Mann, "The Golden Age of Jewish Ceremonial Art in Frankfurt: Metalwork of the Eighteenth Century," *Leo Baeck Institute Year Book*, 31 (1986), forthcoming.

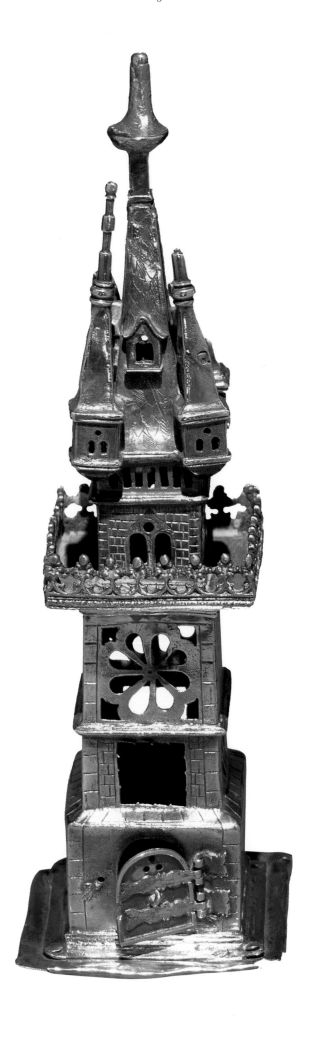

Cooking Pot
Frankfurt, 1579/80
Brass: cast, chased, and hammered
8 3/16 x 9 in. diam. (21.2 x 22.8 cm diam.)
Gift of Mr. and Mrs. Ben Heller, JM 23-64

This finely proportioned cylindrical pot is one of the only works to remain in existence from the early centuries of the Frankfurt ghetto, which later became one of the great centers of Ashkenazi Jewish life. Jews first settled in Frankfurt in the 11th century. In 1424, under pressure from the church and the emperor, the city council segregated the city's Jewish inhabitants in a small area which became known as the Judengasse. Each of the houses of the ghetto was marked by a sign which featured a distinctive symbol or color. Ultimately, many Jewish families adopted last names based on their house signs. For example, the famous Frankfurt banking family, the Rothschilds, derived their name from the red shield which hung from their house (see pp. 82–83). Likewise, the Hebrew inscription on this pot identifies its owner by association with a house sign. It reads:

הירץ פופרט זיין ב[ת] ז[וג] בת משה / צור ליטר / בשאלט לפק

"Hirtz Popert's s[pouse], daughter of Moses zur Leiter, in [the year 5]340 (=1579/80)." To the left of the word *Leiter* is a schematic rendering of a ladder. In this inscription, the owner is not cited by her own name, but as the wife of Hirtz Popert (who died in Frankfurt in 1625) and as the daughter of Moses, who lived in the house with the sign of a ladder.

Another interesting feature of the inscription is the manner in which the year of manufacture is recorded. Since all the letters of the Hebrew alphabet have numerical value, the writer of a Hebrew inscription can either utilize biblical passages, make up his own text, or create plays on words, while indicating a date. On the pot, the letters for the Jewish year 5340 (=1579/80) might be read as the German word *Schale,* meaning pot or vessel, or as a corruption of *cholent,* a stew that is made on Friday before the Sabbath and is cooked overnight.

Medieval and Renaissance brass objects often bear inscriptions, initials, or coats of arms as signs of ownership. Few extant examples, however, bear Hebrew inscriptions. There is an earlier 13th-century alms bowl found in England, but it is of different shape. Of the same date as the Frankfurt pot are three bronze vessels by Giuseppe de Levis of Verona, who was active between 1577 and 1605. In 1984, The Jewish Museum acquired a later baking pot dated 1708, of possible Frankfurt origin (fig. 6). Like the Popert vessel, its inscription details the names of the owners and a date.

VBM

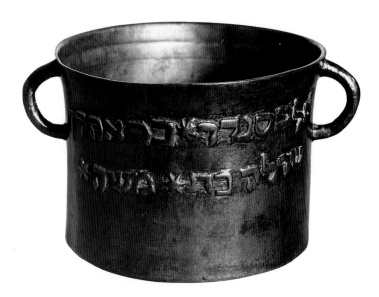

Fig. 6. Frankfurt (?), *Cooking Pot,* 1708/9, bronze. New York, The Jewish Museum, Judaica Acquisitions Purchase Fund, 1984–93.

References:

Der Sammlung Albert Figdor Wien, sales cat., P. Cassirer, Berlin, June 11–13, 1930, part I, vol. 5, no. 420; The Jewish Museum, *Loan Exhibit of Antique Ceremonial Objects and Paintings from the Collection of Mr. M. Zagayaski,* New York, 1951, no. 124; The Jewish Museum, *The Silver and Judaica Collection of Mr. and Mrs. Michael M. Zagayaski,* New York, 1963, no. 51; *The Michael M. Zagayaski Collection of Rare Judaica,* sales cat., Parke-Bernet Galleries, New York, March 18–19, 1964, no. 235; The Jewish Museum, *A Tale of Two Cities,* 1982, no. 172; Oklahoma Museum of Art, Oklahoma City, *Songs of Glory: Medieval Art from 900–1500,* exh. cat., 1985, no. 172.

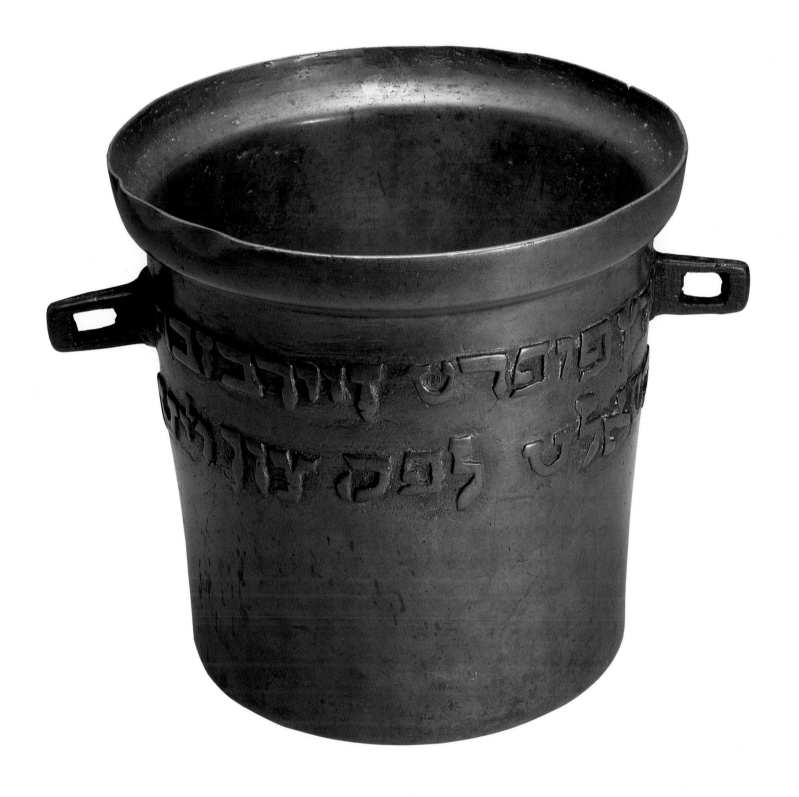

Portion of a Synagogue Wall
Persia, 16th century
Faience tile mosaic
8 ft. 8 in. x 15 ft. 6 in. (264.2 x 472.4 cm)
Gift of Adele and Harry G. Friedman, Lucy and Henry Moses,
Miriam Schaar Schloessinger, Florence Sutro Anspacher, Lucille and
Samuel Lemberg, John S. Lawrence, Louis A. Oresman,
and Khalil Rabenou, F5000

The Jews of oriental communities generally house their Torah scroll in a rigid, cylindrical container known as a *tik*. When not in use, the *tik* may be placed in a conventional ark or in a niche that is part of a synagogue wall, a usage that can be traced back to the period of the early synagogues. Since on some holy days of the Jewish year, three sections of the Torah are read, congregations may use separate scrolls, resulting in the need for three niches. This mosaic once decorated the face of a wall housing niches for the Torah scroll in a Persian synagogue.

The mosaic is composed of monochromatic sections of faience tile which were cut, after firing, to form the design. Arabesques, flowers and leaves create a dense background pattern from which the light blue borders and gold letters appear to project. Hebrew letters form two sentences from Psalms. On the second line is a quotation found on many Torah curtains and reader's desk covers from Islamic countries: "This is the gateway to the Lord, the righteous shall enter through it (118:20)" (see pp. 44–5). The second quotation is "But I through Your abundant love, enter Your house; I bow down in awe at Your holy temple" (Ps. 5:8). The word *heikhal* in this quotation, which generally translates as holy temple, is also used by Jews of Sephardic and Oriental origin to refer to the place in which the Torah is stored in the synagogue. The inclusion of these verses from Psalms on the mosaic wall identify the purpose of the structure, much as Koranic quotations were incorporated into Muslim houses of worship to articulate their function.

The Ancient Persians used glazed tiles as architectural decoration in the 3rd century B.C.E. The technique was revived in the 12th century and evolved by the 15th century into the complex multicolored mosaic seen here. From then on mosaic tiles were used on various Persian buildings both as interior and exterior decoration (fig. 7). The closest stylistic comparisons suggest a date in the 16th century for The Jewish Museum wall.

The size of the wall indicates that it stems from a fairly large synagogue, which implies that the building was erected by a community of some prominence. Several factors point to Isfahan as its probable location. The Jewish community of Isfahan reached a height of prosperity in the 16th century, when the wall was created, though it later declined because of persecutions in the 17th century. The city was a center for this type of tile work and similar decoration is found there on

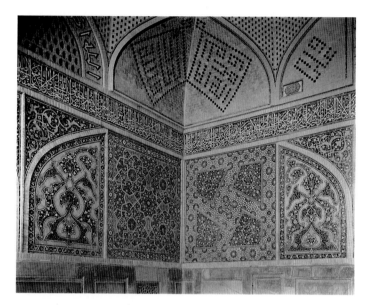

Fig. 7. Isfahan, *"Friday" Mosque,* tilework of the south *iwan*, 15th–17th centuries, tile.

many public buildings (fig. 7). Furthermore, according to the records of the dealer who was instrumental in The Jewish Museum's acquisition of the wall, it was acquired in Isfahan. Whatever its precise origin, this synagogue wall represents a blend of a Muslim Persian tradition of architectural decoration with Jewish patronage and function.
VBM

Reference:
T. L. Freudenheim, "A Persian Faience Mosaic Wall in the Jewish Museum, New York," *Kunst des Orient,* 5 (1968), pp. 39–67.

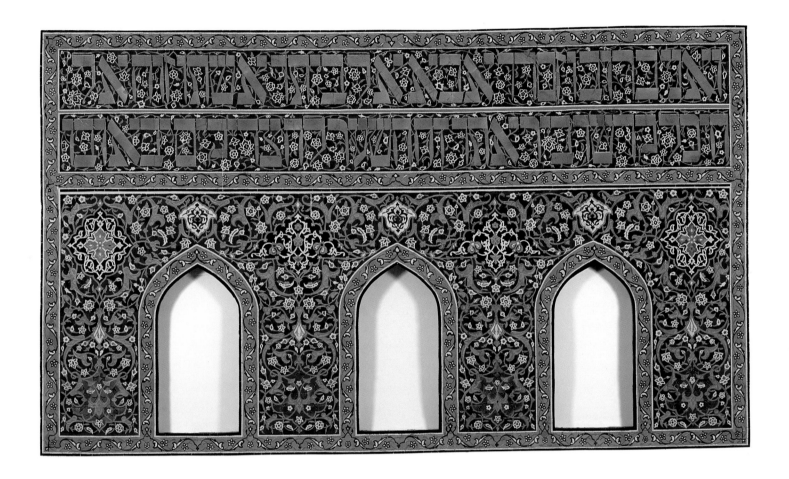

Cushion Cover
Istanbul, late 17th or early 18th century
Silk: embroidered with metallic threads, metallic braid
19 x 21¾ in. (48.2 x 55.2 cm)
Gift of Dr. Harry G. Friedman, F5465

After the Ottoman Turks conquered Constantinople in 1453, they sought to revitalize the former Byzantine Empire by introducing new population groups. Among the arrivals were Jews, most of them refugees from the persecutions and expulsions of Spain and Portugal. These Sephardim brought to Turkey many resources, both economic and intellectual, and they quickly rose in Ottoman society. Prominent Jews were closely associated with the sultan's court as physicians, merchants and diplomats, and were, therefore, exposed to its artistic riches.

As early as the late 15th century, the sultans of Turkey concerned themselves with the production of works of art of high quality for their palaces, mosques, and public buildings. They established workshops for the creation of carpets, tiles, embroideries and the like, under the auspices and control of the court. So highly esteemed were the arts in Ottoman Turkey that many of the sultans themselves trained as artisans, most often as scribes. Since Islam is a strongly iconoclastic religion, the public and official art of Ottoman Turkey generally avoided figural images, with the result that the creative energies of its artists were concentrated on decorative arts like embroidery.

This cushion cover exemplifies both the high artistic level achieved by Ottoman court ateliers and the Jewish assimilation of Ottoman cultural norms. The composition of the cover is distinctive. Narrow bands filled with series of discrete flowers border the cover on three sides and divide it into two horizontal fields. Three large flowers dominate the lower field and floral sprays occupy the corners of the upper section. Similar elements in the same arrangement decorate two saddle cloths produced in an Istanbul court atelier that were presented to King Gustavius Adolphus of Sweden in 1626 (fig. 8). The same "checkerboard" stitch used on the flowers of the cover also appear on the saddle cloths. However, several elements of the cushion cover embroidery indicate a later date: the use of tinsel and the character of the composition, which is less dense, more open.

To the basic composition the embroiderer of the cover added two Jewish motifs, a Star of David enclosing a stylized *menorah*. Executed at the same time as the remainder of the cushion embroidery, the presence of these symbols indicates that the cover was intended, from the first, to serve a ritual function. Nineteenth-century travellers' accounts and historical records suggest two possible uses: for carrying an in-

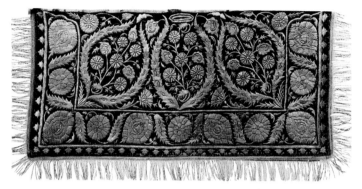

Fig. 8 Istanbul, *Saddle Cloth (Shabrak),* 1626, silk and metallic threads.

fant to the synagogue for circumcision (see pp. 98–9) or for the Passover *seder,* when it is customary to recline as a sign of ease and freedom.
VBM

Reference:
The Jewish Museum, *A Tale of Two Cities,* 1982, no. 163.

Curtain for the Torah Ark
Istanbul (?), Turkey, ca. 1735
Silk: embroidered with silk and metallic threads; metallic lace border
68⅞ x 63 in. (175 x 160 cm)
The H. Ephraim and Mordecai Benguiat Family Collection, S4

Although this is a beautifully embroidered curtain, its Hebrew inscription is poorly executed and difficult to decipher.

ב"עה / בנימין נאבארו הי"ו / ...ומורינו הקדש / לק"ק תלמוד תורה / מורינו נאברו [כך!] ה"י / ובנו הארום וחשוב כה"ר / שלמה נאבארו / נ"ע

"With the help of God, Benjamin Navarro... and our holy teacher. C[ongregation] Talmud Torah. Morenu Navarro and his... son Solomon Navarro..." The information given is also insufficient to place the curtain, though the amuletic symbol above it, a *ḥamsa,* indicates a Middle Eastern origin. It is the embroidered decoration which suggests an attribution.

Its most unusual feature is the depiction of the mosque at center. The embroiderer took extraordinary pains to depict clearly some distinctive features of the building—its broad flight of steps and six Turkish "pencil" minarets. The artist also carefully articulated the masonry and separated parts of the building by varying the direction of the metallic threads. These architectural features characterize the Sultan Aḥmad (Blue) Mosque of Istanbul completed in 1617. As the first mosque in the capital to have six minarets, its design was very controversial and famous. The inclusion of its representation here indicates that this curtain was probably made in Istan-

bul. Yet the composition of the curtain, the framing of the center field by twisted columns bearing flower-filled urns, is based on European models (see pp. 108–9), as is the depiction of the flowers. Though a penchant for naturalistic floral motifs appeared in Ottoman art as early as the 16th century, after the middle of the 17th century, European influence is discernable on works like this curtain in the arrangement of flowers in bouquets and their modeling through shading.

Even before the Ottoman conquest in 1453, the Jewish community of Turkey consisted of a large number of Jews of Venetian and Genoese origin, as well as some Ashkenazim. After the expulsion of the Jews from Spain and Portugal in the late 15th century, the Turkish community grew rapidly due to a large influx of Sephardim who were encouraged to settle in the empire by its Ottoman rulers (see pp. 40–41). This history and the close trading relationships that existed between Ottoman Turkey and Italy in succeeding centuries helps explain the specific influence of European Torah curtains on this work. A related Torah binder and reader's desk cover are also in the collection of The Jewish Museum.
VBM

Reference:
The Jewish Museum, *A Tale of Two Cities,* 1982, no. 196.

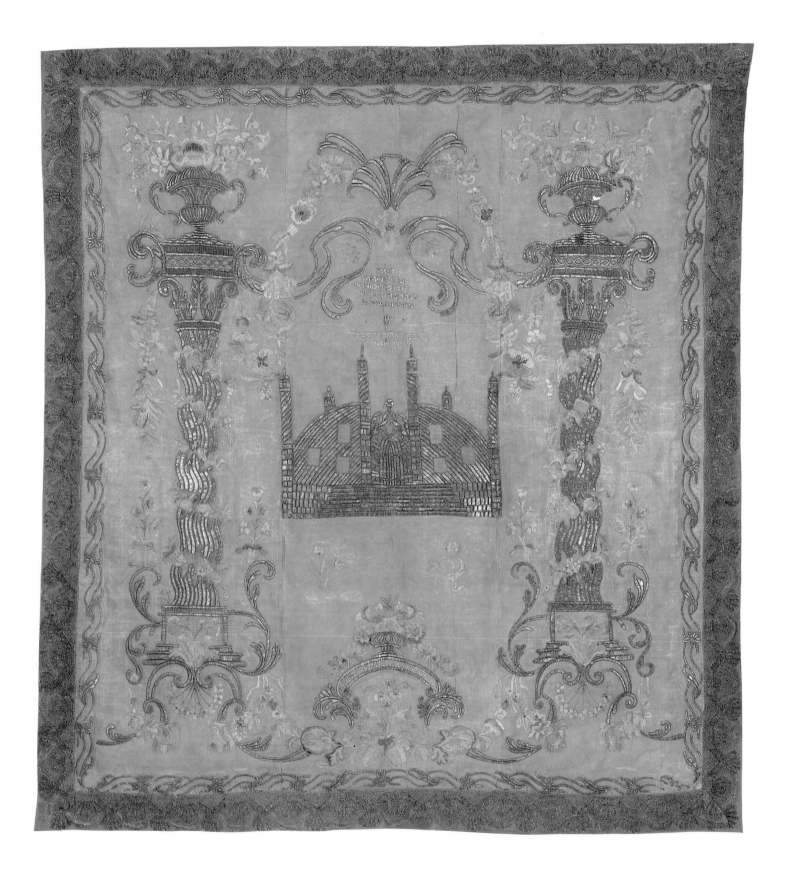

Cover for the Reader's Desk
Turkey, early 19th century
Wood and cotton, in Giordes knot
64⅜ x 47¾ in. (161 x 119 cm)
Gift of Dr. Harry G. Friedman, F5182

One of the most striking examples of Jewish acculturation is a group of wool carpets closely related in form and decoration to Muslim prayer rugs that were used in synagogues as curtains for the Torah ark or as covers for the reader's desk. The earliest example is a 16th-century Cairene rug that still serves as a Torah curtain in the synagogue of Padua, Italy. It combines a typical Mamlūk border design with a center field incorporating Ottoman decorative motifs and a western portal, probably based on the frontispiece of a printed Hebrew book. Later rugs from both Cairo and Turkey, dating from the 17th to the 19th centuries, are closer in style to Muslim carpets.

These rugs are framed by multiple borders of varying widths that are typical of Muslim prayer rugs. On Turkish examples, like this one, the architectual forms of the center field correspond to the representations of the *miḥrab* (prayer niche) on Muslim rugs (fig. 9). What distinguishes carpets made for Jewish ritual purposes from those made for use in mosques are motifs like the blessing hand of the priests (*kohanim*) seen at center bottom on this rug (instead of the praying hands above the *miḥrab* as on Muslim examples) and the incorporation of Hebrew inscriptions. The example discussed here bears particularly lengthy inscriptions that fill parts of the center field and one entire border panel. Most are quotations from Scriptures, but there is also a poignant dedication indicating its donation to a synagogue whose founding members stemmed from Seville, Spain:

הקדש של יהודה דאוילה לק״ק שיוויליא מנחת זכרון לנפש בתי
נארסייה דאוילה שנת וי׳ב׳ר׳כ׳נ׳י׳ ב׳ג׳ל׳ל׳ה׳

"A dedication of Judah d'Avila to the h[oly] c[ongregation] Seville, an offering of remembrance to the soul of my daughter Garcia d'Avila in the year 'And the Lord has blessed me on her account' [a variation of Gen. 30:27, chronogram for [5]368(=1607/8)]." The date on the inscription must refer to a lost model for the rug in The Jewish Museum, since certain of its stylistic features indicate a date in the early 1800s when the imitation of light-colored carpets produced between 1580 and 1650 was in vogue. For example, the stylization of architectural features such as the columns first became common in the 18th century.

Signs of wear and repair in the lower portion of the center field indicate this rug was used to cover a reader's desk where it was damaged by the rolling of the Torah scrolls. It was perhaps the similar function of the prayer rug that led to the

Fig. 9. Ghiordes, Turkey, *Prayer Rug*, end of the 18th century, wool. New York, The Metropolitan Museum of Art, The James F. Ballard Collection, Gift of James F. Ballard, 1922 (22.100.103).

use of the same form as a reader's desk cover. A Muslim worshipper spreads his rug to establish a ritually clean place for prayer; the cover establishes a clean place on which to lay the Torah. It is also interesting that the Sufi mystical tradition ascribed symbolic meaning to the decoration of the prayer rug that relates to an inscription commonly found on Jewish carpets. According to Sufi tradition, the arch of the *miḥrab* represented on a rug is the gate to paradise, which is opened by prayer. Equivalent in meaning is the quotation from Psalms (118:20) found on top of the center field of this rug and many others, "This is the gateway to the Lord, the righteous shall enter through it." Though the first appearance of this quotation on the 16th-century synagogue rug in Padua may have been inspired by a western frontispiece, as were its architectural forms, the repeated inclusion of this theme on later rugs must be due to its apt expression of their iconography. VBM

References:
T. L. Freudenheim, "A Persian Faience Mosaic Wall in The Jewish Museum, New York," *Kunst des Orient,* 5 (1968), pp. 57–58, fig. 12a; The Jewish Museum, *Fabric of Jewish Life,* 1977, no. 54 ; The Jewish Museum, *A Tale of Two Cities,* 1982, no. 197; A. Boralevi, "Un Tappeto Ebraico Italo-Egigiano," *Critica d'Arte,* 49 (1984), pp. 45–46, fig. 13.

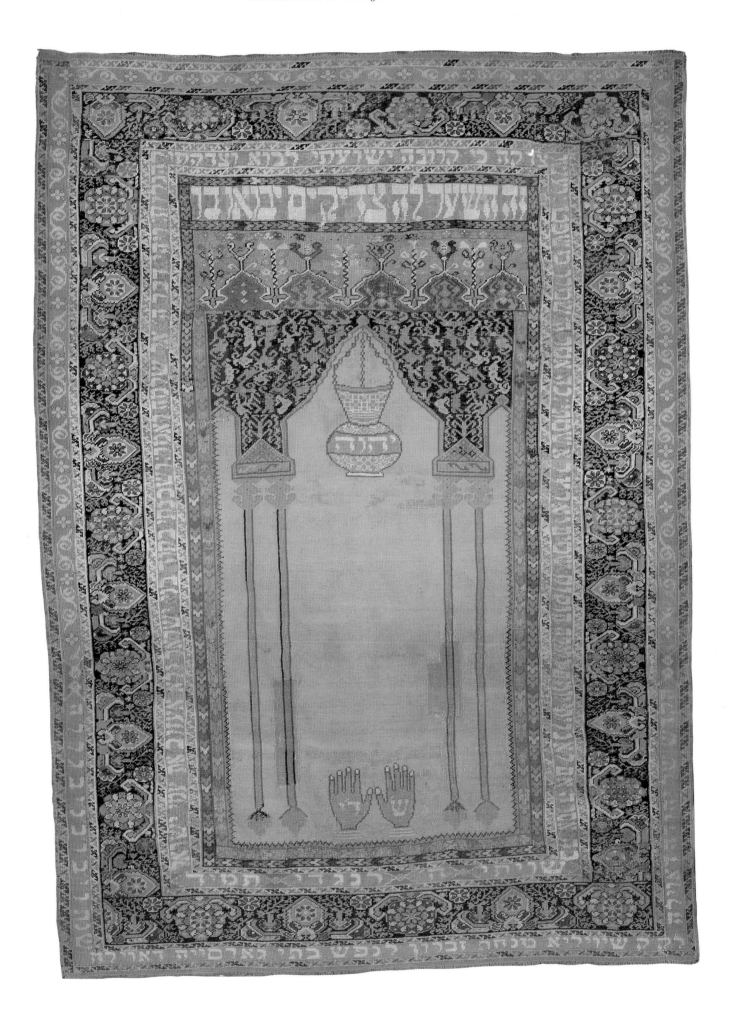

Ewer and Basin Used on Passover
Istanbul, 1840–50
Copper: gilt; repoussé, punched and engraved
Ewer: 12¾ x 8½ in. (32.4 x 21.6 cm)
Basin: 4⅞ x 14½ in. diam. (12.3 x 36.8 cm diam.)
The H. Ephraim and Mordecai Benguiat Family Collection, S77a-c

Fig. 10. Istanbul, *Ewer and Basin,* 1840/1, silver. Istanbul, Topkapi Museum.

In Ottoman Turkey, ewer and basin sets like this one were used for ritual ablutions and domestic purposes. They often bear the name of the owner and a date, engraved in Ottoman characters. The inscription on the Jewish Museum set appears twice, once on the ewer handle and once on the upper surface of the basin: "Aḥmad Pāshā Karīm ibn Sharīf Zuleyha [?] [1]266" (= 1849/50). The final word may be a corrupt form of the last month of the Muslim year, Dhu al-hijja, in which case the date would be October/November, 1850. Some time after this date, the set was acquired by the Benguiat family of Izmir (Smyrna), who used it for ritual handwashings during the Passover *seder.*

The ewer and basin exemplify the high artistic level achieved by metalsmiths of the Ottoman Empire. Both vessels are formed of a common metal, copper, gilt to achieve a high luster. This type of ware, called *tombak,* was a specialty of craftsmen working for the sultan's court in the 16th century, and remained popular through the 19th century. The maker of this ewer and basin created a rich, repeat pattern of serpentine trees growing on a hillock that covers most of the ewer and the broad rim of the basin, linking the two pieces together. The polished forms of the hills and trees stand out against the more matte punched ground, resulting in a rich play of textures.

A nearly identically formed silver set is in the collection of the Topkapi Museum, Istanbul (fig. 10). The set bears an inscription date of 1840/1 and the name of its Muslim owner. This comparison clearly demonstrates how Jews have adapted the forms of surrounding cultures for their own ceremonial uses. Since Jewish law, for the most part, emphasizes function over form and decoration, the history of Jewish ceremonial art is as rich and varied as the many cultures in which Jews have lived.

VBM

References:
Adler, C., and Casanowicz, I. M., *Descriptive Catalogue of a Collection of Objects of Jewish Ceremonial Deposited in the U.S. National Museum by Hadji Ephraim Benguiat,* Washington, D.C., 1901, p. 555, no. 29, pl. 16; Adler, C., and Casanowicz, I.M., *The Collection of Jewish Ceremonial Objects in the United States National Museum,* Washington, 1908, pp. 719–720, no. 77, pl. 83; The Jewish Museum, *A Tale of Two Cities,* 1982, no. 161.

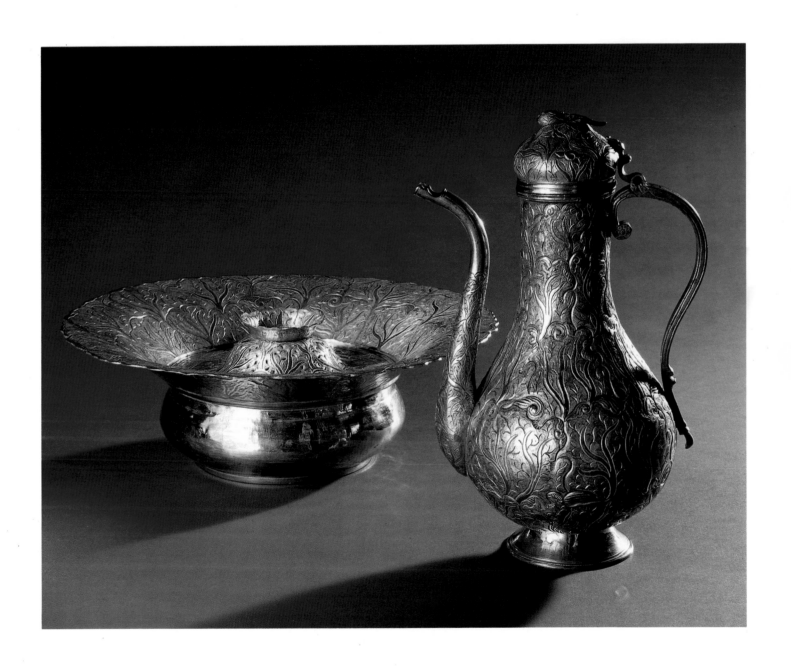

Finials for the Torah Case
Cochin, India, 18th–19th century
Gold: repoussé, cut-out and engraved; tin backing
left: 8 x 10¾ in. diam. (20.3 x 27.3 cm)
right: 7⁵⁄₁₆ x 10⅜ in. diam. (18.7 x 27 cm)
Gift of the Michael and Luz Zak Purchase Fund, 1982–184 a,b

According to their tradition, the Jews arrived in Cochin, on the southwest coast of India, before 379 C.E. and maintained a vibrant community until recent emigration to the State of Israel depleted their ranks. Over the centuries, the community assimilated many Indian customs including a division into castes whose members did not intermarry and who maintained their own synagogues: the White Jews, the Black Jews, and the Freedmen, manumitted slaves, and their offspring. According to a letter in the possession of Jakob Michael, the previous owner, these *rimmonim* or finials for the Torah, belonged to the White Jews' synagogue; however, similar finials were also used by the Black Jews. The finial at right bears an engraved inscription reading:

של מר חלנואה נ"ע

"[This] belonged to Mr. Hallegua, may he rest in peace." The Halleguas are a well-known family of Cochin Jews.

Though resembling one another in technique and form, these *rimmonim* are not a pair. They differ in size and in details of their decoration. It was the custom of the Cochin Jews to place a single *rimmon* like one of these atop the silver or gold case (*tik*) in which the Torah scroll is permanently stored (fig. 11, see pp. 154–55). This usage differs from that of other oriental and Sephardic communities who always place pairs of *rimmonim* on their Torah cases.

Other unusual features of these finials are their material, thin sheets of gold affixed to base metal supports, and their decoration with bands of floral ornaments executed in repoussé. These aspects reflect local Indian influence. Thin plates of silver and gold attached to base supports are traditionally used by Indian silversmiths to decorate large objects like furniture. Their repoussé ornaments were often fashioned from the same molds used for more base metals like copper and brass. Therefore, close parallels for the bands on these *rimmonim* appear on the backplates of copper and brass lamps made in southern India. The cut-out relief on all these works creates an ornamental effect of light and shade, which enhances the decorative motifs engraved and chased on the metal. Finally, the conical finial of these *rimmonim* is another feature borrowed from Indian lamps.
VBM

Fig. 11. Cochin, India, *Interior of the Ark,* Pardesi Synagogue.

References:
Christie, Manson, and Woods International Inc., New York, *Fine Judaica, English and Continental Silver, Russian Works of Art, Watches and Objects of Vertu,* sales cat., October 25–26, 1982, no. 160; The Jewish Museum, New York, *Annual Report 1982–1983,* 1984, pp. 6, 29.

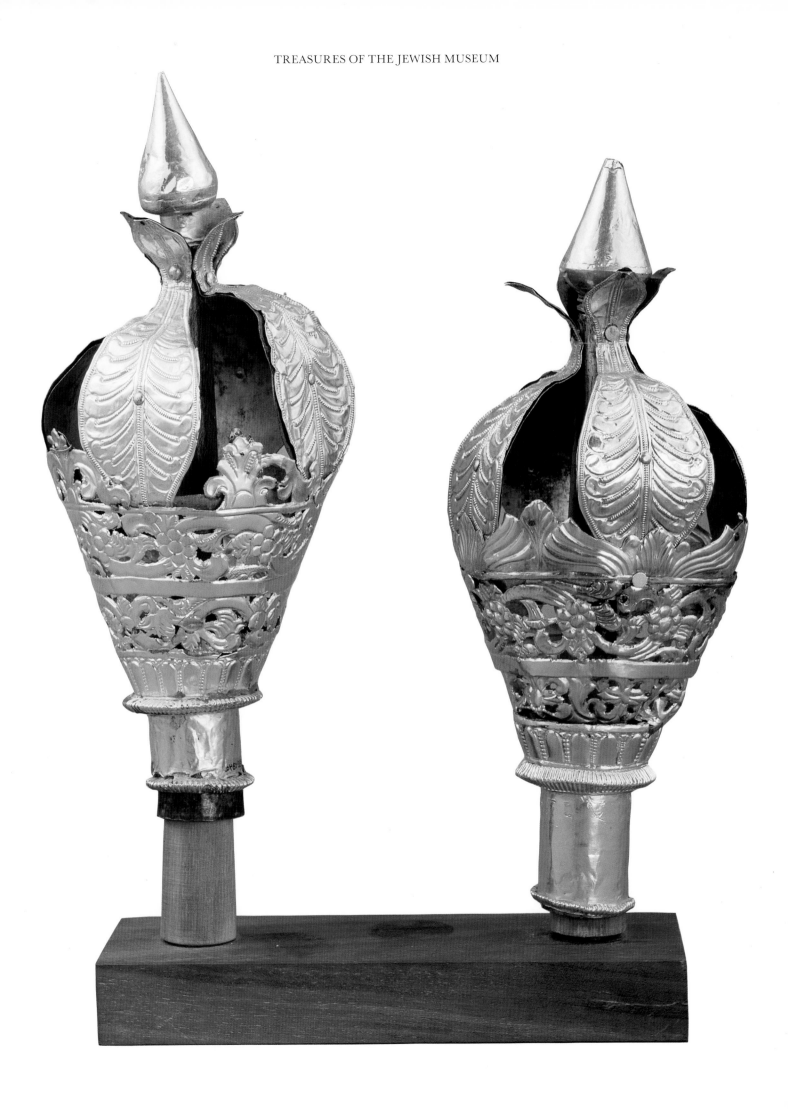

Bowl
Damascus, 1904/5
Brass: inlaid with silver, copper, and gold
5⅜ x 11 1/16 in. diam. (13.6 x 28.1 cm diam.)
Gift of Dr. Harry G. Friedman, F919

Fig. 12. Iran, *Bowl*, 1350–1400, brass and silver. New York, The Metropolitan Museum of Art, Rogers Fund, 1935 (35.64.2).

During the second half of the 19th century, Europeans traveling to or residing in the Middle East began to collect Islamic art, especially works of the Mamlūk period (1250–1517). Ironically, the rising popularity of Islamic art among Europeans coincided with Muslim efforts to modernize in the European manner and the subsequent destruction of many old buildings whose furnishings were collected by foreigners. When Mamlūk antiquities became scarce, enterprising dealers began making imitative glass and metal works for the foreign trade. In Damascus, the art of inlaying metal, an essential feature of Mamlūk style metalwork, was largely in Jewish hands.

Works produced during the Mamlūk Revival (1878–1914) are based on both the types and decoration of earlier pieces. The shape of this bowl is similar to those made in the 14th century. The division of its surface into distinct fields, each with its own inlaid and engraved decorative scheme, also reflects Mamlūk models (fig. 12). The aesthetic impact of the work derives both from the bowl's form and from the shapes and contrasting colors of the various metal inlays employed — copper, silver, and gold or brass.

The inlaid Arabic inscriptions are proverbs: "Whoever is patient attains; Deeds accord with intentions; According to a person's intentions, so is done unto him." Between the proverbs are three circular fields bearing decorative arabesques as well as Stars of David and Hebrew inscriptions: "Send your bread forth upon the water; for after many days you will find it." (Eccl. 11:1) and

שנת / תרסה / עסק / דמשק

"Damascus work, the year [5]665" (=1904/5). Similar inscriptions appear on other pieces that probably came from the same atelier.

The workshops of Damascus became the training ground for artists of the Bezalel School of Arts and Crafts, which was founded in Jerusalem by Boris Schatz in 1906 (see pp. 170–71). As a result, the shapes and techniques once used to create metalwork for Mamlūk sultans enjoyed a second "afterlife," through the 1930s, in works by Jewish artists of Jerusalem.

VBM

Reference:
New York, The Jewish Museum, *The Mamlūk Revival: Metalwork for Religious and Domestic Use,* by Estelle Whelan, exh. brochure, 1981, no. 8.

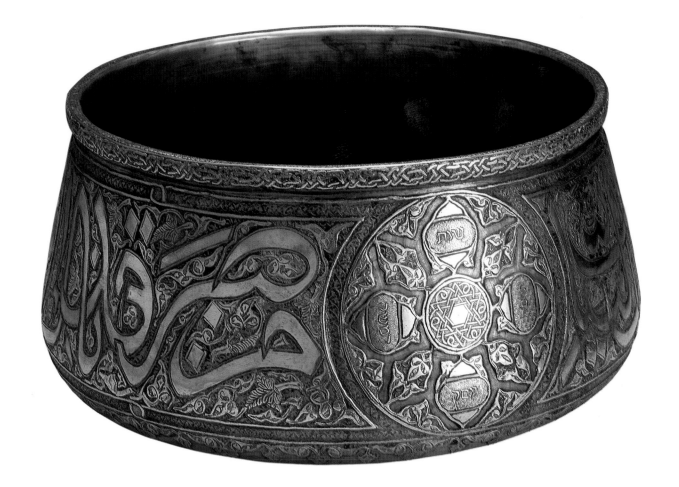

Torah Ark
Urbino, 1533
Wood: painted and carved
94 x 110 x 34 in. (239 x 279 x 86.4 cm)
The H. Ephraim and Mordecai Benguiat Family Collection, S1431

In the period of the earliest synagogues, there were two ways of storing Torah scrolls. One was in a permanent niche within a wall (see pp. 38–39), and the second was in a cabinet or ark. It is this second tradition that was followed in Renaissance Italy according to the images of synagogue interiors in 15th-century manuscripts and the two extant examples: an ark from Modena, dated 1472, now in the Musée de Cluny, Paris, and this ark from Urbino, dated 1533.

What is remarkable about all these Renaissance arks (real and painted) is their lack of any distinguishing features that would identify their function. In form and outer decoration, the two extant examples most closely resemble contemporaneous furniture. The Urbino ark, with its double-tiered structure, classical pilasters, and entablature with inscription is also closely related to the wooden panelling of the ducal palace of Federigo da Montefeltro of Urbino (1422–82) in Gubbio (fig. 13).

It is only the painted decoration that shows this is not an ordinary cabinet. On the exterior, the decoration consists of a series of painted inscriptions. One set, a poem whose rhyme scheme is based on the word *aron* (ark) begins on the right side, continues across the front panels, and ends on the left side. The verses are contained within the two rectangular frames on each panel and are meant to be read from top to bottom before proceeding to the next panel. The poet based his writings on Scriptures, although he altered the wording to suit his rhyme scheme and to include the date and the information that this ark was intended for the synagogue at Urbino. The remaining exterior decoration is a series of quotations from Scriptures inscribed on the frieze. On the interior of the center doors, there are painted Tablets of the Covenant, a common feature of later Italian arks, and additional inscriptions decorate the inner sides of the side doors.

There is evidence of repainting on the exterior panels of the ark, which indicates that the present decoration was not the original. That the ark was altered after its installation in the Urbino synagogue is also shown by an interesting drawing in a manuscript of 1704. It shows that some time in the 17th century a baroque superstructure was added to the basic Renaissance form. Shortly after the writing of the book in which the drawing appears, the community of Urbino declined and its ark was subsequently acquired by a private owner.

VBM

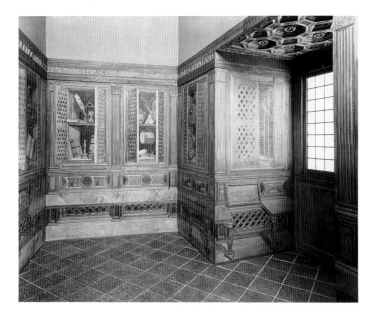

Fig. 13. Francesco di Giorgio of Siena, designer, and Baccio Pontelle of Florence, maker, *Room in the Ducal Palace,* Gubbio, 1479–82, walnut, oak, beech, rosewood, and fruit woods. New York, The Metropolitan Museum of Art, Rogers Fund, 1939 (39.153).

References:
American Art Galleries, New York, *Art Treasures and Antiquities from the Davanzati Palace,* sales cat., 1916, no. 322; Kayser/Schoenberger, *Jewish Ceremonial Art,* no. 1; R. Wischnitzer, "Ark of the Torah, Urbino, Italy, dated 1488," unpublished essay, 1978.

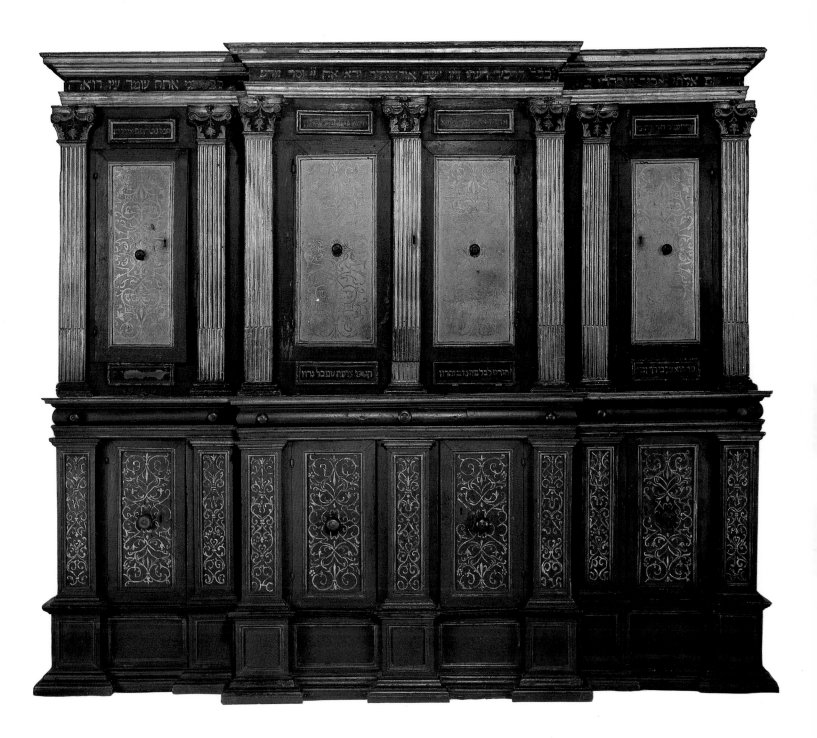

Medal of Grazia Nasi, the younger
Ferrara, 1558
Pastorino di Giovan Michele de' Pastorini (ca. 1508-1592)
Bronze: cast
2⅝ in. diam. (6.6 cm)
Gift of the Samuel and Daniel M. Friedenberg Collection, FB77

This medal is the earliest known example with a Jewish subject and a Hebrew inscription, as well as an extraordinary historical document of one of the most prominent Jewish families of the 16th century. The Grazia Nasi portrayed here was the young wife of Samuel, brother of Joseph Nasi, Duke of Naxos, and nephew of the older Grazia Nasi, a woman of extraordinary wealth and a key figure in dramatic events of international importance.

In the early 16th century, the family resided in Portugal, one of many new Christian families that had abjured Judaism in order to remain in the country after the Edict of Expulsion of 1497. In 1541, the older Grazia Nasi (ca. 1510–1569), known originally as Beatrice da Luna, began an international odyssey that ended when the sultan of Turkey invited her and her family to settle in Istanbul. It was there that her nephew Joseph (ca. 1521–1579) became one of the most powerful men in Turkey and an active participant in international affairs. His brother Samuel (d. 1569) married the younger Grazia (b. 1540) in Italy circa 1558, at the time this uniface medal was created by Pastorino de' Pastorini. At left is the sitter's name in Hebrew characters

<div dir="rtl">גרצ"אה נשיא</div>

and at right is a Latin inscription "A[nno] AE[tas] XVIII" (in the year of her age eighteen).

During the Renaissance, medals became a significant art form as men and women sought to emulate the Romans of antiquity. In imitation of antique coins bearing portraits of Roman emperors, Renaissance rulers and church officials, as well as members of the lesser nobility and the bourgeoisie, commissioned idealized likenesses that expressed their *virtú* (character) and glorified their personalities. Generally, the individual was depicted in a bust portrait that gave an ennobled version of his or her appearance. The surrounding inscription identifies the sitter and may give additional information, as on this example. Since Grazia Nasi, the younger, is known to have been born circa 1540, the inscription giving her age as eighteen indicates a date of 1558 for the medal.

Pastorino de' Pastorini was a well-known medalist who produced several similar portrait medals (fig. 14). Many of them show the subject surrounded by a beaded border and an inscription like those seen on Grazia Nasi's medal, but no other bears a Hebrew inscription.

VBM

Fig. 14. Italy, Pastorini de' Pastorini, *Medal of Francesco de Medici*, 1541–68, bronze. New York, The Metropolitan Museum of Art, Rogers Fund, 1974 (1974.167).

References:
A. Armand, *Les médailleurs italiens des quinzième et seizième siècles,* vol. I, Bologna, 1966, 202, 86; D.M. Friedenberg, *Jewish Medals from the Renaissance to the Fall of Napoleon (1503–1815),* New York, 1970, pp. 44–46, 128; New York, The Jewish Museum, *A Tale of Two Cities,* 1982, no. 144.

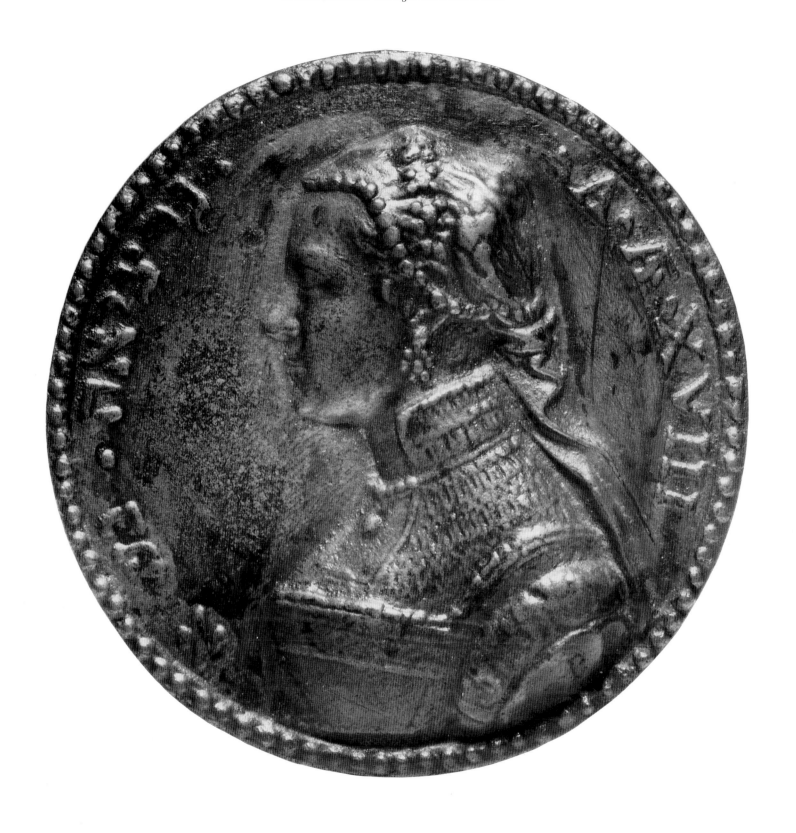

Torah Binder
Italy, 1582/3
Honorata, wife of Samuel Foa
Linen: embroidered with silk threads
7½ x 151½ in. (19 x 285 cm)
Gift of Dr. Harry G. Friedman, F4927

The scribes of Jerusalem began to write the five books of the Hebrew Bible on one scroll some time during the 1st century C.E. Their practice was universally adopted by the 4th century with the result that the Torah became a very large and bulky scroll, necessitating two supporting rods, rather than the single rod in general use during antiquity. The size of the Torah also made necessary the use of a binder to hold the rolled scroll together and to prevent the ripping and tearing of the parchment.

Sephardic Jews of Italy and Turkey developed traditions for decorating and donating Torah binders that contrast markedly with Ashkenazi practices. (See pp. 116–17.) Instead of the symbolic and scenic elements found on northern examples, Sephardic binders are usually embellished with commonplace floral motifs that are also found on ecclesiastical and domestic textiles (fig. 15). The widespread distribution of these embroidery motifs was due to the printing of pattern books in the late 15th and 16th centuries. Motifs, like the repeated pattern of branches, oak leaves, and grape clusters on this example are purely decorative and without symbolic value.

The inscriptions on Italian binders generally indicate their donation by a woman, rather than their dedication in honor of a male child, which was the Ashkenazi usage.

לכבוד התורה התמימה הרימה ידי תרומה אנכי אונוראטה ת"מא אשת כמ"הר שמואל פואה יצ"ו הלא מצער היא שנת השמ"ג לפק

"In honor of the pure Torah, my hand raised an offering, I Honorata . . . wife of . . . Samuel Foa . . . , 'it is such a little one' (Gen. 19:20), the year 5343 (=1582/3)." Sometimes, the inscription is more specific and indicates that the donation was prompted by an important event in the donor's life cycle, such as marriage or the birth of a child. In fact, the role of Italian Jewish women as donors of textiles for the Torah was so prominent as to have been incorporated into the liturgy of Roman Jews. "He who blessed our matriarchs, Sarah, Rebecca, Rachel, and Leah, may he bless every daughter of Israel who makes a mantle or cover in honor of the Torah."

Fig. 15. Italy, *Border,* 16th century, linen and silk threads. New York, The Metropolitan Museum of Art, Purchase, Anonymous Gift, 1879 (79.1.14).

The Foa binder is one of the earliest Italian examples extant. Its composition, a horizontal band of decoration over a band of inscription is relatively simple and may simply be an adapted border decoration with added Hebrew inscription. Other 16th-century examples bear a more complex arrangement: bands of alternating text and decoration, which create stripes that run diagonally in the rectangular field.
VBM

References:
Jewish Museum, *Fabric of Jewish Life,* 1977, no. 16; Cissy Grossman, "Womanly Arts: A Study of Italian Torah Binders in the New York Jewish Museum Collection," *Journal of Jewish Art,* 7(1980), p. 38, fig. 6.

Beaker of the Obuda Burial Society
Georgius Renner (?; Master in 1626)
Hermannstadt, Kingdom of Hungary, ca. 1626
Silver: repoussé, chased, punched, engraved and parcel-gilt
8 5/16 x 4¼ in. (22.6 x 10.9 cm)
Gift of Dr. Harry G. Friedman, F2497

The form and decoration of this beaker closely resemble earlier Renaissance works from German centers. Its simple lines and relatively flat, engraved decorations of intersecting strapwork and trefoil leaves are characteristic of the period (fig. 16).

Jewish ownership of the beaker can only be verified, however, in 1764/5 when it was inscribed as the property of the Obuda Burial Society:

זה שייך לחברא / קדישא ק"ק / אובן ישן / שנת / ת"ק"ד"ה"ל

"This belongs to the Burial Society [of the] h[oly] c[ongregation of] Alt-Ofen (Obuda) [in] the year of [5] 525 (=1764/5). Commissioned by the officers and gravediggers; the officer. . . Zekil and . . . Leib son of Gumpel and . . . Judah Leib." A second inscription indicates that the beaker was later sold in order to raise funds. The new owner promised to bequeath it to the Obuda Burial Society in lieu of burial fees.

גביע הזה / קנה אי"א הרר / חיים ו"ו ז"ל מח"בר' / הקדושה דק"ק
א"י נ"י / ונדב מיד ליתן אותו / לח"ה ה"ו ליום פקודתו / עבור
מעות קברתו / ויותן ע"י יורשיו / ב"ז אדר תק"סנל

"This cup was bought by. . . Ḥayyim W of blessed memory from the Burial Society of the h[oly] c[ongregation of] Alt-Ofen (Obuda) and immediately donated it to be given to the a[bove-named] society on the day of his death for burial fees and it was given by his heirs on the 7th of Adar [5]563 (=March 1, 1803)."

Jewish burial societies were formed to nurse the sick, to bury the dead according to Jewish law, and to care for the bereaved. Among Christians, these functions were performed by guilds, which were essentially economic unions that had social functions as well. Since Jews were not allowed to join guilds in western and central Europe until their achievement of political rights in the 19th century, they were forced to form separate social welfare groups. Still, the Jewish societies were influenced by the structure of the guilds and imitated their

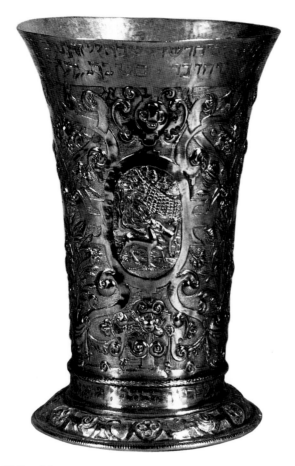

Fig. 16. Frankfurt, *Beaker of the Frankfurt Jewish Community*, ca. 1590, gold. Formerly New York, The Jewish Museum, F 3000.

ceremonies. At annual meetings and banquets, the guilds and societies displayed ceremonial silver and drank toasts from special beakers like this one (see pp. 62–63).
VBM

Reference:
The Jewish Museum, New York, *Le-Hayyim—To Life! Cups of Sanctification and Celebration,* exh. brochure by S.L. Braunstein, [1984], no. 44.

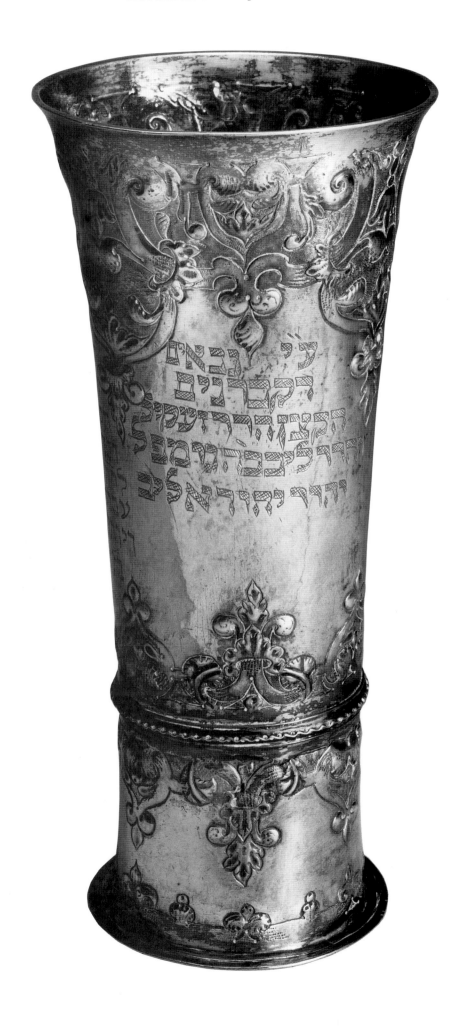

Curtain for the Torah Ark
Italy, 1643/4
Silk and silk damask: appliquéd and embroidered
with metallic threads
65 x 45½ in. (163 x 112 cm)
Gift of Dr. Harry G. Friedman, F3580

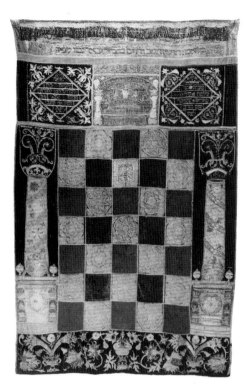

Fig. 17. Salomon Perlsticker (?), Prague, *Curtain for the Torah Ark,* 1547, silk, seed pearls, and metallic threads. Prague, Státní Zidovské Museum.

The practice of hanging a curtain in front of the Torah ark dates back to the period of the early synagogues and is linked to the concept of the holiness of the Torah scrolls contained within. Though no curtains are extant that date before the mid-sixteenth century, there are numerous representations of Torah arks and their curtains in ancient mosaics and gold glass and in medieval manuscripts. All show a curtain formed of a cloth with a single color or an overall pattern. The appearance of the first curtain, now in The State Jewish Museum of Prague is, therefore, remarkable not only for its age but because its composition consists of decorative and symbolic elements executed in silk appliqué with added embroidery (fig. 17).

Similar techniques were used to decorate early Italian curtains like this one. Drawing on the artistic traditions of Renaissance Italy, the maker appliquéd and embroidered vine scrolls and other floral motifs to form self-contained compositions within the rectilinear compartments that form the whole. The result is an additive composition whose elements are symmetrically balanced around the center and whose appliqué technique emphasizes the planar character of the work — all qualities of Renaissance art in general.

Various Hebrew inscriptions fill the cartouches of the center field and the borders. A quotation from Psalms (67:2) begins at the top and continues in the right, left and bottom borders: "May He cause His face to shine toward us; Selah." From top to bottom in the center field the inscriptions read:

כֶּתֶר תוֹרָה / שְׁנַת / שַׁבָּת קֹדֶשׁ / ל-"י- / ה"שׁי

"Crown of Torah/ the year 'a holy sabbath of the Lord'" (Ex. 16:23)/"The L[ord] b[lessed be He]." The word "holy" is marked to indicate it is a chronogram for the year [5]404 (=1643/4).
VBM

References:
Kayser/Schoenberger, *Jewish Ceremonial Art,* no. 7; The Jewish Museum, *Fabric of Jewish Life,* 1977, no. 2.

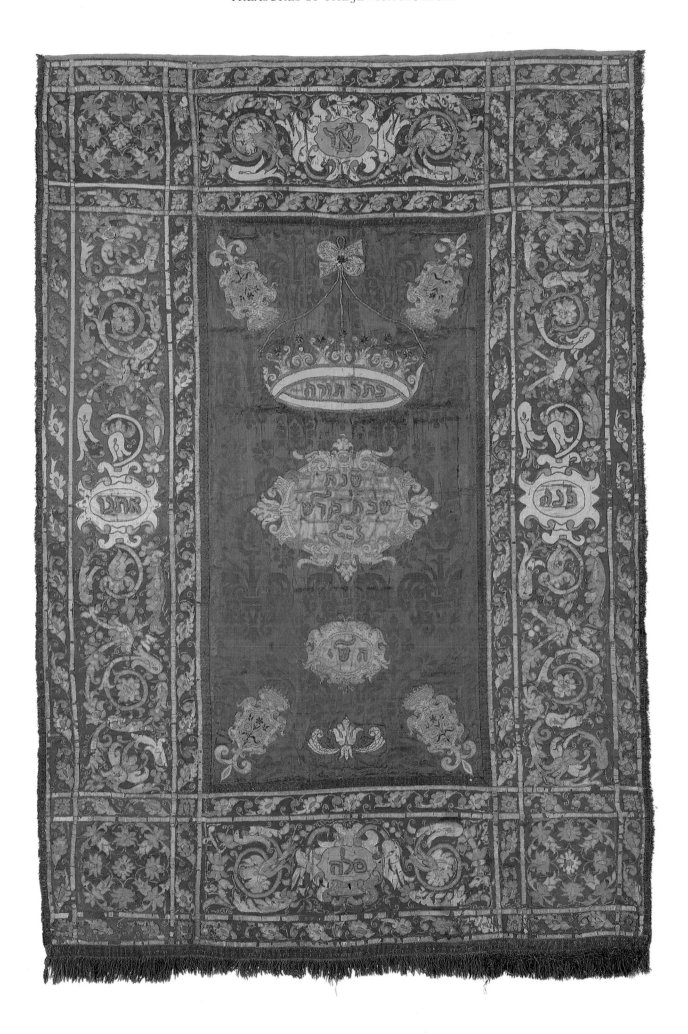

Beaker of the Polin Burial Society
Bohemia, 1691
Glass: enameled
9¾ x 5¼ in. diam. (24.4 x 13.1 cm diam.)
Gift of Dr. Harry G. Friedman, F3211

This work is the oldest glass burial society beaker in existence. Made for the Jewish community of Polin, Bohemia, it is an interesting example of Jewish acculturation through the adaptation of a Bohemian art form.

In 1584, the Hapsburg emperor Rudolf II moved his court to Prague. During his reign, the Bohemian capital became a great center of Renaissance art and scholarship, drawing artists and scholars from all over Europe. Among them were specialists in the arts of cutting and painting glass. The popularity of decorated glass among members of the court influenced other groups — guilds, societies, and noble families — to commission similar pieces (fig. 18).

During the same period, the rabbis of Prague worked at organizing the community in their care. In 1564, Rabbi Eleazar Ashkenazi formed the first modern burial society; its regulations were codified by the great Rabbi Judah Loew, the Maharal (ca. 1525–1609). In effect, the Jewish burial societies of Europe performed some of the same functions for members as did the Christian guilds, leading the Jewish organizations to adopt some of the guilds' trappings and rituals. One of these was the custom of holding festive banquets at which business of the society was enacted and special emblems of the organization were displayed. Some examples are the large drinking vessels decorated with vignettes of members performing characteristic activities. It is in this artistic, social, and religious context that the Polin beaker must be placed. Its decoration features a frieze of burial society members who are marching with a bier towards the cemetery. The accompanying inscription reads:

זאת הזכוכית / שייך לחבורה קדישא / דקברנים מקק פאלין / דורן
מנאי משה בהרר / יעקב פאלין חנוכה תנב / לפק

"This glass belongs to the Holy Society of Morticians of the holy community of Polin. Gift from me, Moses son of Rabbi Jacob Polin, Hanukkah [5]452" (= December, 1691). The same elements (a frieze of figures and an elaborate inscription) remained popular on similar glasses through the 19th century and were imitated on the faience beakers favored by burial societies in nearby Moravia. Both types represent local forms that differ markedly from the silver beakers commissioned by Jewish burial societies in other parts of Europe (see pp. 58–59).

VBM

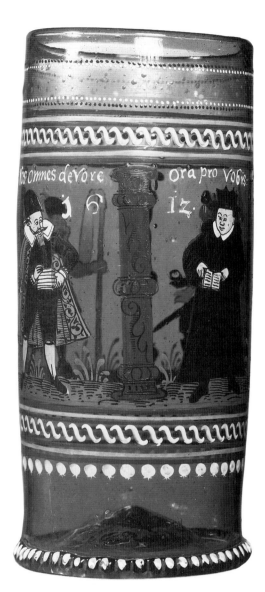

Fig. 18. Bohemia, *Beaker,* 1608, enamelled glass. New York, The Metropolitan Museum of Art, Munsey Fund, 1927 (27.185.15).

References:
Kayser/Schoenberger, *Jewish Ceremonial Art,* nos. 174–174a; I. Shachar, "Feast and Rejoice in Brotherly Love: Burial Society Glasses and Jugs from Bohemia and Moravia," *The Israel Museum News,* 9 (1972), no. 1; D. Altshuler, ed., *The Precious Legacy: Judaic Treasures from the Czechoslovak State Collections,* New York, 1983, pp. 156–7; The Jewish Museum, New York, *Le-Ḥayyim-To Life! Cups of Sanctification and Celebration,* exh. brochure by S. L. Braunstein, [1984], no. 45.

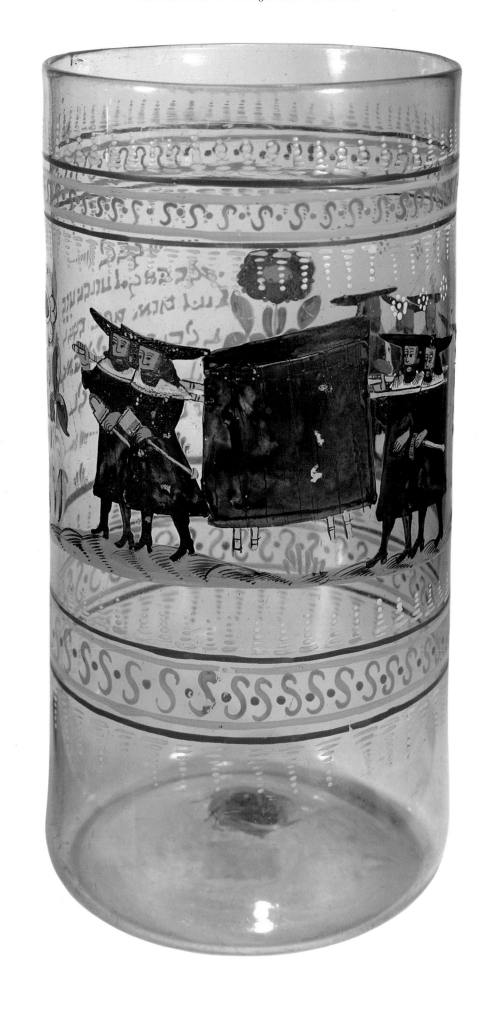

Scroll of Esther
Amsterdam, after 1641
Engraver: Salom Italia (1619–after 1655)
Parchment: engraved and manuscript
7 15/16 x 98 5/8 in. (20 x 250.5 cm)
Gift of the Danzig Jewish Community, D76

The Book of Esther, read on the festival of Purim, recounts the way in which the Jews of Persia escaped annihilation during the reign of King Ahasuerus (probably Xerxes I, who ruled 485–464 B.C.E.). Haman, the King's vizier, plotted to kill all the Jews in the kingdom and cast lots (*purim*) to determine the day of their destruction. His plan was stymied through the intervention of Ahasuerus's beautiful Jewish queen Esther who, guided by her uncle Mordecai, persuaded the King to save the Jews and execute the evil Haman in their place. Having triumphed over their enemies, the Jews of Persia engaged in "days of feasting and joy," and it is this spirit of merry-making which characterizes the celebration of Purim to this day. The text of the Book of Esther is handwritten on a parchment scroll and read publicly in the synagogue on Purim. Congregants follow the text in their own scrolls, which are often lavishly decorated.

The elaborate engraved borders of this scroll are the work of the Jewish artist Salom Italia, born into a family of printers in Mantua in 1619. With the Austrian invasion of Mantua in 1630, Jews were forced from the city, and Salom Italia probably proceeded to the Venetian States before settling in Amsterdam in 1641. In Amsterdam he found a prospering community of Jews with both the means and inclination to commission and collect the works of a young printmaker (see also pp. 68–69).

This scroll was printed from one engraving plate, consisting of four arches, which was repeated five times to produce a series of twenty arches to frame the text. The Dutch cityscape atop each portal reflects the influence of Italia's new home. Each portal is crowned by a broken pediment surmounted by lions. Figures from the Purim story stand flanking the archways, King Ahasuerus facing Queen Esther and Mordecai facing Haman. Below each figure is a scene from the story itself, each printed from a separate plate, comprising a narrative cycle of nineteen images.

The first panel of the scroll consists of naturalistically rendered peacocks and birds, and an empty cartouche intended to frame the blessings recited before reading the scroll. (In a nearly identical scroll, with *putti* instead of lions atop the portals, these blessings appear in the cartouche.) On the lip of the vase of flowers to the left, Salom Italia signed his name in Hebrew. The squirrel to the right is an element from the insignia of the Italia family of Mantua.

Salom Italia's great innovation and contribution to the design of Esther scrolls was setting the text within portals derived from triumphal arches. The practice of conducting triumphal processions through arches dates back to ceremonies for victorious generals in ancient Rome, and the building of temporary arches to honor rulers as they entered a city continued in Europe until the 19th century. By the 16th century the triumphal entries of monarchs were commemorated by the publication of descriptions of the iconographic programs, complete with woodcuts or engravings of the temporary arches and decorations specially created for these events.

In 1642, shortly after Italia's arrival in Amsterdam, the city mounted a magnificent triumphal entry for the Stadholder Frederik Hendrik and his in-laws, the English royal family. Italia may also have been influenced by designs for the 1638 entry of Marie de' Medici into Amsterdam (published in 1639); for example, an arch surmounted by lions with columns similar to the ones on our scroll. Italia's figures flank the arches and stand beneath festoons of fruit suspended from masks. These elements are also found in the decorations for a triumphal entry into Lisbon in 1619 (published in Madrid, 1622).

Salom Italia designed his own version of a triumphal arch from the variety of printed sources available to him. He thus achieved a perfect marriage of form and content, since the Book of Esther recounts the triumph of the Jews of Persia and includes the account of Mordecai's triumphal procession through the streets of Shushan, the Persian capital. This episode was depicted by Rembrandt van Rijn in an etching that was made in Amsterdam around 1641 and was probably known to Italia.

The original owners of this scroll would have understood the reference to triumphal entries in the decorative program. As they unrolled the scroll to follow the text, thereby revealing one arch at a time, they would have been symbolically passing through each portal, thereby reenacting the triumph of Mordecai and of all Jews that is at the heart of the celebration of Purim.
EDB

Reference:
The Jewish Museum, *Danzig 1939*, 1980, no. 48.

Hanukkah Lamp
Italy, 17th century
Brass: cast
12¾ x 15½ in. (32.4 x 39.3 cm)
Gift of Dr. Harry G. Friedman, F2125

The holiday of Hanukkah celebrates an ancient victory, a successful revolt for religious freedom. In 165 B.C.E., the Hasmoneans, a priestly family, led fellow Jews in expelling their Greco-Syrian rulers from Judea. Their victory allowed for the cleansing of the Temple, its sanctification, and the rekindling of the *menorah*, the seven-branched lampstand. This last act became a symbol of the festival. By the time of the Mishnah (ca. 250 C.E.), Jews commemorated Hanukkah through the kindling of lights, one for each of the eight nights of the festival, and placed them outside the home or in a window in order to publicize the victory that is the basis of the holiday.

As a result of these practices, there came to be a close association between Hanukkah lamps and architectural forms that is evident in the earliest extant lamps used specifically for the holiday. In the 13th century, a new type of Hanukkah lamp came into use. It was furnished with a backplate and hanging device and could be hung on the wall, but its decoration was still architectonic. The gabled end of a Gothic cathedral, rose window and all, was the model for the backplates of the first pendant lamps (fig. 19). These examples, with backplates that echo the forms and styles of contemporaneous buildings, set the pattern for future lamps. (See also pp. 110–11.)

This work reflects the style of classical architecture. As part of a wide-ranging recovery of the classical past, Italian architects of the 15th through the 17th centuries modeled their buildings on the Roman ruins they saw around them, and on the architectural principles enunciated by the Roman writer Vitruvius, whose treatise *De Architectura* was "rediscovered" in the early 15th century. "Architecture consists of Order. . .and of Arrangement. . .and of Proportion and Symmetry and Decor and Distribution . . ." wrote Vitruvius (*De Arch.* I, ii, I). He was advocating an architecture whose total effect was additive, the culmination of relationships that were ordered, symmetrical, and based on a common system of proportions.

Vitruvius's words are echoed in the treatises of Italian architects who modeled their buildings on Roman types. For example, the classical insula or block of apartments became the basis of the Renaissance and baroque palace, which in turn served as a model for Italian Hanukkah lamps. The architectural elements of this lamp, an arcade supported by columns that is fronted by a balustrade set at a distance from the plane of the arches, appear on the facades of various Italian palaces of the 16th and 17th centuries (fig. 20).

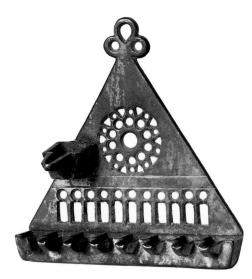

Fig. 19. So. France or No. Spain, *Hanukkah Lamp,* end of the 13th — beginning of the 14th century, bronze. Paris, Musée de Cluny.

Fig. 20. Antonio da Sangallo, the younger, Peruzzi, and Giacomo da Vignola, La Palazzo Caprarola, 1520s–1573.

This Jewish Museum lamp is outstanding for the harmony of its proportions and the purity of its architectural forms, whose spatial relationships echo actual buildings and reflect the sense of order, proportion and symmetry promoted by Vitruvius. On later Italian lamps, the arch becomes a frame for other symbols, and loses the architectural significance seen here.

VBM

Reference:
Kayser/Schoenberger, *Jewish Ceremonial Art,* no. 123.

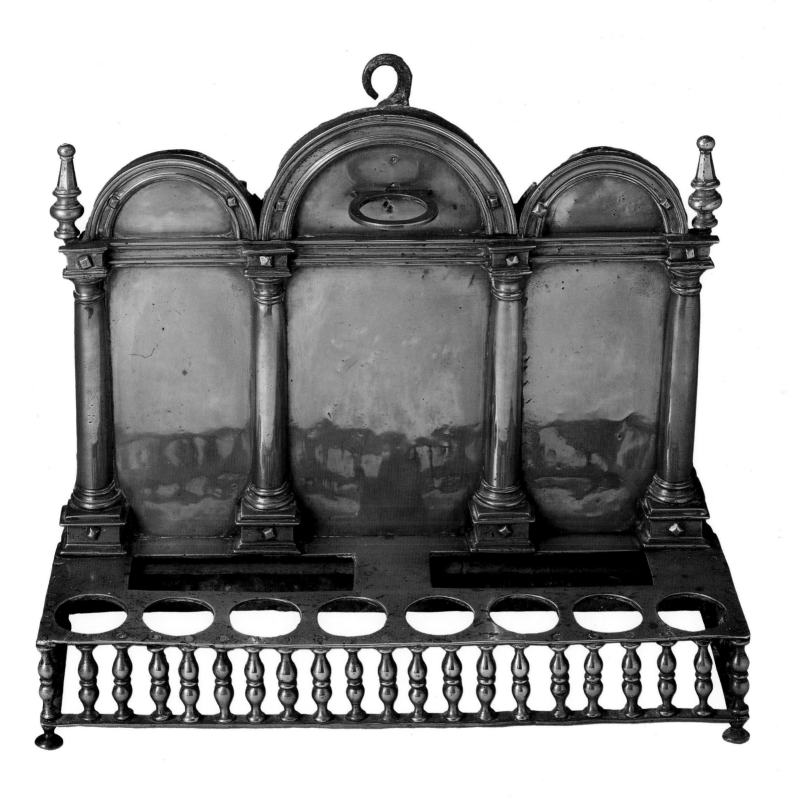

Rembrandt van Rijn (Dutch, 1606–1669)
Jews in the Synagogue
Etching on paper
Signed in upper portion of column on left: "Rembrandt f. 1648"
3 x 5⅛ in. (7.6 x 13 cm)
Gift of Dr. Harry G. Friedman, F4429

The etching of the *Jews in the Synagogue* is a visual document of Jewish life in Amsterdam in the middle of the 17th century. The Dutch people who had struggled for centuries to free themselves from Spanish rule and the Catholic church felt their fight for religious and political freedom paralleled the history of the ancient Jewish nation. The emerging Dutch Republic saw itself as the spiritual descendent of ancient Jewry. Recent scholarship suggests, however, that Dutch tolerance of the Jews who emigrated to Amsterdam reflects rather the insignificant numbers of new arrivals, relative to the expanding native population. Secondly, the Jews lived together in new parts of the city, away from the major centers, and tried to remain obscure in their daily activities.

Rembrandt lived on the Jewish street, the *Jodenbreestraat,* as did other artists, and it is known that he employed Jews as models for many of his biblical paintings. A keen observer of daily life, he may have considered the "Semitic" looks of his Jewish neighbors to be appropriate for the biblical heros and heroines he was portraying.

Spanish and Portuguese Jews began to settle in Amsterdam in the 1590s, Ashkenazi Jews came from Germany in the 1620s; and in 1648–49, Polish Jews fled the infamous Chmielnicki pogroms and sought refuge there. With each new wave of immigration, those Jews already established in the Dutch community felt uncomfortable and embarrassed by the awkward newcomers. By 1648, the Jewish community of Amsterdam was a large and diverse group.

Rembrandt examines the theme of isolation, perhaps the isolation felt by newcomers within the established Jewish community, in this etching of *Jews in the Synagogue.* A lone figure, seated on a stone ledge with his back toward the viewer, is the focus of the composition, visually and thematically. Rembrandt renders his body in full light, whereas the other figures, four pairs of men, move into and out of the light. They wear the costumes of German and Polish Jews and the artist has made no attempt to divide the groups by their native dress. Thus, the theme of isolation is directed at the single figure. Lost in his own thoughts, he is unaware that he is being observed by the viewer or by some of the other men who mill around him. They gather in an undefined space, which some scholars have suggested is the interior of a synagogue. Though no such structure existed in Amsterdam in 1648, the space is probably meant to evoke a religious setting. Rembrandt's treatment of Jews in this etching is a sympathetic but astute observation of individuals within the diverse community.
SJM

Reference:
A.M. Hind, *Rembrandt's Etchings,* London, 1912, no. 234, III.

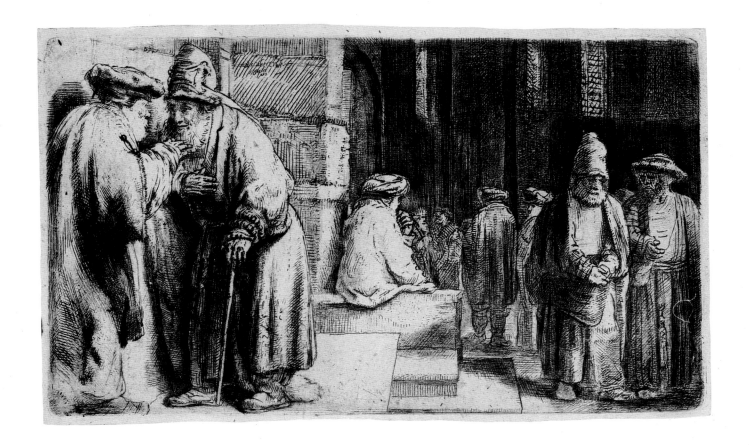

Curtain for the Torah Ark
Venice, 1680/1
Simḥah, wife of Menaḥem Levi Meshullami
Silk: embroidered with silk and metallic threads, metallic fringe
85 1/16 x 55⅛ in. (216.1 x 140.1 cm)
Gift of Professor Neppi Modona, Florence, through
Dr. Harry G. Friedman, F2944

This is an extraordinary Torah curtain for several reasons: its impressive size, beautiful workmanship, and unusual iconography. According to the dedicatory inscription at bottom center, the curtain was made

בשנת / ישא / ברכה / מ׳א׳ת׳ ה׳

"in the year 'He shall carry away a blessing from the Lord'" (Ps. 24:5; chronogram for the year 1680/1),"

מעשה ידי הכבוד׳ מר׳ שמחה אשת כמ מנחם לוי משולמי י׳ץ

"the work of . . . Simḥah, wife of . . . Menaḥem Levi Meshullami. . . ." The dedication reaffirms the significant role played by Italian Jewish women in the creation of synagogue textiles (see pp. 56–57), even among very wealthy and prominent families like the Meshullami, one of the first Jewish families to settle in Venice.

The decoration of the border, a symmetrical flowering vine, is an elaborate version of a motif found on many smaller textiles like Torah binders and reader's desk covers. Neither is the motif of the Tablets of the Covenant surrounded by a glory of clouds unusual. It is found on many Italian Torah curtains of the 17th and 18th centuries and is a specialized case of a baroque convention for the presentation of a holy object or personage. On this curtain, however, the clouds are the upper portion of a landscape linked by the Tablets to a mountain which is identified by another quotation from Psalms as "The mountain which God has desired for His abode" (Ps. 68:17). The reference in this passage is not to Mount Sinai, where the Tablets were received, but to Mount Moriah, on which the Temple was built. Thus the mountain in this curtain has a dual iconographic function. It is both the locus for the giving of the Tablets and the link to the representation of Jerusalem below.

Only one other Torah curtain has similar decoration. On this other curtain, still the property of the Venetian Jewish community, the iconographic elements are part of a continuous landscape inspired by an El Greco painting that was on view in Venice shortly before the curtain was created in 1673. The greater detail and naturalism of the Venice curtain and its earlier date suggests that it was the model for the Meshullami composition, in which the forms are more stylized and disjointed.

Fig. 21. Italy, detail of *Marriage Contract,* 17th century, ink and gouache on parchment. New York, The Library of the Jewish Theological Seminary of America.

What is unusual about these two curtains is the detailed representation of Jerusalem, unique in Torah curtain iconography, but common on another type of 17th-century Italian Judaica, decorated *ketubbot,* or marriage contracts (fig. 21). Since the Italian Jewish marriage ceremony includes the recitation of Psalm 128, which mentions Jerusalem, and remembrances of the city's destruction are part of every Jewish wedding, depictions of the city were appropriate to the decoration of the contracts displayed at the ceremony. Some of these representations are accompanied by another of the inscriptions found on The Jewish Museum curtain: "I prefer Jerusalem above my chief joy" (Ps. 137:6). On 17th-century contracts from northern Italy, Jerusalem is shown as it is on the curtain, encircled by octagonal walls; its center is dominated by the Dome of the Rock, commonly used to signify the ancient Temple. The exact source of the curtains' representations of Jerusalem (distinguished by the elaborate towers at each juncture of the walls and by the main gates in the form of *aediculae*) has not yet been identified. There is no doubt, however, that its use on the curtain was inspired by the decoration of *ketubbot,* creating an iconographic link between two forms of Judaica for which women played a vital role in 17th-century Italy.
VBM

References:
Kayser/Schoenberger, *Jewish Ceremonial Art,* no. 5; The Jewish Museum, *Fabric of Jewish Life,* 1977, no. 3; The Jewish Museum, New York, *The Jewish Patrons of Venice,* exh. brochure by S.J. Makover, 1985, no. 3; Z. Vilnay, *The Holy Land in Old Prints and Maps,* trans. by E. Vilnay and M. Nurock, Jerusalem, 1963, p. 32.

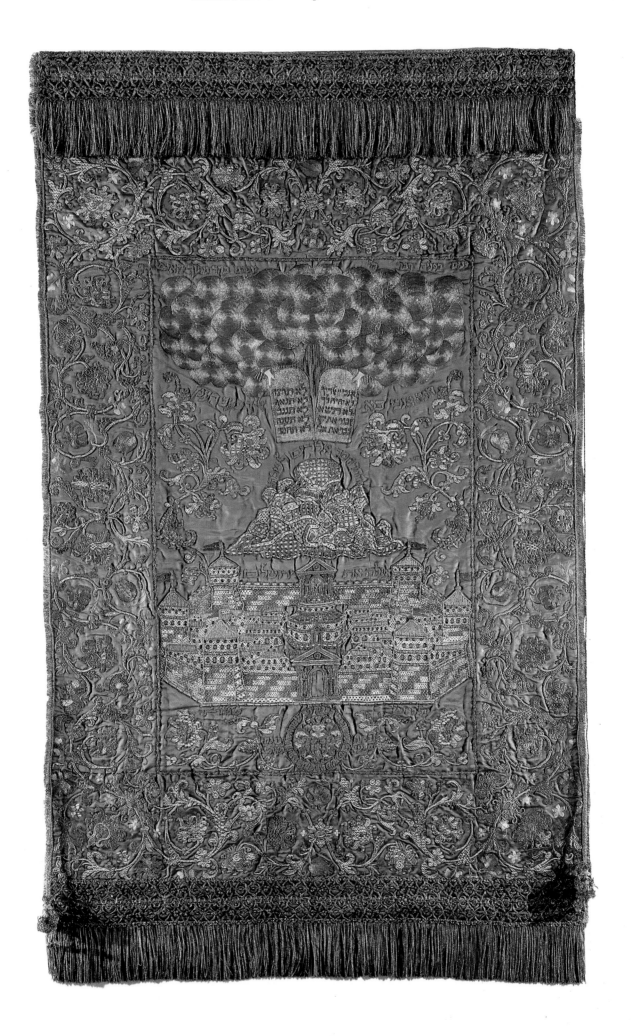

Curtain for the Torah Ark
Venice (?), Italy, 1698/9
Leah Ottolenghi
Linen: embroidered with silk and metallic threads
70 x 48 in. (184 x 122 cm)
Gift of Dr. Harry G. Friedman, F3432

Italian Judaica of the 17th century is distinguished not only by its high artistic quality but also by the existence of many works that incorporate sophisticated iconographic progams. At a time when Ashkenazi marriage contracts were undecorated and Persian examples were ornamented with repeated decorative motifs, Italian Jews were commissioning *ketubbot* painted with biblical scenes, cosmological references, and allegories. While Ashkenazi Jews were fashioning Torah curtains that emphasized the beauty of materials and workmanship and bore limited iconographic references, Italian Jews were creating curtains like this one, whose every image is a symbol contributing to detailed iconographic schemes.

Several themes are represented. The first is the reading of the Torah on the Sabbaths and holy days of the Jewish year, with emphasis given to those times at which special portions of the Torah are read or which celebrate the giving and reading of the Torah. At center are the Tablets of the Covenant on a fiery and flowering Mt. Sinai, a reference to the giving of the Torah, the central historical event celebrated on Shavuot (the Feast of Weeks); below is a cartouche devoted to the holiday of the Rejoicing of the Law when the yearly reading of the Five Books of Moses is concluded and begun again. At the four corners are symbols of a series of four Sabbaths in the spring when there are special readings from the Torah. Four of the six intermediate cartouches are devoted to holiday Sabbaths with similar, special readings.

However, when the pairs of intermediate cartouches are read across, from right to left, a second theme of personal and national redemption is presented. The tombs of the first Jews, the patriarchs and matriarchs, are shown in the second position at right. Opposite is a depiction of the Mt. of Olives, the site of the resurrection of the dead in Messianic times. Below at center right is a cartouche devoted to the Sabbath of Passover, the holiday which marks the birth of the Jewish nation. Its destruction as an independent state is commemorated at left, coupled with the promise of a rebuilt Jerusalem. The next row pairs Hanukkah and Purim, both minor holidays which celebrate God's redemption of his people in post-biblical times.

The symbols chosen to fill the cartouches and the quotations that surround them indicate a third theme. The curtain also presents an *itinerarium* of holy sites: the tombs of the patriarchs, the Mt. of Olives, the altar and menorah of the Temple, and the city of Jerusalem. Other symbols of the Temple are the laver and basins at bottom, which recall ceremonies held during Sukkot. If the central images are read along the vertical axis, then they indicate heaven (the throne of God), Sinai (where heaven and earth met), and the Temple (the abode of God on earth).

Finally, the central depiction of the Tablets flanked by *etrogim* (citrons) and a *lulav* combines all three themes. The *lulav* and *etrog* refer to a place, the flowering Mt. Sinai, but are also a symbol of Sukkot when these plants are used in ritual and special portions of the Torah are read. Thirdly, since ancient times, they have been a symbol of the Messianic Age, since it is believed that Sukkot will be the first holiday celebrated in the restored Temple. (See pp. 26–27). They are thus, also, a symbol of redemption.

A similar curtain is in the Jewish Museum, Florence, but lacks the *tituli* which make explicit the iconography of this curtain. The development of this complex iconographic program in Italy during the 17th century can only be attributed to the free intellectual and artistic interchange enjoyed by Italian Jews with their Gentile neighbors. Travelers' accounts of the periods recount learned discussions on religious symbolism with savants of the ghetto. The many levels of meaning of this curtain are paralleled in the multilayered iconography of contemporaneous church altarpieces.
VBM

References:
Kayser/Schoenberger, *Jewish Ceremonial Art,* no. 5; The Jewish Museum, New York, *Fabric of Jewish Life,* 1977, no. 3; C. Roth, ed., *Jewish Art,* rev. ed. by B. Narkiss, Greenwich, Conn., 1971, p. 121 and fig. 114.

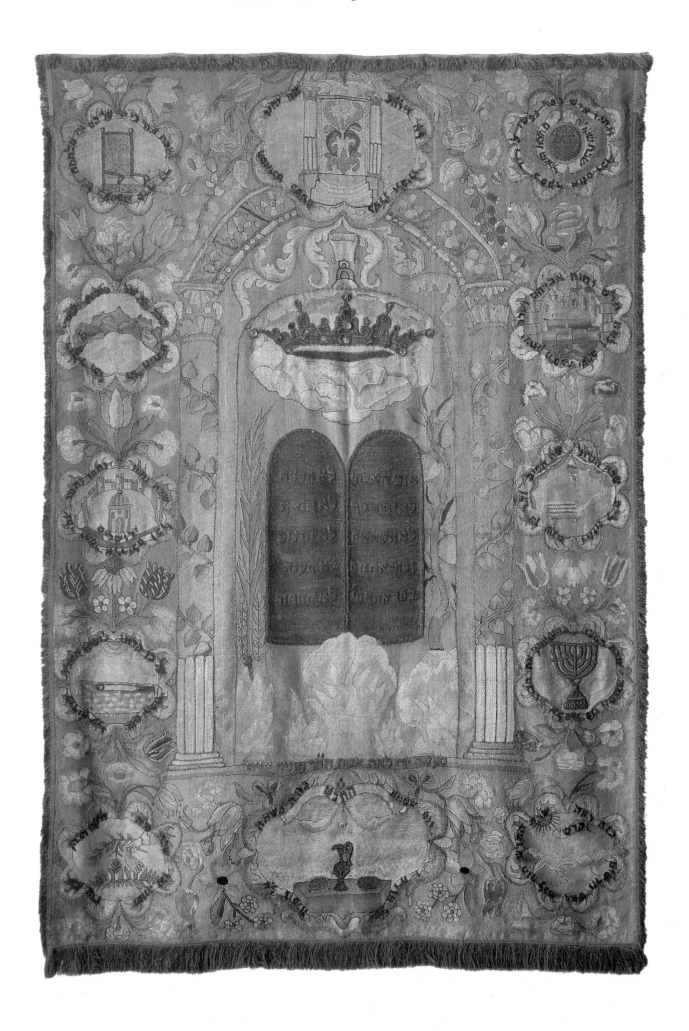

Spice Container
Venice, 17th–18th century
Silver: filigree, parcel-gilt; cloisonée enamels
16½ x 4⅜ in. diam. (41.9 x 11.1 cm)
Gift of Dr. Harry G. Friedman, F3140

During the Middle Ages, the filigree of Venice was so highly prized that the technique was known as *opus Venetum,* Venetian work. The technical mastery achieved by that city's goldsmiths and the beauty of their designs set standards throughout Europe. Filigree was used extensively in Venice and surrounding areas, both as an adjunct to other techniques and to fashion larger works; some examples are reliquary caskets in the form of cathedrals and monstrances in the shape of Gothic towers, which established models for later works in tower form, like this spice container.

The fineness of the wire used on this work and its density create a filigree that is superb technically and that lends a feeling of lightness despite the solid, balanced shape of the hexagonal tower. A backing of gilt silver sets off the designs formed by the filigree wires and lends a sense of depth to the surface of the work. The gilding is picked up by the pennants at each corner and at the apex. Further color accents are furnished by the multicolored cloisonée enameled flowers set in urns on each face of the tower.

The use of spice containers in the shape of towers for the ceremony of *havdalah,* which concludes and separates Sabbaths and holy days from the workday week, is known from medieval Spain and Germany. (See pp. 34–35.) The earliest towers in existence reflect the art and architecture of their country of origin, and the same may be said of this later example. Niches flanked by columns filled with urns of flowers were a favorite motif of Italian baroque art and appear in engravings and wall decorations, as well as metalwork. VBM

Reference:
The Jewish Museum, New York, *The Jewish Patrons of Venice,* exh. brochure, by S.J. Makover, 1985, no. 56.

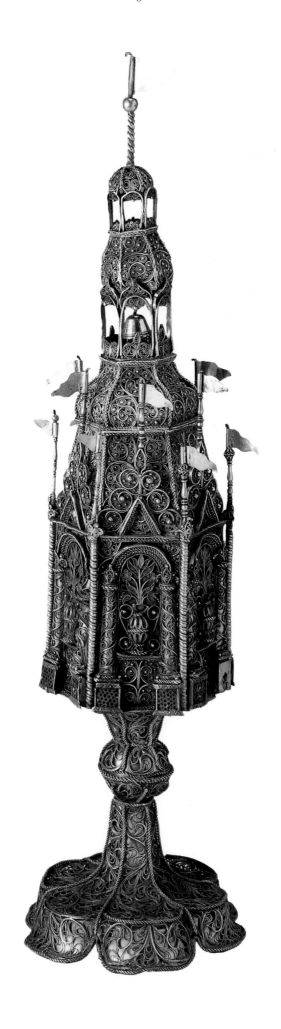

Synagogue *Menorah*
Germany, 17th century and 19th century
Brass: cast, chased, and engraved
36 x 49 in. (91.5 x 124.5 cm)
Gift of Dr. Leon Pachter, 1981–79

Despite the prohibition in Jewish law against the exact replication of the furnishings of the ancient Temple, the placement of a variant type of *menorah,* a branched lampstand, in the synagogue is a very old practice. Representations of synagogue interiors on antique gold glass and mosaics usually show pairs of *menorot* flanking the Torah ark, and fragments of actual examples have been recovered from ancient ruins.

During the High Middle Ages, in the 13th century, the practice began of lighting a *menorah* in the synagogue during the holiday of Hanukkah for the benefit of wayfarers. Such a *menorah* would have been equipped with eight lights and, perhaps, a servitor and was often monumental in size as is this example. Alternatively, the Hanukkah *menorah* may have been lit by a detached candle, a scene shown in late medieval Hebrew manuscripts.

The popularity of the *menorah* as a synagogue furnishing was due to the fact that it had become the preeminent sign of the Jewish people after the destruction of the Second Temple in 70 C.E. (See pp. 26–27.) It was a symbol of the Temple, the ancient center of Jewish spiritual life, and, by inference, reaffirmed the synagogue as its successor. As such, the large standing *menorah* was also included among the furnishings of many churches to signal the Christian belief that the church is the institutional successor to Jewish houses of worship. The earliest documentation of a church *menorah* dates to the 9th century. Thereafter comes a series of church *menorot* that bridge the centuries until the first extant examples of modern synagogue *menorot* in the 15th or 16th century.

The Jewish Museum synagogue *menorah,* then, is part of a group of lampstands that are heir to an artistic tradition incorporating both Jewish and Christian influences. Its form is essentially Jewish in origin, but many of the details belong to a general medieval lamp tradition. For example, rampant lions as base supports appear on medieval German candlesticks and church *menorot.* Branchlike arms with projecting twigs and buds are commonly found on hanging chandeliers of the 15th century and on later examples, as are the crocketed border elements below the candleholders.

The date of the upper portion of the lamp is indicated by the forms of the candleholders and baluster stem. Similar, double-curved candleholders and baluster stems appear on German hanging lamps of the 17th century. Therefore, this upper section (not including the center finial and repairs immediately below it) can be dated then. However, the lower section, the cutout knob and base were fashioned in the 19th century. The most telling indication that this is a later section is the Renaissance style relief border atop the base. On the relief, pairs of lions confront each other across urns of flowers. The style of this relief, its rich detailing and curves recall German cast work of the first half of the 19th century, especially cast ironwork, which at that time was being made into all manner of household objects, even jewelry, executed in a variety of styles including Gothic and Renaissance revival. When the older lamp needed repair, these new sections were added. At a time when most monumental *menorot* were being made in Eastern Europe, this *menorah* is an unusual Western example.

VBM

Note: Unpublished.

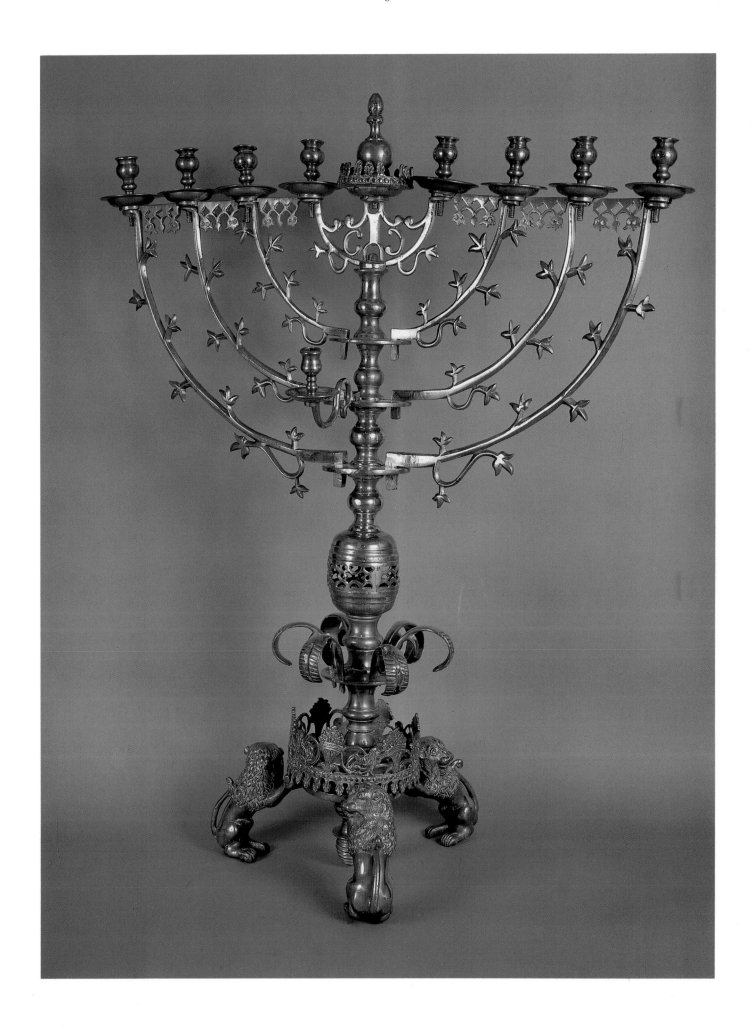

Lord Mayor's Tray
London, 1708–1709
John Ruslen (active 1656–ca. 1715)
Silver: repoussé and engraved
21⅜ x 26½ x 3¼ in. (54.3 x 67.3 x 8.3 cm)
Gift of Mrs. Felix M. Warburg, JM 2-47

In 1656, Jews were readmitted to the British Isles, after a 350-year hiatus, through the joint efforts of Oliver Cromwell and the Dutch messianic scholar Menasseh ben Israel. The following year London's small Spanish and Portuguese community established the Congregation Bevis Marks—still one of that city's major synagogues.

This four-handled tray represents the congregants' 100-year-long annual tradition of offering presentation silver to London's Lord Mayor. Beginning in 1679, silver trays were commissioned for the mayor and sent to him, lavishly filled with sweetmeats. Most of these gifts bear as a central motif the seal of the Bevis Marks Congregation—a Tent of Assembly in the Wilderness, a guard at its entrance, the whole surmounted by a cloud of glory. Similar presentation pieces were also offered to the Lord Mayor by other minority groups, namely the Dutch Reform and French Protestant Churches.

This Lord Mayor's tray was fashioned by John Ruslen, a well-established English silversmith, who had for twenty-eight years provided Jewish ritual objects for Bevis Marks. Aside from his five existing presentation salvers, records indicate commissions for a sanctuary lamp in 1682, a pair of Torah finials (*rimmonim*) in 1702, and the Hanukkah lamp of 1709 depicting Elijah and the Ravens (see fig. 22). The Dutch-influenced repoussé work and chasing of Ruslen's tray demonstrates the polarity of silver styles co-existing during Queen Anne's reign. The ornate, if retardataire, style of this tray was considered appropriate for royal commissions and presentation pieces. Its decoration contrasts markedly with the severity of most silver intended for domestic use during this period. This tray shows the continuing demand for opulent silver that followed the restoration of Charles II in 1660. Charles, who had been in exile in the Netherlands and France, brought with him elements of Dutch taste and that of Louis XIV. These styles were quickly adapted by English artisans.

After 1685, Huguenot silversmiths began to arrive in London when the French revoked the Edict of Nantes that had originally granted religious liberties to Protestants in France. These foreign craftsmen brought new stylistic elements and technical innovation to the repertoire of English silver and, not least, forced unexpected competition upon native silversmiths. The simplicity pervading most Queen Anne silver

Fig. 22. John Ruslen, *Hanukkah Lamp,* 1709, silver. Copyright, University of London, The Warburg Institute.

was due in part to the new regulations requiring higher silver content for plate and the consequent need to reduce the costs of fabrication. The sumptuous Ruslen tray aptly demonstrates that the Bevis Marks congregants spared no expense to honor their Lord Mayor.
NLK

Reference:
C. Roth, "The Lord Mayor's Salvers," *The Connoisseur,* 96 (May 1935), pp. 296–99.

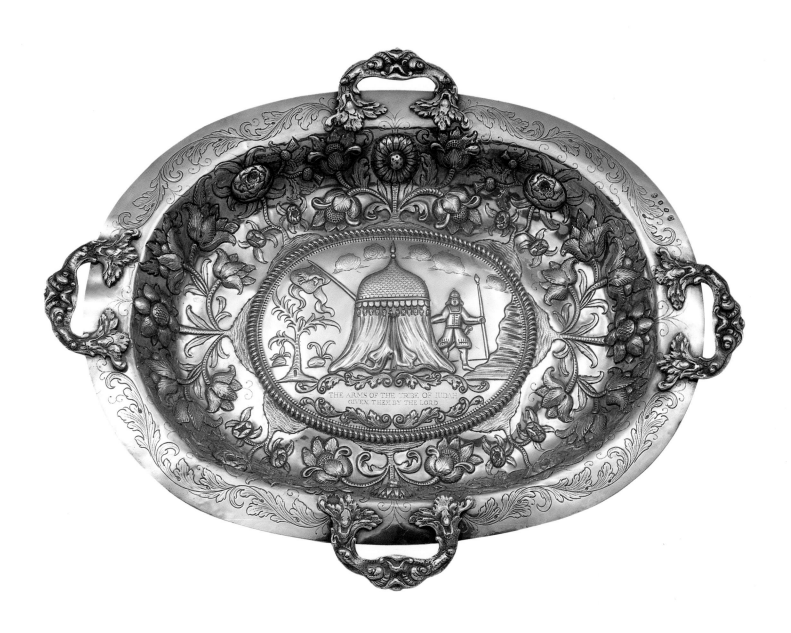

THE ARMS OF THE TRIBE OF IUDAH
GIVEN THEM BY THE LORD

Hanging Lamp for Sabbath and Festivals
Frankfurt, 1680–1720
Johann Valentin Schüler (1650–1720)
Silver: cast, repoussé, and engraved
22¼ x 14½ in. diam. (56.5 x 36.8 cm diam.)
Jewish Cultural Reconstruction, JM37-52

After the 15th century, only Jewish homes continued to use the star-shaped lamps that had been so popular throughout medieval Europe (see pp. 30–31). Because of the strong sense of tradition that dominates Jewish life, these lamps were used well into the modern era — often with more elaborate designs and in finer materials than their medieval precursors. The basic form of the lamp, however, remained unchanged: a star-shaped container for wicks and oil suspended from a shaft, and, below, a catch basin for dripping fuel.

Johann Valentin Schüler fashioned this elaborate baroque lamp for a member of the Frankfurt Jewish community. Together with his brother Johann Michael (1658–1718), with whom he shared an atelier, Valentin Schüler also produced many other types of silver Judaica: Hanukkah lamps of various shapes, candleholders and spice containers for *havdalah,* Torah shields, and elaborate covers for prayerbooks. The works of both brothers are similar in style and often incorporate pieces cast from the same molds, so that it is impossible to tell which Schüler was the author of an unmarked piece. The Judaica of the Schüler brothers seems to have seved as models for younger Frankfurt silversmiths, among them, Johann Adam Boller (see pp. 82–83).

Above the radiating arms that form the star of this lamp rises a complex and intricately worked grouping of figures, animals, and objects. The cylindrical shape of the lower shaft, decorated with masks and spouts, evokes the design of medieval fountains in public squares. Guido Schoenberger suggested that this fountain symbolism would be especially appropriate for Sabbath lamps, since the Sabbath is greeted as a "fountain of blessing" in the *Lekha dodi* ("Come my friend"), a hymn of welcome to the Sabbath that was incorporated into the synagogue services of Frankfurt during the first half of the 17th century.

The small figures standing atop the "fountain" of the lower shaft were cast from stock molds and then modified to fit the Jewish purposes of the lamp. Each holds aloft symbols of the holy days of the Jewish year. The figure bearing *matzah* and a *matzah* iron represents Passover; Sukkot is marked by a *lulav* and *etrog;* Shavuot by the Tablets of the Covenant; Yom Kippur by the knife and chicken used in the *kapporat* ceremony; Hanukkah by a *menorah* and urn for oil; Purim by a *gragger* and scroll case; Rosh Hashanah by a trumpet and "book of life"; and the Sabbath by a flaming *havdalah* candle. Such symbolic figures appear on other types of Judaica made in Frankfurt during the 18th century to mark the times when the objects were used. The small figures of animals and zodiac symbols at the top of the shaft, as well as the rampant lion, appear on other works by the Schülers and their contemporaries.

In 1903, the lamp was transformed into an eternal light. Various additions were made, most of which were removed when the piece was acquired by The Jewish Museum. Only the two flags held by the lion at top remain, because they bear an inscription recording the donation of the lamp by Mathilda Freifrau von Rothschild in memory of her husband, "Shimon, known as Wilhelm Freiherr von Rothschild." VBM

References:
The Jewish Museum, *A Tale of Two Cities,* 1982, no. 116; V. B. Mann, "The Golden Age of Jewish Ceremonial Art in Frankfurt: Metalwork of the Eighteenth Century," *Leo Baeck Institute Year Book,* 31 (1986), forthcoming.

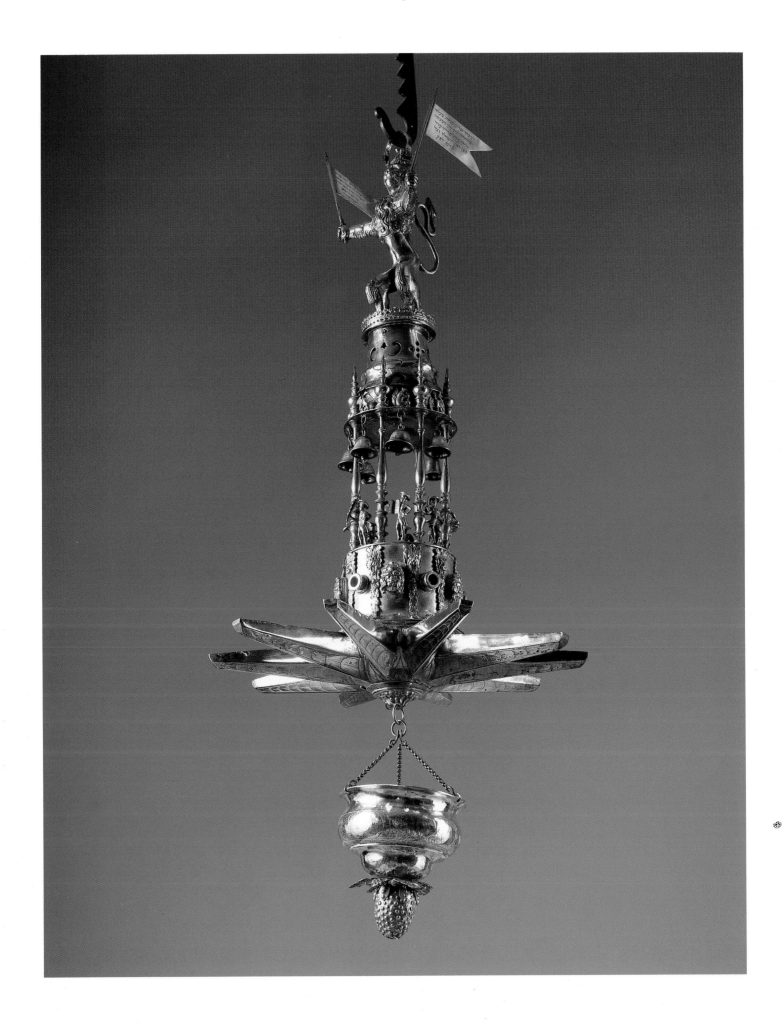

Hanukkah Menorah
Frankfurt, 1706–1732
Johann Adam Boller (1679–1732)
Silver: cast, engraved, filigree, hammered, and gilt,
with enamel plaques
17 x 14½ in. (42.5 x 36.3 cm)
Gift of Mrs. Felix Warburg, S563

In the past, artists consciously modeled their new works on older ones. Artistic innovation occurred within prescribed forms. Therefore, it is always interesting to view a work in which an artist has taken a traditional genre and transformed it by virtue of his own originality. Such is the case of this *menorah* by Johann Adam Boller.

It belongs to a series of *menorot,* branched lampstands decorated with knops and flowers according to the description of the biblical *menorah* (Ex. 25:33) but of a size suitable for home use. In Frankfurt, these *menorot* were first made by the Schüler brothers in the early years of the 18th century and by Boller, as well (see pp. 80–81 and fig. 23). All are closely related in form, proportion, and decoration. Cast figures of the apocryphal heroine Judith holding the head of Holofernes top the center shafts, and additional cast figures of warriors, archers, rampant lions (often holding shields), animals, birds, and flowers were set along the top of the oil containers and support the bases. Victor Klagsbald suggested that these small figures may relate to the house signs of the Frankfurt ghetto (see pp. 36–37).

Boller appears to have later rethought the type and created this *menorah* in which form and decoration are joined in a more dynamic synthesis. The rampant lion holding a shield, which appears on examples by the Schülers, has been greatly enlarged and made part of the shaft of the lamp, a combination of figure and shaft that appeared on German hanging lamps from the 15th century onward. In this case, the lion holds a shield engraved with a stag and a dove, probably an allusion to the names of the lamp's owners. Similarly, Boller invested the decoration with greater iconographic significance by changing the shape of the base from a rectangle to a domed octagonal form to which are affixed four red-and-white enamel scenes from the life of Jacob: his rolling the stone from the mouth of the well (Gen. 39:3), Rebecca's meeting with Eliezer (Gen. 34:18), Jacob's dream (Gen. 38:12), and Jacob wrestling with the angel (Gen. 32:24). These enamels lend a coloristic dimension to this work, which is innovative compared with other *menorot* of the series. Small colored enamel florets on the flowers of the branches and a lavish use of gilding expand the palette of the piece. Though based on a long artistic tradition with biblical sources and models in medieval manuscripts and metalwork, the second Boller *menorah* is a highly innovative and creative work.
VBM

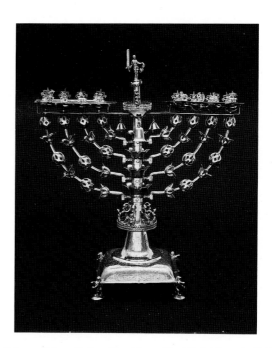

Fig. 23. Johann Adam Boller, Frankfurt, *Hanukkah Menorah,* 1706–32, silver. New York, The Jewish Museum, Gift from the Estate of Alice B. Goldschmidt, 1983–160.

References:
The Jewish Museum, *A Tale of Two Cities,* 1982, no. 121; V. B. Mann, "The Golden Age of Jewish Ceremonial Art in Frankfurt: Metalwork of the Eighteenth Century," *Leo Baeck Institute Year Book,* 31 (1986), forthcoming.

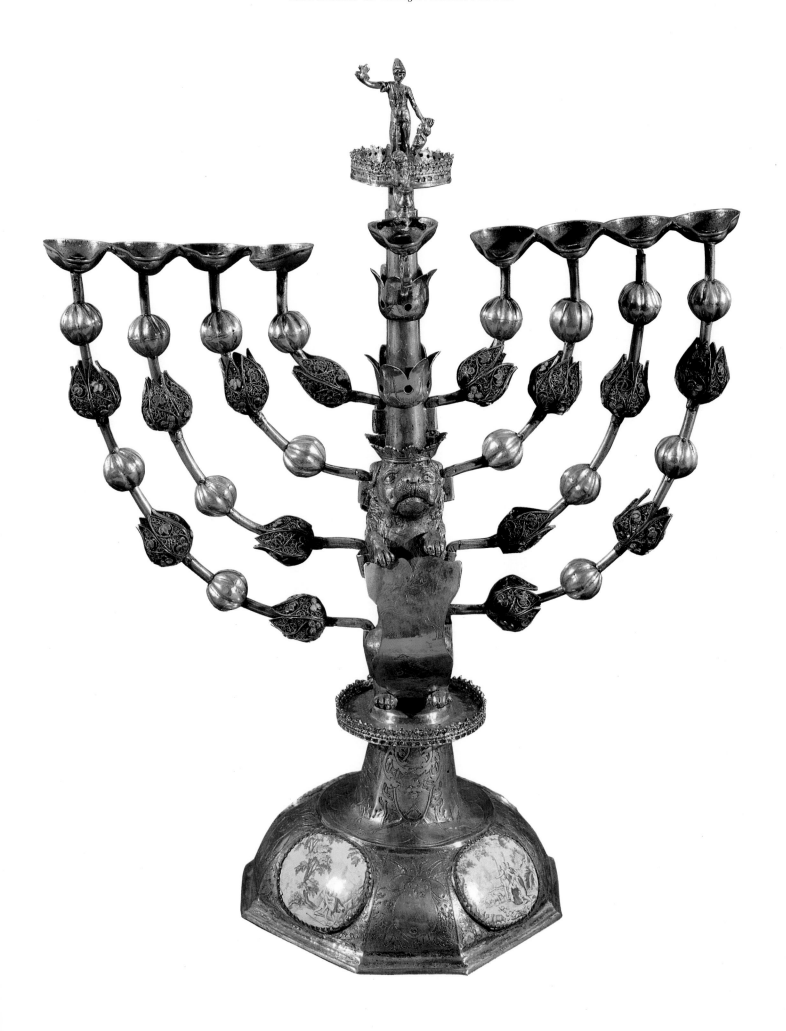

Torah Finials
Frankfurt, 1720
Jeremias Zobel (1670–1741)
Silver: cast, repoussé, stippled, engraved, and gilt
18 x 7 in. diam. (45.7 x 17.8 cm diam.)
Gift of Dr. Harry G. Friedman, F3685

The staves of Torah scrolls have been decorated with ornamental finials (*rimmonim*) since antiquity. Many of the earliest finials were formed as inseparable parts of the staves. However, by the 12th century, when Maimonides (d. 1201) was writing his great treatises on Jewish law, it had become common to make independent finials, leading Maimonides to discuss legal issues involving the sale of consecrated objects for fund-raising purposes. At all times, the dedication of finials — of wood, silver, or gold — testified to the piety and reverence felt by the donor toward the Torah.

Jeremias Zobel, who created this pair of *rimmonim*, belonged to a group of guild silversmiths in Frankfurt that worked actively for Jewish patrons from the end of the 17th century until about 1800. After 1711, when fire destroyed the city's two synagogues and most of the houses on the Judengasse, the principal street of the ghetto, these silversmiths were kept busy with commissions for new works of ceremonial art. In addition to *rimmonim*, Zobel created spice and candleholders for *havdalah* (see pp. 34–35), as well as other Judaica.

In these Torah finials, the tapering form of the towers, together with the bulbous cushions on which they rest, convey a sense of growth and movement accentuated by the turning shapes of the repoussé leaves that adorn them. The towers are simultaneously buildings, with supporting columns, articulated masonry and arcades, and fantastic structures with ornamental grotesques that fill the corners. This combination of the natural and the imaginary marks the baroque character of the work.

Equally baroque in character is Zobel's treatment of the tower. He took a solid architectural form and opened it up by piercing each story and placing an openwork crown at the top. Then he added curved grotesques at the corners to create irregular contours. The result is a dynamic interaction between solid and void that characterizes many Torah ornaments produced in Frankfurt in the early 18th century, as well as baroque art in general.

VBM

References:
Kayser/Schoenberger, *Jewish Ceremonial Art,* no. 29; The Jewish Museum, *A Tale of Two Cities,* 1982, no. 69; V.B. Mann, "The Golden Age of Jewish Ceremonial Art in Frankfurt: Metalwork of the Eighteenth Century," *Leo Baeck Institute Year Book,* 31 (1986), forthcoming.

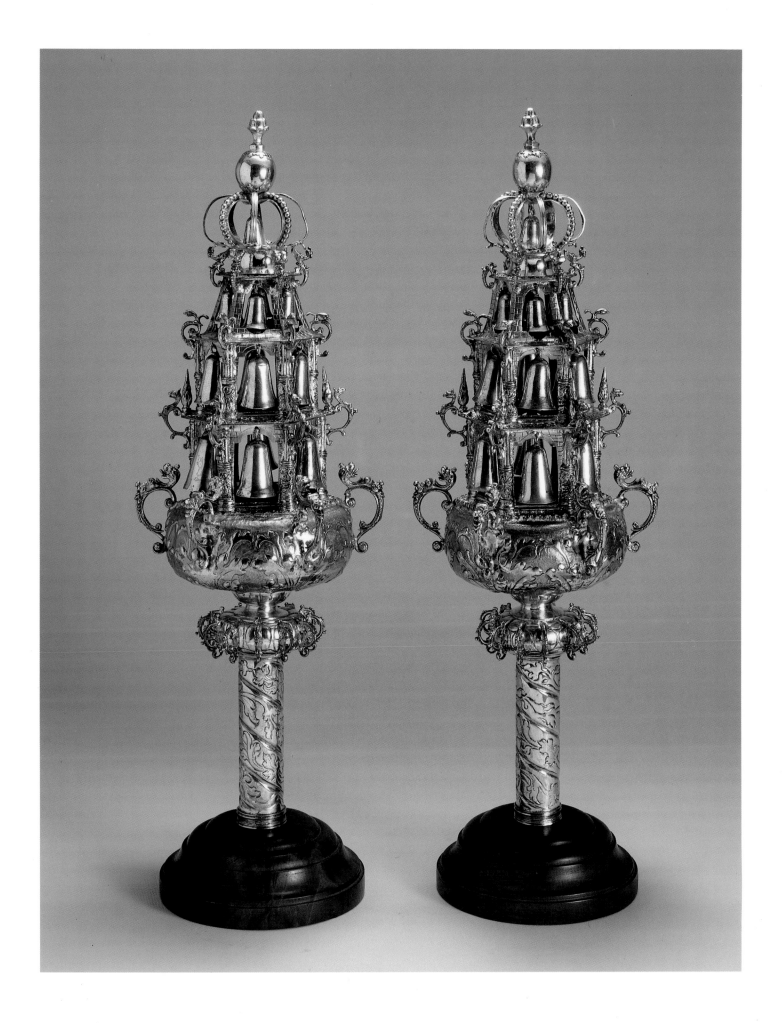

Sukkah Decoration
Trieste, ca. 1775
Israel David Luzzatto (1746–1806)
Ink and watercolor on paper
20 x 15½ in. (50.8 x 39.4 cm)
The H. Ephraim and Mordecai Benguiat Family Collection, S256

Micrography has been called the only original Jewish art form. This *sukkah* decoration is an excellent example of the art, the use of lines of miniature writing to form images. Here the text of Ecclesiastes shapes an astrolabe, an instrument used to measure the sun's altitude. It was probably chosen as an allusion to the repeated references to the sun and its movements in the text.

The holiday of Sukkot (Tabernacles) was one of the great festivals of the Temple in Jerusalem. Its name derives from the *sukkah* (booth) that individual families build as a reminder of the temporary dwellings inhabited by their ancestors during the forty-years journey in the wilderness. During the holiday, the *sukkah* is the locus of meals, of study, and even a place to sleep. Its decoration varies according to the customs of the country in which the owner resides. Italian Jews of the 18th century favored elaborate paper decorations incorporating texts and images appropriate to the festival. Since the reading of Ecclesiastes in the synagogue is a special tradition of this holiday, this text became a favorite source of motifs and several extant Italian decorative cycles for the *sukkah* are based on it. Luzzato's elaborate micrography was part of a similar set, the remainder of which is now in the Smithsonian Institution (fig. 24). Each of these six additional panels bears one or two passages from Psalm 76 whose third line begins "In Salem also is set His tabernacle (*sukko*)," making it an appropriate text to be used for a cycle of *sukkah* decorations. The lettering, floral decoration, and palette of the Smithsonian plaques indicate that they are the work of the same artist as the larger Ecclesiastes piece in The Jewish Museum, though the latter is the only one signed by the artist, Israel David Luzzatto.

Luzatto's micrography draws on an artistic tradition that is first known in the works of a family of scribes active in Tiberius in the late 9th century. Instead of merely listing notes to the Scriptures they were copying, these scribes arranged their minute writing into designs whose small size and patterns contrasted with the larger letters and regular lines of the main text. Their achievement was something new, unrelated to the Carolingian practice, based on antique precedent, of filling drawn outlines with lines of text. In micrography, the line of text is the line of drawing, and when the image relates to the content of the text and both relate to the purpose for which the image was made, as here, then the result is a work of harmonious unity.

VBM

Fig. 24. Israel David Luzzatto, *Sukkah Decoration,* ca. 1775, ink and watercolor on paper. Washington, National Museum of American History.

Reference:
New York, The Jewish Museum, *The Jewish Patrons of Venice,* exh. brochure, by S. J. Makover, 1985, no. 36.

Pair of Finials
Mantua, 17th–18th century
Maker: SIC
Silver: cast, repoussé, engraved
24 x 5 in. diam. (61 x 12.5 cm)
Gift of Samuel and Lucille Lemberg, JM 20-64 a,b

In the Cathedral of Palma de Majorca rest the oldest known pair of Torah finials, their possession by the church a vivid reminder of the expulsion of the Jews from Spanish and Portuguese territories in the 1490s (fig. 25).

The finials date to the 15th century. Some aspects of their decoration, like the horseshoe arches, are local features that recall the age of Muslim rule on the Iberian peninsula and the hybrid Mudéjar art that developed as a result. Viewed from the perspective of later Judaica the most significant feature of the *rimmonim* is their tower form, clear evidence of a Spanish tradition underlying the appearance of the same type in centers to which the Sephardim fled after the expulsion.

Italy was one of those centers. In the 16th century, its ancient Jewish community (see pp. 26–27) was revitalized by the coming of thousands of Sephardim who brought with them traditions of intellectual and cultural achievement, as well as literary and artistic genres undeveloped elsewhere in the Jewish world of their time. Secular and religious Hebrew poetry and the illumination of marriage contracts were part of the Sephardic artistic tradition, as was tower-form metalwork for both synagogue and home use. (See pp. 74–75.) Another Spanish usage transferred by Sephardim to their new homes was the custom of decorating the corners of the reader's desk in the synagogue with finials similar to those used to ornament the staves of Torah scrolls. The large size of these finials and their very heavy weight suggest that they were used on a reader's desk rather than on a Torah.

The body of each *rimmon* is a three-storied hexagonal tower. Torus moldings mark the base and entablature of each story, and spiral pilasters are set on every corner. A balustrade runs in front of each story; its corners support urns of flowers set on scroll-shaped bases. The result is a complex architectural form that projects forward in space on several levels. The basic form is, however, obscured by urns filled with cast flowers and other applied ornaments that fill the arches, hide the balustrade, and overlay the spiral pilasters. The largest urn and flower ensemble serves as a finial.

The blurred outline that results, the obscuring of the boundaries of the object, and the richness of ornament find parallels in other Italian baroque metalwork. A pair of lavish multistoried candlesticks made in Rome in the mid-18th century show these same characteristics as well as the three-dimensional floral elements and *clipeus* motifs found on these *rimmonim.*

VBM

Fig. 25. Spain, *Torah Finials*, 15th century, silver. Palma de Majorca, Cathedral.

References:
Kayser/Schoenberger, *Jewish Ceremonial Art*, no. 22; The Jewish Museum, New York, *The Silver and Judaica Collection of Mr. and Mrs. Michael M. Zagayski*, exh. cat. by G. Schoenberger and T. Freudenheim, 1963, no. 3; Parke-Bernet Galleries, New York, *The Michael M. Zagayski Collection of Rare Judaica*, sales cat., 1964, no. 293; The Jewish Museum, New York, *The Jewish Patrons of Venice*, exh. brochure by S.J. Makover, 1985, no. 9.

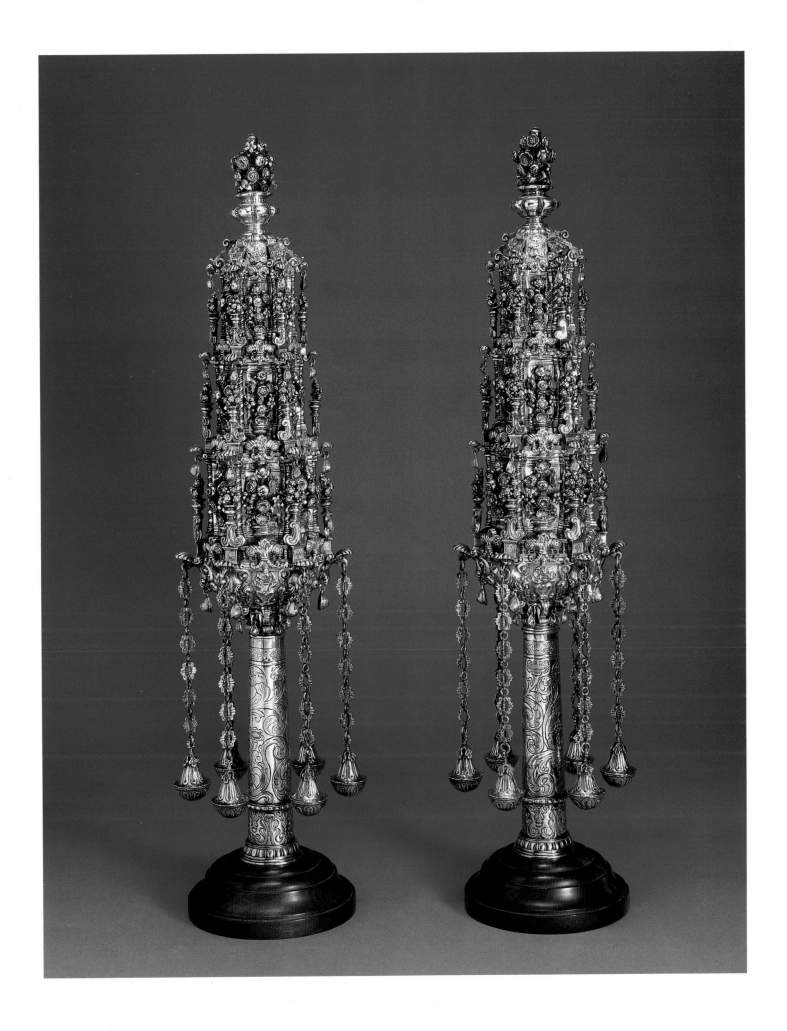

Book Cover
Rome, 18th century
Maker: EB
Silver: respoussé, hammered, and chased
12¾ x 9¾ in. (32.5 x 24.3 cm)
Gift of Mr. and Mrs. Albert A. List, JM 3-72

The exchange of wedding gifts (*sivlonot*) by a bride and groom was such a prevalent custom that the rabbis began to discuss its legal implications and to regulate it in the Talmudic period. The custom took many forms, varying from place to place. In some Ashkenazi communities, silver belts were exchanged and were then worn at the wedding. Clothing, even shoes, were also mentioned in accounts of *sivlonot*. In Italy, a common gift was a prayer book in a special cover; the very ornate ones exchanged by the wealthy were of silver.

This book cover, then, exemplifies an Italian Jewish marriage custom. It also illustrates another widespread practice among wealthy Italian Jews, their adoption of unofficial coats of arms as family emblems. In the central cartouche on the front of this cover is a gate on which rests a couchant lion, the emblem of the Portaleone family, a distinguished family whose name is derived from a quarter near the ghetto in Rome. The back cover is decorated with the crest of the Grassini family, two rampant lions flanking a tower, indicating that the cover was made to celebrate a marriage between the two families. This use of coats of arms by Italian Jews was unofficial and did not conform to any heraldic standards. As a result, the crest of a single family often changed over time or varied from branch to branch. Italian Jews placed their coats of arms not only on personal possessions like this cover but also on their tombstones, their donations to synagogues, and, in the case of publishers, on the title pages of printed books.

Above each coat of arms is a single crown, which may refer to the crown of Torah (learning) or to the crown of a good name, as an illustration of a popular maxim from the Ethics of the Fathers (4:17), "Rabbi Simeon said: There are three crowns: the crown of Torah, the crown of priesthood, and the crown of royalty; but the crown of a good name excels them all." The remainder of the decoration consists of repoussé leaf and scroll forms and is similar to the decoration on silver covers made for Christian missals in the 18th century. The prayer book inside this example is a *mahzor,* a holiday prayer book printed according to the Roman rite in Mantua, 1712–15. VBM

Reference:
The Jewish Museum, New York, *The Book and its Cover: Manuscripts and Bindings of the 12th through the 18th Centuries,* exh. brochure, by V.B. Mann, 1981, no. 34.

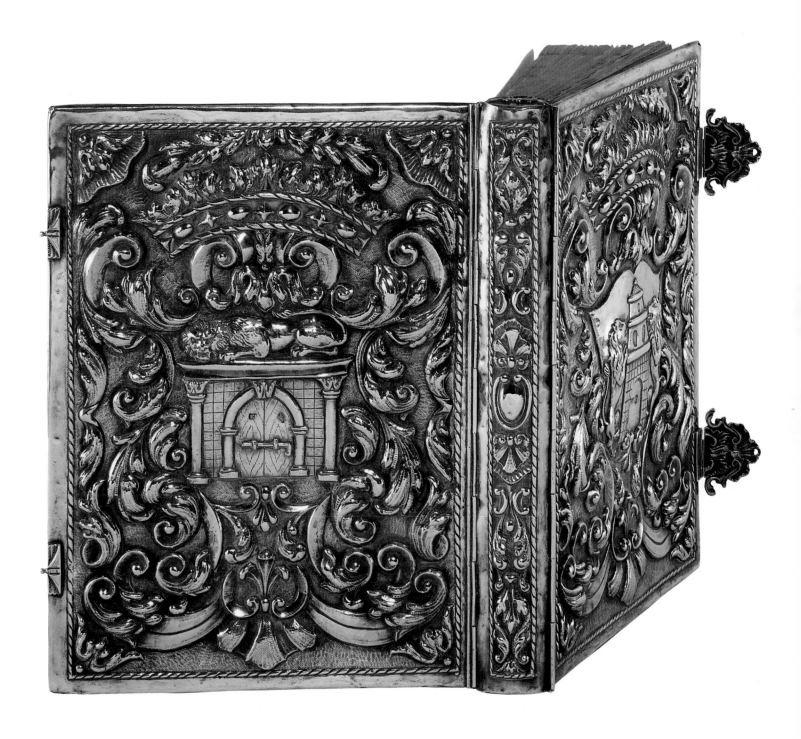

Marriage Contract
Livorno, 1751
Pen and ink, gouache, and gold paint on parchment
21 x 13½ in. (53.5 x 34.5 cm)
Gift of an anonymous donor, U8440

Fig. 26. Giovanni di Isodoro Baratta, Livorno, *Crucifixion of St. Peter,*
ca. 1740, marble. Livorno, Chiesa di S. Ferdinando.

Fig. 27. "Interior of the Synagogue," *Guida . . .di Livorno,* Livorno, 1903.

For more than 2,500 years, Jewish brides have received a written contract from their grooms as an integral part of the marriage ceremony. Some scholars believe that the institution of the *ketubbah* (contract) may be even older. By the 10th century, Jews living in the Levant had begun to decorate their contracts, a custom that prevailed only in Oriental and Sephardic communities until the modern era. This magnificent example was created for the marriage of two Sephardim, Eliahu, son of Solomon Judah Ḥayyim Teglio al-Fierino, to Duna Rachel, daughter of Isaac Yeshurun. The ceremony took place on Wednesday, the 6th of Adar, 5511 (=1751), in Livorno, a city that was settled in the late 16th century by Sephardic Jews and New Christians (Marranos) who wished to return to Judaism.

The city boasted a magnificent synagogue which was enlarged and refurbished over a period of many years in the 18th century (see fig. 27 and pp. 150–51). In 1740, Isidoro Baratta, a sculptor from Carrara, was chosen to design an elaborate marble ark. The overall structure of his design as well as many of its details were incorporated into the rich frame of this *ketubbah.* The columns turned at an angle to the plane of the entablature, the rococo cartouches above and below the central area, and the differently colored marble inlays are features appearing on both the ark and the *ketubbah.* Though putti were not part of the decoration of the ark, Baratta carved framing figures similar to those on the *ketubbah* in the local church (fig. 26). The decoration of the *ketubbah* is thus heavily dependent on Baratta's work in Livorno.

The use of a fanciful combination of figures and architecture as a frame for texts has a long tradition in manuscript illumination. From the 16th through the 18th centuries it appears in the design of frontispieces in printed books, and on earlier Italian *ketubbot.* The achievement of the artist who decorated this contract was to have wed these many traditional elements into a balanced yet dynamic composition that is unified by a harmonious palette of blue, green, red, gold, and white.
VBM

Note: Unpublished

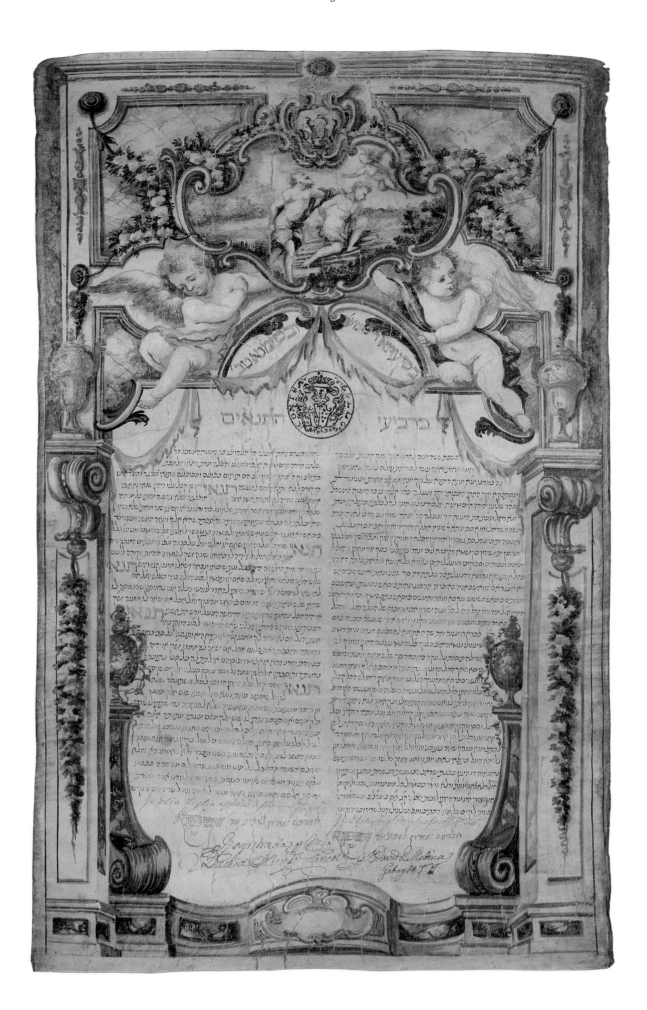

Torah Shield
Augsburg, ca. 1715
Zacharias Wagner (ca. 1680–1733)
Silver: repoussé, cast, engraved and gilt
16⅜ x 11 15/16 in. (42.2 x 30.3 cm)
Gift of Dr. Harry G. Friedman, F70 c

Until recently, the Torah shield was a functional device for indicating the reading to which a scroll was turned. As on this example, a series of plaques inscribed with the names of holy days and Sabbaths were placed in a small box on the shield and changed as necessary. Unlike finials, which have a long history as decoration for the Torah (see pp. 84–85), the functional shield is a new appurtenance, first mentioned in the 15th century by a German rabbi, Israel ben Pethaḥiah Isserlein (1390–1460), who complained that the reading plaques did nothing to enhance the beauty of the Torah. By the 16th century, Rabbi Isserlein's complaint was no longer valid, as shields were made of silver and decorated. A few early examples are extant from both Germany and Italy and other shields are mentioned in contemporaneous literary sources.

Generally, little 17th-century Judaica has survived, including shields. Whether little was made, or much destroyed, we do not now know. In any case, the early 18th-century examples, like this shield, evidence a spirit of experimentation in composition and iconography which suggests that no satisfactory solutions to these problems had yet evolved. Since the shield was a relatively new type of ceremonial object, there was no long tradition governing its appearance and decoration. Beyond the required box for plaques and a chain to hang the shield from the staves of the scroll, the silversmith seems to have been free to draw on the decorative vocabulary of his age, with perhaps one or two motifs added that had Jewish significance.

For most of the decoration of this shield, Zacharias Wagner chose a fanciful melange of naturalistic elements whose spatial relationships to one another are ambiguous. There is a colonnade rendered in skewed perspective, naturalistic grape vines, a table bearing a bowl of fruit, and a *clipeus,* all of which stand on a tiled floor that recedes backward in space. These motifs can be found on secular silver from Augsburg of the same period (fig. 28). Most of the symbolic elements are concentrated above the box for plaques. Two rampant lions, symbols of the tribe of Judah and the people of Israel, bear aloft a laver and basin, probably an allusion to the donor. Lavers

Fig. 28. Johann Valentin Gevers, Augsburg, *Pair of Wall Sconces,* 1732, silver.

and basins are traditional symbols of the Levites who assist the *kohanim* (priests) by washing their hands before congregational blessings. The specific form of the lions (with doubled tails) implies that this shield was intended for a Bohemian synagogue, perhaps one in Prague, the capital, since a lion with two tails is the symbol of both the city and the country, and Judaica from the area often bears lions of this form. VBM

References:
Kayser/Schoenberger, *Jewish Ceremonial Art,* no. 47; H. Seling, *Die Kunst der Ausgberger Goldschmiede 1529–1868, Band I, Geschichte und Werke Abbildungskatalog,* Munich, 1980, pp. 158–59, fig. 709.

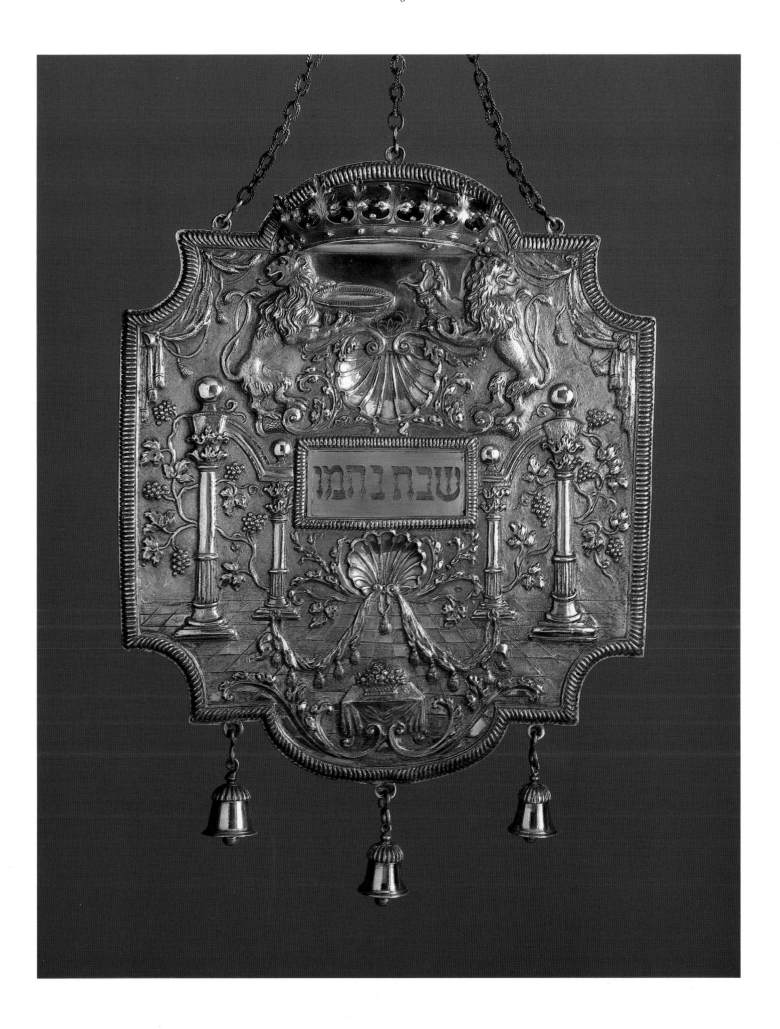

Prayer Book
Vienna, 1716/7
Aryeh Judah Loeb ben Elhanan Katz
Ink and gouache on vellum; engraving on paper
One folio: 12¾ x 8⅜ in. (32.38 x 21.27 cm), 209 folios
Gift of Evelyn and Bob Roberts, JM 85-79

Book of Blessings
Fürth, 1735
Ink and gouache on parchment
One folio: 3¾ x 1¹⁵⁄₁₆ in. (9.45 x 4.85 cm), 72 folios
Permanent Loan of George and Bee Wolfe, L1985.13.2

Both of these works were unknown prior to their arrival at The Jewish Museum. They belong to a group of manuscripts for private and public use that were written and decorated in Central Europe during the first half of the 18th century. The names of the scribes and artists who signed these manuscripts indicate that most came from Moravia. They later worked in Vienna, Fürth, Altona, and even Copenhagen, largely for private patrons, executing *haggadot* for Passover, books of blessings for men or women, and other works of small format. Occasionally, these artists received commissions for larger texts, like this prayer book, which became communal property.

The manuscripts of this Moravian School represent a renaissance of Hebrew book illumination, centuries after the invention of printing. It is a unique phenomenon, partly explained by the fact that the scribal arts have never died out among Jews since some sacred scrolls, such as the Torah, must be handwritten according to Jewish law. The increased wealth of many Jews in the early 18th century, particularly those who served as court functionaries, is another factor that contributed to a rebirth of the art of illumination. Not all of its causes are understood.

What is most interesting about the revival is that the artists modeled their illuminations after printed books, both Jewish and Gentile. Most of the manuscripts of the Moravian School, like the Prayer Book in the Jewish Museum, have title pages on which figures of Moses and Aaron flank the text, with additional vignettes above and below, all set within an architectural frame. This composition is based on frontispieces like those of a Yiddish Bible printed in Amsterdam in 1679 and the famous *Haggadah* printed in the same city in 1695. A debt to Amsterdam printing is explicitly acknowledged by most scribes of the Moravian School and by the scribes of these two manuscripts. On the title page of the Prayer Book, Aryeh Judah Loeb Trebitsch wrote:

פה ווין באותיות / אמשטרדם / המהוללה

"Here in Vienna in the renowned letters of Amsterdam." However, his debt to printing goes even further. Many of the pages with elaborate figural compositions are hand-colored engravings on paper that has been pasted to the vellum folio. Only the more decorative compositions that are inserted within the text, like the one illustrated here, are entirely the work of Aryeh Judah Loeb. Another significant feature of this manuscript are four undecorated folios later inserted in the text that bear prayers commemorating pogroms suffered by the Jewish community of Trier in 1675, where this manuscript was found.

The decoration of the Book of Blessings, like its size, is on a much smaller scale. Within the text there are only three miniatures; they illustrate passages referring to Hanukkah, Purim, and the blessing over the new moon. The remainder of the decoration consists of the head of an angel, floral arrangments, and ornamented initial words and titles. The most elaborate miniature is the frontispiece, with Moses and Joshua, an unusual choice that may refer to the name of the patron. The ewer and basin at bottom suggest that the patron was also a Levite. Another owner added an elaborate silver cover with inlaid intaglio representations of Moses and Aaron that is too large for the present contents; that cover may have originally enclosed a manuscript with the more common Moses and Aaron frontispiece.

VBM

Reference for Prayer Book:
The Jewish Museum, New York, *The Book and its Cover: Manuscripts and Bindings of the 12th through 18th Centuries,* exh. brochure, by V.B. Mann, 1980, no. 24.

Note: Book of Blessings: Unpublished.

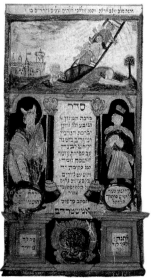

Cushion Cover for the Circumcision Ceremony
Austrian Empire, 1779/80
Silk velvet: embroidered with silk and metallic threads
28½ x 26½ in. (72.4 x 67.3 cm)
Gift of Dr. S. A. Buchenholz, S1015

Jewish law requires every father to bring his son into the Covenant of Israel by having him circumcised at the age of eight days, just as Abraham circumcised Isaac. The biblical passage recording this paradigmatic act is embroidered in the circular frame on this textile (Gen. 21:4). Another biblical leader remembered at circumcisions is Elijah the prophet (9th century B.C.E.), who fought for the reinstitution of the ceremony after its lapse due to foreign influence. To honor Elijah, Jewish law requires that an empty chair, known as the "Chair of Elijah," be reserved for the prophet at every circumcision.

The inscription at the top of the circular field indicates that the cushion was made for an Elijah Chair: "This is the throne of Elijah of blessed memory," (from the circumcision service). The inscription continues,

יֵשׁ שָׂכָר לִפְעֻלָּתֵךְ * לפק

"For there is a reward for your labor," (Jer. 31:16) a chronogram for the year [5]580 (=1779/80) and a play on the name of the male donor, which is embroidered below the central scene.

הרר יששכר המכונה בער ב'ה יונה / אולמא זצ'ל וזוגתו מרת רבקה / בת א'מו הג'הג א'בד מ'הו / וואלף לוי נרו

"Issachar, known as Baer, son of Jonah Ulma, of blessed memory, and his wife Rebecca, daughter of . . . Rabbi Wolfe Levi . . ." The first two words of the chronogram, when combined, form the first name, Issachar.

Pictorial motifs fill the remainder of the cover. At the corners are the floral sprays commonly found on German embroideries of the 18th century. There are no embroidered parallels, however, for the most important element of the decoration, the central scene. The father of the child stands at center right draped in a prayer shawl, gazing at his son in the arms of the *sandak* (godfather) who is seated on one side of a double bench. The empty left seat is that reserved for Elijah. The *mohel* (circumciser), knife in hand, approaches from the left followed by a man bearing a vial containing a medicinal substance. (See pp. 156–57.) At far right are two men holding aloft goblets, labeled in Hebrew abbreviations "cup of blessing" and "cup of suction" (the cup in which drawn blood from the wound is placed).

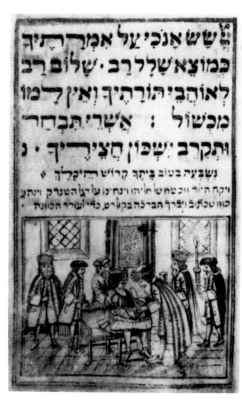

Fig. 29. Rechnitz, Austrian Empire, "Circumcision Scene," *Mohel Book,* 1747, ink and gouache on parchment.

This depiction is probably based on an illumination from a manuscript containing the prayers recited at circumcision, a manuscript similar to a *Mohel Book* (circumciser's record) written in Rechnitz in 1747 (fig. 29). Though there are many corresponding details in the two images, they are not exactly alike and another, similar manuscript must have served as the model for the embroiderer. *Mohel Books* were a popular genre of the Moravian school of illumination. (See pp. 96–97.) The similarity between the cushion cover and the Rechnitz illumination suggests that The Jewish Museum cushion cover was also created in the Austrian Empire.

References:
H. Frauberger, "Über Alte Kultusgegenstände in Synagoge und Haus," *Mitteilungen der Gesellschaft zur Erforschung Jüdischer Kunstdenkmäler,* 3–4 (1903), p. 90; Kayser/Schoenberger, *Jewish Ceremonial Art,* no. 159; The Jewish Museum, New York, *Fabric of Jewish Life,* 1977, no. 138.

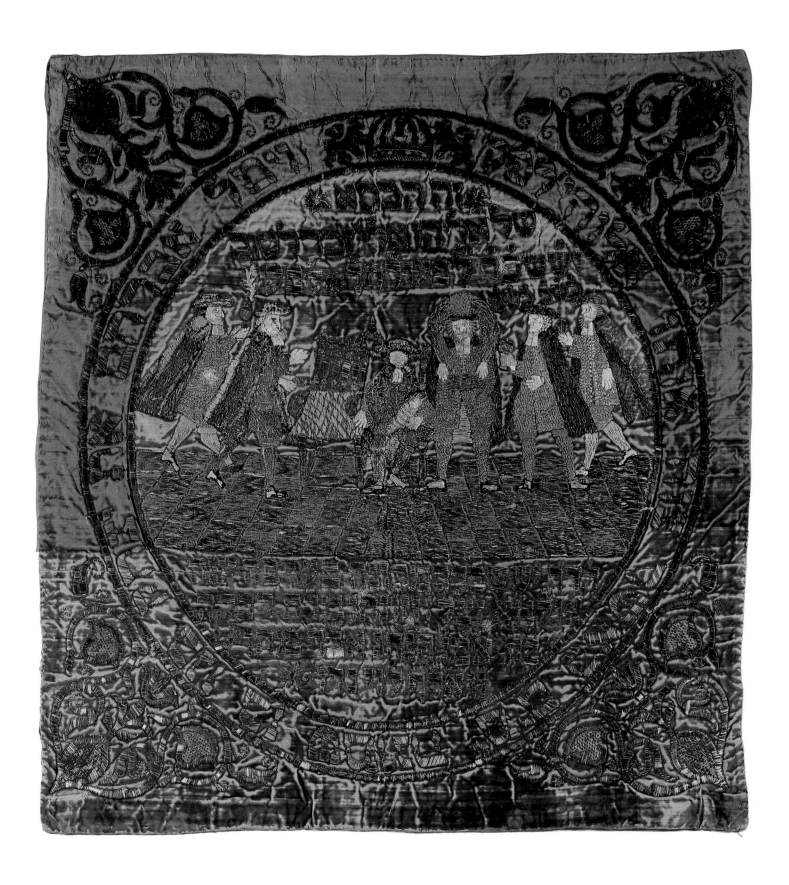

Hanukkah Lamp
The Hague, ca. 1750
Reymer de Haan (?)
Silver: repoussé, chased and cast
12 x 9 7/16 x 2¼ in. (30.5 x 24.3 x 5.7 cm)
Gift of Dr. Harry G. Friedman, F3693

Fig. 30. Amsterdam, "Frontispiece," *Sefer Zichron Moshe,* 1748.

Some of the objects utilized for the practice of Jewish ceremonies are identical in form and decoration to works in general use. (For examples, see pp. 46–47, 58–59, and 90–91.) It is the function of these works that is primary, not their form or decoration. Other rituals are so unique in character as to require ceremonial objects of specific form. Such is the case with the lamps used for the holiday of Hanukkah. They must incorporate eight lights, one for each day of the festival. Furthermore, Jewish law requires that all the lights be on the same level.

An early solution to these requirements was the "bench-type" lamp, seen here, in which all the lights are ranged in a horizontal row. The earliest extant example dates to the 12th century and consists of just the horizontal element containing the oil containers. Later examples, like this one, often have an added backplate which serves as a reflector and sometimes as a support for the *shammash* (or servitor), the ninth light used to kindle the others. Most Hanukkah lamps with backplates are decorated with symbols or scenes related to Jewish life and lore (see pp. 110–11). This lamp is an exceptional example; its backplate is a pure rococo cartouche whose asymmetric form and floral, scroll, and shell motifs are characteristic of the period. In effect, the silversmith has grafted a reflector from a wall lamp (fig. 28) onto a bench-type light and has integrated the two parts by repeating scroll elements on the front of the bench and through the three-dimensional flowers that "spill over" from the backplate onto the oil containers. Similar motifs were used on other secular silver of the period and for a wide range of decorative uses, for example, the frontispieces of Hebrew books printed in Amsterdam (fig. 30). VBM

Reference:
Kayser/Schoenberger, *Jewish Ceremonial Art,* no. 127

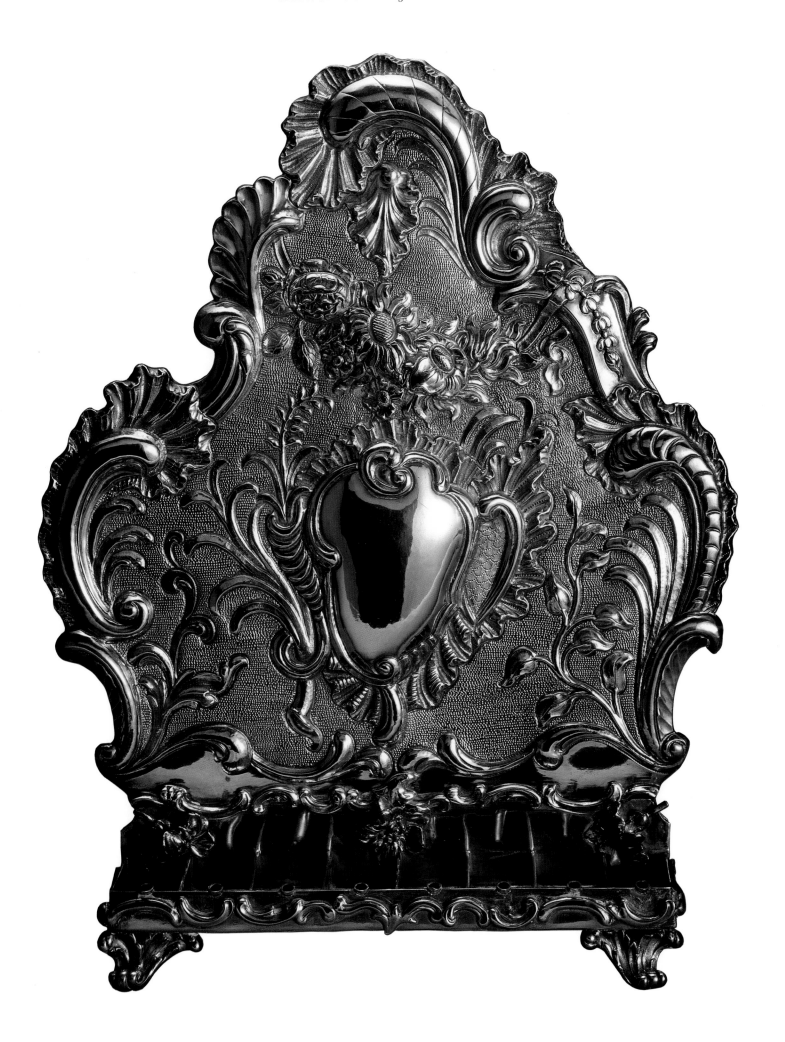

Torah Crown
Lemberg (Lvov), Galicia, 1764/5–1773
Silver: repoussé, cast, cut-out, engraved, parcel gilt;
semiprecious stones; glass
19¼ x 8⅜ in. diam. (49 x 22 cm)
Gift of Dr. Harry G. Friedman, F2585

A close examination of the inscriptions and structure of this crown reveals that it was made and decorated in two phases. The longest inscription on a gilt cartouche of the lower band reveals that the older, lower section was given by a couple in honor of their sons:

ז'נ האלוף / המרוממ ... / ... מו' משה ב'ה / יצחק מענקם זל איש
צבי ואשתו / החשובה ... מרת רחל בת מ שמעון זל / עבור בניהם
שיזכו לנד' / לתורה ולח' ולמ' טו' א'ם / לסדר ולפרט והיה כ'י'
א'ש'ר' / ירים משה' ידו וגבר ישראל

"T[his] was g[iven] by Moses son of Isaac Menkes . . . and his wife . . . Rachel, daughter of Moses Samson in honor of their sons, may they be privileged to raise [them] to Torah to the wedding canopy and to good deeds (from the circumcision ceremony) [in the year] 'Then whenever Moses held up his hand, Israel prevailed' " [Ex. 17:11; chronogram for [5]525 (=1764/5)].

The decoration of this lower portion largely consists of architectural and ornamental elements: pilasters and arches, fruits, rococo scroll and shell forms, and animals. Eight or nine years after its fabrication, a second donor added the rampant griffins, the upper circlet, and the domed section. The griffins rest on rococo scroll consoles, which obscure some of the original floral motifs. The second donor added engraved silver dedicatory panels to the lowest tier in memory of his parents.

יזכור / אלהים את נשמת / אדוני אבי מורי ה"ה / האלוף ... /
שמעון ב"מ אברהם / ז"ל בעבור שאני נודר זאת ... / אמי ... / ה"ה
מ" ייטה בת הרבני מ" / צבי הירש זל

"May God remember the soul of my father . . . Simon son of Abraham because I am donating this for the memory of his soul . . . and [for] my mother Yetta daughter of Zvi Hirsch . . ." and a date, on the second upper circlet:

נגמר בער"ה ת'ק'ל

"Finished on the eve of Rosh Hashanah (the New Year) [5]534" (=1773).

The second donation, the upper section, is the most interesting portion of the crown. The cast griffins that support it are relatives of the heraldic, guardian figures found on the contemporaneous carved wooden arks of Galician synagogues. (See pp. 110–11.) They support a circlet bearing a complete cycle of zodiac signs, each labeled in Hebrew. This astrological cycle has a long history in Jewish art from the period of the mosaic pavements of ancient synagogues, through medieval decorative arts and illuminated manuscripts (see pp. 32–33), to printed versions of the same texts dating to the 18th century. Another possible influence on the iconography of the Lvov crown was the famous painted ceiling of the nearby Chodorów wooden synagogue whose program included a zodiac cycle surrounding a central circle with a double-headed eagle, symbol of the Polish kingdom that ruled Galicia until 1772. (The same political symbol appears on the lower tier of the crown.) However, the symbols of the crown cycle differ markedly from those of the painted ceiling in both their forms and surrounding inscriptions, which suggests that the silversmith had another model, probably a printed prayer book or *haggadah*.

By adding another tier and a dome, the second, unnamed donor created a crown whose complex structure reflects the multitiered architecture and furnishings of Galician synagogues of the 17th and 18th centuries. He also set a pattern which would be followed by numerous East and Central European Torah crowns into the 20th century.
VBM

References:
S. S. Kayser, "A Polish Torah Crown," *Hebrew Union College Annual*, 18 (1950–51), pp. 493–501; Kayser/Schoenberger, *Jewish Ceremonial Art*, no. 35; C. Roth, ed., *Jewish Art*, rev. ed. by B. Narkiss, Greenwich, Conn., 1971, p. 121 and fig. 114.

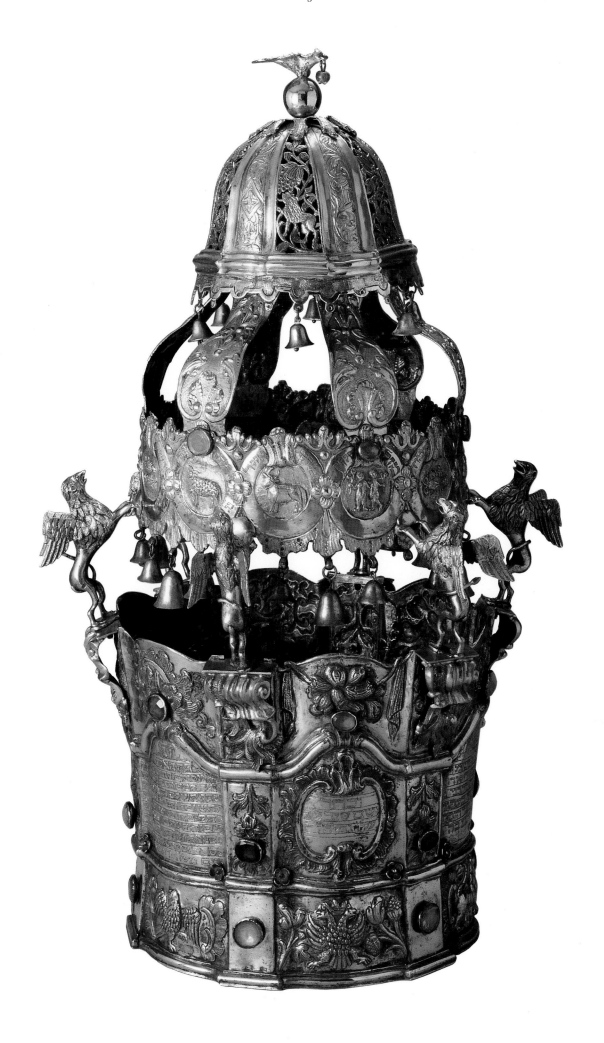

Coffee Service
Staffordshire, England, 1769
Salt-glazed stoneware: painted with overglaze polychrome enamels
Tray: 13 in. diam. (33 cm); Coffee Pot: 8⅜ x 7½ in. (21.3 x 18.4 cm);
Pitcher: 5 x 4 in. (12.7 x 10.2 cm); Waste Bowl: 2½ x 5⅝ in. diam.
(6.3 x 14.3 cm); Sugar Bowl: 3¼ x 3 15/16 in. diam. (8.2 x 10 cm)
Gift of the Felix M. and Frieda Schiff
Warburg Foundation, JM 26-59 a–e

In Staffordshire, England, during the last decade of the 18th century, two Dutch brothers, the Elers, introduced new techniques to the local pottery industry. What distinguished their wares was a salt glaze, which was later refined to produce a milky white color. White salt-glazed stoneware reached the peak of its popularity in the years 1750–70, when this coffee set was made. The forms, colors, and decorative motifs of The Jewish Museum pieces can all be paralleled in other Staffordshire stoneware of the 1750s and 1760s.

As in other European centers of the period, the potters of Staffordshire sought to imitate Chinese porcelains whose importation competed with the output of local factories. For that reason, they often favored decorative schemes based on Chinese porcelains, such as the landscape vignette and the diaper panels alternating with single floral motifs on the interiors of The Jewish Museum's waste and sugar bowls. Other Staffordshire ware with these interior decorative motifs have exteriors painted with Chinese figures (fig. 31). The unique aspect of The Jewish Museum set is the substitution of a representation of a Jewish wedding and Hebrew inscriptions for the usual chinoiserie.

The scene on the platter shows six figures: two officiants, two witnesses, the groom, and a heavily veiled bride. Instead of standing beneath a free-standing marriage canopy, the bridal couple are wrapped in a large prayer shawl. This custom was depicted in several 18th-century engravings, though none appears to have served as a model for the painted scene. An eagle at top center bears a banner inscribed with a biblical quotation, which serves as a chronogram:

ישיש עליך אלהיך כמשו'ש / ח'ת'ן' על כ'ל'ה' לפ"ק

"As a bridegroom rejoices over his bride, So will your God rejoice over you [5]529"(=1769) (Is. 62:5). Further information is inscribed on the vessels: (on the coffee pot):

נעשה / לכבוד הר"ר הילל בן כ'הרר / טוביה ז'ל / וזוגתו / מרת / ברענדלה בת / מהורר אלעזר סג'ל / ז'ל

(front) "Made in honor of . . . Hillel son of . . . Tuviah of b[less-ed] m[emory]," (back) "and his wife . . . Brendele daughter of Elazar Segel, of blessed memory;" (on the pitcher):

Fig. 31. Staffordshire, England, *Bowl,* ca. 1750, stoneware with overglaze enamels. Kansas City, The Nelson Atkins Gallery (Gift of Frank P. and Harriet C. Burnap).

על ידי הקטן צבי הירש בן כמהורר אברהם יצו

"by. . .Zvi Hirsh son of. . .Abraham" (on the sugar bowl, front and back):

באמשטרדם / כ"ד סיון / ת'קכ"ט לפ"ק

"in Amsterdam, 24th of Sivvan [5]529"(=June, 1769) (and on its cover): "Anno 5529" (in the year 5529 = 1769).

The use of the word "made" in the inscription does not mean that Zvi Hirsh actually fashioned his wedding present, but is a common way, in older dedicatory inscriptions, of expressing that an individual commissioned a work to be done. It is only with this interpretation that one can reconcile the information in the inscription that the set was "done in Amsterdam" with the very clear artistic evidence that it was made and decorated in Staffordshire.
VBM

Reference:
Kayser/Schoenberger, *Jewish Ceremonial Art,* no. 170.

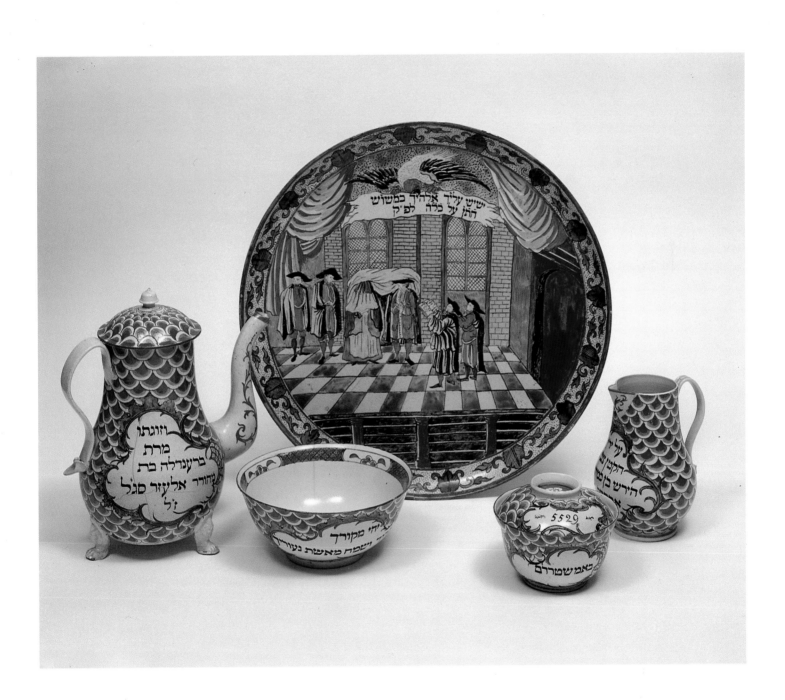

Mantle for the Torah Scroll
Amsterdam, 1771/2
Silk and metallic brocade; velvet: embroidered with silk
and metallic threads
Oval top: 12⅜ x 10¼ in. diam. (31.5 x 26 cm diam.)
Body: 34⅝ x 41 in. (88 x 104 cm maximum width)
The H. Ephraim and Mordecai Benguiat Family Collection, S18

Although the Talmud (250–500 C.E.) mentions the use of beautiful silks to wrap the Torah scroll (Sabbath:133b), the form that these coverings took is unknown. Our earliest knowledge of their shape comes from late medieval manuscript illuminations. A depiction of the synagogue on the eve of Passover in the Sarajevo Haggadah, a 14th-century Barcelona manuscript, shows a member of the congregation closing the Torah ark (fig. 32). Within are scrolls dressed in mantles whose hems flare outward to form a skirt. Sephardic Jews continued to use mantles of this distinctive form wherever they traveled after their expulsion from Spain in 1492 — to Holland, Turkey, Italy, and other countries. According to its inscription, this example was dedicated in Amsterdam by Asher Anshil, son of Abraham Schoelhoff (Andries Abraham Schoelhoff), and his wife Ḥavah Hevi, daughter of Wolf Reintel (Eva Benjamin de Joseph).

אשר / אנשיל בן / כהר"ר אברהם / שול האף ז"ל / ואישתו מרת /
חוה העווי בת / פ"ו כהר"ר וואלף / רינטל ז"ל

The final line of the inscription is a chronogram for the year 1771/2:

יהי לבי תמים / בחקיך / פרי צדיק / עץ חיים

"May I wholeheartedly follow Your laws" (Ps. 119:80); "The fruit of the righteous is a tree of life" (Prov. 11:30). Both the donor and his father-in-law served as *parnassim*, officials, of the Amsterdam Jewish community.

An 18th-century French brocade forms the major portion of the mantle. The use of expensive imported materials is characteristic of textiles made for the Torah, and signifies the reverence in which the sacred Scriptures are held. What distinguishes this mantle is its complex iconographic program, largely embroidered on an inset panel of red velvet that forms the front. Two themes are presented. One derives from a saying in the Ethics of the Fathers: "There are three crowns: the crown of Torah, the crown of priesthood, and the crown of royalty. . ." (4:17). Three appliqué crowns embroidered in silk and metallic threads illustrate this maxim, two on the front, and the third, on the back. The second theme implicit in the representation of two symbols of the ancient Temple, the seven branched *menorah* and the table of shewbread (below the dedicatory inscription), is the belief in the coming of the Mes-

Fig. 32. Barcelona, "Passover Eve in the Synagogue," *Sarajevo Haggadah,* second half of the 14th century.

sianic Age and the rebuilding of the Temple in Jerusalem. Its inclusion links the decoration of this mantle with the more extensive Temple iconography of 18th-century Torah curtains and valances (see pp. 108–9).
VBM

Reference:
The Jewish Museum, *Fabric of Jewish Life,* 1977, no. 34.

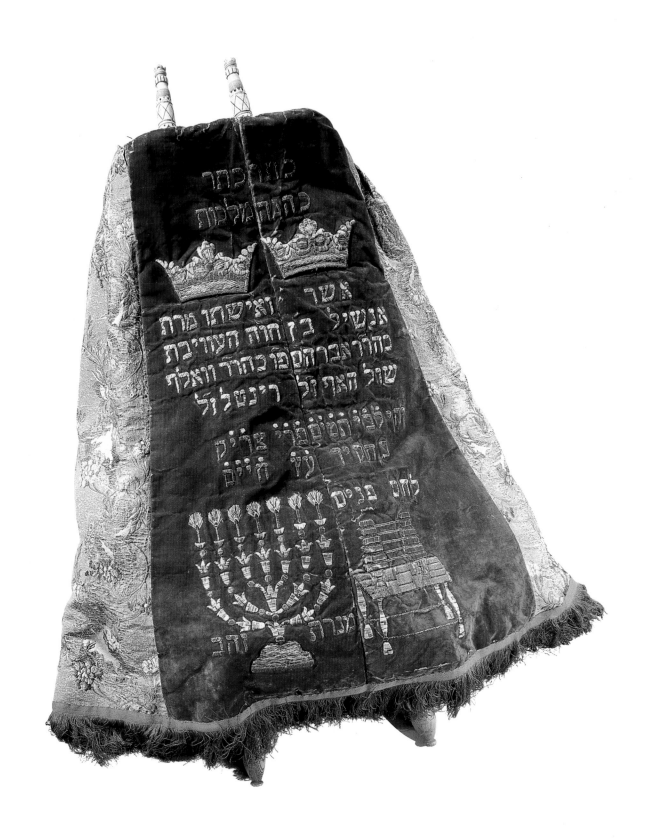

Curtain and Valance for the Torah Ark
Bavaria, 1772/3
Jacob Koppel Gans
Velvet: cut and uncut, embroidered with metallic and silk threads
Curtain: 84 x 64½ in. (213.4 x 163.8 cm)
Valance: 37½ x 67½ in. (95.3 x 171.5 cm)
Gift of Dr. Harry G. Friedman, F1285a,b

Since Jews were generally not allowed to join guilds in German-speaking lands before their achievement of civil rights in the 19th century, early signed works of ceremonial art made by Jews are exceedingly rare, if one discounts works of folk art made by untrained craftsmen. This Torah curtain and matching valance are an exception. The text of a cartouche at bottom left on the curtain reads:

נעשה / ידי להתפאר / בע״זה יעקב קאפל / בן מה״ורר יהודא / ליב ז״ל גנש ג׳ש׳ / היכשטטט

"'My handiwork in which I glory' (Is. 60:21)...Jacob Koppel son of Judah Leib, of blessed memory, Gans G[old]s[chmid] (or G[old]s[ticker]), Hochstadt." Opposite the inscription is a cartouche that contains a chronogram indicating the date. The other personalized inscription appears at the top of the curtain and indicates the donor:

ר׳ יעקב קיצינגן ש״י בן המנוח כ״ה ליב ק׳ / ז״ל וזוגתו מרת הינדל תי׳ בת האלוף והקצין כ״ה / טעבלי אולמא שלי״טא מפפערשא

"Jacob Kitzingen son of the deceased Rabbi Leib K[atz], of blessed memory, and his wife Hendel daughter of...Teveli Ulma...from Pfersee." In these inscriptions, the places of origin as well as most of the family names are those of towns in Bavaria, which suggests that the curtain was made there.

Indeed, this curtain and valance represent a late flowering of a type that had been established in Bavaria in the 1720s by another Jewish embroiderer who signed his works: Elkone of Naumberg. The valance of a curtain made by Elkone for a synagogue near Augsburg (as is Pfersee) also bears three crowns, symbolic of Torah, priesthood and royalty, and five vessels of the ancient Tabernacle, arranged in the same order and similar in form to those on Jacob Koppel Gans' work. Elkone may have been inspired by a series of valances with Tabernacle vessels made in both Prague and Frankfurt during the second decade of the 18th century (fig. 33). His work, in turn, served as a model for that of Jacob Koppel Gans. It was Gans' original achievement to have closely integrated the decoration of the valance with that of the curtain by repeating the same symbols on both: the *menorah,* the crown, and the heraldic double-headed eagle.

VBM

Fig. 33. Prague, *Valance for the Torah Ark,* 1718/9, velvet with silk and metallic threads. New York, The Jewish Museum, H. Ephraim and Mordecai Benguiat Family Collection, S1.

References:
F. Landsberger, "Old Time Torah Curtains," *Hebrew Union College Annual,* 19 (1945–46), pp. 353–89, fig. 10; Kayser/Schoenberger, *Jewish Ceremonial Art,* no. 9,a,b; The Jewish Museum, *Fabric of Jewish Life,* 1977, no. 22.

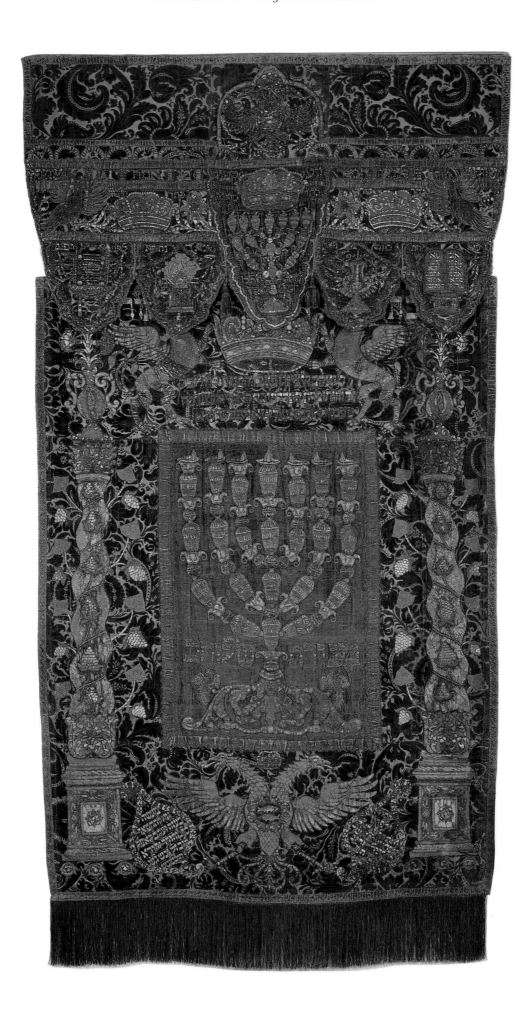

Hanukkah Lamp in the Form of a Torah Ark
Brody, 1787
Maker: BZK
Silver: repoussé, openwork, appliqué, chased, cast, cut-out, and
parcel-gilt
27½ x 17⅜ in. (69.8 x 44.1 cm)
The H. Ephraim and Mordecai Benguiat Family Collection, S260

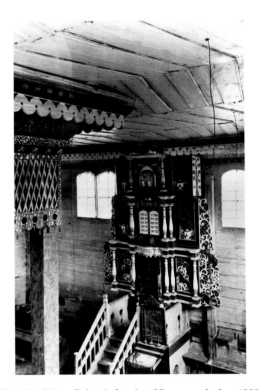

Fig. 34. Sidra, Poland, *Interior of Synagogue,* before 1939.

Architectural motifs have a long association with the decoration of Hanukkah lamps, since there is an ancient Jewish practice of placing the lit lamp before the facade of a home or within a window facing the street. (See pp. 66–67.) This elaborate and magnificent work is unusual in that the architecture represented is an interior structure and one that is quite specific. The backplate is based on the elaborate wooden Torah arks that once adorned Polish synagogues (fig. 34).

The wooden synagogues of Poland were masterpieces of the carpenter's art in both their exterior structure and their interior decorations. Greatest attention was lavished on the major centers of interest during services: the Torah ark and reader's desk. Arks were often several stories high, their basic function as a cabinet for scrolls almost obscured by elaborate columned superstructures overlaid with vegetation inhabited by birds and animals. Two aesthetic principles dominated the creation of these arks: a strict symmetry and *horror vacuii.*

The same principles appear in the ark on this lamp. Pairs of heraldic animals face one another across the central vertical axis. For example, griffins support a crown symbolic of the Torah, which is aligned with the meeting point of the ark doors. As on the actual wooden arks, there is a demarcation of treatment between the "structural" architectural members of the decor (columns and entablature), which are fairly plain in form, and the areas around them, which are overlaid with dense silver vegetation that contrasts with the gilt ground. It is this part of the decoration, filled with motifs as if the artist possessed a fear of empty spaces, a *horror vacuii,* that is most reminiscent of folk art (see p. 131). However, the skill of the artist is evident in the graceful forms of natural life and in the inclusion of sophisticated motifs like the rococo scrolls and cartouche at bottom.
VBM

Reference:
Kayser/Schoenberger, *Jewish Ceremonial Art,* no. 138.

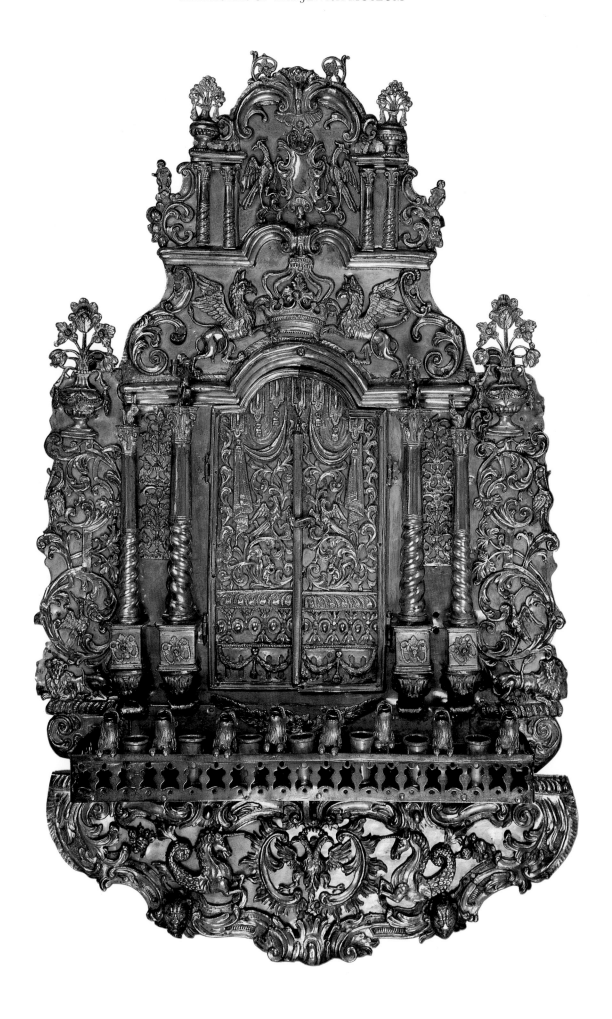

Omer Calendar of Moses Mendelssohn
Germany, ca. 1780
Pen and ink and gouache on parchment
26½ x 3½ in. unframed (67.3 x 8.9 cm)
Gift of Dr. Harry G. Friedman, F3855

The practice of counting the days between the second day of Passover and the first day of Shavuot (The Feast of Weeks) is rooted in a biblical passage inscribed around the square at the top of this calendar. "And from the day on which you bring the sheaf of wave offering — the day after the Sabbath — you shall count off seven weeks" (Lev. 23:15). Since a dry measure of barley, the *omer,* was brought to the ancient Temple in Jerusalem each of the forty-nine days between the two festivals, the entire period came to be known as the *omer* and special calendars were written incorporating the formula recited each night. (See pp. 130–31.)

This example is distinguished both by the charm and delicacy of its decoration and its historical associations. At bottom is an inscription which reads:

להיקר והנעלה משה מנדלזוהן יצ'ו

"To the beloved and esteemed Moses Mendelssohn." Mendelssohn (1729–86) was one of the central figures of the German Enlightenment. His belief in the power of reason, his concern for general philosophy, aesthetics, and language brought him into a circle of progressive German thinkers that included Gotthold Ephraim Lessing (1729–81), one of Mendelssohn's close, lifelong friends. Mendelssohn's prominence in German intellectual circles resulted in attempts to convert him to Christianity. Consequently, the philosopher was compelled to articulate his views on Judaism. Though a practicing Jew in the traditional sense, as exemplified by this *omer* calendar, Mendelssohn was a pioneer mediator between the Jewish world and the Gentile. His writings on Judaism were the first clear articulation of the parameters of Jewish thought in German.

The decoration of the calendar seems to have been inspired by the association of the counting with a plant offering brought to the Temple. A flowering vine rises through the formulae and floral sprays flank the *menorah,* the quintessential symbol of the ancient House of God in Jerusalem. Additional flowers fill the large letters at top and the interstices between them. This monumental script is related to manuscript illumination (see pp. 96–97) and to the decoration of embroidered 18th-century Torah binders (fig. 35), which were sometimes designed by professional scribes, the same professionals who would have been commissioned to create a calendar like this one. The scribal arts also inspired the form of the

Fig. 35. Germany, *Torah Binder,* 1748, linen and cotton threads. New York, The Jewish Museum, Gift of Dr. Harry G. Friedman, F508.

menorah inscribed with Psalm 67 at bottom of the calendar. Similar *menorot* appear in 18th-century manuscripts, like the Prayer Book on p. 97 Finally, the floral theme of the decoration is echoed in the personal dedication inscribed at the bottom which expresses the hope that Mendelssohn "will flower like the palm tree and the tree which is planted on pools of water." (Ps. 1:3)

VBM

Reference:
The Jewish Museum, New York, *The Paintings of Moritz Oppenheim: Jewish Life in 19th Century Germany,* exh. brochure, by N. L. Kleeblatt, 1982 (unnumbered).

Torah Ark
Westheim bei Hassfurt, Bavaria, 18th century
Pinewood: carved and painted; fabric: embroidered with metallic threads
113 x 63 in. (287 x 160 cm)
Gift of Arthur Heiman, JM 138-47

Fig. 36. Nabratein, Ancient Israel, *Fragment of a Torah Ark,* second half of the 3d century C.E., marble.

Like other works of Judaica, the Torah ark resembles the art of its time. Built as a cabinet to hold scrolls, its exterior sometimes reflects contemporaneous furniture or architectural decoration. (See pp. 52–53.) However, with some frequency, the Torah arks of various ages and places, like this one, bear traditional symbols whose association with the ark goes back to antiquity.

This brightly colored example represents a cabinet maker's attempt to imitate fine work in inexpensive materials. The grain of marble is simulated by painting; colored paint on carved wood replaces inlays of differently colored stone, gilded stucco, and rococo cartouches. The composition as a whole resembles the altarpieces of rural churches of the 18th century or the painted decoration of Bavarian houses.

The most astonishing and original section of the ark is its superstructure. Above the cabinet proper is a segmented tympanum with a scroll motif at center that is a stylized version of the *clipeus,* the shell that signified honor and immortality in the ancient world. On it are perched two sculpted lions with demonic faces, who hold aloft a sequined fabric crown labeled below "Crown of Torah." Their golden yellow bodies stand out against a draped cartouche whose colors harmonize with those of the ark. The folk artist who created this composition gave a very individual interpretation to a traditional iconographic program whose antiquity has been confirmed by recent archaeological discoveries. At Nabratein, in the Galilee, are the remains of a synagogue, dated to the second half of the third century, whose ark was decorated with two confronted lions surmounting a *clipeus* (fig. 36).

Some of the links connecting the early ark with its Bavarian "descendent" are known. Later Byzantine period mosaics still show the same iconography in conjunction with Torah arks and an Italian rabbinic text of the 16th century discusses the decoration of an ark with sculpted lions. The continued appeal of this iconographic program to the makers of Torah arks must be ascribed to its inherent suitability. Heraldic pairs of powerful beasts as guardians of the sacred is a usage, rooted in ancient Near Eastern art, that was transmitted to the West during centuries of political and cultural contact. The lion has been a symbol of Judah since biblical times, and as Judah was the preeminent tribe of Israel, its sign became a symbol of the nation.

VBM

Reference: Brian de Breffny, *The Synagogue,* New York, 1978, pp. 145–6.

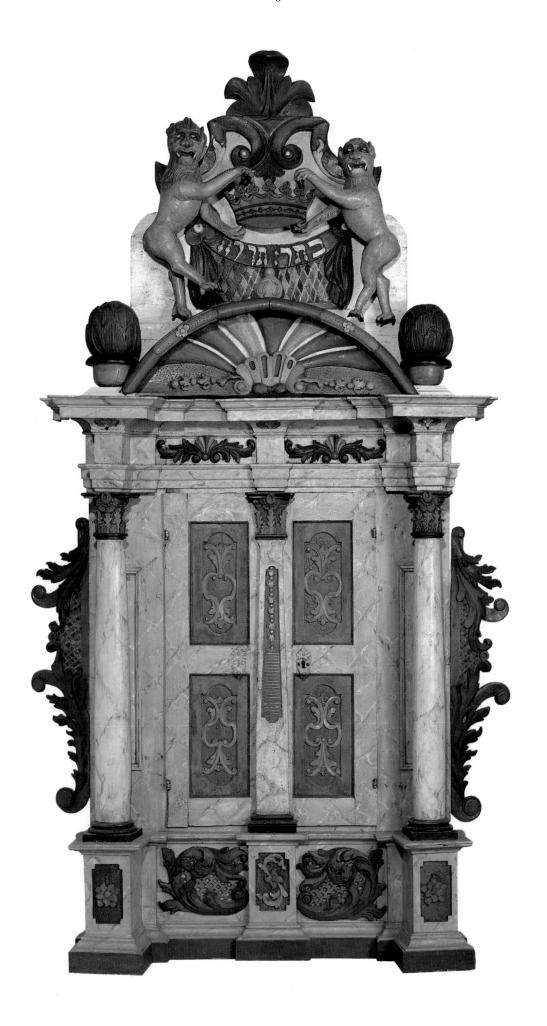

Torah Binder
Schmalkalden, Germany, 1762
Linen: embroidered with silk thread
7 1/16 x 137 in. (18 x 348 cm)
Gift of Dr. Harry G. Friedman, F5096

The Torah binders of Ashkenazi Jews were donated for an entirely different purpose than Sephardic examples. (See pp. 56–57.) Formed of the linen swaddling cloths used at circumcisions, they were dedicated in honor of a male child at the time of his first visit to the synagogue or on a similar occasion. As a result, the decoration of Ashkenazi binders, known as *Wimpeln,* was based on an inscription drawn from the circumcision service. The text includes the name of the child (here: David known as Tevle, son of Shmayah), his date of birth, and the wish that he grow to knowledge of the Torah, to the marriage canopy, and to a life of good deeds.

In its simplest form, the decoration of an Ashkenazi binder was limited to an embroidered or painted inscription that was generally executed by a relative or skilled professional. An inventive designer could elaborate the form of each letter, as here, or surround the inscription with decorative border motifs. The text offered several possibilities for pictorial vignettes, a zodiac sign next to the date of birth (in this example, Cancer), symbols associated with the name of the boy or his father, and depictions of the Torah and marriage scenes inserted in the wish for the child's future. Added subtexts were another pretext for illustration. This binder bears the first half of the injunction "Be swift as an eagle, strong as a lion . . ." [to do the will of your creator] (Ethics of the Fathers 5:23).

Unfortunately, most binders do not include information about their place of origin. However, this work can be securely placed in Schmalkalden, in the province of Hessen-Nassau, because three very similar binders from that town were published before the war. All were dedicated in honor of three sons of the same father, Shmayah, between the years 1758 and 1765. The David son of Shmayah of this binder, born in 1762, must have been their brother.
VBM

Reference:
The Jewish Museum, *Fabric of Jewish Life,* 1977, no. 150.

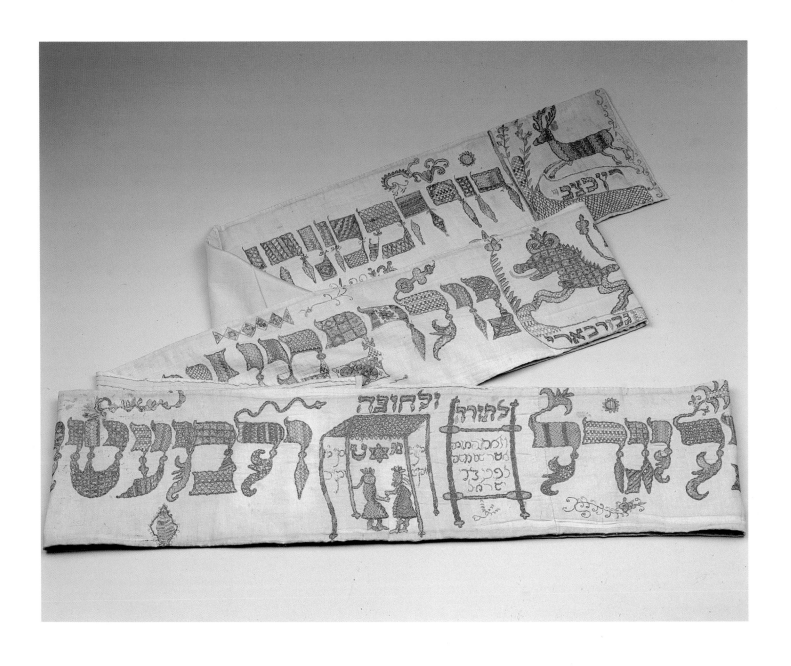

Marriage Contract
Trieste, 1774
Ink, gouache, gold paint on parchment: cut-out
27¾ x 22¼ in. (70.5 x 56.5 cm)
Gift of Dr. Harry G. Friedman, F5355

This *ketubbah* (marriage contract) exemplifies an alternative folk style which existed alongside the high art of contracts like that written in Livorno in 1751. (See pp. 92–93.) It belongs to a closely-related group of contracts from Ancona, Senigallia, and Trieste, all cities on the northern Adriatic coast, that were written and decorated between 1772 and 1776 by one atelier, if not by one artist.

The example in the Jewish Museum's collection is typical. Its parchment is rectangular at bottom and arcuated at top. Within are a series of borders of varying widths, each filled with a different decorative scheme. Those at center echo the shape of the text field, while the outer borders follow the edges of the parchment. From the way in which the text of the contract overlaps the border at various points, it appears that the artist first created the frame; then the text was added. This sequence explains why the biblical scenes on this contract — Adam and Eve, the Sacrifice of Isaac, and Lot and his Daughters — bear no relationship to the contract. They do not refer to the name of the groom, Samson son of Kalonymos ha-Levi, nor to that of the bride, Grazia, daughter of Asher Fano. This lack of pictorial reference to the family contrasts with many other Italian *ketubbot,* such as the earlier Livorno example where the Sacrifice of Isaac pertains to the father of the bride. The same is true of the biblical scenes on other contracts of this series. Evidently, their creator had a stock series of scenes and decorative motifs, including Labors of the Months, flowers, and ornamental scripts, from which he drew for the composition of individual contracts. In most cases, the owners purchased a finished border composition and then engaged a scribe to fill in the text.

A distinctive feature of this group of *ketubbot* is the use of cut-out within the cartouches enclosing figures and the inner border. The folk art of paper-cutting was traditional in many countries and was also widely practiced by Jews. The rude modeling of the pen drawn figures, the flat colors of the flowers, and their patterned interior lines are all characteristic of the work of an untutored artist working within a folk tradition.

VBM

Note: Unpublished.

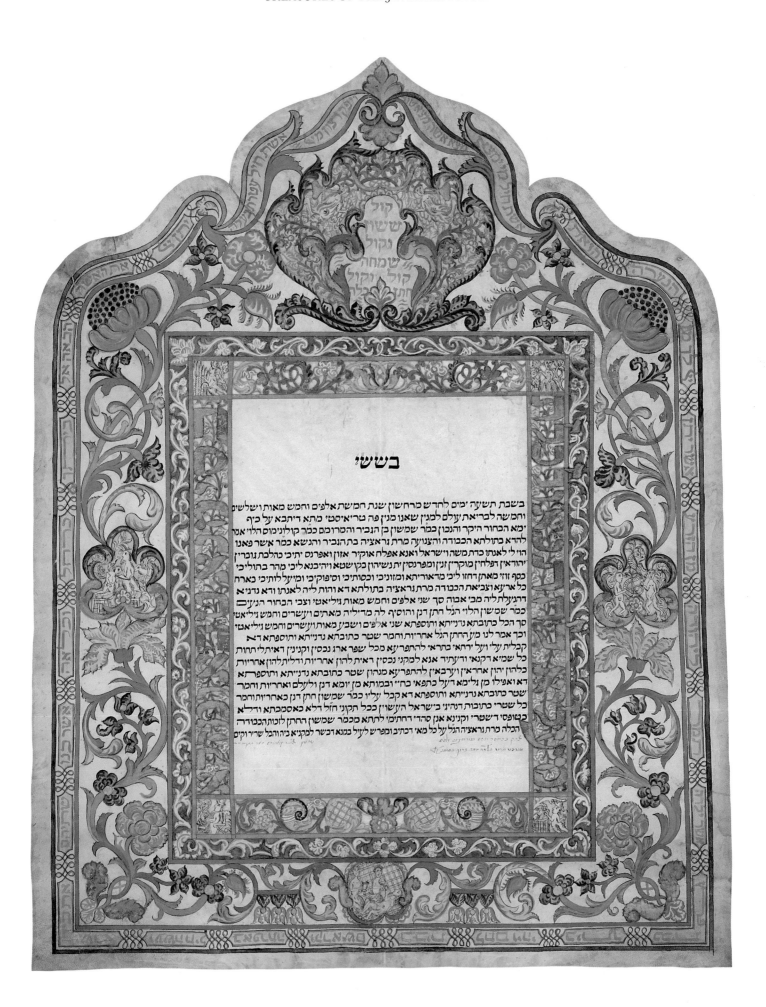

Mizraḥ
Metz(?), 1799
Joel Feuersdorf (French or German, 18–19th cent.)
Watercolor, gouache, and ink on paper
13½ x 14¾ in. (34.3 x 37.5 cm)
Gift of Dr. Harry G. Friedman, F4915

Trompe l'oeil, ("deceiving the eye") refers to the pictorial format in which an artist with precisionist skill, momentarily deceives the viewer into believing that a painted surface is real. This mode of representation was particularly well known in 17th- and 18th-century Europe and found renewed popularity in 19th-century America. Joel Feuersdorf has adapted trompe l'oeil sources for his naive-style decoration. The artist may have known the painter F. G. Schumann's 1797 work which portrays many of the same elements (a nearly identical playing card, sheet music, written documents) arranged in a format similar to Feuersdorf's *mizraḥ* (see fig. 37).

Feuersdorf's application of trompe l'oeil prototypes for folk art seems a contradiction in terms. This untrained artist did not possess the academic ability to create the visual subterfuge that is implicit in trompe l'oeil; yet his juxtaposition of form, image, and color produces a work of great aesthetic appeal. In contrast to the visual cunning of the trained painter, Feuersdorf's guile here emerges from a form of verbal and visual allusion, common to Jewish folk art, rather than from optical illusion.

Feuersdorf's decoration is a complex juxtaposition of images and text, some of the latter sadly indecipherable due to the deterioration of the paper. In accordance with the trompe l'oeil tradition, the work is not meant as narrative. Its textual fragments include Psalms, Prophets, the Grace after Meals, and the Ten Commandments, along with portions of prayers which refer to the various Jewish festivals: the Festival of Lights, the Feast of Esther, Tabernacles, and the Jewish New Year. Playing cards, sheet music, a ram's horn (*shofar*), and the posthumous portrait of the artist's grandfather David Dispeck comprise some of the representational repertoire. Talmudic scholar Dispeck, honored through several references here, directed the yeshivah at Metz in France and later became a rabbi in Bayreuth, Bavaria. On the basis of its French inscriptions, one assumes that Feuersdorf created this work in France during the year of Napoleon's new Consulate.

Contrasting with the trompe l'oeil painter's representation of real objects, Feuersdorf has invented objects suitable for paying homage to his forebear and his religion. The artist appears to have concocted a print of Dispeck in the tradition of 17th- and 18th-century printed portraits (see p. 124). This custom was generally reserved for a handful of highly renowned Jewish scholars. Feuersdorf's transformation of the King on the playing card into the harpist, psalmist, and

Fig. 37. F. G. Schumann, *A Reichs Thaler Note,* 1797, ink and watercolor on paper.

biblical monarch refers to his grandfather's first name and to Dispeck's book *The Garden of David.* The French word *citoyen* (citizen), located to the left of the central rectangle among a jumble of indistinct and deliberately hidden words, must allude to the newly granted civil rights for Jews brought about by the French revolution.

Other examples of visual and verbal associations are evident throughout. Some subtle references and their fascinating interconnections await interpretive discovery. The complex restoration, currently in progress, will facilitate the reconstruction of missing and presently illegible passages.
NLK

Reference:
M. L. d'O. Mastai, *Illusionism in Art: Trompe l'Oeil. A History of Pictorial Illusionism,* New York, 1975.

Tiered Seder Set
Poland, 18th–19th century
Brass: cast, cut-out, engraved; wood: painted and stained;
ink on paper; silk: embroidered; linen; cotton
13¾ x 14 in. diam. (35 x 35.5 cm diam.)
Gift of the Danzig Jewish Community, D115

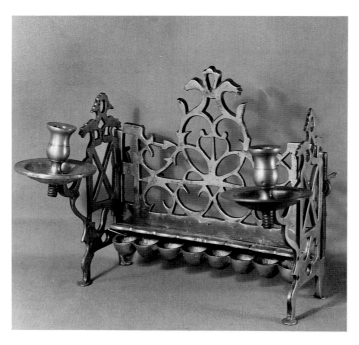

Fig. 38. Eastern Europe, *Hanukkah Lamp,* 18th century, brass. New York, The Jewish Museum, Gift of Dr. Harry G. Friedman, F483.

All over the world, Jews hold a home service called the *seder* on the first two nights of Passover. They tell the story of the Exodus and eat symbolic foods which recall the bitterness of bondage and the haste in which the ancient Israelites began their flight to freedom. This unique *seder* set combines wooden trays for *matzah,* the unleavened bread, with wooden holders for the other symbolic foods and a pedestal for the wine cup that is always filled for the prophet Elijah, herald of the messiah.

Though there are other 19th-century examples of tiered *seder* sets, none are similar to this one. Most are refined pieces made in Germany by trained silversmiths, or are imitations in base metals. They lack the robust energy that is conveyed by this piece with its rampant lions who stand, mouths agape, holding cartouches bearing the blessings recited over the symbolic foods. The curves of the lions' bodies and their notched paws are echoed in the shapes of the grillwork beneath that surrounds the wooden trays. Similar brasswork appears on East European Hanukkah lamps of the 18th and 19th centuries (fig. 38). Rampant lions often decorate the backplates of these lamps, while decorative grillwork sometimes forms an apron panel in front of the lights. The maker of the Danzig *seder* set was familiar with the artistic traditions of the lamps. In this work, he wed familiar forms to new materials, creating a dynamic composition that rises from the dark wooden base, through the open pattern of the middle zone to the triumphant lions; the whole is crowned by the base for Elijah's cup, which would have added a further, vertical accent.
VBM

References:
Katalog der alten jüdischen Kultusgegenstände Gieldzinski-Stiftung in der Neuen Synagoge zu Danzig, Danzig, 1904, no. 81; *Sammlung jüdischer Kunstgegenstände der Synagogen-Gemeinde zu Danzig,* Danzig, 1933, no. 115; Kayser/ Schoenberger, *Jewish Ceremonial Art,* no. 109; Roth, C., *Jewish Art,* 2nd ed., New York, 1971, pl. 25; The Jewish Museum, *Danzig 1939,* 1980, no. 51.

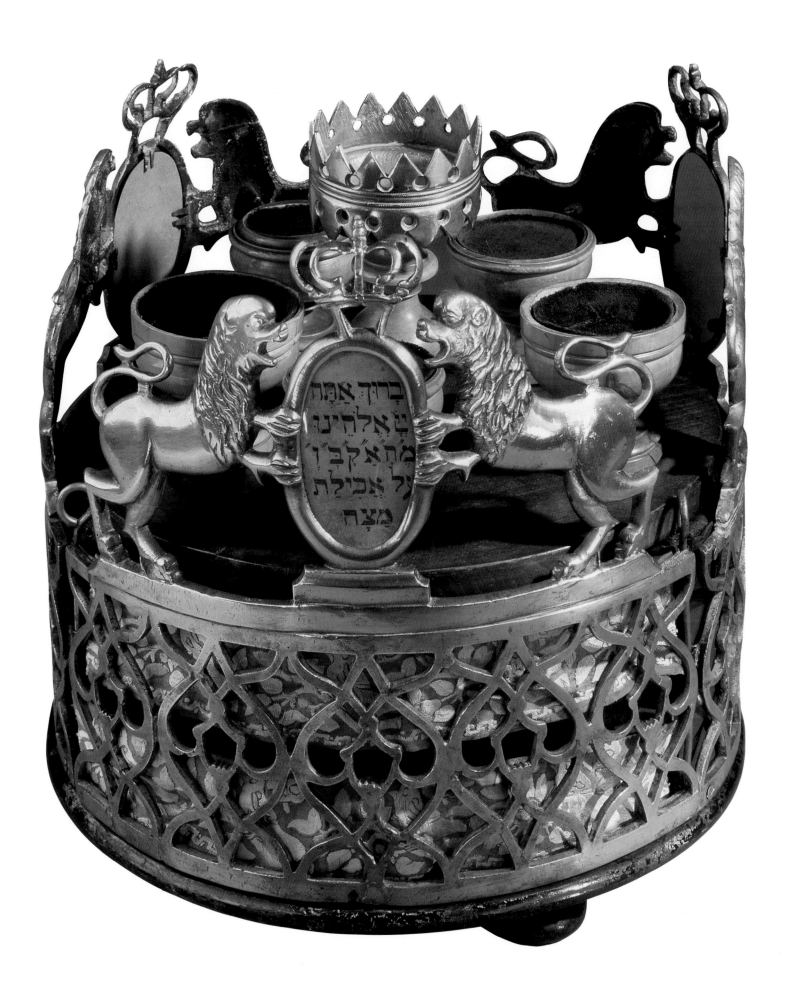

Artist Unknown
Portrait of Tiah Waill, ca. 1805–1810
Gouache and pen on paper, 10¼ x 7¼ in. (26 x 18.4 cm)
Gift of Dr. Harry G. Friedman, F4574

Fig. 39. Elimelech Filter, *Rabbi Jonathan Eybeschutz,* late 18th century, etching. New York, The Jewish Theological Seminary of America.

The splendid portrait of Rabbi Tiah Waill by this European naive painter defies classification because the scholarship on European folk art, unlike that on American folk art, categorically excludes portraiture, accepting only utilitarian objects in the canon of "primitive" style.

This gouache must therefore be judged on its own visual merits: its juxtaposition of bright colors and clear forms, and the effective attempts to distinguish surface textures. Particularly noteworthy are the numerous stylized details such as the marbleized effects on the column, the sitter's colorful library, the exaggerated wood grain of his desk, the mannered braided beard, and the glazed highlights of his black robe. For his compositional source, the artist probably used etchings of a rabbinic scholar, a type of portraiture popular in the 18th century that frequently presented learned men among their literary holdings. In fact, the widely distributed etched portrait of Waill's teacher, the noted Jonathan Eybeschütz (see fig. 39) used a format similar to Waill's painted depiction. Eybeschütz also sits, book in hand, in front of his library, with a drape parted on the right. The laudatory Hebrew and German inscriptions beneath the Eybeschütz portrait are similar both in their location and in meaning to the Hebrew and French honorific memorials for Waill.

Tiah Waill (also spelled Weil) was born in Prague in 1721, son of the noted Rabbi Nethanel Waill from whom he received his early instruction. Upon the expulsion of the Jews from Prague in 1745, the younger Waill left for Metz where he studied with Eybeschütz. Waill eventually returned to Prague, remaining there until 1770 when he succeeded his recently deceased father in the rabbinate of Karlsruhe. A kabbalist of great piety, his only known publication is a commentary on the Passover *ḥaggadah.* Based on its French inscription, this posthumous portrait can be dated between the sitter's death in 1805 and the year 1810 when the French domination of Karlsruhe, the capital of the Germanic Duchy of Baden, ended.
NLK

תורת הרב מהו' טיאה וייל זצ״ל אב״ד דקק קארלסרוהע

T. WAILL.

Grand Rabbin de Carls-Ruhe duché de Bade

Hanukkah Lamp
Eastern Europe, 19th century
Bronze: cast
29¾ x 26½ x 13¾ in. (75.5 x 67.3 x 34.9 cm)
The Rose and Benjamin Mintz Collection, M446

Fig. 40. Russia, *Candlesticks,* late 18th century, silver. New York, The Jewish Museum, Gift of Mrs. Miriam Miller, 1985–170 a,b.

This elaborate lamp incorporates a veritable menagerie of animal forms: griffins, lions, birds, deer, fish, dolphins, elephants, a gorilla, and a bear. By arranging all the figures in heraldic pairs aligned along a central vertical axis, the artist achieved a controlled composition despite the multiplicity of forms. This axis is emphasized by the protruding candle-holder for the *shammash* or servitor at top center. The remaining eight candleholders needed for the holiday sit on the bench below. (See pp. 66–67.)

Many aspects of this lamp recall East European folk art and other forms of Judaica created within that tradition. For example, a network of forms is created by setting the animals of the backplate within dense foliage and then casting only the positive images, leaving the interstices empty when the lamp is seen against the space surrounding it. The result is an aesthetic effect similar to that of the art of paper-cutting. (See pp. 130–31.) The symmetry and denseness of the lamp composition also recall paper-cuts, as well as the wooden Torah arks of Eastern Europe and the carvings on tombstones. However, sections of the base and backplate, which contain heraldic pairs of animals or birds set within a frame, relate to another, simpler type of Judaica, the backplates of less elaborate Hanukkah lamps (fig. 38). In effect, this lamp combines several backplates into a single unit. In creating the much more complex composition of this lamp, the artist also drew on the traditions of more sophisticated decorative arts. The decoration of the lamp includes cast three-dimensional animal figures: a pair of elephants, a muzzled circus bear (at left), a gorilla (at right), and the dolphin lamp feet. Similarly, cast dolphins and lions form the stems of East European silver candlesticks dated to the 18th and 19th centuries (fig. 40). Another tradition related to this lamp is that of decorative ironwork, particularly the cast openwork that reached a high degree of sophistication in the first half of the 19th century.

Few bronze Hanukkah lamps are known that are as complex and skillfully produced as this one and on the same scale. It probably represents a special commission whose particular decoration reflects the fantasy of its maker or patron, or both. VBM

Reference:
M. Narkiss, *The Hanukkah Lamp,* Jerusalem, 1939, pp. 49–50, figs. 113–14 (Hebrew).

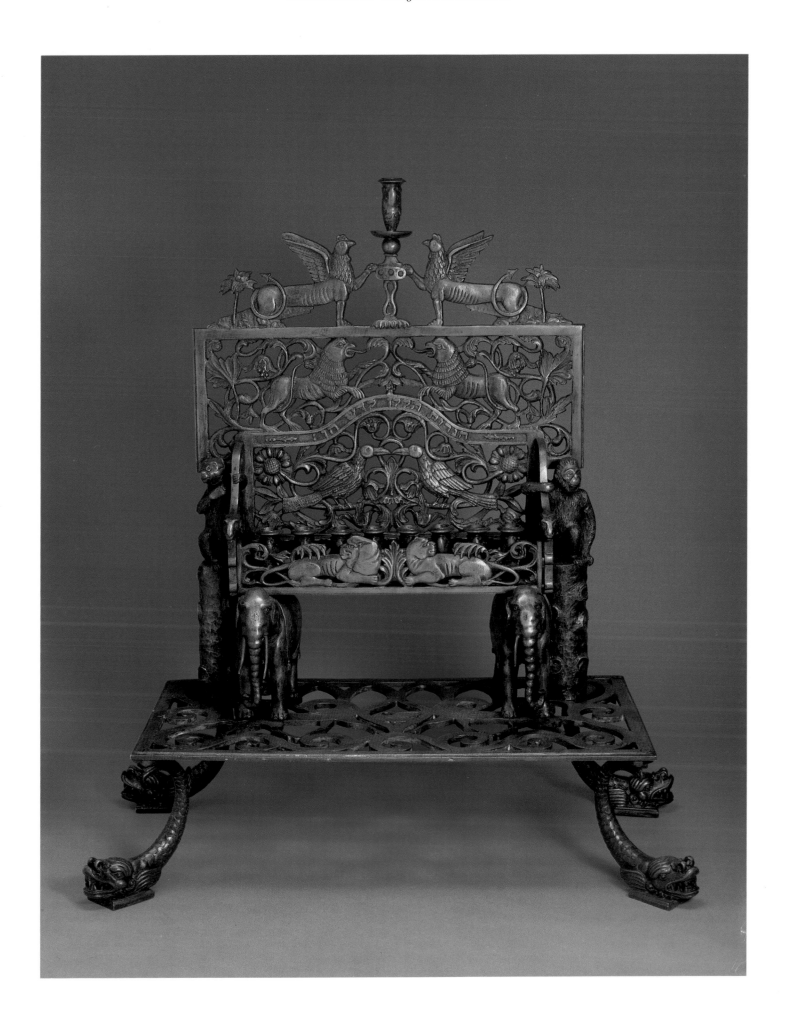

Shiviti
Istanbul, 1838/9
Moses Ganbash
Paint, ink and collage elements on paper
34 1/4 x 42 3/16 in. (87 x 107.2 cm)
Gift of Dr. Harry G. Friedman, F5855

A *shiviti* is a plaque or paper inscribed with Psalms 16:8 "I am ever mindful of the Lord's presence." (See pp. 138–39.) This example is highly unusual in that its purpose as set forth by the biblical quotation at top center is combined with a detailed topographic map of holy sites of the land of Israel. The map is oriented from west to east with the Mediterranean Sea in the foreground and the Dead Sea at top right. This is the viewpoint found in the earliest printed Hebrew map published in Amsterdam in 1620/1 and widely dispersed in the map of the very popular Amsterdam Haggadah of 1695. Major sites on this map are distinguished by the title "the holy city;" they are Jerusalem, Safed, Hebron and Tiberius (in descending order of size and importance). An amusing detail is the steamship flying a Turkish flag in the foreground, which is explained by the artist's inscription found in the bottom corners (at right)

הכותב / הצעיר משה גאנבאש / הי"ו / ניכתב בקושטה יע"א

"The scribe . . . Moses Ganbash . . . written in Istanbul" (at left)

בשנת / קוה אל ה' חזק / ויאמץ לבך וקוה... / לפ"ק

"In the year 'Look to the Lord; be strong and of good courage; O look . . .'" (Ps. 27:14). This last sentence is a chronogram yielding the date 1838/9.

Panoramic maps like this one, which list the holy sites of Judaism and emphasize places associated with famous religious leaders, were very popular in the 19th century. The earliest related work dates 1837 and was hand-drawn by Ḥayyim Shleimah Luria from Tiberius. Later examples, based on an original by a Safed artist, were published in Germany and Poland during the last quarter of the century. The Jewish Museum work, though similar to the others, differs from them in details and is more elaborate both in technique and composition. The ground lines of the map and extensive areas of the border (like the flowering vines) are formed of cut paper collage. Further, the broad outer border of the top and sides does not appear on the other maps. This border contains, at bottom, the artist's name and date of the work (mentioned above) inscribed within *aediculae*. Above, on either side, is a representation of Jericho whose seven walls are depicted as a maze inscribed: "Now Jericho was shut up tight. . . ." (Joshua 6:1). Above the mazes are ornamental gates, each bearing an urn planted with a grape vine; the urn and vine are repeated on either side of the *shiviti* quotation at top center. Finally, there are mystical prayers inscribed in the top corners.

The purpose of these panoramic maps is set forth in the inscription of the inner borders: to remind the viewer of the places and people associated with the land of Israel. It is a purpose which harmonizes well with that of a *shiviti*, since the land of Israel and the events that took place there are major themes of Jewish liturgy. Moses Ganbash's achievement was to combine the two forms within a single composition that is further unified by the repetition in the border of motifs found on the central map. The architectural frames of the inscriptions and the gateways echo the buildings on the map, and the mazes are themselves a type of map.

VBM

Reference:
The Jewish Museum, *A Tale of Two Cities,* 1982, no. 175.

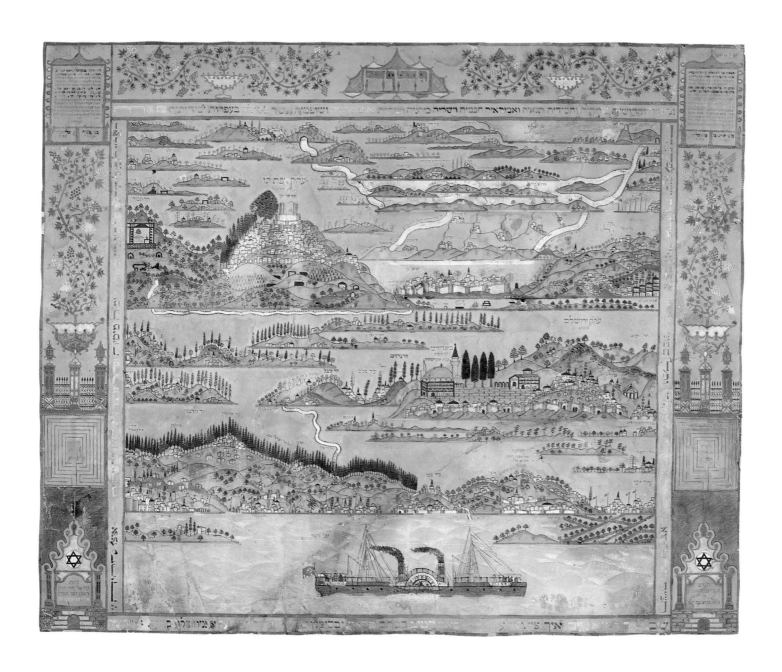

Memorial Plaque and *Omer* Calendar of a Society for the
Study of Mishnah (*Ḥevrah Mishnayyot*)
Rochester, New York, 1904
Baruch Zvi Ring (1870–1927)
Ink, gold and silver paint, colored pencil, and watercolor on cut paper
55 x 50 in. (130.7 x 127 cm)
Gift of Temple Beth Hamedresh-Beth Israel, Rochester, 1983-229

Over the centuries, immigrants to the United States have brought with them the traditions and culture of their native lands including particular forms of folk art, like the *fraktur* of the Pennsylvania Dutch. Jewish immigrants from Eastern Europe, who arrived in great numbers in the late 19th century, brought the art of paper-cutting, which they employed for many types of written documents connected with religious ceremony. Baruch Zvi Ring (Ringiansky) came to Rochester from Vishya, Lithuania, in 1902, two years before he created this work as well as several others of smaller size. His earliest known paper-cut had been created in Europe when Ring was only ten years old. It shows the same love of intricate patterns and clarity of composition seen here.

This monumental work serves two functions; in effect it combines two types of religious documents. One is the *omer* calendar that marks the forty-nine days beginning with the second day of Passover and ending with the first day of Shavuot (the Feast of Weeks). At the time of the Temples in Jerusalem, a measure of barley (*omer*) was offered daily during these seven weeks, hence the name. The two outer circles of the center field are the calendar. The first holds the blessing said nightly at the counting and the formula for the first night; the outer band of roundels contains formulas for the remaining nights. However, the calendrical function of this work is almost subsumed by its major purpose: to list the names of deceased members of the congregation whose memory the society honored by studying a portion of the Mishnah (the oral law) on the anniversary of death. These names are inscribed in the penultimate border of the sides and bottom and in the spaces between the lower pairs of columns. The remaining texts written in small letters are: (between the upper columns) prayers said after the study session; one includes the name of the deceased, the other is the *kaddish;* (on the lower column base) four texts from the Mishnah whose initial letters form *neshamah,* the Hebrew word for soul; and an open book of the Mishnah (represented at bottom). The texts in large letters on the flags and top roundels give the name of the society:

חברה / משניות / דבית / המדרש / הגדול

"The Society for the Study of Mishnah of Beth Hamedresh Hagodol"[name of the synagogue]. Those in the center circles tell of its founding

נתיסדה פה ראטשעסטער / ביום ג / א דר"ח / אדר שנת / תרסד / לפ"ק

"established here in Rochester on Tuesday, the first day of the New Moon of Adar, the year [5]664" (= February 16, 1904). The bottom roundels detail the society's obligations to study in memory of the deceased. Finally, the artist's signature appears in the lozenges attached to the lower roundels:

מעשה ידי להתפאר / ממני / ברוך צבי בן יעקב / רינג

"My handiwork in which I glory (Is. 60:21) From me, Baruch Zvi son of Jacob Ring."

These numerous texts are unified by their placement within a symmetrical composition balanced along the central vertical axis. Not only the texts but also the figurative motifs appear in pairs, with the single exception of the signs of the zodiac, which are divided into two rows of six, one alongside each of the long lists of names. They were probably included to signify the year cycle of commemorations. (See pp. 32–33.) Another unifying factor is the related scale of all the cut-outs that form overall background patterns against which the texts and figures stand out as reserved areas. This relationship of form and ground, as well as the *horror vacuii* evident in this composition, are characteristic of Eastern European folk art (pp. 126–27). Only the text and the American form of the eagles framing the Crown of Torah mark this work as having been made in the United States.

VBM

Reference:
The Jewish Museum, New York, Museum of American Folk Art, New York, *The Jewish Heritage in American Folk Art,* exh. cat., by N. L. Kleeblatt and G. Wertkin, 1984, no. 80.

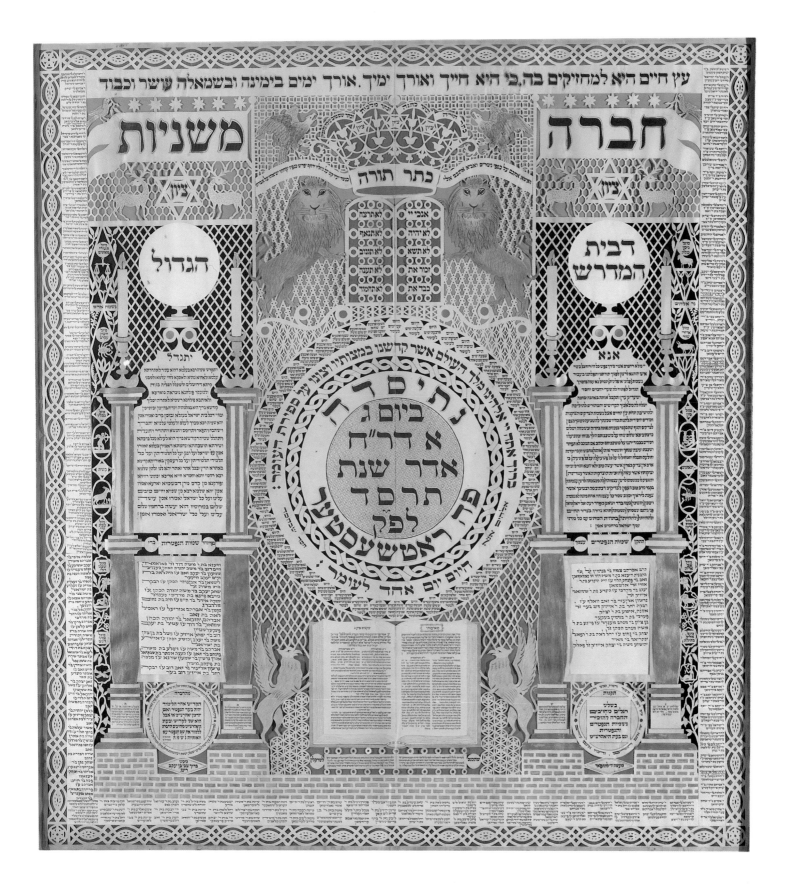

Jewish New Year's Greeting
Nome, Alaska, 1910
Attributed to Happy Jack (Eskimo, ca.1870–1918)
Engraved walrus tusk with gold inset
10 x 1 in. diam. (25.4 x 2.5 cm diam.)
Gift of the Kanofsky Family in memory of Minnie Kanofsky
1984–71

The genesis of Alaska's Jewish community coincided with the purchase of the territory by the United States in 1867. It is believed that some Jews sailed there with the Russian fishing fleets in the 1830s and 1840s, but it was not until a Jewish-owned firm, the Alaska Commercial Company, secured the seal-fishing rights that known Jewish traders began regular visits to the territory. In 1885, the first permanent Jewish settlers arrived in Juneau.

The Klondike gold rush of 1897, soon followed by another discovery of gold near Nome, brought thirty thousand miners, fortune-hunters, and businessmen into Cape Nome. A number of Jews joined the immigration and Eskimos also sought a share of the bonanza. Several hundred of the latter rapidly established a market for native clothing, along with carved ivory figurines, cribbage boards, and other souvenirs.

The tradition of walrus-tusk carving is centuries old in Alaskan Eskimo communities and developed quite separately from the whaleman's scrimshaw. However, with the coming of the whalers in the 19th century, both expanded their repertoires as Eskimo carvers and scrimshanders exchanged techniques and materials. The complexity and diversity of Eskimo subjects increased as more sophisticated interpretations displaced schematic figures and linear ornamentation. Eskimo carvers quickly learned to copy illustrations or photographs in what is termed a Western pictorial style.

The most innovative and influential of the carvers was the Alaskan Eskimo Angokwazhuk, nicknamed "Happy Jack." He is credited with the introduction, after 1892, of the art of engraving walrus tusks with a very fine needle, which resulted in an almost perfect imitation of newspaper halftones and fabric textures. The carvers enhanced the incised lines by filling them with India ink, graphite, or ashes.

Most of the engraved walrus tusks are unsigned, but several closely resemble the object shown here. A cribbage board, for example, assumed to be by Happy Jack, is embellished with portraits of a couple separated by a nosegay (see fig. 41). Even though he could not read or write, Happy Jack reproduced written inscriptions; one work included the full content of a Packer's Tar Soap label with its portrait, pine cones, and slogan. While some other native carvers also had the ability to copy the inscriptions and photographs provided by their customers, they lacked his consummate skill.

On this tusk, the artist has ably recorded the faces and attire of a religiously observant Jewish couple. The woman

Fig. 41. Attributed to Happy Jack, *Cribbage Board,* 1900-1915, walrus tusk. Anchorage Museum of History and Art.

seems to be wearing a wig and is dressed in a typical turn-of-the-century style. The man's beard is neatly trimmed; his top hat suggests a holiday or formal occasion. The Hebrew inscription delivers the traditional Jewish New Year salutation: "May you be inscribed for a good year, 5671(1910)." In English is added: "Nome, Alaska."

This walrus tusk was formerly in the collection of Dr. Morris Last, and it is believed to portray his parents.
AF

Reference:
For a discussion of Happy Jack see D. J. Ray, "Happy Jack: King of the Eskimo Carvers," *American Indian Art,* 10, no. 1, Winter 1984, pp. 32–47.

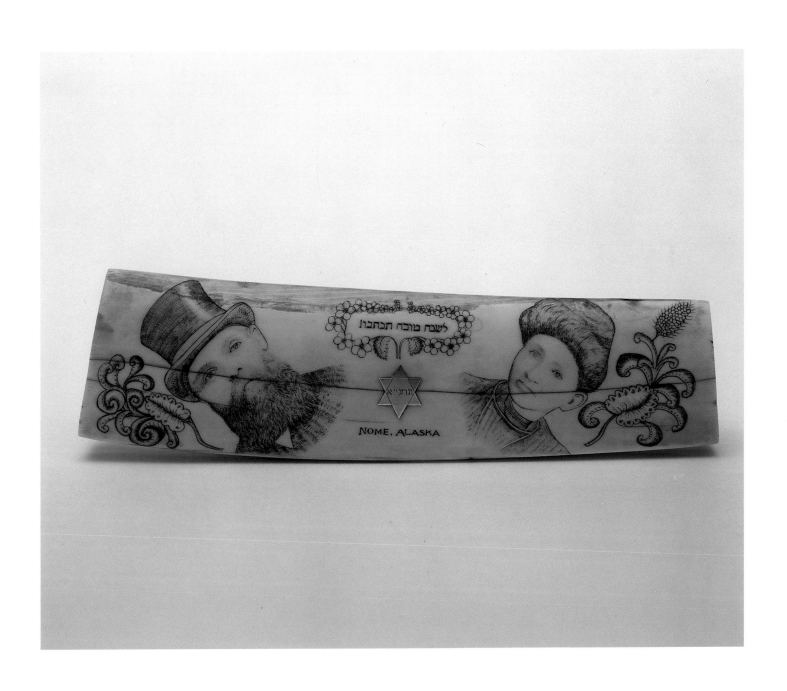

Torah Crown
Berlin, 1779
Joachim Hübner (ca. 1705–1780)
Silver: cast, repoussé, engraved, parcel-gilt;
semiprecious stones; glass stones
16 x 8¾ in. dm. (40.6 x 22.2 cm)
Gift of the Danzig Jewish Community, D61

The earliest reference to crowns as Torah decorations occurs in writings attributed to the Hai Gaon, one of the outstanding leaders of Babylonian Jewry during the late 9th century. He discusses the legal implications of a current practice, women using their jewelry to fashion a crown for the scrolls on Simḥat Torah, the festival of the Rejoicing of the Law. The same problem faced Rabbi Abraham ben Nathan of Lunel (ca. 1155–1215), who resided in France and Spain. The writings of both rabbis indicate that in the high Middle Ages the concept of the crown as decoration for the Torah was known from one end of the Jewish world to the other, but that the crown was impermanent, returning to its owner after use. Rabbi Abraham of Lunel suggested that the legal issues arising from a crown made of women's jewelry would be obviated if the community would commission a crown specifically for the Torah. His advice was taken, at least by the mid-14th century, to judge from the illuminations of Spanish Hebrew manuscripts like the Sarajevo Haggadah, which show Torah scrolls in their ark (fig. 32).

Another community to commission a crown for the Torah was the Jewish community of Arles, France. In 1439, they ordered a crown from Robin Asard, a well-known silversmith, that was to be hexagonal with a crenellated tower at each corner. Between the towers, Asard was instructed to make crenellated walls, so that the whole resembled the foundation of a fortress. Many of the surfaces were to be ornamented with the most beautiful leaves that the silversmith could make, appropriately parcel-gilt. Unfortunately, only the contract with its detailed description survives; the crown itself does not.

The opposite is true of this crown, which first belonged to the synagogue of Schottland, a suburb of Danzig, and then to the Great Synagogue of the capital. All we know of it comes from the work itself: its hallmarks, inscription, provenance, and style. The hallmarks indicate it was made by Joachim Hübner, a Berlin silversmith, in 1779. The inscription tells that the crown was dedicated over twenty years later:

כתר תורה / שייך לאלופי חברה קדישא / וג"ח י"צו / ד"ק"ק
שאטלנד שנת תקסג לפ"ק / נעשה ע"י הגבאים ר' שמעון ור'
שמואל

"This crown belongs to the leaders of the Burial and B[enevolent] Society. . .of the h[oly] c[ongregation of] Schottland, the year [5]563 (=1802/3) commissioned by the officers. . .Shimon and Shmuel."

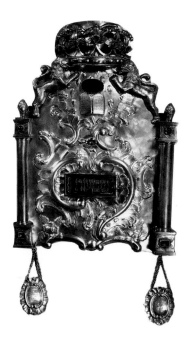

Fig. 42. Joachim Hübner, Berlin, *Torah Shield,* 1750–80, silver and glass stones. New York, The Jewish Museum, Gift of the Danzig Jewish Community, D150.

A date late in Hübner's career as a master silversmith accords well with the style of the crown's decoration. The encircling wreaths are a popular neoclassical motif. Hübner's placement of the wreath parallel to the neutral plane of the circlet shows that he had absorbed the aesthetic sense of the movement, which drew its inspiration from antique sources and which sought in classical art an antidote to the frivolity of the rococo. Hübner's embrace of neoclassical style on this crown is even more interesting when viewed in the context of one of his other works purchased by the Schottland Burial Society, a Torah shield whose most dominant decorative motif is an exuberant rococo cartouche (fig. 42). The identical provenance of both these works allows us a glimpse into the changing stylistic affinities of a master silversmith of the 18th century and sheds interesting light on the patronage of a small Jewish community. Despite the existence of an active silversmiths guild in Danzig itself from which other Jews had commissioned many works of ceremonial art, the officers of the Schottland Burial Society preferred the works of a silversmith from the larger center of Berlin.
VBM

Reference:
The Jewish Museum, *Danzig 1939,* 1980, no. 74.

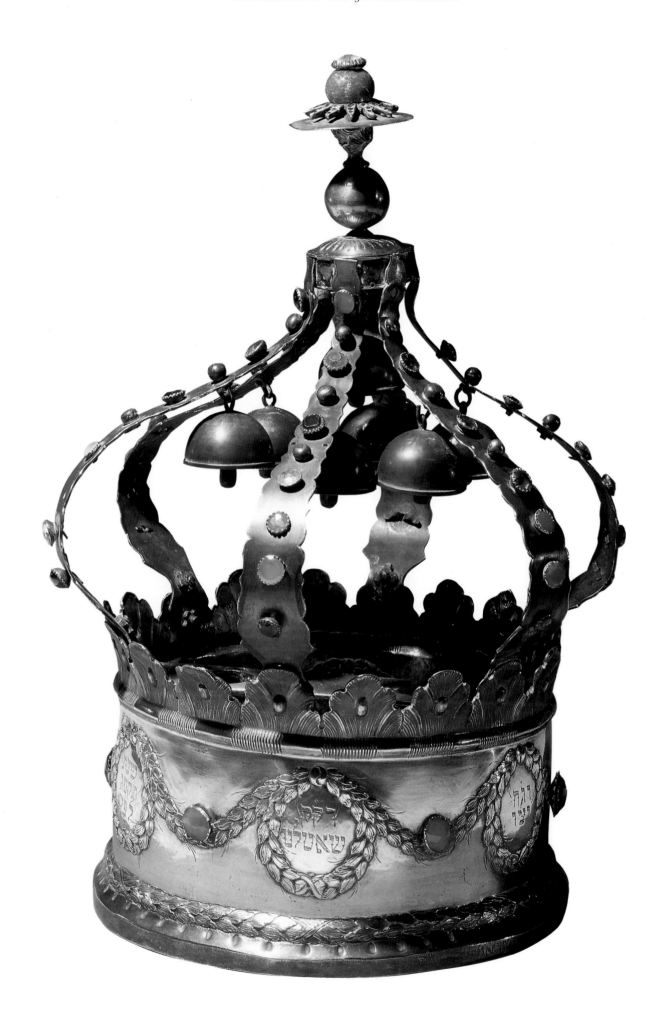

Torah Finials
British Colonies, probably North America or
the West Indies, ca. 1800
Master: E.R. or F.R.
Silver: cast, cut-out, parcel-gilt, engraved and punched
17 15/16 x 5⅜ in. diam. (45.1 x 14.3 cm)
Promised bequest of Jacobo and Asea Furman

The mid-18th century discovery of ancient Pompeii with its wealth of classical frescoes and objects inspired a return to classical motifs and symmetry in European silver design and ornamentation. In England, one of the main centers of the neoclassical style, silversmiths created works with light, graceful shapes and delicate decoration. These *rimmonim* (Torah finials) exemplify the British neoclassical style of the late 18th century in their open, airy form, consisting of two cylindrical bands alternating with three tiers of classical palm leaves and sheaves. The effect of openness is further enhanced by the cut-out roundels in the central band and by the simple engraved floral decoration that catches and reflects the light. This technique of decoration was commonly used for silver cruet stands, cake baskets, sugar bowls, and salt cellars, as exemplified in the work of the Bateman firm and others (fig. 43). The Batemans produced several pairs of *rimmonim* that are similar in form and style to the pair shown here.

British neoclassicism disseminated to Europe and to the far-flung British Colonies, where it was frequently imitated. These *rimmonim* are probably examples of colonial silver, for their hallmarks are similar but not identical to those in the well-documented British hallmark system. There were no official assay offices or registries of silversmiths' marks in the colonies during this period, and silversmiths were free to mark their works as they wished. Many, particularly in America and Canada, chose to use "pseudo-British" hallmarks.

During the period when these *rimmonim* were fashioned, Jewish communities existed in the British (or former British) territories of America, Canada, and the West Indies. As little has been published on West Indian silver work, and even less on Jewish ceremonial silver from that region, these *rimmonim* may be rare and important examples of this genre.
SLB

Fig. 43. Robert Hennell, London, *Sugar Bowl,* 1783/4, silver. New York, The Metropolitan Museum of Art, Rogers Fund, 1911 (11.135.2).

Reference:
The Jewish Museum, New York, *Personal Vision: The Furman Collection of Jewish Ceremonial Art,* exh. cat. by S. Braunstein, 1985, no. 9.

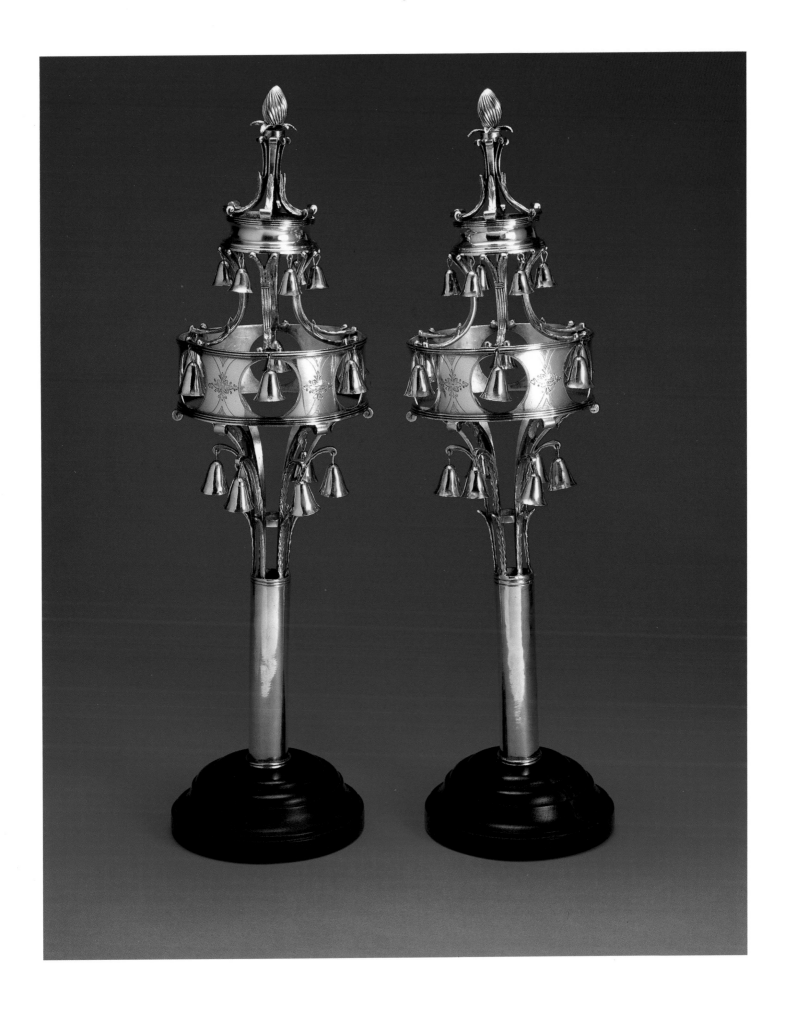

Shiviti
Prussia, 1804 (date of inscription)
Brass; repoussé and gilt; ink on parchment
29¼ x 30⅛ in. (74.5 x 76.5 cm)
Gift of the Danzig Jewish Community, D89

The purpose of a *shiviti* is to remind the worshipper of God by presenting a sentence from Psalms (16:8): "I am ever mindful of the Lord's presence." It was common practice to place tablets bearing the quotation near the reader's desk in a synagogue. This example stood in that position in the Great Synagogue of Danzig until its destruction in 1939. From the dedicatory inscription along the bottom, however, it is obvious that this *shiviti* was made for another house of worship, as it predates the building of the Great Synagogue by some sixty years.

זאת נדב הרר מנחם מנים בר"ח משוערזענץ ואשתו מרת פוינל ת'
שנת תקס"ד לפ"ק

"This was donated by Menaḥem Manus son of H. of Schwersenz and his wife Feigel . . . the year [5]564 (=1803/4)." Since the building of the Great Synagogue marked the union of previously independent communities, its leaders made a conscious effort to symbolize unification by incorporating older works of ceremonial art from the constituent congregations, like this *shiviti.*

The donors' inscription is also interesting as an illustration of the way that many East European Jews established family names. Menaḥem Manus is described as coming from Schwersenz, a city near Posen (Poznan). A Torah binder belonging to his son that is dated 1796 is also part of the Danzig collection, which indicates that the family probably resided in Danzig at the time this *shiviti* was made. By the first World War, Schwersenz had become the family name. Phillip Schwersenz, who died "for the fatherland," is listed on the veteran's memorial plaque of the Great Synagogue.

Beyond its documentary significance, this *shiviti* is an interesting example of the transition from the rococo to the neoclassical. A clear sense of architectural order is presented by the simple outlines and prominent moldings of the plaque. The covered urns which flank the segmented pediment are a favorite neoclassical motif. Yet the remaining motifs are rococo forms, such as the cartouches and shell motifs of the tympanum. In part, this melange of styles may be due to an older model used by the artist for the Tabernacle implements. He probably based his forms on a manuscript illumination or on early 18th-century valances for the Torah ark (see pp. 108–9).

VBM

References:
Sammlung jüdischer Kunstgegenstände der Synagogen-Gemeinde zu Danzig, Danzig, 1933, no. 89, pl. 8; F. Landsberger, *A History of Jewish Art,* New York, 1973, pp. 33–34, Fig. 13; The Jewish Museum, *Danzig 1939,* 1980, no. 109.

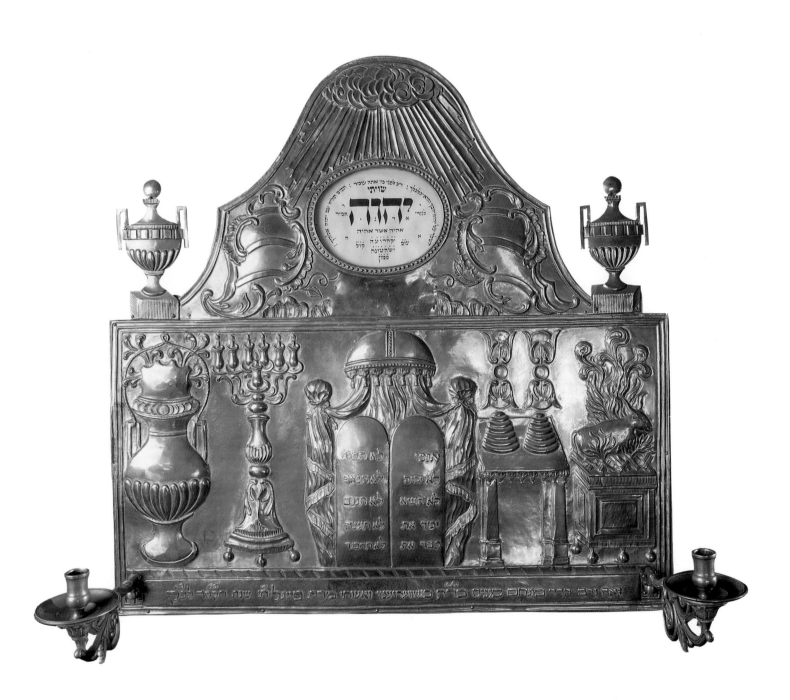

Thomas Sully (American, 1783–1872)
Portrait of Sally Etting, 1808
Oil on canvas, 30 x 25 in. (76.2 x 63.5 cm)
Gift of William Wollman Foundation, F4610

Portraiture remained the predominant aspect of American artistic production for the increasingly prosperous population during the colonial period and in the early years after the Revolution. Portrait painter Thomas Sully was but one of the many artists to record the images of America's extremely small Jewish community. In fact, the list of other major artists to receive Jewish commissions is quite impressive, and includes Gilbert Stuart, Rembrandt Peale, and John Wesley Jarvis.

Here, Sully depicts 32-year-old Sally Etting in the fashionable Roman-inspired clothing and coiffure of the neoclassical era, a style well suited to the ideology and aspirations of the Federal period of the early Republic. The sitter was born in York, Pennsylvania, to a family who would maintain civic and social prominence for generations. Her father, Elijah Etting, an Indian trader and supplier to the Revolutionary army, died when she was a child. Her family subsequently moved to Baltimore.

Sally Etting's highly successful brother Reuben, an important political figure in Baltimore and Philadelphia, may have commissioned this likeness of his maiden sister. Sully's journals noted a portrait of another Miss Etting, perhaps Sally's sister, and several portraits of the prominent Gratz family of Philadelphia, relatives of the Ettings. This latter group includes the 1831 portrait of the renowned social activist Rebecca Gratz, the purported inspiration for Sir Walter Scott's heroine of *Ivanhoe.* It may have been these Philadelphians who suggested Sully's service to the Ettings.

This portrait was executed just three months after the English-born Sully first settled in Philadelphia, the city which would become his home for the remaining sixty-five years of his distinguished career. The perseverance, industriousness, and talent he demonstrated during his first year there enabled him to depart for London in 1809 to advance his career. There, upon the recommendation of Charles Willson Peale, he studied with the eminent English-based American artist Benjamin West. After returning to Philadelphia early in 1810, Sully took up portrait commissions and within twenty years had become one of America's most prominent portraitists. In the words of the historian William Dunlap, Sully was "prince of American portrait painters."
NLK

Reference:
Smithsonian Institution Press, Washington, D.C., *Mr. Sully, Portrait Painter. The Works of Thomas Sully (1783–1872),* exh. cat. by Monroe H. Fabian, 1983 (published for the National Portrait Gallery).

Hanukkah Lamp
Germany, ca. 1830
Brass: hammered and chased; painted cast iron, and cast brass
15¼ x 14⅝ x 2½ in. (38.7 x 37.2 x 6.4 cm)
Gift of the Danzig Jewish Community, D208

The excitement surrounding the excavations at Pompeii and Herculaneum in the mid-18th century inspired a change in taste that gradually supplanted the delicate frivolity of rococo forms with the more austere styles of Greco-Roman antiquity. In contrast to the freer adaptation of these same sources during earlier periods, the full-blown neoclassic style at the turn of the 19th century strove for near replication of archaeological prototypes. The artists best known as purveyors of these "refined" ideas were Percier and Fontaine in France and Thomas Hope in England. Their designs encompassed every minute detail of interior ornamentation and were applied with a preference for symmetry, high contrast, and elegance of outline. Allegorical references suiting either the function of the room or the personal interests of its inhabitant were often devised for decorative schemes. Neoclassic taste arrived somewhat later in Germany and reached its zenith through the inventive expressions of the Berlin architect/designer Karl Friedrich Schinkel whose approach to Greco-Roman sources occasionally bordered on archaeological duplication.

This unusual, mannered Hanukkah lamp is representative of the pervasiveness of neoclassical style and demonstrates all its hallmarks — the use of antique sources, symmetry, and the favoring of contrasting materials, colors, and textures. The hammered and chased brass backplate of this wall sconce is a neoclassical adaptation of older baroque forms. On it are mounted two griffins, a flaming altar in cast iron, and a brass-helmeted female head, probably that of Minerva. The cast parts were possibly produced in Berlin, a major center for iron castings and the focus of Schinkel's greatest influence. Stylistically, these decorative elements are remarkably similar to those on a cast-iron tobacco humidor from Berlin (see fig. 44) that also uses griffins flanking a flaming lamp.

The holiday of Hanukkah commemorates the triumph of Judah Maccabee over the Syrians in 165 B.C.E. and the consequent miracle of the lights when the Temple menorah burned for eight days on a one day supply of oil. The setting of this legendary event in the Greco-Roman world and its affinity with neoclassicism's affection for themes of victory would have been difficult for the literal mind of the era to ignore.

It is not known whether the stock figures on this lamp were the conscious choice of the commissioner and are intentionally allegorical or simply result from a practical configuration of antique-inspired forms. The heraldic figures of the

Fig. 44. Germany, *Tobacco Box with Griffins*, ca. 1820–25, cast iron. Berlin, Kunstgewerbemuseum.

eagle-headed lions, commonly associated with conquest or strength, might be a free association with the ancient Jewish hero. Likewise, the head of the Goddess of War might be another reference to Judah Maccabee. The flaming altar could simply allude to the miracle of the lights. It may, however, relate to two issues discussed in the passages that are read during Hanukkah (Num. 7:1–8:4). These verses relate to the offerings accepted by Moses for the altar of the tabernacle and the seven lamps that were to be placed before the lampstand. If such references were intended on this Hanukkah lamp, the central element could be meant to suggest either the altar for offerings or the lampstand. Although the question of whether such a sconce, created from available stock decorations, contained a conscious iconographical scheme must remain unanswered, the ingenuity of both commissioner and craftsman in the creation of this highly unusual and stylish lamp must be admired.
NLK

Reference:
The Jewish Museum, *Danzig 1939*, 1980, no. 160.

Beaker
Vienna, 1826–1830
Jacob Schuhfried (1785–1857)
Glass: painted and parcel-gilt
4 15/16 x 3 3/4 in. (12.5 x 9.5 cm)
Gift of Dr. Harry G. Friedman, F4382

Glass and porcelain were among the favored materials for domestic wares during the Viennese Biedermeier period (1815–48). This phenomenon resulted in part from the high cost of precious metals. It also demonstrated a reaction to the wholesale meltdown of church, public, and privately owned gold and silver authorized by the financially troubled state in 1806. Economics aside, these warmly glazed, painted, and handblown products (contrasting with the cool elegance of silver) harmonized well with the lighter woods then popular for Viennese furniture.

The Schuhfried beaker is decorated with the representation of the interior of the Seitenstettengasse Synagogue in Vienna. A classically derived flared cylinder with a heavy faceted base, it is a product of the great revival of glass decoration in the early nineteenth century. Samuel Mohn had introduced the technique of transparent enamel painting on glass upon his arrival in Vienna in 1811. Within a year Anton Kothgasser decorated his first glasses in this manner as a means of supplementing his income as painter at the Viennese Porcelain Factory. Schuhfried, employed by the same firm, soon became Kothgasser's most noted associate. Although Schuhfried is generally cited for his city views and landscapes, he also painted other beloved themes: portraits, flowers, animals, emblems, and allegories. Because Schuhfried did not sign his works, this glass, and for that matter much of his oeuvre, was considered to be Kothgasser's. The discovery of Kothgasser's and Schuhfried's joint record book has permitted a reattribution of this beaker and many other works to the latter's hand. Schuhfried's style is considered "poetic" and is certainly more impressionistic than Kothgasser's. This contrast may be seen in the comparison between Kothgasser's depiction of the exterior of a Catholic house of worship, the prominent Gothic St. Stephen's Cathedral (see fig. 45), and Schuhfried's representation of the interior of the newly constructed, neoclassically decorated Judentempel. Schuhfried's record book of 1825–1830 indicates that he decorated two glasses with views of the Judentempel, one of which may be The Jewish Museum's work.

The Judentempel was the first official public synagogue that Viennese Jews were permitted to build after their readmission to the capital late in the 17th century. Designed by Josef Kornhausel, who had been court architect to the Prince of Liechtenstein, its oval-domed interior with Ionic columns

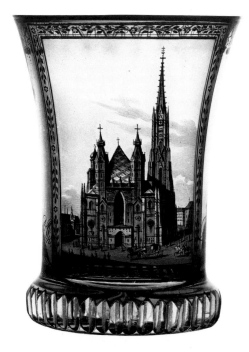

Fig. 45. Anton Kothgasser, *Beaker with a view of St. Stephen's Cathedral,* 1825, glass. Vienna, Österreichisches Museum für Angewandte Kunst.

and two-tiered gallery reflects his numerous commissions for theaters. In deference to the demands of the local public authorities, the nondescript exterior facade blended with the two adjoining buildings. However, its stylish neoclassical interior, as well as the classical connotation of its name, sought to attract the assimilating, modern Viennese Jew.
NLK

Reference:
R. von Strasser, *Die Einschreibebüchlein des Wiener Glas-und Porzellanmalers Anton Kothgasser,* 1977.

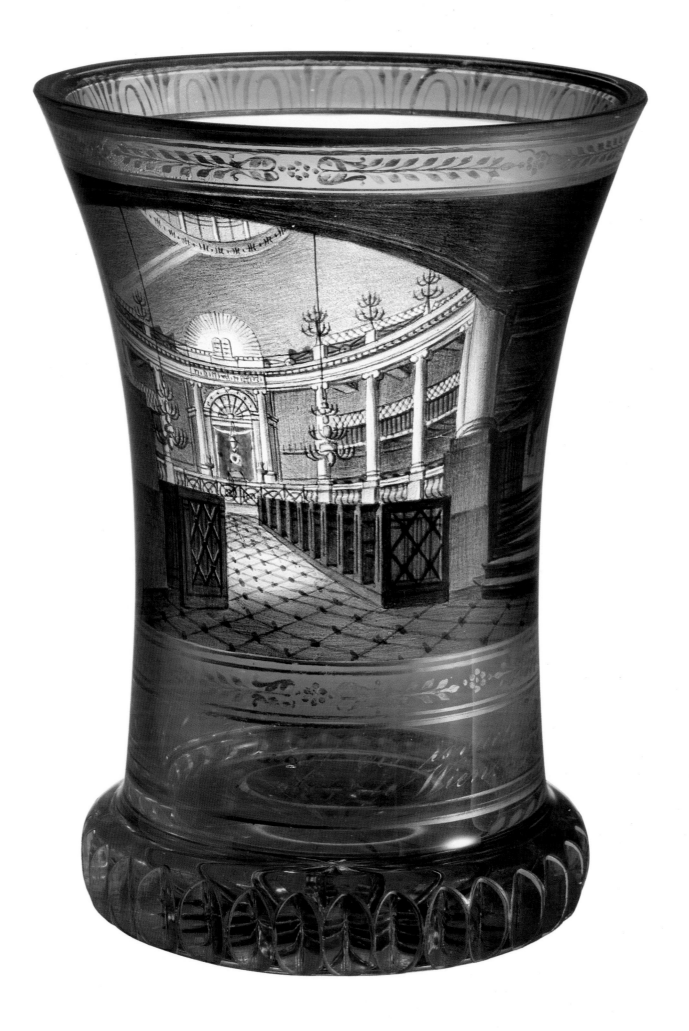

Wedding Sofa
North Germany, possibly Danzig, 1838
Birch veneer over pine, lindenwood, painted and gilded, upholstered
38¼ x 63 x 28 in. (97 x 160 x 71 cm)
Gift of the Danzig Jewish Community, D280

The term "Biedermeier" refers to the relatively peaceful period in German-speaking countries between 1815 and 1848. It is also applied to the style of artistic production at this time. Never before in the history of Western art was a period so influenced by the tastes of the bourgeoisie rather that those of royalty, the church, or the military. With an emphasis on family, order, and tradition, Biedermeier ideology reflects the embodiment of eternal human values. Jews, who were recently granted new civil liberties, must have felt a special alliance to a society that was beginning to accept them and to espouse principles similar to their family-oriented faith.

The ritual function served by the wedding sofa was probably the veiling of the bride by her groom prior to their nuptial vows, a custom which dates to at least the Middle Ages. The carefully carved detail of male and female clasped hands in the upper central cartouche symbolizes the union and the initiation of family life. This splendid example of Biedermeier furniture is perhaps the only extant Jewish wedding couch.

Probably commissioned for the Mattenbuden Synagogue in Danzig, the sofa is inscribed with the Hebrew date for "1838" coinciding with the building of a new structure for the congregation; the donor's name is recorded in synagogue documents. Its curious original upholstery stuffing of kelp and seashells is evidence that the couch was manufactured near the sea, possibly in Danzig proper.

Most furniture of this period emphasized comfort and simplicity, generally showing a preference for plain surfaces and indigenous wood. Nevertheless, lavishly decorated works such as this example are documented. The sofa's rather ornate embellishment — its gilt Hebrew donor inscription,* the carved and applied gilt ornaments, and the *faux* carved drapery swags — are well suited to its ceremonial intent. The sofa's form as well as its decorative elements of palmettes and leaves strongly suggest English Regency prototypes of the previous decade common in North German Biedermeier (see fig. 46). The frontal emphasis typical of Biedermeier furniture contrasts with the Regency's more sculptural and three-dimensional design. The exuberant decoration on this sofa is typical of the post-1830 Biedermeier style generally known as "Second Rococo." From that date until the end of the era, this furniture increasingly incorporated curvilinear forms.
NLK

Fig. 46. English, *Design for a Sofa,* 1826. From P. and M.A. Nicholson's *The Practical Cabinet-Maker, Upholsterer and Complete Decorator,* 1826.

Reference:
The Jewish Museum, *Danzig 1939,* 1980, no. 10.

* Hebrew inscription and English translation:

ז"נ ה"ה היקר המרומם הרר שלמה פרידלענדער / עם זונתו
הצנועה מרת דאברה שתחי': תקצח

"T[his was] d[onated] by the revered Rabbi Shlomoh Friedländer with his modest spouse Dobrah . . . [5]598" (=1838).

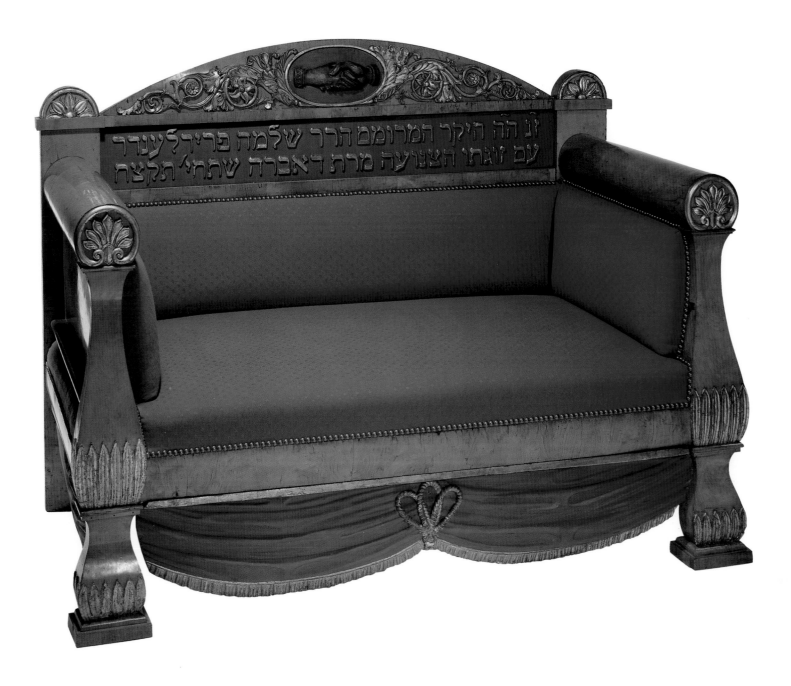

Moritz Daniel Oppenheim (German, 1800–1882)
The Return of the Jewish Volunteer from the Wars of Liberation to
His Family Still Living in Accordance with Old Customs
(Rückkehr des Freiwilligen aus dem Befreiungskriege zu den nach
alte Sitte lebendem Seinen), Frankfurt, 1833–34
Oil on canvas, 34 x 36 in. (86.4 x 91.4 cm)
Gift of Mr. and Mrs. Richard D. Levy, the owner maintaining
life rights, 1984–61

The Enlightenment of the 18th century and its Jewish counterpart, the *Haskalah*, resulted in the emancipation of Jews and their subsequent reception into professional fields previously closed to them. No account of this emancipation in Western Europe is complete without a discussion of the painter Moritz Daniel Oppenheim. Through the lifting of restrictions, Oppenheim, an observant Jew, was able to acquire proper academic training and become a professional and highly successful artist.

The Return of the Jewish Volunteer, one of Oppenheim's most significant paintings, is likewise a signal work in the history of the artistic contribution of Jews. It is generally said to represent the first effort of a known Jewish artist to confront a specifically Jewish subject. Like the themes of numerous works of the Romantic School, and more specifically that of Biedermeier painting in Germanic countries, the work falls into the category of *historical genre*. Oppenheim represents a wounded soldier in a Hussar's uniform who has just returned to his family after helping to defend Germany against the Napoleonic armies. In his haste to be reunited with his family, the young man has, contrary to Jewish law, traveled on the Sabbath.

Love of detail and the petit-bourgeois concerns of the Biedermeier period are evident in this comfortable domestic setting. Jewish ritual objects and foods are carefully depicted in addition to the patriotic portrait of Frederick the Great, ruler of Prussia. The soldier's mother and siblings appear in various states of concern and delight as they fawn over their just-returned relative and simultaneously express admiration for his uniform and other military accoutrements. The father's rapt gaze at his son's Iron Cross, a military decoration which is also a Christian symbol, reveals both pride and skepticism.

The Return of the Jewish Volunteer, painted during a period when Jewish civil rights were again in a tenuous state, has been interpreted as a reminder to Germans of the significant role played by Jews in the Wars of Liberation. The subtle political overtones of *The Return* are indeed unusual in the generally apolitical nature of Biedermeier art.

The departure of the volunteer was a popular theme in early 19th-century art and may have served as one source for Oppenheim's inversion of that theme in *The Return*. He may well have known François Rude's Paris monument, *The Departure of the Volunteers*, also begun in 1833, along with numerous

Fig. 47. Philipp Otto Runge, *The Return of the Sons (Die Heimkehr der Söhne)*, 1800, pen and ink. Hamburg, Kunsthalle.

genre representations of the departure subject executed around the time of the French Revolution. The latter were certainly known to Oppenheim during his earlier stay in Paris around 1820. One of the rare examples of Oppenheim's theme are the numerous drawings for the proposed painting *Die Heimkehr der Söhne (The Return of the Sons*, circa 1800) by the eminent German artist Philipp Otto Runge (1777–1810) (see fig. 47). The conception and composition of Runge's work is startlingly similar to Oppenheim's; they both depend compositionally on the numerous popular 18th-century interpretations of the *Return of the Prodigal Son*. It is indeed likely that Oppenheim would have been familiar enough with the oeuvre of the German master to make use of it for reinterpretation.

Oppenheim's privileged life and artistic career are charmingly chronicled in his autobiography, *Erinnerungen (Remembrances)*. The part recording his stay in Rome is a particularly poignant one which details the conflicts of an observant Jew, united with his fellow artists in creative sensibility, but separated from them in his religious beliefs and practices. NLK

Reference:
The Israel Museum, Jerusalem, *Moritz Oppenheim: The First Jewish Painter*, exh. cat. by Elisheva Cohen, 1983.

Solomon Alexander Hart, R.A. (English, 1806–1881)
The Feast of the Rejoicing of the Law at the Synagogue
in Leghorn, Italy, 1850
Oil on canvas, 55⅝ x 68¾ in. (141.3 x 174.6 cm)
Gift of Mr. and Mrs. Oscar Gruss, JM 28–55

Nineteenth-century British artists, perhaps more than those of any other nation, traveled extensively throughout the Continent, North Africa, and the Near East supplying visual records of monuments, places, and people. This phenomenon resulted from the isolation of the British Isles and was a continuation of the 18th-century tradition of the Grand Tour, in which nobles and gentry frequently engaged the services of an accompanying watercolor artist to document sites. The first Jewish member of the Royal Academy, Solomon Alexander Hart—following the lead of his countrymen (e.g. J. M. W. Turner and David Roberts)—visited Italy in 1841–42 and made an elaborate series of drawings of historical sites and architectural interiors, which he hoped to publish.

Although the publication of these works never came to fruition, the studies provided Hart with the basis for numerous future canvases. Three of his entries to the Royal Academy in 1850 demonstrate his likely use of these studies: *Interior of a Church in Florence; Interior, St. Mark's, Venice;* and *The Rejoicing of the Law,* a view of the interior of the Leghorn Synagogue. The inspiration for Hart's Italian tour, his proposed publication, and his depiction of ecclesiastical architecture, may indeed have come from the example of the well-traveled and noted British painter, David Roberts, who was coincidentally Hart's neighbor in London. Roberts had in 1837 published a portfolio of Spanish scenes similar to Hart's later proposed Italian one which included church interiors, and he showed several similar works at the Royal Academy between 1836 and 1850 (see fig. 48). In fact, Roberts exhibited three church interiors along with Hart's similar subjects in the same 1850 hanging at the Royal Academy.

One of Hart's works listed in the 1850 Royal Academy exhibition catalogue appears to be the painting illustrated here. It may be based on an 1845 entry of the same title. Using one of the artist's few observations of a Jewish structure during his Italian tour, the work shows the interior of the magnificent synagogue in Livorno (see fig. 27). This interior is perhaps the foremost example of the lavish redecoration common to Italian synagogues in the 18th century. Hart captures a romantic vision of the exotic dress of his Italian coreligionists as they parade the scrolls of the law on Simḥat Torah, the Feast of the Rejoicing of the Law. This marks the end of the fall harvest festival, Sukkot, and is the holy day on which the yearly cycle of reading the Pentateuch ends, immediately beginning again with Genesis.

Fig. 48. David Roberts, R. A., *The Church of the Nativity, Bethlehem,* 1840, oil on canvas. Paisley, Scotland, Paisley Museum and Art Galleries.

Hart's numerous other Jewish subjects reveal his ability to cleverly use his artistic resources and his visibility at the Royal Academy to demonstrate Judaism's significant cultural impact. Yet in his long and distinguished submission of entries to the Royal Academy he seems always to temper his Jewish themes with English and Christian ones. This sensibility to social and religious equality was triggered by the issue of civil rights for English Jews, which was debated by Parliament in 1833. Hart's aforementioned 1850 Royal Academy entries are examples of this balance in Christian and Jewish ecclesiastical interiors. Historical themes, so popular during the 1830s, could be for Hart nationalistic as in the artist's *Sir Thomas Moore Receiving the Benediction of his Father* (1836) or could be presented with a Jewish perspective in his *The Conference of Menasseh ben Israel and Oliver Cromwell.* Similarly, Hart's literary themes are chosen from masterpieces of English prose and poetry such as Shakespeare's *Merchant of Venice* and Scott's *Ivanhoe,* which embody Jewish characters.

NLK

References:
A. Ziegler, "Jewish Artists in England," *Studio,* CL III (1957), p. 1–2;
R. Ormond, "The Diploma Paintings from 1840 onwards," *Apollo,* 89 (1969), pp. 56–7.

Spice Container
Poland, 1810–1820
Silver: repoussé, cast, engraved, filigree, chased, parcel-gilt
20½ x 5 x 5 in. (52 x 12.7 x 12.7 cm)
The H. Ephraim and Mordecai Benguiat Family Collection, JM 34-51

The extraordinary form of this spice container combines two types: the tower that had been traditional in the West since the Middle Ages (see pp. 34–35) and the fruit-form container that became popular in Eastern Europe from the 18th century on. In a tour-de-force composition, the silversmith made the multistoried tower into a frame for "growing" plants. Linking the two forms are the many repoussé floral motifs that decorate the base and the other architectural elements.

Though the source of the tower-form spice container in the medieval censer tradition is known (see p. 34), the basis of the second type, the fructiform container, has never been established. Its appearance in Poland during the 18th or 19th centuries may represent another instance of Middle Eastern influence on East European decorative arts and on Judaica in particular. During the 16th century, the Ottoman Empire reached its apogee in terms of territorial conquest. In Europe, the sultans controlled the Balkan peninsula and portions of the lands now belonging to Hungary, Czechoslovakia, and Austria. As a result, new genres, techniques, and compositions became part of the artistic heritage of middle Europe, the area from which most Jews immigrated to Eastern Europe. In the 18th century, long after the Ottoman expulsion from Europe, artistic influence flowed from Turkey as the result of trade and an exchange of workers. Turkish weavers labored in Polish factories producing fabrics that were incorporated into Jewish ceremonial objects or that influenced their design; this was part of the "Turkomania" that seized Europe in general. It is tempting to see in the parallels between Turkish fructiform containers and those from Eastern Europe another instance of cross-cultural influence (fig. 50).

A lengthy, engraved inscription covers the base and the bottom of the sunflower. It records the twenty male donors whose names are inscribed in an unusual matrilineal form. This spice container came in a leather case inscribed

שנת / תקטו / לפ״ק / מבארדטשיב

"the year [5]515 (=1855/6) from Berdichev." The date of this inscription is now partially obliterated. In any case, the spice container may have been made some thirty years earlier. The distinctive cast lions that hold aloft the crown appear on a series of Torah crowns in various collections that date from 1806–19 (fig. 49).

Berdichev was the home of the Hasidic *rebbe* (rabbi) Levi Isaac (ca. 1740–1810), the founder of Hasidism in central

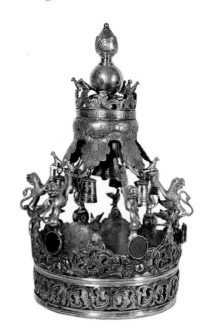

Fig. 49. Master B. M., Poland, *Torah Crown*, ca. 1809–10, silver. Gift of the Danzig Jewish Community, D52.

Fig. 50. Turkey, *Spice Container*, 19th century, silver. New York, The Jewish Museum, Gift of Dr. Harry G. Friedman, F4072.

Poland. The matrilineal names engraved on this spice container may reflect the Hasidic custom of using the mother's name on written, personal requests to the *rebbe*.
VBM

Reference:
Kayser/Schoenberger, *Jewish Ceremonial Art*, no. 91.

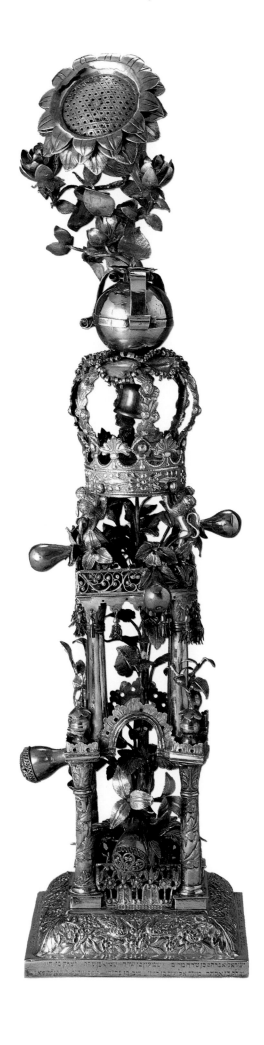

Torah Case with Rimmonim (*Tik*)
Paris, ca. 1860
Maurice Mayer
Silver: repoussé, cast, and parcel-gilt
29½ in. high x 36½ in. diam. (74.9 x 92.7 cm)
Museum purchase, S1456

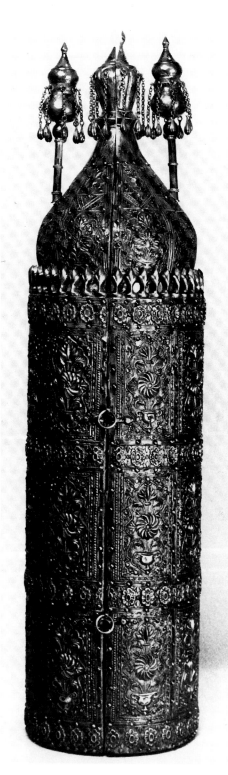

Sephardic congregations traditionally house their Torah scrolls in wooden or metal cases known as *tiks*. Such cases provide both adornment and protection for the Scrolls of Law, existing as counterparts to the Western Torah mantle (see p. 106), shield (see p. 94), and Torah finials (see p. 84). Consequently, the *tik* form results in a composite solution to the beautification of ritual and the safety of the penned parchment, both of which are prescribed by Jewish law.

The sumptuous elegance of this French example dates from Napoleon III's reign and bears many characteristics of the somewhat confused and little understood Second Empire. That style's fondness for elaborate decoration and rococo sources is evident in the ornate repoussé, the scrollwork, and the parcel gilding. The fabrication of complex objects much beloved during the reign of the last of the Bourbons makes the *tik's* intricate form perfectly suitable to the mentality of that period.

During the Napoleon III era, newly developed tastes for antiques and historicism created a large market for copies, adaptations, and sometimes even forgeries. This phenomenon led to the production of emulated medieval, Renaissance, rococo, and Islamic furbishings. It is likely that Mayer, a silversmith and supplier to the royal court, used *tiks* of Eastern manufacture as prototypes. He may have known, for example, the Ottoman work dated the same year which was made for the noted financier Abraham Camondo (see fig. 51). However, his reliance on rococo decorative patterns demonstrates a Westernized approach to this Eastern form. NLK

Reference:
Philadelphia Museum of Art, Philadelphia, *The Second Empire Art in France under Napoleon III*, exh. cat., 1978.

Fig. 51. Ottoman Empire, *Torah Case,* ca. 1860, wood covered with repoussée and parcel gilt panels. Paris, Musée de Cluny.

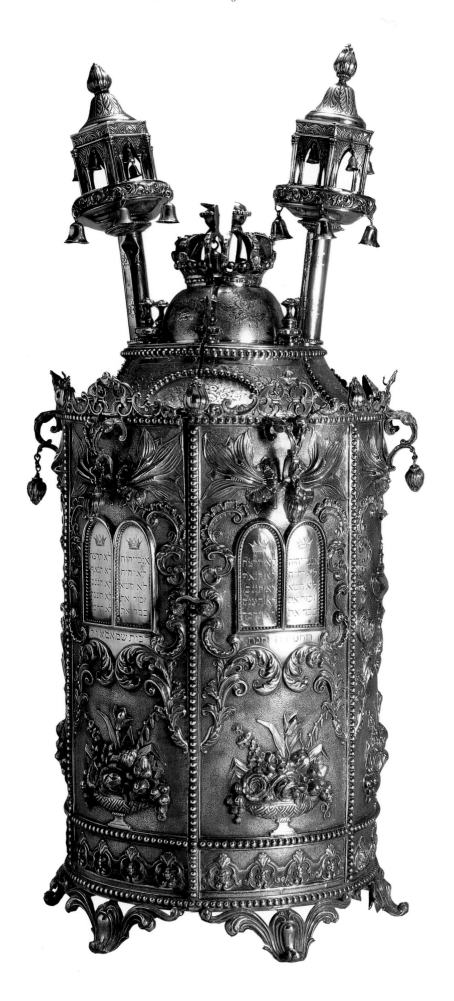

Circumcision Set
Holland, 1827 and 1866
Box: silver: filigree, cast and hammered; inlaid
with semiprecious stones
Utensils: silver: cast, filigree and hammered; mother-of-pearl: carved
Box: 9½ x 7⅜ x 4⅛ in. (24.1 x 18.7 x 10.5 cm)
The H. Ephraim and Mordecai Benguiat Family Collection, S232

Fig. 52. Holland, *Miniature Chair,* 19th century, silver. New York, The Metropolitan Museum of Art, The Joseph M. and Aimee Loeb May Collection, 1963 (63.53.224).

The importance of circumcision in Jewish life, its significance as the ceremony by which a male joins the covenant binding the House of Israel, led men to specialize in this type of surgery and to train in the Jewish laws governing its execution. At the very least, the specialist, known as a *mohel* (circumciser), owned a knife used exclusively for the ceremony. He often had accessories as well: a shield, scissors, vials for unguents, and shallow bowls. Sometimes the *mohel* commissioned illuminated manuscripts to contain the necessary prayers and to serve as a register. (See p. 98 and fig. 29.)

This set of instruments and their box was commissioned by members of the Torres family during the 19th century. One of the two earliest pieces, the shield, bears a name and date in Hebrew:

יעקב נעמיאס טורים / י'צ'ו תקפז

"Jacob Nehemias Torres, [5]587" (=1826/7) and a coat of arms. The family crest is repeated on the lyre-shaped shield, which must have been made at the same time. Some four decades later, in 1866, the elaborate filigree box, its rack, and the remaining instruments were fashioned, probably for another member of the family who had inherited Jacob Torres' shield and vial, as well as his occupation.

Dutch silversmiths often utilized filigree for small works such as decorative, miniature household objects (fig. 52). Therefore, use of this technique was appropriate for the circumcision utensils. However, the extensive filigree of the larger box is unusual and lends a sense of delicacy and preciosity to the work. The fineness of the materials and excellent craftsmanship demonstrates the importance placed on circumcision by the Torres family and by the Jewish community in general.
VBM

Note: Unpublished

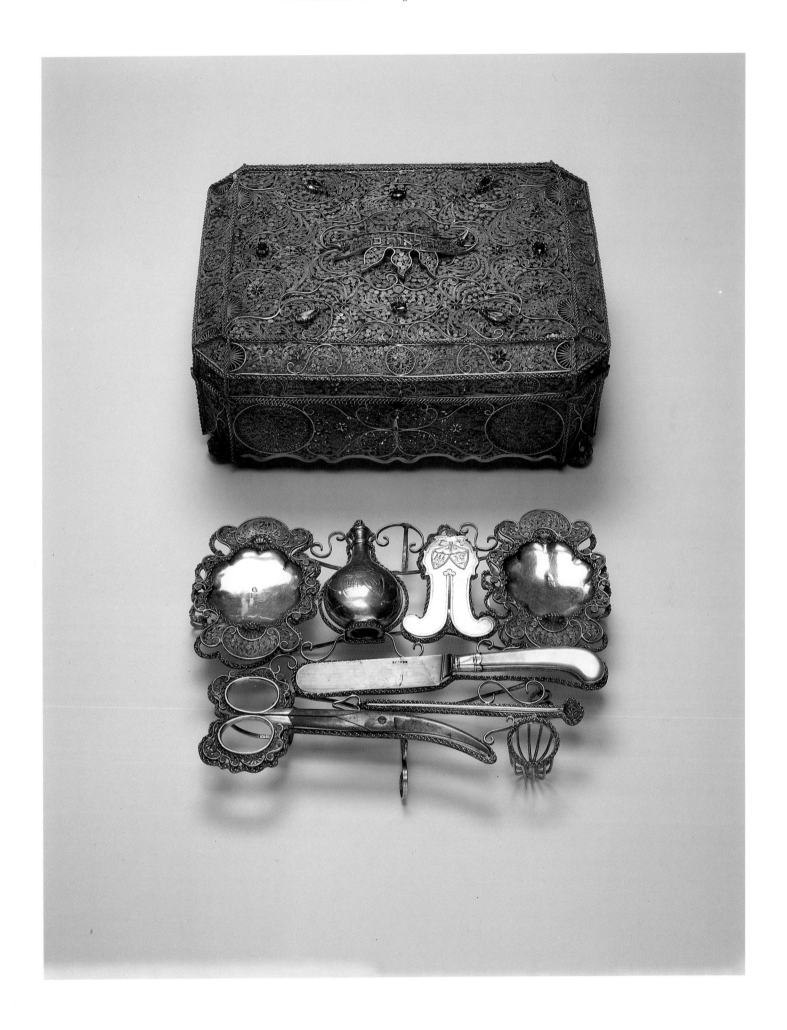

La Maison Bonfils (French, 1867–ca. 1907)
The Western Wall (1867–ca. 1907)
Albumen print, 8⅞ x 11 3/16 in. (22.4 x 28.3 cm)
JM 89-68

Throughout the nineteenth century, the Near East was a fertile visual resource for artists. The first photographs of this region date from 1839, the same year Daguerre made his new invention public. Photographic images of remote corners of the world became exceedingly popular with both tourists and armchair travelers in Europe and America. During the 1850s Francis Frith, Maxime Ducamp, and Auguste Salzmann made photographs of the Near East that have become key documents in the history of photography. Following their example, Félix Bonfils (1831–1885), Zangaki, and the Abdullah brothers rank among the numerous observers of the Orient during the last quarter of that century who produced large quantities of superb photographs. The Bonfils photograph of *The Western Wall* is but one representation of The Jewish Museum's significant collection of over sixty works of these artists. La Maison Bonfils, established in Beirut in 1867, continued after the death of its founder, Félix. His wife Lydie, son Adrien, and successor Abraham Guiragossian are also credited with contributions to the tens of thousands of prints and lantern slides produced by this studio.

The Western Wall is both real and evocative of the prominence this location has for Judaism. The wall was originally a supporting structure of the Second Temple that was destroyed in 70 B.C.E. It has become a symbol of the Jewish Diaspora and at the same time, of the hope for a spiritual and physical rebulding of Israel.

This image and the other photographs by Bonfils and his colleagues record not merely locations but strive to capture the flavor of the monumental ruins, people, and landscapes of Egypt, Palestine, Syria, and Greece. These visions of this remote reality, not unlike the meticulously researched biblical images of James Tissot (see p. 164) reflect the 19th-century notion that these areas had endured unaltered from biblical days. For the minds of progressive Western men during that century, the hallowed ground of the forebears of the Judeo-Christian world had remained frozen in time.
NLK

Reference:
Rochester, International Museum of Photography and Cambridge, Mass., Harvard Semitic Museum, *Remembrances of the Near East: The Photographs of Bonfils, 1867–1907,* exh. cat., 1980.

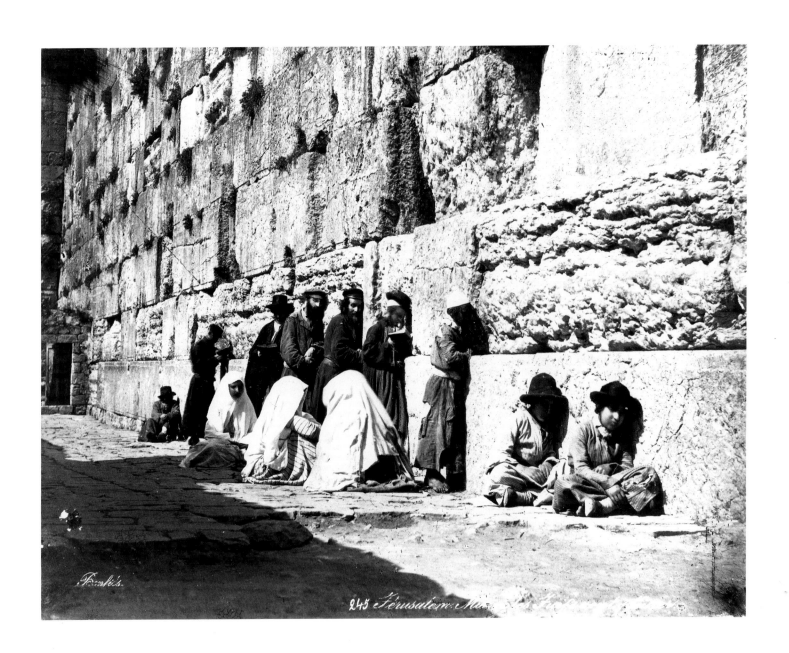

Jozef Israëls (Dutch, 1824–1911)
A Son of the Ancient Race, ca. 1889
Oil on canvas, 43½ x 33¾ in. (110.5 x 85.7 cm)
Museum purchase through The Eva and Morris Feld Purchase Fund,
1985-123

Aside from Vincent Van Gogh who worked for most of his short life in France, Jozef Israëls ranks as the most important Dutch painter of the 19th century. Israëls was the founder and leading member of the Hague School, a movement with roots in both 17th-century Dutch painting and in the more recent 19th-century French Barbizon School. This group of artists also included Johannes Bosboom, the Maris brothers, Anton Mauve, and Paul Gabriël. Together, they would dominate the Dutch art world from 1870 until the turn of the century. Hague School artists are known for their depictions of the flat landscape, and preference for portraying peasants and fishermen in small villages—all incorporated into a tonal style, nearly colorless, which merged Realism and Romanticism.

Israëls's observations of fishing communities and aspects of Jewish life are now considered to be the most important themes in his work. Yet the earlier notion that Israëls rarely treated Jewish-related subject matter is closer to the truth. In fact, only four specific titles in his oeuvre relate to his religious heritage: *The Rabbi, A Son of the Ancient Race, Torah Scribe,* and *The Jewish Wedding.* Some might add to this Israëls's self-acclaimed masterpiece *David and Saul,* based on the Hebrew Bible. As in the case of many of Israëls's subjects, several versions of most of these titles exist.

The Jewish Museum's *A Son of the Ancient Race* is one of the several reworkings depicting a secondhand clothes peddler in Amsterdam's Jewish quarter, based on an 1888 watercolor in the Rijksmuseum, Amsterdam which includes a young girl seated on the peddler's lap. For Israëls, children served as elements of hope within scenes of sorrow and poverty. Yet for the oil version the artist preferred to concentrate entirely on the figure of the weary man. Israëls has moved the now solitary figure close to the middle of the canvas according to the compositional conventions of the Hague School. *A Son of the Ancient Race* exemplifies Israëls's compassionate observation of contemplative generic types. Having already dealt with issues of sorrow, piety, old age, and the acceptance of fate in the lives of Dutch peasants, he now directed these themes toward a humble member of his own religion. Although the sitter is known as Jacob Städel, the anonymity typical of the artist's titles suggests that the peddler's condition can be applied not just to Jews or the Dutch, but to all people.

During his lifetime, Israëls had established an important reputation in his own country, as well as in England, France, and America. In 1910, he was honored by an individual exhibition of over forty of his works at the Venice Biennale. His funeral in 1911 was marked by great ceremony and was an occasion of national mourning in Holland.
NLK

Reference:
Royal Academy of Arts, London, *The Hague School: Dutch Masters of the 19th Century,* exh. cat., 1983.

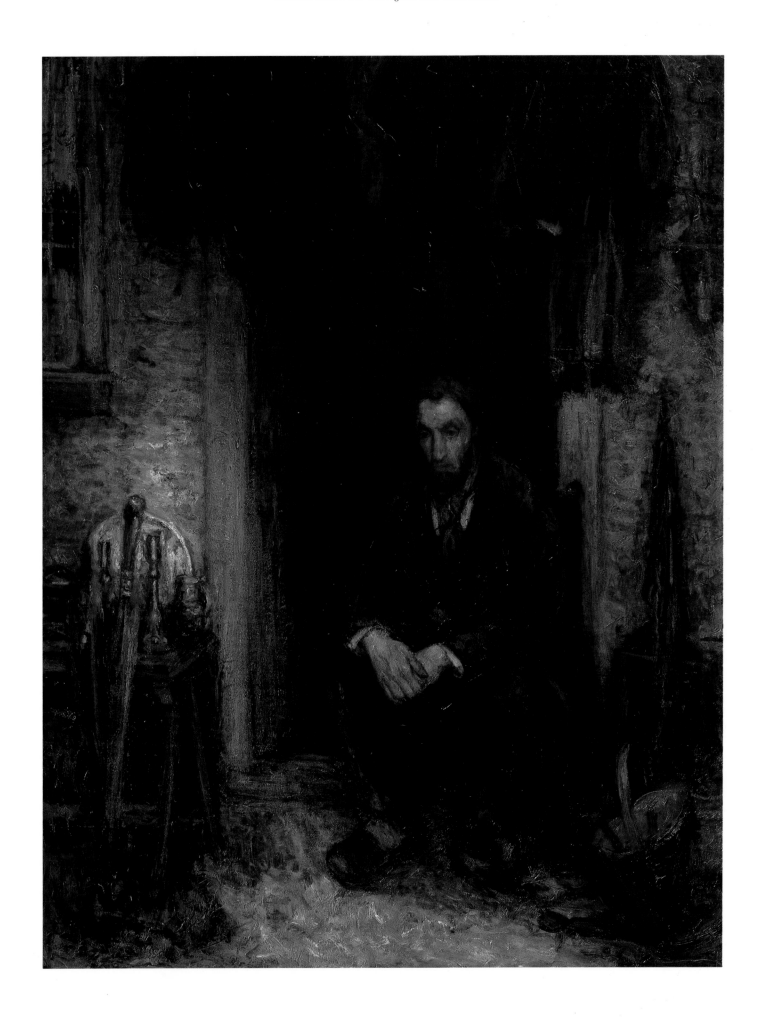

Jacques-Emile-Edouard Brandon (French, 1831–1897)
Silent Prayer, Synagogue of Amsterdam, "The Amida"
("La Gmauida"), 1897
Oil on panel, 34½ x 68½ in. (87.7 x 174 cm)
Gift of Brigadier General Morris C. Troper in memory of his wife
Ethel G. Troper and his son Murray H. Troper, JM 78-61

The observation of contemporary life, so important to both Impressionist and Realist artists during the last half of the nineteenth century, finds a particularly personal expression in the work of Edouard Brandon. The momentary glimpses of the synagogue services Brandon records are entirely natural and uncontrived, yet maintain the dignity of both ritual and environment. The large depiction of *Silent Prayer, Synagogue of Amsterdam, "The Amida",* one of Brandon's last works, is founded on his thirty-year-long production of similar subjects. The curious spelling of its title is a transliteration of the Sephardic pronunciation of the Hebrew *Amida,* or *Silent Prayer,* the silent devotion which is part of the three traditional daily and holiday services.

Silent Prayer is set in the same Portuguese congregation as his first and much acclaimed *Sermon of the Dayan Cardozo, the Synagogue of Amsterdam, July 22, 1866. The Sermon,* exhibited in the Paris Salon of 1867, was deemed "the work of a master" by the eminent critic Théophile Gautier. No doubt this acclaim encouraged Brandon's continued interest in the depiction of life in the synagogue.

The artist received his formal education at the Ecole des Beaux-Arts in Paris. He followed artistic routes typical for many emancipated Jews in the last century before he turned to his preoccupation with contemporary Jewish life. Brandon's career began pragmatically with the production of paintings with Christian subjects, so much in demand during the period of prosperity and superficial piety that marked the reign of Napoleon III in France. His paintings of the life of St. Bridget, exhibited in the Salon of 1861, brought him a commission to decorate the oratory dedicated to the same female saint in Rome two years later.

The Kiss of the Mother of Moses exhibited in the Salon of 1866 seems to serve as a bridge between Brandon's Christian themes and his Jewish ones. It demonstrates his ability to bring a fresh approach to routine subjects from the Hebrew Bible, a likely indication of his awareness of the English Pre-Raphaelite's rejection of these hackneyed subjects.

In addition to his regular entries in the Salons, Brandon also participated in the historic 1874 exhibition held in the studio of the photographer Nadar. This is now remembered as the first Impressionist exhibition. Because his works of the late 1860s and 1870s display none of the lightness of tonality that shares stylistic and ideological affinities with the Impressionists, he did not show in their later exhibitions. The late

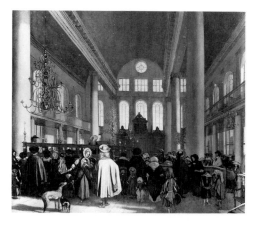

Fig. 53. Emanuel de Witte, *Interior of the Portuguese Synagogue in Amsterdam,* 1680, oil on canvas. Amsterdam, Rijksmuseum.

work discussed here, however, demonstrates a clarity and a concern for the effects of light that betray an ultimate influence of Impressionism on Brandon.

Silent Prayer was composed in the artist's studio at Rouen from numerous studies made on site. One of these studies is in The Jewish Museum collection and clearly shows a difference in vantage point from the finished work. As writing or drawing in any form are prohibited under Jewish law on Sabbath or holidays — the very moments so many of his works record — it is unlikely that Brandon made studies from direct observation at these times.

The Portuguese Synagogue of Amsterdam is one of the earliest, most impressive, and beautifully appointed synagogues in Europe. It was constructed between 1671 and 1675 and still remains one of Amsterdam's landmarks. The new structure met with both praise and criticism from Amsterdam's extensive Dutch Reformed community. Brandon was certainly not the only artist to record his impression of this noteworthy interior. The best-known artistic representation of the synagogue, found in Emanuel de Witte's famous 17th-century depiction (see fig. 53), is now a treasure of the Rijksmuseum, Amsterdam. The synagogue's stately exterior and interior also prompted numerous popular 17th- and 18th-century prints.

NLK

Reference:
W. Johnston, *Nineteenth-Century Paintings in the Walters Art Gallery,* Baltimore, 1982, p. 131.

James Jacques Joseph Tissot (French, 1836–1902)
Joseph Dwelleth in Egypt, ca. 1896–1902
Abram's Counsel to Sarai, ca. 1896–1902
Gouache on board, 9 1/16 x 10⅞ in. (23.2 x 27.7 cm);
5 15/16 x 8⅛ in. (15.2 x 20.7 cm)
Gift of the heirs of Jacob Schiff, 1952–141 and 1952–88

Few reputations have benefited as much from the recent appreciation of the wide-range of 19th-century art as James Tissot's. While most of the reawakened respect for his works focuses on his depictions of fashionable society of Paris and London, he also produced numerous religious themes. Indeed he devoted most of the final two decades of his career to illustrating the Bible.

Tissot's idea for illustrating the life of Jesus prompted his travels to Palestine and the Near East in 1886. His purpose was to observe the landscape where biblical narrative originated, to research archaeological sites, and to study ethnological details—all assumed unchanged for nearly two millennia. His goal, a historically accurate visual recreation of biblical passages, resulted in nearly 400 drawings. These met with enormous public success and were subsequently published.

Tissot also made a trip to Palestine in 1896 to gather material for another series of drawings illustrating the Hebrew Bible. This project occupied much of the artist's time until his death in 1902. About half the works in this series were in fact left to the execution of several other artists. The Hebrew Bible suite, published in 1904, toured the United States for some years. Curiously, Tissot's biblical paintings were the very works that turn-of-the-century audiences most associated with his name.

Tissot's attempt at historical veracity can easily be faulted by contemporary standards. Nevertheless, the rich, romantic, and accessible images he left provided sources for the biblical visions of 20th-century film-makers from D. W. Griffith to Steven Spielberg.

In the "imaginative" truth of his reconstructions, the artist fell prey to pitfalls not only of biased, inaccurate research, but also of personal penchants evident in his earlier works. For example, he used the headdress of a recently excavated Greek bust as a model for the coiffures of his biblical heroines. This prop served both his predilection for archaeological sources and his love of complex, well-designed costume so apparent in his society painting. Tissot's observation of the brightly colored camelback traveling compartment, erroneously considered an ethnographic prototype, provided him with as much local color as the banners on his earlier masterpiece, *The Ball on Shipboard* (see fig. 54). The artist's totally undocumented pastiches are evident in *Joseph Dwelleth in Egypt.* Here motifs found on Egyptian jewelry have become imaginary stan-

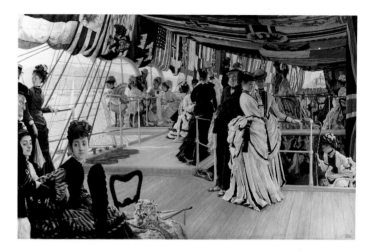

Fig. 54. James Jacques Joseph Tissot, *The Ball on Shipboard,* ca. 1874, oil on canvas. London, The Tate Gallery.

dards, transforming history into pageantry. Finally, Tissot had no compunction about rendering Joseph with the same youthful face throughout the series of works that record his long life span.

Tissot's former companion, Kathleen Newton, whose premature death helped turn the society artist into biblical chronicler, served frequently as the inspiration for his matriarchs and heroines. Tissot not only recalls her oval face and fine features in *Abram's Counsel,* but also adapts the intimacy of his depictions of their life together in London to the narration of the relationship between Sarai and Abram in the desert.
NLK

Reference:
The Jewish Museum, New York, *J. James Tissot: Biblical Paintings,* exh. cat., essay by Gert Schiff, 1982, pp. 19–50.

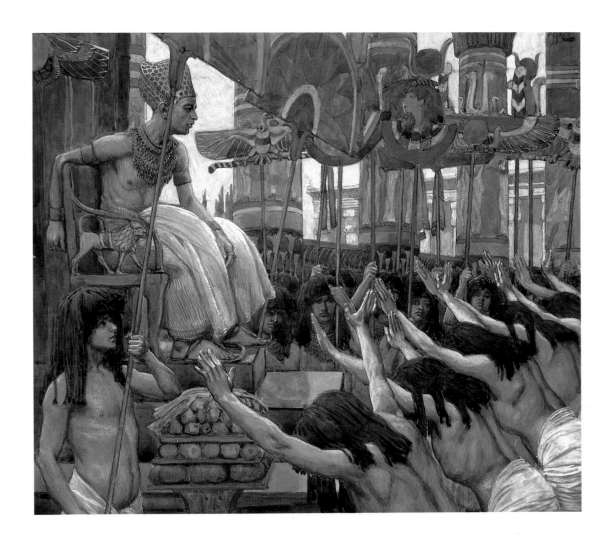

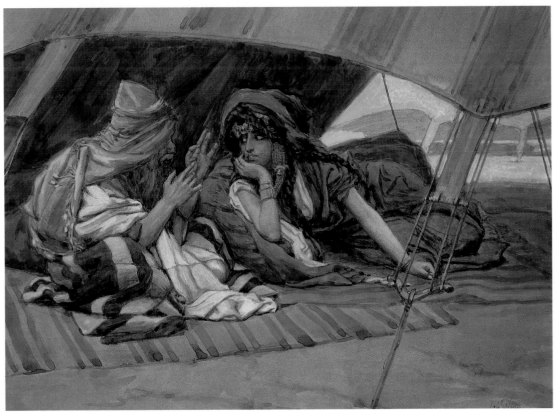

Samuel Hirszenberg (Polish, 1865–1908)
The Black Banner (Czarny Sztandar), 1905
Oil on canvas, 30 x 81 in. (76.2 x 205.7 cm.)
Gift of the Estate of Rose Mintz, JM 63-67

The influence of social and political events on much of the art produced in the 19th century has been a topic for considerable exploration in recent years. The French painters such as Courbet, Millet, and Daumier have become paradigms of the socially motivated artist whose images provide visual chronicles of the grim realities of peasants and the urban poor. Following this thematic path, Samuel Hirszenberg ranks as one of the first artists to expose the sad plight of his fellow Jews in Russian-dominated Poland at the turn of the century, showing such political statements as *Le Juif Errant* in the 1900 Paris exposition, *En exil (Juifs)* at the Paris Salon of 1905, and this work in the Salon of 1906.

The Black Banner, one of Hirszenberg's many politicized statements, depicts masses of black-clad Hasidic men carrying a coffin. An open book strapped to the casket acts as the sole white relief on an exceptionally dark field. The stares of horror, shock, and fear far exceed those of mourning for the passing of any single soul. Two terrified faces staring out at us — the one on the left probably the artist's self-portrait — recall the unforgettable expressionist depictions of Hirszenberg's contemporary, Edvard Munch.

The anguished expression of Hirszenberg's multitudes and the painting's stirring motion echo historical events. The early years of the 20th century witnessed the intensified devastation of East European Jews through numerous pogroms that had begun in 1881–82. The Kishinev and Homel pogroms of 1903, for example, and the notorious Zhitomir massacre in 1905, led to the deaths of thousands of Jews.

The year of *The Black Banner* coincides with the founding of the "Union of the Russian People"— a right-wing, rabidly anti-Semitic political movement. It was the armed gangs of the Union, called "The Black Hundreds," that carried out the pogroms. Their official newspaper was called *The Russian Banner,* and the Czar's financial support was dubbed "black money." Hirszenberg's title thus makes a blatantly cynical play on the nicknames of the Union's crews and their propagandistic vehicles, and suggests that the coffin bears the body of one of their victims.

Of the several contemporaneous paintings that may have inspired *The Black Banner* is Giuseppe Pellizza da Volpedo's *The Fourth Estate* (1898–1901), a work which Hirszenberg may have seen or heard about during his stay in Italy in the late 1890s (see fig. 55). *The Fourth Estate* reflects Pellizza's socialist leanings and his observation of the desperate conditions of

Fig. 55. Giuseppe Pellizza da Volpedo, *The Fourth Estate,* 1898–1901, oil on canvas. Milan, Civica Galleria d'Arte Moderna.

workers in his native town in Piedmont. It compares in both theme and format to Hirszenberg's *Black Banner.* But unlike Pellizza's determined armies of workers, Hirszenberg's masses, in both their placement on the canvas and their emotional expressions, leave little room for hope in the future.

The most obvious source of inspiration for Hirszenberg is a French painting that, by 1905, had already become a classic. The resemblance of *The Black Banner's* composition, subject, and tonality to Courbet's *Burial at Ornans* of 1849 readily suggests the strong influence of the French masterpiece on this Polish artist. Yet Hirszenberg replaces the stasis and silence of Ornan's stolid citizens with the animation and clamor of the Jewish wanderers.
NLK

Reference:
Städtische Kunsthalle, Düsseldorf, *Bilder Sind Nicht Verboten,* exh. cat., no. 58, 1982, entry by N. Kleeblatt.

Isidor Kaufmann (Austrian, 1853–1921)
Friday Evening, ca. 1920
Oil on canvas, 28½ x 35½ in. (72.4 x 90.2 cm)
Gift of Mr. and Mrs. M. R. Schweitzer, JM 4-63

Artists as stylistically and geographically diverse as Paul Gauguin in France, Fritz von Uhde in Germany, and Isidor Kaufmann in Austria often sought escape from the density, commercialism, and moral decay of the great urban centers of the late 19th century. Their search for simplicity and traditionalism led them to the folk society of the nearby countryside. Although formal religious practice was of diminished importance for some of these artists, their respect for the apparent peace and beauty of these more pious lifestyles drew each to observe his coreligionists: Gauguin was attracted to the Catholicism of the Breton peasants, Fritz von Uhde to the fundamentalist Protestantism in various parts of Germany, and Kaufmann to the Hasidic Judaism in neighboring Galicia, Hungary, and Poland.

Friday Evening depicts a lone woman seated beside a table prepared for the inauguration of the Sabbath. The two lit candles flickering on the heavily starched table linen indicate that she has already invoked the blessing which begins the Sabbath. Her attire, including a folk headdress and embroidered bib, shows her conformity with orthodox traditions concerning modest dress, but also labels her as *retardataire*. The presence of candlelit sconces and chandelier in the era of electricity further confirm the old-fashioned lifestyle. The comfortably furnished room signals a middle-class home in a village. One assumes that the sitter awaits the return of her husband from synagogue.

Kaufmann has left *Friday Evening* unfinished. This fact, coupled with the artist's substitution of canvas for his usual mahogany panels, suggests that the work was painted late in his career. Large passages of washlike application of paint in the unfinished areas, so pleasing to the contemporary eye, and the areas of evident underdrawing provide the viewer with a privileged glimpse of the working methods of an artist renowned for his highly finished surfaces.

The isolation of the sitter in *Friday Evening* is typical of Kaufmann's treatment of the religiously devout (see also fig. 56). These individuals at first seem rapt in their ritual observance. Yet their eyes are diverted from their spiritual mission and from the viewer. They are lost in a reverie evoking the subjects of the late 19th-century Northern Symbolist painters, who turned away from the material world of Impressionism toward the inner world of mysterious, often unresolved, emotions.

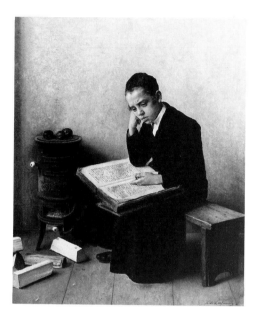

Fig. 56. Isidor Kaufmann, *Yeshivah Boy at Study,* ca. 1900, oil on panel. Santiago, Chile, Asea and Jacobo Furman Collection.

Kaufmann's meticulous depictions of religious study and ritual are not religious paintings per se. The works became popular with the increasingly assimilated and cosmopolitan Jewish bourgeoisie of *fin de siècle* Vienna. For Kaufmann's patrons, these paintings served a curious two-fold purpose. On the one hand, they linked past and present, providing a representational connection with the Jewish ancestral heritage of the artist's clientele; on the other, they functioned as one of the status-laden trappings of the clients' properly furnished parlors.
NLK

References:
K. Schwarz, *Jewish Artists of the 19th and 20th Centuries,* 2d ed., Freeport, New York, 1970, p. 42; Yeshiva University Museum, New York, *Families and Feasts: Paintings by Moritz Daniel Oppenheim and Isidor Kaufmann,* exh. cat., 1977; B. Grimschitz, *Austrian Painting from Biedermeier to Modern Times,* Vienna, 1963, p. 9.

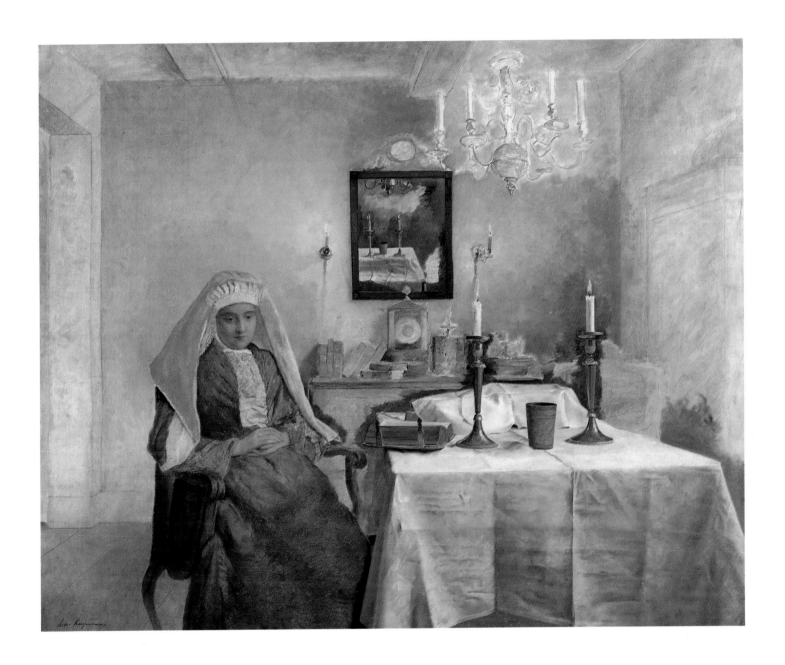

Boris Schatz (Russian, 1866–1932)
Self-Portrait, ca. 1930
Oil and resin on panel, in an repoussé brass frame
30½ x 27 in. (77.5 x 68.6 cm)
Gift of Dr. Harry G. Friedman, F4357

Son of a Lithuanian Hebrew teacher, Boris Schatz abandoned his traditional Jewish studies to devote himself to art. At an early age he met the noted Russian romantic sculptor Antokolski, a coreligionist who encouraged the youth to study in Paris. By Schatz's twenty-second birthday, he was ensconced in the capital of the art world, where he trained along conservative, academic lines. He quickly found acceptance in the official Paris art circles, and his Salon entries ultimately brought him acclaim. In 1896, he was summoned to Sofia, Bulgaria, as court sculptor to Prince Ferdinand. There he also founded Bulgaria's first arts and crafts school.

Schatz left Bulgaria in 1906 to establish the Bezalel School of Arts and Crafts in Jerusalem, his most renowned accomplishment. An early and ardent follower of Zionism, he had his own ideas about an artistic style suitable for a new Jewish nation. Through periods of prosperity and adversity, he ran the school for over twenty years, offering courses in thirty-five different types of materials and techniques. Schatz sought to provide training and jobs for the generally impoverished native Jews and for the newer immigrants from Eastern Europe. The distinctive style he evolved—an eclectic synthesis of Oriental symbols in the classically based European manner—was his attempt to embody Zionism's ideological goals.

This self-portrait and its handmade frame, although created in America during a fund-raising campaign, documents the interrelationship of art and craft in the Bezalel School approach. Schatz himself—in a flattering likeness that makes him look a decade younger than his years—sits surrounded by the products of the school. The work is rendered in dark earth tones, in a weak resinous medium, on a reappropriated wood panel—a frugality no doubt learned in Palestine, where natural and manufactured resources were scarce. The finely wrought repoussé frame bears Schatz's monogram in Hebrew and an inscription from the Song of Songs. The latter was then loosely translated: "I am for my *people* and my *people* are for me," instead of the currently accepted *beloved,* as an appropriate plea for his cause.

Schatz's artistic philosophy can be viewed as an offshoot of the numerous arts and crafts movements in late 19th-century England, Germany, and Central Europe. In reaction to the shoddy design and machine-made excesses of the Industrial Revolution, these movements stressed high-quality design and hand workmanship that reflected each nation's stylistic heritage. Palestine, however, had neither a mechanized society to react against nor an inherent style from which to adapt. Schatz's attempt at the creation of a "Jewish" style thus conforms with the nationalistic goals of other arts and crafts movements.
NLK

Reference:
The Israel Museum, Jerusalem, *Bezalel of Schatz, 1906–29,* exh. cat. by N. Shiloh-Kohen, 1982.

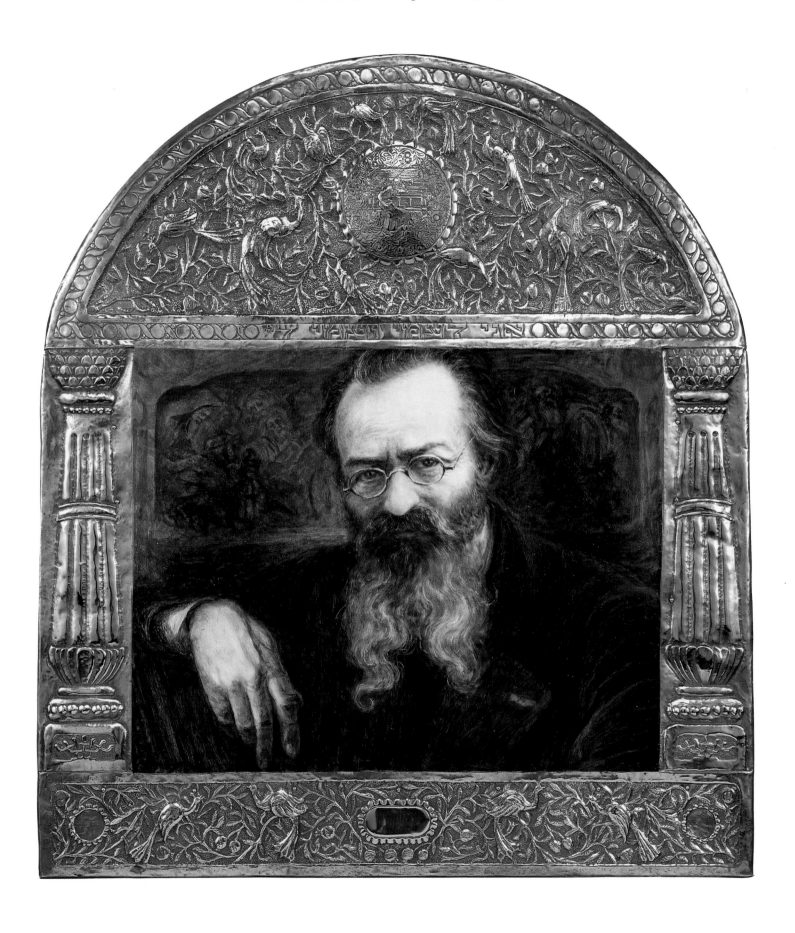

El Lissitzky (Russian, 1890–1941)
Illustration from *Had Gadya* Suite *(Tale of a Goat),* 1919
Colored lithograph on paper, 10¾ x 10 in. (27.3 x 25.4 cm)
Promised gift of Leonard and Phyllis Greenberg, L1985-4

The *Had Gadya,* a charming ten-verse Aramaic ditty based on a German ballad, is chanted at the conclusion of the Passover *seder* service. This song has been variously interpreted both textually and visually. Its verses describe a young goat, recently purchased by a father (made personal to each individual chanter by the pronoun "my" father). The goat is consumed by a dog, and the song continues to recount a succession of assailants until God destroys the final perpetrator, ending the vicious cycle. Generally considered an allegory for the oppression and persecution of the Jewish people, the various villains have been likened to aggressor nations in Jewish history. Yet God's triumph leaves hope for the survival of the Jewish community. The poem has been frequently illustrated as part of the *haggadah* — the text for the *seder* ritual — a work that in itself was an illustrator's favorite because of its popular appeal.

El Lissitzky's folio of printed illustrations, based on his 1917 watercolors of the same subject, is unusual for its lack of association with the text of a *haggadah.* The *Had Gadya* derives mainly from the artist's involvement with pictures for Yiddish children's books executed between 1917 and 1919. El Lissitsky uses an architectural framework incorporating imaginatively designed, folk-based Hebrew typography as a border for each narrative sequence. The effect is a step in the development of a more abstract style. This culminates in El Lissitzky's remarkable artistic invention, which he referred to by the acronym *Proun* ("for the new art"). These later drawings, paintings, and geometric constructions became totally non-objective, relinquishing specific Jewish subject matter in a successful merger of art and architecture.

Sources for El Lissitzky's illustrations can be found in Jewish popular prints, Hebrew illuminated manuscripts, and the figurative style of Russia's famous painted wooden synagogues. His art also reflects his fascination with typography, Chagall's romantic expressionism, and suprematist avant-garde art. This combination of sources is a logical outgrowth of El Lissitzky's education and his maturing interests during the second decade of this century.

Denied admission to a Russian art school, El Lissitzky studied architcture in Darmstadt, Germany, where he is known to have become acquainted with that city's great Jewish masterpiece, the 15th-century *Darmstadt Haggadah.* He also made frequent trips to study the architecture of the Worms Synagogue, then the oldest in Europe. When he returned to Russia in 1914, he soon became involved with the Jewish Ethnographic Society, which financed his expeditions to explore the Jewish art and architecture along the Dneiper River. There he was particularly moved by the fascinating architecture of the wooden synagogues and their imaginative and lushly painted interiors.

Although he exhibited his works in 1916 along with the first suprematist works of the noted Russian constructivist Malevich, El Lissitzky continued for the next several years to illustrate children's books using as inspiration the folk motifs he had previously gathered. In 1919 Chagall, head of the Vitebsk School of Art in Russia, offered him the position of Professor of Architecture there. Chagall's resignation later that year brought El Lissitzky into closer contact with suprematism through Chagall's successor, Malevich, the inventor of that movement.

The creation of the *Had Gadya* illustrations coincides with the year of the Bolshevik victory and prompted the popular notion that El Lissitzky saw the allegorical tale of survival and the triumph of good over evil as an analogue to the success of the Russian Revolution. If intentional, this is again testament to the universality of the song's meaning and its numerous possibilities for interpretation.

NLK

References:
C. Abramsky, "El Lissitzky as Jewish illustrator and typographer," *Studio International,* 172, No. 882 (October, 1966), pp. 182–85; A. Kampf, "In Quest of the Jewish Style in the Era of the Russian Revolution," *Journal of Jewish Art,* 5 (1978), pp. 48–75.

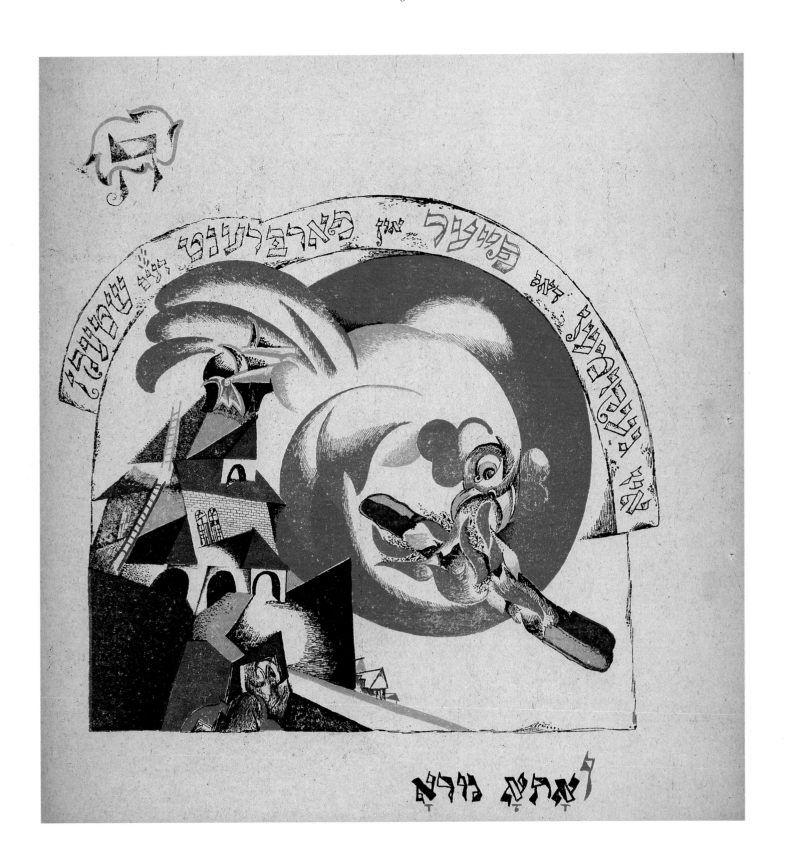

Marc Chagall (French, b. Russia, 1887–1985)
Father's Grave, 1922
Etching, 4½ x 5¾ in. (11.4 x 14.6 cm)
JM 198-67a

Marc Chagall's visions of a folkloric life in the Jewish quarter of Vitebsk have become icons to both Jews and Christians. His ethereal impressions of rabbis and soldiers, lovers and acrobats, donkeys and fish — along with his Hebrew Bible heroes and the special Jewish twist he gives to Christian subjects — encompass the range of the human condition through a highly personal symbolism. The artist's life, nearly as well known as his art, reads like a carefully choreographed, if slightly bittersweet, success story.

The graphic works of Chagall, and particularly his book illustrations, hold a significant place within this oeuvre. Commissioned by such eminent dealers as Ambrose Vollard in Paris and Paul Cassirer in Berlin, these illustrated texts include LaFontaine's *Fables,* Gogol's *Dead Souls,* the Bible, and the artist's autobiography, *Mein Leben.* In the complex evolution of 20th-century book illustration, which runs the gamut from naturalism to nonobjectivity, Chagall's production has been praised for its sensitive realization of both the author's text and emotional intent.

Chagall studied etching in Berlin with the well-known print maker Hermann Struck, an Orthodox Jew, Zionist, and author of *The Art of Etching.* Under his guidance, Chagall quickly absorbed the rudiments of the new technique. Although executed within a few weeks, this series of etchings serves to demonstrate the range of his style.

The illustration shown here is from Chagall's first attempts at printmaking. It was executed during his stay in the German capital from 1922–23, a period during which the artist devoted more energy to graphics than to painting. Intended to illustrate the memoirs he had written previously, the series was ultimately published by Paul Cassirer as the portfolio *Mein Leben,* (1923). As Chagall's Russian writing style had proved too difficult to translate readily, the written autobiography was published sometime later.

Other plates from the portfolio in The Jewish Museum's collection such as *Beside My Mother's Tombstone, The Rabbi,* and *The Talmud Teacher* come directly from the artist's charming, if quirky, text. The supplementary plate, *The Rabbi* (fig. 57) is a reworking on copper of his 1914 oil *Feast Day (Rabbi with Etrog).* The reversal of the composition indicates his close reliance on the 1914 work. The holiday is obviously Sukkot, the fall harvest festival, in which blessings are recited over the symbolic citron and branches of palm, myrtle, and willow. The peculiar small figure standing on top of the rabbi's head

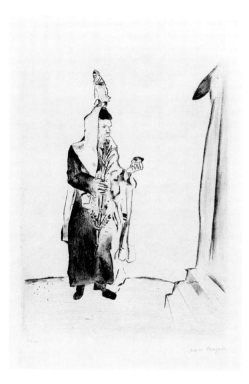

Fig. 57. Marc Chagall, *The Rabbi,* 1922, etching. New York, The Jewish Museum, JM 172-67.

poses questions for interpretation. Art historians have noted sources in Christian art for Chagall's handling of this image. For example, there is a similarity between the rabbi's prayer shawl and the drapery of the Madonna's cloth of honor in early Renaissance paintings; between the citron and palm branch and the traditional attributes of Christian saints. The personal nature of Chagall's vision, his curious use of Christian art-historical sources, and his possibile visual play on Yiddish phrases for this print (and others) add further interpretive confusion. Such ambiguities, precisely what the artist desired, are expressed by his own ideas about not limiting the meaning of his works.

NLK

Reference:
Royal Academy of Arts, London, *Chagall,* exh. cat. by S. Compton, 1985; F. Meyer, *Marc Chagall,* New York, 1957, pp. 315–320.

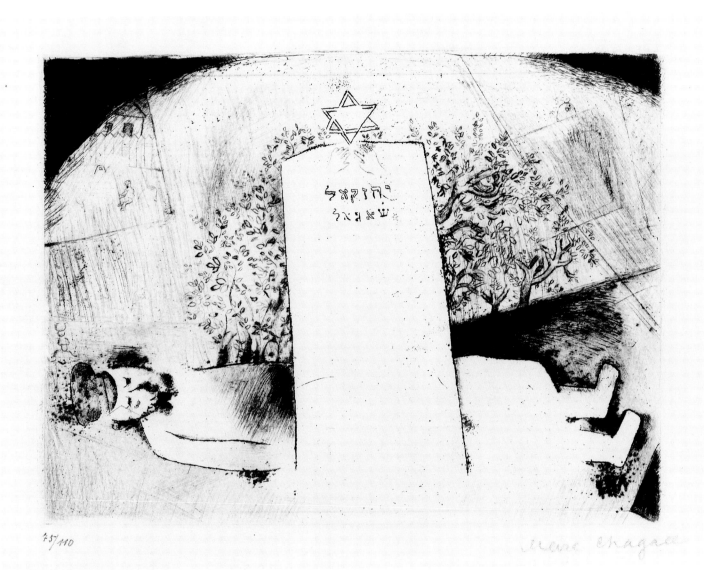

75/110 Marc Chagall

Wall Hanging
Offenbach, Germany, 1925
Berthold Wolpe (British, b. Germany, 1905)
Workshop of Rudolf Koch (German, 1876–1934)
Undyed hand-woven linen; embroidered with dyed linen
106⅜ x 57 in. (271 x 145 cm)
Gift of Milton Rubin, JM 33–48

The elegant simplicity of this embroidered hanging was a product of the sophisticated partnership of an imaginative student, a knowledgeable master craftsman, and an enlightened patron: Berthold Wolpe, Rudolph Koch, and Siegfried Guggenheim, respectively. Its aesthetic appeal depends on the expressive design of its Hebrew letters that inscribe the text of the grace after meals and the superb craftsmanship of the handweaving and embroidery.

Rudolph Koch became primarily known as a fine book designer and creator of new typefaces. His fascination with letters, words, and his profound admiration of the Bible led him to design many Christian texts. Simultaneously, his long-time interest in medieval embroidery encouraged him to study handweaving, spinning, and dyeing. It was through these media that Koch's obsession with decorative lettering would reach a new level of sophistication. By 1924 he had set up a textile workshop but had not yet received any commissions. A commission from his long-time friend Siegfried Guggenheim resulted in five religious textiles for the Guggenheim home.

For this work, Koch drew on the skills of his twenty-year-old student and Guggenheim's coreligionist Berthold Wolpe to create a design based on Hebrew letters. Wolpe clearly was influenced in his modernization of Hebrew letters by his master's ideas about the stylization and simplification of Renaissance Latin typefaces. He also incorporated Koch's theory about the word as an almost self-sufficient means of decoration. The simplicity of this textile design and its reliance on traditional techniques also relate to the contemporaneous development of textile workshops of the early Bauhaus. Wolpe, who immigrated to England in 1935, is now famed for the excellence of his own typefaces and the more than 1,500 books and jackets designed for the firm of Faber & Faber. Like his former teacher, his respect for the past has led to creative adaptations of traditional techniques and designs. Wolpe acknowledges the influence of Koch, whose style had its origins in the Jugendstil, the German version of art nouveau, and in the numerous arts and crafts movements that spread across Germany in the late 19th and early 20th centuries.

The symbiotic relationship of this creative trio led to further developments. It was Guggenheim's Jewish textile commissions that again encouraged Koch to produce a series of seven large tapestries based on both the Hebrew and Christian Bibles. These were intended as church decorations. At the same time, Wolpe produced another Jewish ceremonial work in a different medium for the Guggenheim dining room. Wolpe's copper ewer and basin of 1926 carry the Hebrew benediction for the ritual washing of hands before meals. Guggenheim could thus begin and end his meals using finely wrought contemporary works in the observance of traditional Jewish practice.

The triumvirate's efforts culminated with the Offenbach Passover *Haggadah* of 1927, published and edited by Guggenheim himself. The book used one of Koch's innovative Latin type designs for the German translation opposite Wolpe's Hebrew lettering of the original text. Woodcut illustrations by another member of the workshop further enriched the *Haggadah*. Koch noted in a publication that, for him, this collective effort gave the work its fundamental value.
NLK

References:
S. Guggenheim, *Rudolf Koch: His Work and the Offenbach Workshop,* Woodstock, Vermont, 1947; Victoria and Albert Museum and Faber & Faber, London, *Berthold Wolpe: A Retrospective Survey,* exh. cat., 1980.

ברוך אתה יי אלהינו מלך העולם הזן
את העולם כלו בטוב בחן בחסד
וברחמים הוא נתן לחם לכל בשר כי
לעולם חסדו ובטובו הגדול תמיד לא
חסר לנו ואל יחסר לנו מזון לעולם ועד
בעבור שמו הגדול כי הוא זן ומפרנס
לכל ומטיב לכל ומכין מזון לכל בריותיו
אשר ברא. כרזר אתה ייי הזן את הכל ◆
ונא אל תצריכנו ייי אלהינו לידי
מתנת בשר ודם ולא לידי. הלואתם כי
אם לידך המלאה הפתוחה הקדושה
והרחבה שלא נבוש ולא נכלם לעולם
ועד ◆ הרחמן הוא ימלוך עלינו לעולם
ועד: הרחמן הוא יתברך בשמים
יבארץ ◆ הרחמן הוא יפרנסנו בכבוד
◆ עשה. שלום במרומיו הוא יעשה
שלום עלינו ועל כל ישראל ואמרו אמן

Passover Set (Epergne)
Frankfurt, 1930
Ludwig Wolpert (1900–1981)
Silver, ebony, and glass
10 in. high x 16 in. diam. (25.4 x 40.6 cm)
Promised gift of Sylvia Zenia Wiener

The aesthetic principles advocated by the Bauhaus in the 1920s—that form and function were mutually dependent, that fine design should be aimed at mass production, that ornament should be banned—have pervaded international artistic thought for much of this century. At first considered radical by many, today's continued production of numerous Bauhaus designs testifies to their viable aesthetic and practical values.

Ludwig Wolpert is the first metalworker to apply these progressive principles to the fabrication of Jewish ceremonial art. His Passover *seder* epergne of 1930 may in fact be his masterpiece. Its conception and execution aptly express the ideas generated by the Bauhaus School during its years first at Weimar and then in Dessau. Wolpert certainly gleaned some of these concepts from his Bauhaus-trained teacher, while other Bauhaus dictates were relayed to him through publications and professional colleagues.

The form of this set is based on earlier, lavishly decorated Passover epergnes (see p. 122); however, following Bauhaus precepts, Wolpert combined the visual effect of the epergne with its essential functions. Three circular tiers above a conforming silver base are joined at equidistant points by vertical ebony and silver mounts. Notched to support the glass shelves, the mounts double as handles. Horizontal silver bands that separate each tier slide open to reveal a space, within which *matzah* can be placed. The cut-out Hebrew inscription:

כום ישועות אשא ובשם ה' אקרא

(I will lift the cup of salvation, and call upon the name of the Lord.)

appears on the glass-lined silver goblet. This receptacle holds the wine symbolically set aside for the Prophet Elijah, while glass dishes in silver bases are meant to contain ritual foods.

The design of the epergne, aside from the cut-out inscription, is founded entirely on the appeal of its contrasting materials. Wolpert's inspiration for his combination of wood, glass, and metal may have come from Josef Albers's berry dishes and tea cups of 1923–25 (see fig. 58). Yet Wolpert applies these ideas to an infinitely more complicated object with a rationality and a thorough understanding of the relationship of weighted objects in three-dimensional space. This latter conception conforms with the thinking of Moholy-Nagy, an im-

Fig. 58. Josef Albers, *Tea Glass and Saucer,* 1925, heat-resistant glass, porcelain, steel, and ebony, 2 in. New York, Collection of The Museum of Modern Art, Gift of Josef Albers.

portant teacher at the Bauhaus, who strove to derive uncompromising new forms that could also be mass produced. Although the construction of this *seder* plate was too complicated for large-scale production, it was carefully replicated several times.

A substantial part of Wolpert's later work, including Hanukkah lamps, memorial lights, and *kiddush* goblets, was indeed designed for mass production. Ultimately, the artist successfully adapted Bauhaus philosophy to the production of well-designed ritual domestic wares still available today. NLK

Reference:
The Jewish Museum, New York, *Ludwig Wolpert, A Retrospective,* exh. cat., 1976.

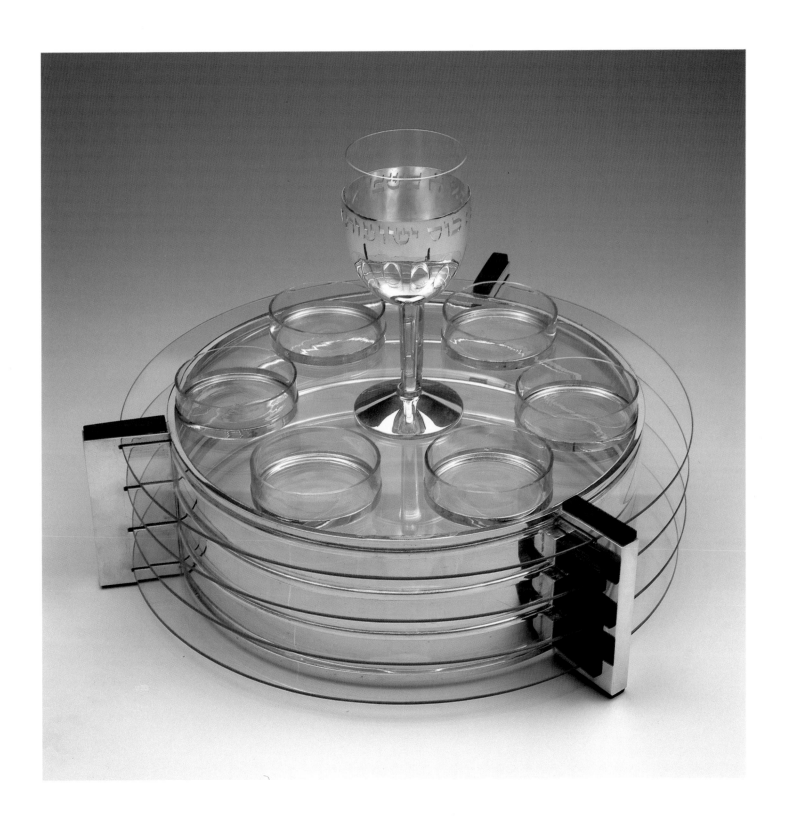

Chaim Soutine (Lithuanian, 1894-1943)
Pot of Flowers, ca. 1930
Oil on canvas, 25⅝ x 21⅜ in. (65.1 x 54.3 cm)
Gift of Mr. and Mrs. Daniel Goldberg, JM 94-52

Fig. 59. X-ray photograph of *Pot of Flowers.*

From the early years of this century through World War II, a significant number of Jews settled in Paris to study and practice painting and sculpture. Many of these individuals became highly successful, and the group as a whole had a re-markable visibility among the French people. As Romy Golan recently observed, the French tried to dissociate these foreigners from their own artistic tradition. In so doing, writers and critics formulated theories about a Jewish style, which was frequently characterized as degenerate. Others regarded these artists in a more positive light, seeking to find in their work a laudatory reflection of Jewish creativity. In fact, neither the implicit racism of the first group nor the romantic chauvinism of the second has much foundation in the works themselves.

In Soutine's case, his work has until quite recently been associated with Hebrew spiritualism and the emotionalism emanating from "typical shtetl environments." Although this myth is easily refuted — as demonstrated by the critic Harold Rosenberg — the reasons for its creation are fascinating to the history of art criticism and 20th-century Jewish history. Soutine's paintings neither depict Jewish subject matter nor are titled with any reference to the religion of his birth.

Soutine was born to a poor family in Smilovitchi, Lithu-ania. He studied painting in Minsk and Vilna before leaving for Paris in 1913. There, while enrolled at the Ecole des Beaux-Arts, he lived for several years in dire poverty. In 1916 he moved to the noted artist's colony "La Ruche" in Montpar-nasse, where he met Lipchitz, Modigliani, and the dealer Zborowski, the latter giving Soutine his first show in 1919.

Soutine soon became associated in the popular con-sciousness with Modigliani, Pascin, and Utrillo, a group com-monly known as *"les peintres maudits"* (the ill-fated painters). They were perceived as a quartet of stylistically diverse artists — all but one Jewish — because of the similarity of their high-strung temperaments and indigent lifestyles.

Soutine's fortunes changed quickly after 1923, when his works were acquired by the noted Philadelphia collector Albert Barnes. Although the artist had become celebrated at a relatively early age, he continued to live in shabby quarters, painting his now esteemed canvases of decaying meat and vegetation, which have been interpreted as allusions to mortality.

According to information given by Soutine to the artist Sacha Moldovan, *Pot of Flowers* was painted around 1930.

However, the work bears a strong resemblance to a group of Soutine's dark-ground paintings of gladioli executed around 1919. Seen via X-ray (see fig. 59), the work shows evidence of repainting over another similar pot of flowers, an apt dem-onstration of the artist's habit of reworking — sometimes actually destroying — earlier pictures that he found unsatisfac-tory. His nervous brushwork on the sanguine-colored blos-soms compares to that of his notoriously expressive and infamous images of bloody sides of beef. (These works, coin-cidentally, have been interpreted as an expression of the artist's ambiguous reaction to Jewish dietary laws.) Soutine's intuitive approach, his turbulent brushstrokes, and his ap-parent negation of the canvas can be seen to prefigure Abstract Expressionism.
NLK

References:
H. Rosenberg, "Jews in Art" from *Art and Other Serious Matters,* Chicago, 1985, p. 264 (first published in The New Yorker, 22 December 1975); The Jewish Museum, New York, *The Circle of Montparnasse, Jewish Artists in Paris, 1905–1945,* exh. cat. by K.E. Silver and R. Golan, 1985; Los Angeles County Museum of Art, *Chaim Soutine,* exh. cat. by M. Tuchman, 1968; P. Courthion, *Soutine, Peintre du Déchirant,* Lausanne, 1972.

Reuven Rubin (Israeli, b. Romania, 1893–1974)
Arab Fisherman, 1928
Oil on canvas, 29½ x 24 in. (74.9 x 61 cm)
Promised gift of Mr. and Mrs. Harold J. Ruttenberg

By 1920, many young artists in Israel reacted against the classical Western orientation of Jerusalem's Bezalel Academy. They became disenchanted with the use of Oriental motifs and local landscape in the service of biblical subjects. Instead, these painters and sculptors — who knew contemporary European artistic developments firsthand — sought to incorporate everyday visions of the Near East into a modernist artistic vocabulary. Thus, influenced by the newly adopted use of the modern Hebrew language, they defined their goals for a "Hebrew" rather than a "Jewish" art.

Reuven Rubin was one of the most important of these young pioneers. His new land served him as a constant source of inspiration. The lyricism of his *Arab Fisherman* (also known as *Goldfish Vendor*) is typical of Rubin's joyous vision of the land of Israel. The painting also exemplifies a recurrent theme in Israeli art of that decade — the portrayal of the Arab. The appeal of the physical vitality of these people becomes almost stereotypical in the literature and art of the 1920s. According to Nahum Gutman, Rubin's colleague, the Arab who main-

tained a continuing tie with the land constitutes the antithesis of the Diaspora Jew. His sense of belonging and his instinctual assets are exaggerated, even monumentalized.

Rubin's paintings of that period have been stylistically linked to the French naifs such as Henri Rousseau and André Bauchant. Also evident is the debt owed to the Jewish members of the School of Paris, particularly Modigliani whose monumental figures seem to press the boundaries of the canvas and could easily have served to trigger Rubin's powerful figure. Yet Rubin's primitivism must also be viewed in the light of other Israeli paintings of the decade; their pervasive aesthetic combined the tenets of modernism with an innocent depiction of the land creating a style appropriate for the infancy of Israel's national rebirth.
NLK

Reference:
The Jewish Museum, New York, *Artists of Israel: 1920–1980,* exh. cat., 1981, p. 118.

Max Weber (American, 1881–1961)
The Talmudists, 1934
Oil on canvas, 50 x 33¾ in. (127 x 85.7 cm)
Gift of Mrs. Nathan Miller, JM 51-48

The advent of modernism which seemed to eliminate most narrative themes from the artistic repertoire, coincided with an influx of Jews into the visual arts. As a result, the Jewish painter no longer needed to reconcile his religious background with his goals as an artist. Abstract, formal elements — composition, color, and the surface treatment — were all that seemed necessary to create pictures. Nevertheless, after a brief immersion in the new modern syntax, certain Jewish painters did adapt the vocabulary of modern painting to representations of Jewish themes. In France, Marc Chagall created his mythical images of Russian shtetl life through a synthesis with Cubist style, while the English artist Jacob Kramer fused Vorticism into pictures of cogent Jewish spirituality.

Max Weber, one of the vanguard American modernists, was one of these few artists to include religious subjects in his work, and he was considered the first American exponent of Jewish imagery. Weber's early work shows the Fauve influence of his teacher Henri Matisse and the Cubist influence of Braque and Picasso. But there is little evidence of his later inclination toward Jewish subject matter until 1918. As a response to the death of his father in that year and to moral disillusionment with American art and world values during the war, Weber's art turned inward. He pursued the spiritual over the material values he had previously espoused and concentrated on human activity over formal experimentation. Weber painted a series of heads of rabbis and scenes of Jewish ritual such as his 1919 *Sabbath* as the coalescence of his religious background with his artistic goals.

The thirties are considered by Milton Brown to be the first period in which Weber's art represents a mature integration of personal expression and style. *The Talmudists,* rendered in the dark earth-tone palette of Weber's Depression period works, has a nervous line and Mannerist composition that betrays Weber's admiration of El Greco. Weber was capable here of making a lyrical transformation of Christian aesthetics into Jewish spirituality. He appropriated the gestures of El Greco's ecstatic Christian figures and saints for the excited gesticulation of the mystical Hasidic sect. His portrayal of the scholars interacting with their sacred texts and with each other demonstrates Weber's passionate interest in the meaning of spirituality, communication, and gesture.
NLK

Reference:
The Jewish Museum, New York, *Max Weber: American Modern,* exh. cat. by Percy North, 1982; M. Brown, *American Art from the Armory Show to the Depression,* Princeton, New Jersey, 1952.

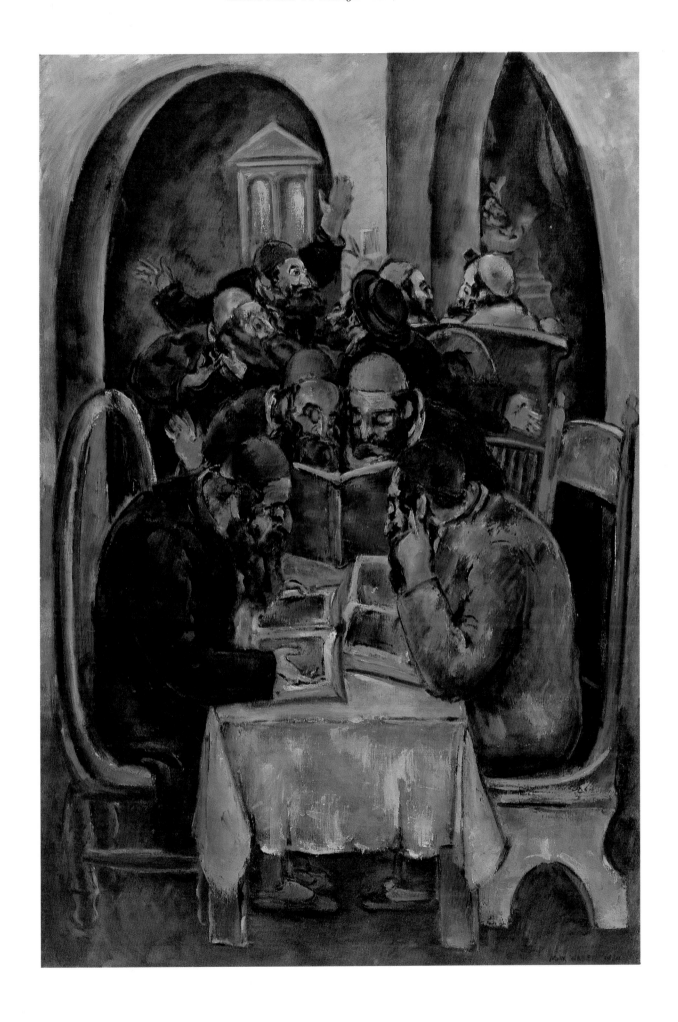

Jacques-Emile Blanche (French 1861–1942)
The Son of the Rabbi and his Daughter: Marriage at the Synagogue
(Le fils du Rabbin et sa fille: Mariage à la Synagogue), 1935
Oil on canvas, 39¾ x 31⅞ in. (101 x 81 cm)
Gift of Mr. and Mrs. Morris Joffe, by exchange, 1985–122

The Jewish subjects depicted in *Marriage at the Synagogue* as well as in *Dreamer of the Ghetto,* painted the same year, represent anomalies within the oeuvre of the Christian artist Jacques-Emile Blanche. Blanche, a wealthy society painter, traveled in the most sophisticated artistic, literary, and aristocratic circles in Paris, London, and Dieppe. His career is said to have begun in the company of Monet, Renoir, and Manet, and to have ended within the realm of the Bloomsbury set. Concentrating on portraits of these acquaintances in the bravura style of the French-based Italian Giovanni Boldini, his elite sitters included Proust, Henry James, Degas, Rodin, and Cocteau (see fig. 60).

The depiction of the seemingly unsophisticated subjects in *Marriage at the Synagogue* is thus a radical departure from Blanche's usual interests. The sobriety of the father and daughter — surprising for the joyous occasion indicated by the title — their pale faces and the menacing guard who looms in the background add to the ambiguity of the scene. Their East European dress implies that they may be foreign-born and perhaps recent immigrants to France. While the two are hardly flattered by Blanche, the study is sympathetic and shows the artist's concern for his subjects' emotional state. It is possible that Blanche intended this as a social statement arising from French reactions to Hitler's rise to power. This could explain the guard's presence and the somber state of the protagonists. Hitler's racism and totalitarian regime had indeed greatly disturbed the artist. The year of this work witnessed the expulsion of three thousand foreigners from France and the establishment of new laws enforcing strict limitations on immigration. Blanche may also have been aware of the internal dissension among French Jews, which manifested itself in the way both Christians and Jews distinguished between the privileged status of native-born *Israélites* and the foreign-born *Juifs.*

Some of Blanche's ideas about Jews could have come in part from his intimate friendship with his next-door neighbors in Dieppe, the prominent Jewish family of the writer and librettist Ludovic Halévy. These *Israélites,* though known sympathizers with the plight of foreign Jewry, were themselves totally assimilated. (Their close friendship is chronicled in Degas's beautiful pastel, *Six Amis à Dieppe,* which includes among others, Ludovic and Daniel Halévy and Blanche.) Yet Blanche's own writings reveal a duality in his reactions to Jews. On the one hand, he considered them inbred and made

Fig. 60. Jacques-Emile Blanche, *Portrait of Jean Cocteau,* 1912, oil on canvas. Copyright S.P.A.D.E.M., Paris/V.A.G.A., New York, 1986.

negative mention of what he perceived as the Jewish manipulation of the art market; on the other, he regarded the large number of Jews in the Parisian art world at the time as a vigorous and noteworthy development.
NLK

References:
Jacques-Emile Blanche, *Portraits of a Lifetime, 1870–1914,* New York, 1938, and *More Portraits of a Lifetime, 1918–1938,* London, 1939.

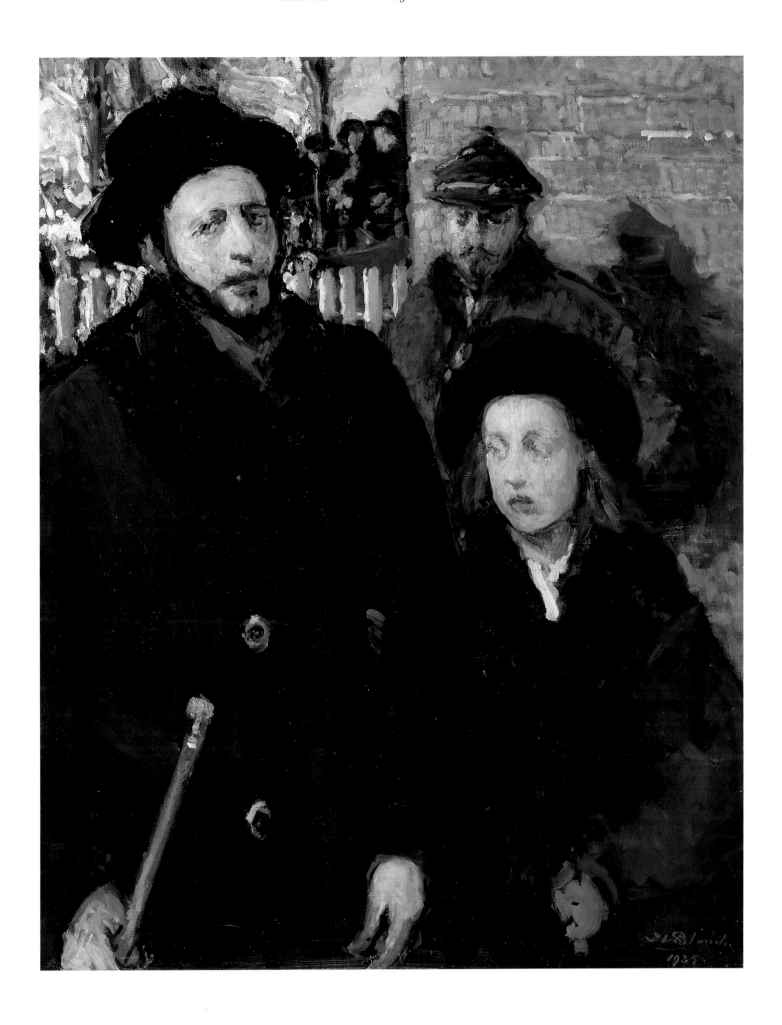

Jacques Lipchitz (American, b. Lithuania, 1891–1973)
The Sacrifice, 1949–1957
Bronze, 49½ in. high, 24¼ x 24¼ in. base
(125.7 cm high, 61.6 x 61.6 cm base)
Gift of Mr. and Mrs. Albert A. List, JM 16–65

Lithuanian-born Jacques Lipchitz arrived in Paris in 1909, and was confronted by an art world dominated by the stylistic revolution of Cubism. Three years later, he was introduced to Picasso and other Cubist painters and sculptors. His rapid absorption of the formal elements of that movement, including the influences of primitive art, led to his first successful sculptures. His own Cubist works created between 1915 and 1919 maintain a significant place in the art of that period.

For nearly a decade, Lipchitz developed new formal approaches to sculpture, including experimentation with solids and voids, and large scale works. By the mid-1930s, his once strict formalism yielded to an interest in thematic works, specifically ones concerned with the major issues of man's struggle with the world, with others, and with himself. He sought to express these thematic ideas while at the same time striving for technical innovation.

One can best appreciate *Sacrifice* (which Lipchitz considered his major work) by understanding its predecessors within his oeuvre — formally, thematically, and personally. The work takes a place in Lipchitz's ongoing focus on heroic struggle, beginning with his *Jacob Wrestling with the Angel* of the early 1930s. The transformation of the biblical theme into a mythological one in his *Prometheus and the Vulture* series of 1933–37 was a response to the oppressive threat of Nazism, a threat that ultimately forced Lipchitz to flee France and seek refuge in America.

The immediate iconographic precursor for *The Sacrifice* is Lipchitz's technically complex *The Prayer* of 1943 (see fig. 61). In this he alludes to the curious, primitive, and sometimes controversial ritual of *kapparot* — the custom of symbolically transferring personal sins onto an animal. *The Prayer* actually shows a disemboweled fowl, spewing forth both the guilty as well as the innocent victims. The latter serves as a metaphor for the suffering of the Jewish people at that time.

The *Sacrifice* of 1949–57 revives this previous theme, now in response to the success of the heroic struggle over the founding of Israel. The lamb, a symbol Lipchitz considers Christian, refers to his hopes for a peaceful coexistence between Judaism and Christianity. While the fragmented nature of *The Prayer* reflects his technical difficulty during its execution and symbolizes the profoundly hopeless moments of World War II, the artist has approached *Sacrifice* with a forceful unity of spirit and form that expresses his renewed affirmation of life.

NLK

Fig. 61. Jacques Lipchitz, *The Prayer,* 1943, bronze. Philadelphia Museum of Art. Gift of R. Sturgis and Marion B. F. Ingersoll.

Reference:
J. Lipchitz with H. H. Arnason, *My Life in Sculpture,* New York, 1972, pp. 160–163 and 178–183.

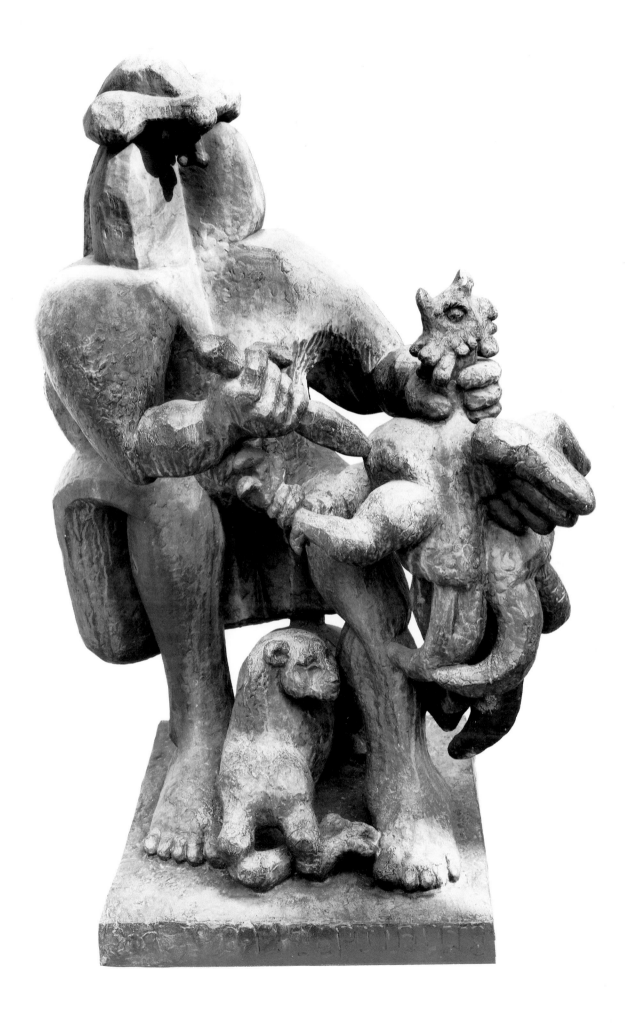

Torah Curtain
Millburn, New Jersey, 1950–1951
Adolph Gottlieb (American, 1903–1974)
Velvet: appliqué, embroidered with metallic thread,
upper section: 80½ x 112¾ in. (204.5 x 286.4 cm)
lower section: 81½ x 121¾ in. (207 x 309.2 cm)
Extended loan by Congregation Bnai Israel, Millburn, NJ

A surprising number of commissions for ecclesiastical decoration went to major European painters and sculptors in the years following World War II — a response to the mediocrity of religious furnishings in the previous hundred years. Reestablishing the long tradition of using master artists in such projects, churches and synagogues commissioned Leger, Chagall, Matisse, Rouault, and Moore, among others, to execute stained glass, vestments, liturgical objects, and other embellishments.

Adolph Gottlieb's Torah curtain is an American expression of this revival. During the postwar boom in synagogue construction, sweeping redefinition of synagogue design began. Based on a modernistic aesthetic, it rejected historical and symbolic references. Many architects considered symbols appropriate only on liturgical objects in the sanctuary. Sparse decoration was standard practice.

In a bold step, Percival Goodman, architect for the Millburn synagogue, charged three emerging, avant-garde artists with commissions to decorate that building. Adolph Gottlieb, Robert Motherwell, and Herbert Ferber, each of whom has since become recognized as a major figure in the Abstract Expressionist movement, supplied a Torah curtain, a lobby mural, and an exterior sculptural relief, respectively. Gottlieb's design for the curtain (actually executed by the women of the congregation) is a late example in the development of his pictograph paintings of 1941–53. It reflects these compartmentalized canvases, which in turn were influenced both by the grid-based works of Mondrian and by the sectional arrangement of religious narrative cycles of the early Italian Renaissance.

The forms contained within Gottlieb's compartments, and the meanings of these forms, are related to unconscious expressions associated with primitive art — cave painting and American Indian art — as well as with Carl Jung's writings about native symbols and the "collective unconscious." Gottlieb's pictograph style was therefore easily adaptable to the creation of a ritual object using symbols of Jewish collective consciousness. In this curtain, he abstracts such basic elements of religious belief as the Tablets of the Law, the Twelve Tribes, the Temple, and the Ark of the Covenant. He also includes stylizations of objects developed for synagogue use (Torah mantles and Torah shields) and emblems which have become synonymous with Judaism (the Lion of Judah and the Star of David).

Fig. 62. Adolph Gottlieb, *Letter to a Friend,* 1948, oil and tempera on canvas. Copyright, 1979, Adolph and Esther Gottlieb Foundation, Inc.

Gottlieb has been noted for his frequent use of sexual references and his predilection for visual puns. *Letter to a Friend* of 1948, in its use of male and female symbols, is an example of the former tendency (see fig. 62). In this Torah curtain he intended the W-form pictograph at the lower right corner to represent a "breastplate" (a common term for Torah shield). It seems to depict the chain by which that ornament is hung over the Torah staves. There can be little doubt that these two pendulous shapes, generally associated in Gottlieb's work with female breasts, are an intentional pun on "breastplate". However, the serpentine outline can also be perceived as the artist's usual visualization of the *male* symbol. This combination of the male and female in one image is a common reference to the life force, and in this case embodies Gottlieb's ideas of the universality and continuity of human existence. Ultimately, this avant-garde adaptation of traditional symbols becomes an expression of the viable continuum of Jewish ceremony, so significant a concept after the devastations of World War II.
NLK

References:
A. Kampf, *Contemporary Synagogue Art,* New York, 1966, pp. 75–86, 198, 242–7; The Adolph and Esther Gottlieb Foundation, New York, *Adolph Gottlieb: A Retrospective,* exh. cat. by L. Alloway and M. D. Mac Naughton, published by the Arts Publisher, 1981.

Ben Shahn (American 1898–1969)
Marriage Contract (Ketubbah), 1961
Ink, watercolor, gold paint, and pencil on paper
26½ x 20½ in. (67.3 x 52.1 cm)
Gift of the Albert A. List Family, JM 99–72

Most decorated Jewish marriage contracts use ornamental motifs as framing devices for their written Aramaic text (see p. 92 and p. 118). Ben Shahn's *Ketubbah* is a marked departure from this model. In the superb execution of this document, the artist has integrated floral and foliate decorations within his lyrical Hebrew calligraphy, the predominant design element.

While Shahn's artistic personality emerged through the religious themes in his illustrations for the 1931 *Haggadah for Passover,* he would not return to such subjects for many years. The artist spent most of the 1930s and 1940s as a social realist painter. Along with so many other painters and sculptors during those difficult years, Shahn felt that art could help right the inequities of society. His terse visual commentaries on such topical subjects as the Sacco and Vanzetti case, Nazism, poverty, and labor problems brought him great recognition as both a humanitarian and an artist. It was after World War II that he turned inward through what has been called his transition from social to personal realism. During this period he incorporated allegory and religious and philosophical symbolism in his work, often based on his own cultural heritage.

Shahn's updating of the traditional *ketubbah* results from his changing stylistic and subjective concerns. He became fascinated with letters, both Hebrew and English, which became esential elements in his work. This calligraphic preoccupation led to his 1954 illustrations for *The Alphabet of Creation,* a book which related a parable of the origin of the Hebrew alphabet. His own combination of these twenty-two letters become a personal stamp and appears on most of his prints and drawings after 1960, including this *Ketubbah.* Like the butterfly stamp of James Whistler and the Japonist monogram of Toulouse-Lautrec, this symbol shows Shahn's stylistic inspiration as coming from outside mainstream Western culture.

The expressive style of Shahn's Hebrew characters changes with the meaning of each theme he depicts. For this *Ketubbah,* which is presented at the joyous celebration of marriage, he develops a commanding but elegant Hebrew appropriate to the legal nature of the document and the solemnity of the moment—a calligraphy markedly different from the flame-like evanescences in his tribute to the Feast of Lights, Hanukkah (see fig. 63). As had been the custom of Hebrew scribes throughout the ages, Shahn adds eccentric elements to certain letters. Most notable here is the oft-repeated, stylized Star of David.

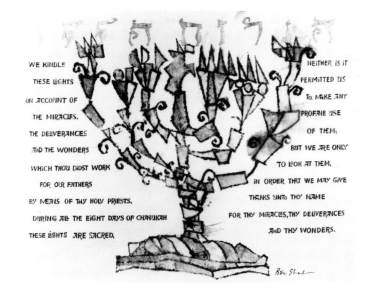

Fig. 63. Ben Shahn, *We Kindle These Lights,* 1961, gouache and gold leaf on koshi paper. New York, The Jewish Museum. Gift of Mr. and Mrs. Albert A. List Family.

Shahn's meandering floral and foliate forms refer to Psalm 128:3, a common visual allusion in Jewish marriage contracts: "Thy wife is a fruitful vine in the midst of thy house, thy children are as young olive trees set around thy table." NLK

Reference:
The Jewish Museum, New York, *Ben Shahn: A Retrospective, 1898–1969,* 1976.

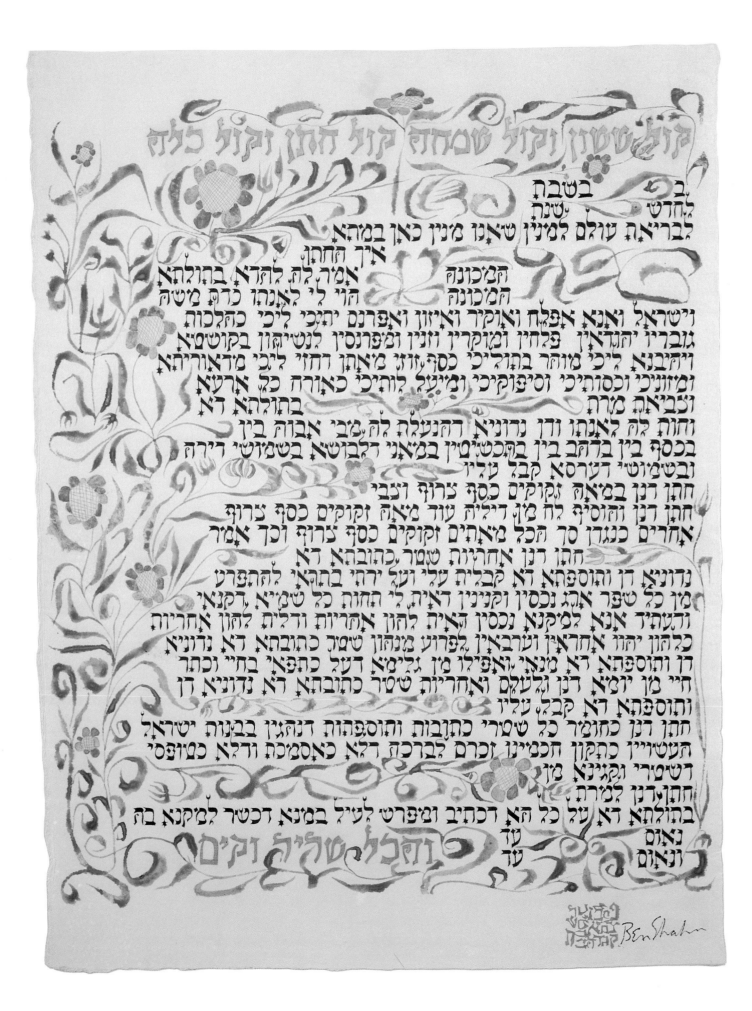

Torah Crown
New York, 1959
Moshe Zabari (1935–)
Silver: raised and forged; pearls
13½ x 15⅜ in. (34.3 x 39 cm)
Gift of the Albert A. List Family, JM 85-69

This is not a Torah crown in the usual sense, modeled on the regalia of kings and queens. The artist eschewed any association with crowns that were meant to be worn. This work is a Torah crown only in the sense that it is a unified ornament that encompasses both staves of the Torah scroll.

Nevertheless, there are references in this work to the traditional type. Like the older crowns, Zabari's work is a three-dimensional form that circumscribes space. Its three-dimensionality is underscored by pendant pearls, which establish successive points from which to measure the space occupied by the form. When the crown is carried in procession, the pearls shake and the silver curves quiver to lend the kinetic sense which was conveyed on older crowns by pendant bells.

In the purity of its forms, in its emphasis on the beauty of materials, and in its avoidance of extraneous decoration the Zabari crown conforms to the modernist aesthetic. It is also a totally modern work in its emphasis on function. Whereas on older crowns the utilitarian tubes that fit the crown to the staves of the Torah are hidden beneath an ornamental exterior (see pp. 103 and 135), on the Zabari crown they are in the open, an important element of the design. They draw attention to the staves, known in Hebrew as "trees of life," which, to the artist, are the second most important part of the Torah next to the parchment. He sees the crown as an ornament for the staves as much as an ornament for the scroll.

The exuberant curves of the Zabari crown link it to other decorative arts of the 1950s when curved, organic forms dominated. At the same time, they express the sense of celebration traditionally associated with crowns, which are used in the larger world at times of pomp and circumstance, and in many synagogues only on festivals. In recognition of the joyful character of the holidays, the crown replaced the finials used week after week, on ordinary Sabbaths.
VBM

Reference:
Encyclopedia Judaica, Yearbook for 1975–76, cols. 428-29, pl. 7.

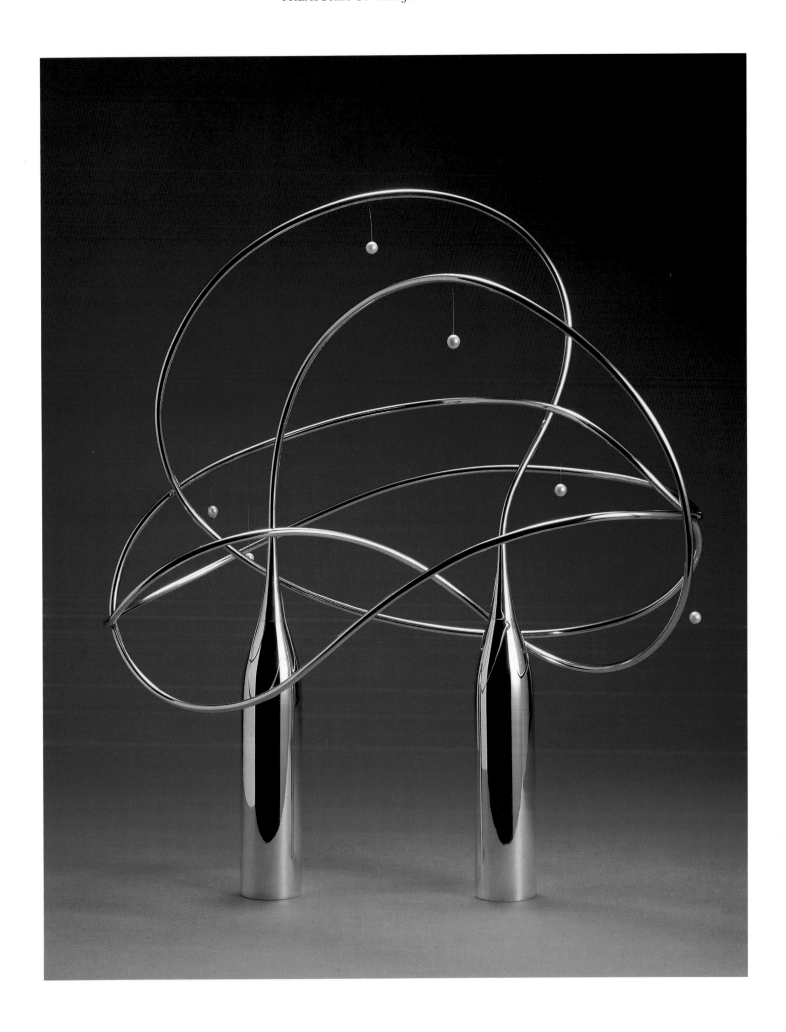

Leonard Baskin (American, b. 1922)
The Altar, 1977
Carved, laminated lindenwood
60 x 71 x 36 in. (152.4 x 180.3 x 91.4 cm)
Gift of Mr. Herman Tenenbaum and the Saul and Suzanne Mutterperl
bequest, by exchange. in honor of Mildred
and George Weissman, 1984-142

Leonard Baskin's figurative art stems from his deep understanding of artistic and literary traditions of both Western civilization and Judaism. The themes he derives from biblical, mythological, and other sources forcefully convey the dilemma of contemporary man.

The representational nature of Baskin's sculpture and graphics has been noted as an anomaly within the prevailing Abstract Expressionist and Minimalist aesthetic under which he matured. While certain stylistic conventions of these movements have found their way into his art, Baskin must be identified with the vital current of realism that continued to develop alongside abstraction in the post-war years.

For Baskin, meaning can be expressed only through the human figure. His realism is indeed a reductivist one; he pares his forms just as he condenses content. As noted by Irma Jaffe, mortality, grief, suffering, and homage are themes which inform Baskin's works. What at first appears as a pessimistic vision is filtered through the artist's manipulation of these emotions into an expression of renewal and hope.

The Altar, ranks as Baskin's greatest carving. It is the most refined synthesis of metaphysical themes with those of the Hebrew Bible and the artist's strong Jewish background. Out of this mass of wood emerges the figure of the trusting Isaac stretched out on the altar upon which Abraham dutifully prepared to sacrifice him. Isaac's back fuses with that of the angel who has come to retract God's order and with Abraham, who faces in the opposite direction, bewildered but relieved. Baskin's sculptural union of each of the three ancient protagonists—Isaac, Abraham, and the angel—projects the analogous tripartite conflicts within each man's psyche—id, superego, and ego, respectively.
NLK

Reference:
I.B. Jaffe, *The Sculpture of Leonard Baskin,* New York, 1980.

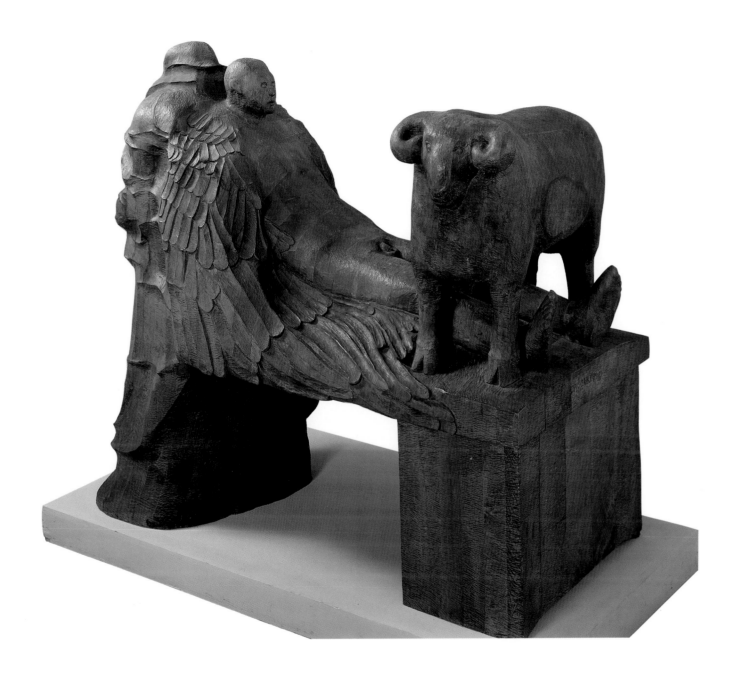

Benni Efrat (Israeli, b. 1936)
August, 1978–1979
Wood, latex, acrylic, and electric light projection
52 x 17 x 51 in. (132.1 x 43 x 129.5 cm)
Gift of Stanley and Selma Batkin, 1981-2

Israeli artist Benni Efrat has become part of the international avant-garde during the past decade, establishing his reputation through major exhibitions in Europe, Israel, and the United States. By means of manipulating objects, paint, and film, he analyzes light, shadow, color, and material, and conveys ideas about illusion and reality. Efrat seeks to represent cultural man through accessories, appliances, and electronics. These combine-media works have been called successors to Robert Rauschenberg's well-known innovation of the 1960s, combine-painting.

August employs a pentagonal door and frame, an open box painted black inside, and a hidden projection device, all within a black-ceilinged room. This configuration creates an ambiguous spatial situation. The light within the box is the force illuminating the colors painted on the open lid, the door, doorframe, and ceiling. These colors exist only by way of light, the energy that is the vision-producing part of the spectrum. Yet the color and light in this work dematerialize its tangible surfaces. Applicable here is the astute observation of art historian Flor Bex that instead of the expression of the illusion of reality, Efrat states the reality of illusion.
NLK

Reference:
Galerie de France, Paris, *Benni Efrat: Quest for Light,* 1982.

Joshua Neustein (Israeli, b. Danzig, 1940)
Weimar Series II, 1981
Paper and acrylic construction
74¼ x 58⅛ in. (188.6 x 147.6 cm)
Gift of Stanley and Selma Batkin, 1981–241

Fig. 64. Dorothea Rockburne, *Seraphim: Love*, 1982, watercolor on vellum. Private collection: Courtesy Xavier Fourcade, Inc.

Art critic Robert Pincus-Witten coined the term "epistemic abstraction" for the art movement that began simultaneously in both New York and Jerusalem around 1968. The term refers to art pertaining to the nature of knowledge, hence how a viewer understands basic physical truths. The New York epistemologists Mel Bochner and Dorothea Rockburne are concerned with the visual examination of Pythagorean theorem and the golden mean ratio, respectively. Israeli artist Neustein's work concentrates on a comprehension of the fold, the tear, and the cut. In his use of these methods for the manipulation of paper, Neustein makes the viewer retrace the artist's process — imagining a restraightening, realigning, and mending. The beholder is also forced to contemplate what is hidden under and behind the visible artwork.

Neustein's constructions during the formative years of "epistemic abstraction" (1968–72) were leaden gray, devoid of color. It was only in 1978 with the beginning of the Weimar series that he began to employ color. Named for the failed Republic during which the violent palette and brush work of German expressionism conveyed the artists' frustrations, Neustein's homage to Nolde, Kirschner, et al. is best expressed in his own words as an "attempt to paint portraits of paintings in their own debris." The adjectives "fragile," "torn," and "impermanent" are frequently used to describe Neustein's constructions and apply as well to the work of other Israeli members of this movement — notably Pincas Cohen Gan and Benni Efrat. These Israelis opt for destructive physical processes such as tearing, erasing, scratching, or as with Efrat, optical negation of the physical surface through light (see p. 198). The contrast between their nihilistic expressions and the constructive and more mathematically analytical techniques of their American counterparts (see fig. 64) convey different national concerns. The Israeli artists' vandalization of their own material apparently echoes the precarious war-torn plight of the Jewish state.
NLK

Reference:
R. Pincus-Witten, "The Neustein Papers," *Arts Magazine,* 52, No. 2 (October, 1977), pp. 102–115.

George Segal (American, b. 1924)
The Holocaust, 1982
Plaster, wood, and wire, 10 x 20 x 20 ft. (304.8 x 609.6 x 609.6 cm)
Museum purchase through an anonymous gift, 1985–176 a-l

The creation of works of art relating to the Holocaust and the memorializing of its victims has been approached cautiously in the forty years since those tragic events. Questions about whether this subject should be conceived abstractly or realistically have vied with notions about whether it is even fitting to attempt a tangible monument to these martyrs. However, in 1981, the city of San Francisco, determined to establish such a memorial, organized a committee to oversee a sculptural competition for the commission. Segal, asked to submit an entry, used his hallmark technique of casting living persons directly in plaster for this original model. This plaster was selected to be cast, and that bronze is now prominently displayed near San Francisco's Palace of the Legion of Honor. The work is clearly one of the most important artistic statements of this devastating moment in 20th-century history.

In his haunting representational manner, using plaster casts of actual individuals and real props, Segal has condensed many of the horrific images of the manic devastation into one. A pile of corpses lies behind a barbed wire fence; a solitary survivor stands mute in the foreground, clutching the sharp metal. The artist used photographs taken shortly after the Allied liberation of the camps as his sources. Similar photographs of disordered mounds of cadavers had already served Picasso for his well-known painting, *The Charnel House* (see fig. 65). Segal reacted strongly to the obscene disarray of bodies he was forced to confront in these visual documents. He was shocked by the notorious disregard of the usual sacred rituals of death.

As noted by Sam Hunter, Segal purposely organized the composition to neutralize chaos and inject human meaning into this sculptural transposition from journalistic photography. The indistinct modeling of the ten bodies and the presence of a lone survivor relieve the harrowing reality, permitting the viewer enough remove to engage in Segal's tragic poetry.

The ordered composition functions on numerous levels relating to artistic and literary sources, to Segal's personal iconography, and to his earlier works. The stack of corpses is a realization of Segal's earlier but unexecuted conception for the FDR Memorial, the discomforting motif which he had also considered for *The Execution* of 1967. The star-shaped arrangement of the bodies in *The Holocaust* includes the figure of a woman holding a half-eaten apple, an allusion to Eve; a figure with outstretched arms, symbolic of Jesus and suffering; and an older man lying near a young boy, referring to

Fig. 65. Pablo Picasso, *The Charnel House*, 1944–45, oil and charcoal on canvas, 6 ft. 6⅝ in. x 9 ft. 2½ in. (199.8 x 250.1 cm). Collection, The Museum of Modern Art, New York. Acquired through the Mrs. Sam A. Lewisohn Bequest (by exchange) and Mrs. Marya Bernard in memory of her husband, Dr. Bernard Bernard, William Rubin and Anonymous Funds.

Segal's earlier, controversial *Abraham and Isaac*. The man poised by the fence is based on a Margaret Bourke-White photograph and was modeled from Segal's friend, an Israeli survivor of the camps. That presence suggests hope and survival. His psychic isolation and mental pain, exaggerated by an unconscious clutching at the sharp-edged wire, are perhaps best described in the words of another survivor and eloquent witness of these atrocities, Elie Wiesel: 'How can one repress the memory of indifference one had felt toward the corpses. Will you ever know what it is like to wake up under a frozen sky, on a journey toward the unknown, and record without surprise that the man in front of you is dead, as is the one before him and the one behind you? Suddenly a thought crosses one's mind: What if I too am already dead and do not know it?'

NLK

References:
S. Hunter and D. Hawthorne, *George Segal,* New York, 1984, pp. 132–134; P. Tuchman, *George Segal,* New York, 1983, pp. 58–107; E. Wiesel, *A Jew Today,* New York, 1978, p. 188.

Alain Kirili (French, b. 1946)
Commandment II, 1980
Forged iron, 17 elements, approximately 14½ in. high (37 cm)
Museum purchase through funds provided by Vera and Albert List,
Joan and Hyman Sall, and Fine Arts Acquisition Fund, 1984–137

Alain Kirili sculpts forged iron abstractions that hover near, but never dissolve into, nonobjectivity. These sculptures have been noted by the critic Donald Kuspit as a fusion of French formalism with American energy. Kirili's European sensibility was nurtured by his observation of conceptual trends in the American-dominated sculpture of the late 1960s and early 1970s. Ironically his work matured in the late 1970s at the very moment European art and representational subjects again became prominent forces in the contemporary art world. The resultant power of Kirili's sculpture is comparable to that of Hans Hofmann's late painting. Both artists successfully merge European confinement and intellectualism with America's vastness and physicality.

Kirili learned iron forging from American and Austrian craftsmen, and while the technique for his works is primitive, his repertoire comes from the thoroughly sophisticated knowledge of Western and Eastern art. Sources for his work range from Nepalese figures and medieval funerary monuments to the abstractions of Clyfford Still, Barnett Newman, and David Smith. Kirili scrutinizes these sources for their emotive power, which he transmutes into his essential forms. As has been eloquently noted by Robert Rosenblum, Kirili's sculptures encompass a range of universal experience dealing with, among other themes, myth and religion, and life and death.

Each of the six sculptures of the *Commandment* series consists of individual floor pieces composed of symbolic elements precariously supported by small rectangular blocks. Each top is a unique form and symbol, each identical base provides a unifying repetition; yet the tops and bases also can be "read" together as one unit or idea. This series results from Kirili's own admitted fascination with scriptural, monotheistic, and traditional concepts.

Based on Kirili's firsthand observations of the changeless art of the Torah scribe, these sculptures attempt to render in three dimensions the squarish forms of the Hebrew letters that comprise the holy scrolls. The sculptor transforms penned ink into forged iron as he visualizes the conceptual imperatives behind the commandments set forth in the text. Through slight variations in each form, Kirili suggests the different aspects of each commandment. Through the grouping of individual elements, he implies the commandments' unity. The top-heavy pressure of the symbols on their almost-too-weak bases, and the integral relationship of symbol to base, suggest dutiful fulfillment of the commandments by the commanded.

In selecting a title for his conceptual amalgam of Hebrew letters and religious ideas, Kirili seized upon the similarity in both shape and meaning of his *Commandments* to Torah finials (see p. 88). The Hebrew word for these crowning ornaments of the Holy Scroll means pomegranates, fruits traditionally associated with fertility. According to legend its seeds were said to number 613, the exact number of commandments in the Pentateuch. Kirili compares his manipulations of form to the variations of the symbol-laden pomegranate shapes of Torah finials.

NLK

References:
Galerie Adrien Maeght, Paris, *Alain Kirili,* exh. cat. by D. Kuspit, 1984; Kunstmuseum Düsseldorf, *Alain Kirili,* exh. cat., 1983.

The following list of works was selected to provide a basic introduction to the field of Jewish art for the English reading public, and cannot take into account the numerous works consulted in the preparation of this book.

D. Altshuler, ed., *The Precious Legacy: Judaic Treasures from the Czechoslovak State Collections,* New York, 1983.

J. Gutmann, ed., *Beauty in Holiness: Studies in Jewish Customs and Ceremonial Art,* New York, 1970.

J. Gutmann, *Jewish Ceremonial Art,* New York, 1964.

The Jewish Museum, New York, *Artists of Israel: 1920–1980,* exh. cat. by S. T. Goodman, Detroit, 1981.

The Jewish Museum, New York, *The Circle of Montparnasse: Jewish Artists in Paris 1905–1945,* exh. cat. by K. E. Silver and R. Golan, New York, 1985.

The Jewish Museum, New York, *Danzig 1939: Treasures of a Destroyed Community,* exh. cat., New York, 1980.

The Jewish Museum, New York, *Jewish Themes in Contemporary American Art,* exh. cat. by S. T. Goodman, New York, 1982.

The Jewish Museum, New York, *A Tale of Two Cities: Jewish Life in Frankfurt and Istanbul 1750–1870,* exh. cat. by V. B. Mann, New York, 1982.

The Jewish Museum, New York, and the Museum of American Folk Art, New York, *The Jewish Heritage in American Folk Art,* exh. cat. by N. L. Kleeblatt and G. C. Wertkin, New York, 1984.

Journal of Jewish Art, Center for Jewish Art, Hebrew University, Jerusalem.

A. Kampf, *Jewish Experience in the Art of the Twentieth Century,* South Hadley, Mass., 1984.

C. H. Krinsky, *Synagogues of Europe,* Cambridge, Mass. and London, 1985.

F. Landsberger, *A History of Jewish Art,* 2d ed., New York and London, 1973.

M. Narkiss, *Hebrew Illuminated Manuscripts,* Jerusalem, 1969.

C. Roth, *Jewish Art: An Illustrated History,* 2d ed., Greenwich, Conn., 1971.

A. Rubens, *A History of Jewish Costume,* 2d ed., New York, 1973.

A. Rubens, *A Jewish Iconography,* rev. ed., London, 1981.

I. Shachar, *Jewish Art and Tradition: The Feuchtwanger Collection of Judaica,* trans. by R. Grafman, Jerusalem, 1981.

R. Wischnitzer, *The Architecture of the European Synagogue,* Philadelphia, 1964.

R. Wischnitzer, *Synagogue Architecture in the United States: History and Interpretation,* Philadelphia, 1955.

ABSTRACT EXPRESSIONISM — art also known as "action painting" that obliterates the distinctive aspects of line, form, perspective, and color in order to allow the artist greater freedom to explore and externalize his subconscious. Its essence was the spontaneous expression of the artist in nonobjective visual terms, without conscious references. Produced in New York in the 1940s and 1950s, its leading exponent was Jackson Pollock.

ASHKENAZI — in medieval Hebrew lit. "German"; conventional term used to designate Jews of West or East European origin.

THE BAUHAUS — school of architecture, industrial design, and craftsmanship founded in Weimar, Germany, in 1919 by Walter Gropius; it advocated a synthesis of art and technology. Its teachers included Lyonel Feininger, Paul Klee, and Wassily Kandinsky.

BARBIZON SCHOOL — a group of French landscape painters centered in the village of Barbizon in the Forest of Fontainebleau from the 1830s to the 1870s; their goal was the observation and accurate recording of nature.

BAROQUE — a period largely in the 17th century whose art is marked by three-dimensionality, by the interaction of the space of the work and the space surrounding it, and by a heightened sense of drama.

BIEDERMEIER — style of furniture and interior decoration favored by the middle class in Germany and Austria during the years 1815–1848. Also refers to paintings of this period that offered visions of coziness, informality, and comfort beloved by the bourgeoisie.

BIMAH — a raised platform in the synagogue from which the Torah is read.

CHRONOGRAM — the writing of a date by means of words or biblical verses, based on the numerical value assigned to each letter in the Hebrew alphabet.

CUBISM — a style of art cofounded in 1907 by Pablo Picasso and Georges Braque that stressed abstract structure at the expense of other pictorial elements. It is characterized by the breaking up of natural forms and the simultaneous display of several points of view of the fragmented object.

CURTAIN FOR THE TORAH ARK — a curtain hung in front of the Torah ark in synagogues. It may have a matching valance.

DIASPORA — Jewish settlement outside the land of Israel.

ETROG — citron, a fruit resembling a lemon; it is one of the four species of plants used during the liturgy of the Sukkot holiday.

FAUVISM — movement centering around a group of French painters, led by Matisse, who exhibited at the Paris Salon d'Automne of 1905 and subsequently received the derogatory appellation "*les fauves*" (French, "the wild beasts"). Their works are characterized by vivid colors, violent distortions, flat patterns, and bold brushwork.

HAGGADAH — the liturgical order of service for the *seder*. Also the term for the book containing the service.

HALAKHAH — generic term for Jewish law based on the Torah, the Talmud, and rabbinic exposition.

HAMSA — in Arabic lit. "five"; a hand-shaped amulet. It is commonly used by both Muslims and Jews as an apotropaic device against the evil eye.

HANUKKAH — a Jewish holiday commemorating the victory of the Hasmoneans over their Greco-Syrian overlords in 165 B.C.E. and the establishment of religious freedom in ancient Israel.

HASIDISM — Jewish mystical and religious movement founded in Poland about 1750; distinguished by mass enthusiasm, group cohesion, and charismatic leadership.

HAVDALAH — in Hebrew lit. "separation"; a ceremony held to mark the end of Sabbaths and holy days and the beginning of the workday week.

HUPPAH — a canopy under which the bride and groom stand during their wedding ceremony.

IMPRESSIONISM — French movement whose aim was to achieve greater naturalism by the exact analysis of tone and color and by attempting to simulate actual reflected light by means of small dots and strokes which, while blurring the details, would retain the general impression. The first impressionist exhibition, held in Paris in 1874, included paintings by Monet, Renoir, Pissarro, Cézanne, and Degas.

JUDENGASSE — in German lit. "Jew's street"; the main street in the Jewish ghetto of Frankfurt.

KETUBBAH — in Hebrew lit. "that which is written"; a Jewish marriage contract.

KIDDUSH — prayer of sanctification over wine recited on Sabbaths and festivals.

KOHEN — priest; a descendant of Aaron, the biblical high priest (plural: *kohanim*).

LEVITE — a descendant of the tribe of Levi, aides to the priests of the ancient Temple.

MATZAH — unleavened bread eaten during Passover.

MEGILLAH — a scroll, e.g., *Megillat Esther,* the Book of Esther written on a scroll.

MENORAH — a seven-branched candelabrum found in the biblical sanctuary and Jerusalem Temple; a similar candelabrum found in a synagogue; an eight-branched candelabrum used during the Hanukkah festival (plural: *menorot*).

MINIMALISM — reductive movement of the 1960s and 1970s in New York espousing minimal color and minimal image to achieve the greatest effect. The painting rejects subject matter, space, and texture, and relies exclusively on elementary shapes and flat color. The sculpture, usually monumental in scale, eliminates all personal overtones and emphasizes geometric forms and symmetry to project its presence.

MISHNAH — body of Jewish oral law or *halakhah* edited by Rabbi Judah ha-Nasi around the beginning of the 3d century C.E.

MODERNISM — a practice pertaining to modern times; the self-conscious break with the past in the quest for new modes of expression. Modernism implies an artist's right to recreate nature and to reject previously established artistic principles and conventions, and proclaims his right to express his subject, feelings, or thoughts in any way he deems necessary.

NEOCLASSICISM — the revival or adaptation of aesthetic principles or style embodied in the art and architecture of ancient Greece and Rome.

OMER — period between the second day of Passover and the first day of Shavuot.

PARIS SALON — an annual juried exhibition of painting and sculpture dating from the 17th century and organized since 1881 by the Société des Artistes Français.

PASSOVER — the spring pilgrimage festival commemorating the Exodus from Egypt (Heb. *Pesach*).

PRE-RAPHAELITE BROTHERHOOD (PRB) — an association formed in London in 1848 by William Holman Hunt, John Everett Millais, and Dante Gabriel Rossetti who sought to restore the principles characteristic of Italian art before Raphael. Their clear-colored paintings are typified by serious subjects, often religious, charged with symbolic meaning, and executed in sharp focus.

REALISM — movement going back to Courbet and Manet in the 1850s signifying an adherence to real life, however coarse or ugly, and the absolute repudiation of idealization in art.

REGENCY — an English classical revival style, at its height during the period of George IV's regency as Prince of Wales from 1810 to 1820, incorporating Greek, Roman, and Egyptian motifs.

RENAISSANCE — a period beginning in the 14th and 15th centuries marked by a revival of classical texts, forms, structures, and style.

RIMMON (IM) — in Hebrew lit. "pomegranate(s)"; adornment for the staves of the Torah scroll.

ROCOCO — a decorative style of the 18th century characterized by a lightness and playfulness of forms and iconography whose quintessential motif is the shell (*rocaille* in French).

ROMANTICISM — style characterized by an emphasis on the imagination, expression of passion, love of the exotic, awe of nature, and an interest in illustrating literary themes. Embodied in the art of Eugene Delacroix, the movement reached its height around 1830 in France, England, and Germany.

ROSH HASHANAH — the New Year; holy days occurring on the first and second days of the Hebrew month of Tishri.

SEDER — in Hebrew lit. "order"; term given to the fourteen-part order of liturgical home service for the first two nights of Passover, which includes recitation of the story of the Exodus from Egypt, accompanied by ritual eating and drinking.

SEPHARDI — in Medieval Hebrew lit. "Spanish" or "of Spain"; conventional term used to designate Jews of Spanish and Portuguese ancestry.

SHAMMASH — in Hebrew lit. "servant" or "one who ministers"; used to designate a synagogue functionary (sexton) and, specifically, the candle or light on the Hanukkah lamp that kindles (serves) the eight other lamps.

SHAVUOT — Feast of Weeks; a two-day festival commemorating the giving of the Torah at Sinai and the bringing of offerings to the Temple in Jerusalem, which occurs seven weeks after the second day of Passover.

SHIVITI — a plaque hung in a synagogue inscribed with the verse *shiviti hashem lenegdi tamid* "I am ever mindful of the Lord's presence" (Ps. 16:8).

SPICE CONTAINER — a container for spices used during the *havdalah* service.

SUKKAH — in Hebrew lit. "booth"; a temporary shelter erected during the Festival of Sukkot (Feast of Tabernacles) to recall the homes inhabited by the ancient Israelites during their wanderings in the desert.

SUKKOT — Feast of Tabernacles; in Hebrew lit. "booths"; festival which falls four days after Yom Kippur, at the time of the autumnal harvest.

TALLIT — a prayer shawl (plural: *tallitot*).

TALMUD — in Hebrew lit. "study" or "learning"; rabbinic commentary on the Mishnah. The Babylonian Talmud was compiled circa 500 C.E., the Jerusalem Talmud circa 400 C.E.

TORAH — a parchment or leather scroll inscribed with the first five books of the Hebrew Bible.

TORAH ARK — a cabinet set in or against one wall of a synagogue. It holds the Torah scrolls and is the focus of prayer.

TORAH BINDER — a band that holds the two staves of a Torah scroll together when the Torah is not being read.

TORAH CURTAIN — see Curtain for the Torah ark.

TORAH MANTLE — a cover of silk or other precious fabric that encases the Torah scroll and is removed for reading.

TORAH SHIELD — a metal plaque hung from the staves of a Torah, sometimes having small interchangeable plates inscribed with the names of holy days, indicating the appropriate readings.

VORTICISM — an English movement founded by Wyndham Lewis in 1912; its abstract geometric compositions were directly related to machines and the industrial age.

WIMPEL — the Ashkenazi name for a Torah binder.

YOM KIPPUR — in Hebrew lit. "Day of Atonement"; a day of fasting and prayer that falls on the tenth day of the Hebrew month of Tishri.

Z.L. — z(ikhrono) l(ivrakhah) (fem. zikhronah l(ivrakhah)), in Hebrew lit. "may his (her) remembrance be for a blessing"; a Hebrew honorific used after the name of a deceased person.

Photographs of comparative works of art reproduced in this catalogue have been supplied, in most cases, by the owners or custodians of the works as cited in the captions. The following list applies to photographs for which an additional acknowledgment is due and to the photographs of Jewish Museum works:

Helene Adart: fig. 19

Art Resource: figs. 1, 7, and 20

Bildarchiv Foto Marburg: fig. 5

Will Brown: p. 131

Christie's: fig. 28

Geoffrey Clemens: p. 83

Coxe-Goldberg: pp. 31, 33, 35, 113, 133; fig. 40

Galerie de France: p. 199

Meiron Excavation Project: fig. 36

John Parnell: pp. 27, 29, 37, 39, 41, 45, 51, 53, 55, 57, 59, 61, 65, 67, 69, 75, 79, 85, 89, 93, 95, 97, 99, 101, 109, 115, 117, 119, 121, 125, 129, 141, 143, 145, 149, 153, 155, 159, 161, 165, 167, 169, 171, 175, 177, 179, 181, 185, 187, 189, 191, 195, 197, 201

Nicholas Sapieha: pp. 49, 77, 87, 91, 97, 111, 151

Dr. Johanna Spector: fig.11

S.P.A.D.E.M., Paris, N.A.G.A., New York, 1985: fig. 60

Malcolm Varon: pp. 43, 47, 63, 71, 73, 81, 105, 107, 123, 135, 139, 147, 157, 193

Israel Zafir: p. 183

Alan Zindman: p. 204